15

795

THE UNTERMYER COLLECTION

Highlights of the

UNTERMYER COLLECTION

of English and Continental Decorative Arts

The Metropolitan Museum of Art

ON THE COVER: Pilgrim bottles, about 1690 (no. 51) Photo by William F. Pons

Catalogue designed by Peter Oldenburg
Composition by Custom Composition Company
Printed by Nicholas/David Lithographers
Copyright © 1977 by The Metropolitan Museum of Art

Library of Congress Cataloging in Publication Data

New York (City). Metropolitan Museum of Art.
 Highlights of the Untermyer Collection of English and
continental decorative arts.

 1. Art, Decorative—Exhibitions. 2. Untermyer,
Irwin—Art collections. I. Title.
NK613.N48M476 1977 745′.094′07401471 77-12235
ISBN 0-87099-169-8

Foreword

For his munificence and his devotion to the Metropolitan Museum and its collections, Judge Untermyer will be remembered as one of the institution's greatest benefactors. By gift and bequest, he gave to the Museum one of the finest and largest collections of English decorative arts, dating from the sixteenth century to the end of the eighteenth, as well as an exceptional collection of Continental porcelain and bronze sculpture. Long known as one of the finest of its kind, the Untermyer Collection has transformed the Metropolitan's collection of English decorative arts into one of the most important outside England.

A superb collector whose discriminating eye was not affected by changing tastes, Judge Untermyer was the first in the United States to collect English needlework, and, beginning in the early 1940s, he was among the first in the country to collect Meissen porcelains. In later years, he continued to acquire outstanding examples of English furniture and rarely missed an opportunity to satisfy his passion for English silver. Since it had always been his intention to bequeath his collection to the Museum, he was careful never to duplicate, but rather to complement, existing Museum holdings.

The Museum benefited from his wise counsel as a member of the Board of Trustees from 1951 to 1971. He served on the Executive Committee, the Acquisitions Committee, and as Trustee Chairman of the Visiting Committee to the Western European Arts Department. From 1971 until his death in 1973 he was a Trustee Emeritus.

As an admiring friend and fellow Trustee of Irwin Untermyer for many years, I take great personal pleasure in this exhibition and publication, both of which honor his memory by showing the range of his magnificent generosity. All of us at the Metropolitan are most grateful for the support of the Untermyer family in this endeavor.

DOUGLAS DILLON
President
The Metropolitan Museum of Art

Introduction

Few private collections in our time have been more consistently museum-oriented than the Untermyer Collection. Begun in New York around 1912, it grew over sixty years, through a constant process of addition, improvement, and refinement. In 1941, when Judge Untermyer first offered to bequeath it to the Museum, it already had the clearly defined categories that it had at his death in 1973: English furniture and silver, English and Continental embroideries, English and German porcelain of the eighteenth century, and medieval and Renaissance bronzes.

About 1950, the Judge felt that his already large collection should be described and illustrated in a series of catalogues. Toward this end he had the good fortune to obtain the assistance of Yvonne Hackenbroch, a distinguished art historian, who later became one of our curators. Six catalogue volumes were published between 1957 and 1963, followed by a revision of one of them in 1969. Even then the Judge continued to add to, and to refine, his collection, which he housed in his spacious apartment at 960 Fifth Avenue. During the last years of his life he was more than ever interested in English silver and English furniture, and he purchased during this period some of his most important pieces.

As a result of Judge Untermyer's generous and enlightened foresight, the objects that have come to the Museum, 2,129 in number, will not remain together but go to strengthen three different areas of our European holdings. Their most significant contribution will be to our collection of English decorative arts, which, thanks to them, will now be nearly without rival. The German porcelains, hardly to be matched anywhere outside Germany, will give the Museum eminence in this field. The Museum's collection of Renaissance bronzes will also be substantially enlarged and strengthened by the Judge's numerous distinguished examples, both Italian and Northern.

Prior to this distribution, we present in this exhibition the very best of the entire collection, both to suggest the Judge's total achievement as a collector and to pay tribute to his sense of quality, the broad range of his historical and cultural interests, and his independent taste for the unique and the rare.

The exhibited objects have been studied by curators of the departments of Medieval Art and Western European Arts over a period of some three years, and the catalogue they have prepared reflects scholarship published over the last twenty years in almost all the fields represented in the collection. In many cases, recent literature and the publication of

new documents have led to identifications and findings substantially different from those proposed in the earlier Untermyer catalogues.

We have also had the opportunity to review the physical condition of all objects with the help of our Conservation and Research Laboratories. Much new information has resulted, especially for the furniture and the bronzes.

The large number of ceramics (859) made a selection of highlights especially difficult. The entries included here were confined to the ceramics about which Miss Hackenbroch felt that she could provide essentially new information. For a fair assessment of the collection, therefore, the reader will still have to turn to the earlier catalogue volumes on German and English porcelains.

The study of the collection and the preparation of this catalogue have benefited from the generous assistance of many individuals. All involved, I am sure, will join me in expressing gratitude to Yvonne Hackenbroch, whose initial research on the entire collection provided the starting point for all the entries, and who contributed first-hand records and other information concerning the provenance of the furniture and the bronzes. Among those in the Museum, James Parker selected the pieces of furniture catalogued by William Rieder; Jessie McNab Dennis helped with the identification of heraldry on several of the silver pieces and with Clare Le Corbeiller and Penelope Hunter Stiebel assisted with a great many problems, especially those pertaining to conservation and photography; Edith Standen advised Jean Mailey in connection with the textiles.

Among those outside the Museum, Ingelore Menzhausen gave Miss Hackenbroch access to unpublished archival material in Dresden concerning the porcelains; Colin Eisler helped Miss Mailey with the study of No. 345; Richard E. Stone contributed his technical expertise to the study of many of the bronzes; Peter Meller, Jennifer Montagu, Anthony Radcliffe, and Jörg Rasmussen advised James Draper while cataloguing the bronzes and other sculpture; Benno Forman, Christopher Gilbert, John Hardy, Helena Hayward, and Colin Streeter helped William Rieder in connection with the furniture entries; and Sarah Coffin volunteered time and effort in assisting Miss Hackenbroch with research on the silver collection.

Within the Museum again, James Draper coordinated many of the tasks in preparing the catalogue, Pamela Gibney reviewed the text of the silver and porcelain entries, and Laura Camins helped edit and check references for the silver and porcelain entries.

It is my hope that this catalogue will not only serve as a useful companion to the exhibition but make a significant scholarly contribution to the different fields represented in it.

OLGA RAGGIO
Chairman
Department of Western European Arts

SILVER

The entries are by
YVONNE HACKENBROCH,
Consultative Curator, Department of Western European Arts.

Abbreviations

Christie's Bi-Centenary
Review, 1966

Christie's Bi-Centenary Review of the Year, 1766–1966, London, 1966

Clayton, 1971

M. Clayton, *The Collector's Dictionary of the Silver and Gold of Great Britain and North America*, New York, 1971

Grimwade, 1976

A. G. Grimwade, *London Goldsmiths, 1697–1837*, London, 1976

Hayward, 1959

J. F. Hayward, *Huguenot Silver*, London, 1959

Jackson, 1911

C. J. Jackson, *An Illustrated History of English Plate*, 2 vols., London, 1911

Oman, 1970

C. C. Oman, *Caroline Silver*, London, 1970

Untermyer *Silver*, 1963

Y. Hackenbroch, *English and Other Silver in the Irwin Untermyer Collection*, New York, 1963

Untermyer *Silver*, 1969

———, *English and Other Silver in the Irwin Untermyer Collection*, rev. ed., New York, 1969

1.

Jug

Tigerware and silver gilt
Maker's mark: CA in monogram (on neck and
 cover)
London: 1555
H. 7¾ in (19.7 cm.)
68.141.144

This Rhenish jug, in English mounts of the period
of Mary Tudor, is of a type known as tigerware, the
name referring to the mottled brown of the stone-
ware. Though the jugs had a great vogue through-
out the Elizabethan age, few were made later. The
mounts of this early example are relatively narrow
and plain. A tigerware jug of 1556 by the same
maker is in the Victoria and Albert Museum. Such
jugs were not only mounted by London goldsmiths
but also by provincial masters, such as C. Eston of
Exeter, whose mark is found on an example in the
Untermyer Collection (1974.28.211). Later exam-
ples have broader foot- and neckbands, higher
domed covers with finial, and increasingly elaborate
embossed decoration. Besides tigerware jugs, jugs
made of white pipe clay from Siegburg, also in the
Rhineland, were popular in Elizabethan England.
Two such jugs with unmarked silver-gilt mounts
are in the Untermyer Collection (1970.131.1, 2).
All these mounted vessels, combining the useful
with the decorative, are typical of the Elizabethan
domestic scene.

EXHIBITED: British Antique Dealers' Association,
 Christie's, London, 1932, *Art Treasures Exhibition,* no.
 446.
REFERENCES: Untermyer *Silver,* 1969, no. 6, ill.

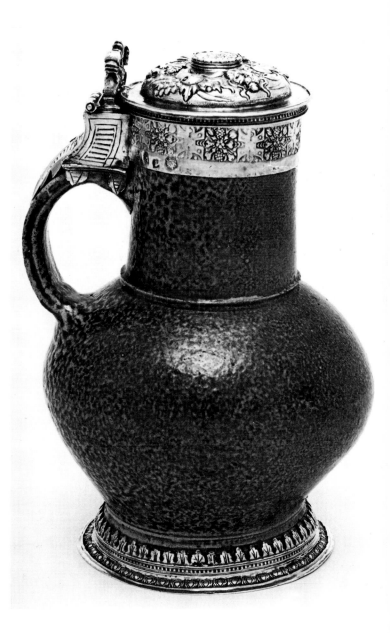

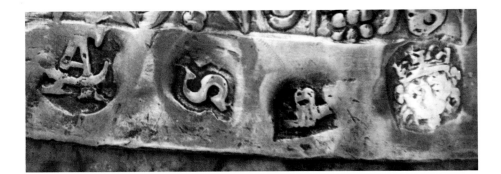

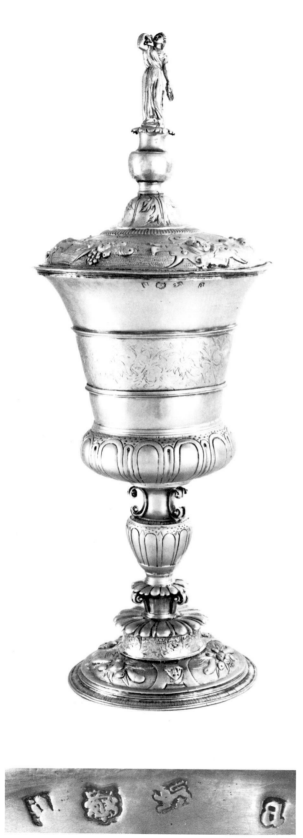

2.

Covered cup

Maker's mark indistinct
London: 1558
H. 14½ in. (38.8 cm.)
68.141.298a, b

Made during the year of Queen Elizabeth I's accession, this cup recalls some of the designs that Hans Holbein the Younger had produced for Henry VIII, for example, those depicting the gold cup of Jane Seymour. The ornamentation, however, has been modified to include embossed floral motifs, bunches of fruit, and masks, all of which were to become characteristic of the Elizabethan style. The finial figure, on the other hand, is an addition that may have replaced a vase-shaped one. Among similar cups is the one presented by Sir Martin Bowes to the Goldsmiths' Company in 1561; also the pair of cups which Archbishop Parker gave to Trinity College on New Year's Day, 1569, and to Gonville and Caius College, Cambridge, in the same year.

EX COLL. W. R. Hearst, St. Donat's Castle, Glam., Wales (Christie's, 14 December 1938, lot 105, ill.); S. J. Phillips.

EXHIBITED: British Antique Dealers' Association, Christie's, London, 1932, *Art Treasures Exhibition,* no. 450.

REFERENCES: C. R. Beard, *Connoisseur,* CII, 1938, p. 288, ill.; Untermyer *Silver,* 1969, no. 1, frontispiece.

3.

Toasting fork

Unmarked, dated 1561
England
Exotic hardwood and silver
L. 34½ in. (87.7 cm.)
Device: (engraved on handle) initials GR, a rail (chain), and a tun (barrel), a pun on last name of George Railton of Norfolk
68.141.297

Apparently the earliest surviving English toasting fork. Another silver-mounted example appears in

the inventory drawn up at the death of Thomas, Lord Warton, in 1568, when his fork was valued three shillings fourpence.

EX COLL. George Railton; A. G. Paterson (Sotheby's, 27 January 1966, lot 148, ill.).
REFERENCES: Untermyer *Silver,* 1969, no. 8, ill.; Clayton, 1971, p. 318, fig. 668.

EX COLL. Rt. Hon. Sir Samuel Montague, first Lord Swaythling (Christie's, 6–7 May 1924, lot 115); W. R. Hearst.

EXHIBITED: Burlington Fine Arts Club, London, 1901, *Exhibition of a Collection of Silversmiths' Work of European Origin,* pl. 49, fig. 1; Burlington Fine Arts Club, London, 1910, *Early Chinese Porcelain,* no. 6, ill.

REFERENCES: R. L. Hobson, *Chinese Pottery and Porcelain,* London, 1915, II, pp. 6, 74; H. P. Mitchel, *Country Life,* XLVI, 16 August 1919, p. 208, ill.; C. J. Jackson, *English Goldsmiths and Their Marks,* London, 1921, p. 100; Y. Hackenbroch, *Connoisseur,* CXXXVIII, 1956, p. 183, no. 3, ill.; H. Honour in *The Tudor Period: 1500–1603,* Connoisseur Period Guides, I, New York, 1957–58, pl. 45A.

4.

Cup and cover

> Porcelain and silver gilt
> Maker's mark: bird in shaped shield (on foot and cover)
> London: 1565–70
> H. 7⅜ in. (18.7 cm.)
> 68.141.125

Incorporating a Chia Ch'ing period (1522–66) porcelain bowl (red outside, blue and white inside), this rare cup was presented by James II to H. Green of Rolleston Hall, Groom of the Stairs, with whose descendants it remained until purchased by Lord Swaythling. A cup just like it was presented by a Mr. Lychfelde to Queen Elizabeth as a New Year's gift in 1582: "Item one Cvp of Pursseline thonesyde paynted Red the foute and Cover sylver guilt poiz all/xiiij oz. quarter. exr. a Ringe Lyk a snak on the top of the Cover" (A. J. Collins, *Jewels and Plate of Queen Elizabeth I, in the Inventory of 1574,* London, 1955, p. 592). The final, in the shape of a snake ring, is emblematic of self-consuming Time and the victory of Truth, derived from contemporary emblem books. Lychfelde's cup and this one have almost identical weights.

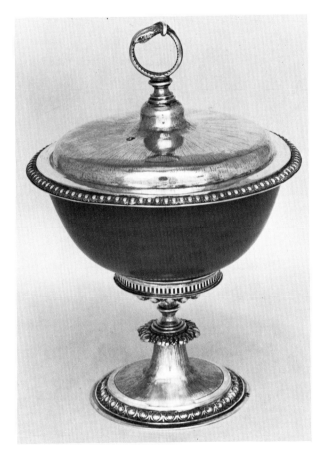

5.

Covered jug

Maker's mark: ER in monogram (three times)
London: 1566
Carved coconut and silver gilt
H. 9 in. (22.9 cm.)
Heraldry: (on cover) a talbot (hunting dog)
68.141.204

Such cups, mounted in silver or silver gilt, were favorite table decorations in the late Middle Ages; most of the coconuts were polished, a few engraved. In the sixteenth century the shells began to be cut with figural scenes in low relief to harmonize with their elaborate raised and embossed silver mounts. The scenes here, Netherlandish in style, represent Isaac blessing Jacob, Jacob wrestling with the angel, and Rebecca and Eliezer at the well. A similar coconut forms part of a covered cup in the Lee of Fareham Collection, Royal Ontario Museum, Toronto (W. W. Watts, *Works of Art in Silver and Other Metals Belonging to Viscount and Viscountess Lee of Fareham,* London, 1936, pl. 40). The talbot crest was the badge of the Earls of Shrewsbury, the most distinguished of whom was George, sixth Earl, the nobleman entrusted with the custody of Mary Queen of Scots.

EX COLL. Up Park Heirlooms; S. J. Whawell; S. J. Phillips.

EXHIBITED: Grafton Galleries, London, 1928, *Exhibition of Art Treasures, under the Auspices of the British Antique Dealers' Association,* no. 923, ill.; Residence of Sir Philip Sassoon, London, 1929, *Loan Exhibition of Old English Plate and Decorations and Orders, for the Benefit of the Royal Northern Hospital,* no. 61, pl. 4; British Antique Dealers' Association, London, 1932, *Art Treasures Exhibition,* no. 453, ill.; Victoria and Albert Museum, London, 1962, *International Art Treasures Exhibition,* no. 293.

REFERENCE: Untermyer *Silver,* 1963, no. 3, ill.

6.

Covered cup

Maker's mark: M with line across
London: cup 1575, cover 1581
H. 6½ in. (16.5 cm.)
1974.28.151a, b

This maker's mark appears on several beakers. The body of a covered example of 1573, in the City Art Gallery, Manchester, is engraved almost identically. Characteristic of both are their engraved bodies and embossed covers. This seemingly intentional contrast in methods of decoration may be the result of increasing German influence. Another cup by the same maker, 1579, without a cover and encircled by an engraved band above the plain body, is in the Untermyer Collection (68.141.192). The same mark is on a beaker and a parcel-gilt flagon, both 1577, both in the Sterling and Francine Clark Art Institute, Williamstown, Mass. Two beakers by the same maker, 1601, have tapered cylindrical bodies; one is in the City Art Gallery, Manchester (*Catalogue of Silver,* 1965, no. 5, pl. 5); the other in the Wadsworth Atheneum, Hartford, Conn. (*Elizabeth B. Miles Collection of English Silver,* 1976, pp. 36–37, ill.). Such covered cups are often referred to as Magdalen cups, a name suggestive of their similarity to the ointment jars held by St. Mary Magdalen in paintings depicting the washing of Christ's feet.

REFERENCE: Y. Hackenbroch, *Connoisseur,* CLXXX, 1972, pp. 119–120, fig. 5.

7.

Standing salt

Maker's mark: bull's head (on salt and cover)
London: 1581
Silver gilt
H. 10 in. (25.4 cm.)
68.141.93

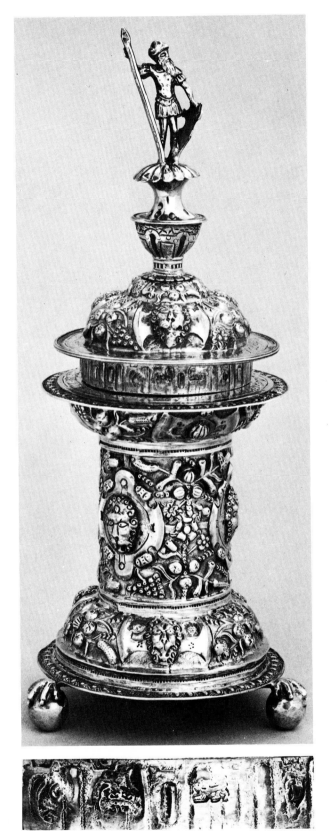

This type of salt, with heavily embossed allover decoration based on German engraved designs, had a great vogue in Elizabethan England. The three claw-and-ball feet are of Chinese derivation. The finial figure on the tight-fitting cover—refined salt was costly and easily spoilt by humidity—is clad in Roman armor. The combination of such disparate motifs shows the receptiveness of the Elizabethans to new impressions and the widening of their artistic horizons.

EX COLL. Courtnay Vivian; R. W. M. Walker (Christie's, 11 July 1945, lot 229, ill.).

REFERENCE: Untermyer *Silver*, 1969, no. 14, ill.

8.

Communion cup

> Maker's mark illegible
> London: 1584
> Parcel gilt
> Inscription: SOVTH MORTON
> H. 7¼ in. (18.4 cm.)
> 68.141.296

The suggestion that every English church should convert its chalice into a communion cup was first made by Matthew Parker, Archbishop of Canterbury, and Edmund Grindal, Bishop of London. The communion cup was restored to the laity in 1548, and it was then that it was often made with a paten cover. Early in the reign of Queen Elizabeth the conversion was made mandatory. The new form is deeper and more capacious than that of the earlier chalice, to suggest the separation from the Catholic church and Rome. Communion cups are usually of striking plainness, although occasionally, as here, the name of the church or parish is inscribed.

REFERENCE: Untermyer *Silver*, 1969, no. 192, ill.

9.

Tankard

Maker's mark: JH, two pellets above, one below (on tankard and cover)
London: 1585
H. 7¾ in. (19.7 cm.)
68.141.113

The encircling moldings are reminiscent of the hoops that bound the staves of earlier barrellike wooden vessels. The strapwork engraved on the matted ground and the embossed decoration on the foot and cover derive from German and Flemish engraved designs of the kind found in the workshops of Continental Protestant silversmiths who took refuge in England.

REFERENCES: R. Came, *Silver,* London, 1961, fig. 23 (erroneously dated 1580); Untermyer *Silver,* 1969, no. 15, ill.

10.

Covered cup

Maker's mark: RW, pellet below, possibly Ralph Warren (on foot, rim, and cover)

London: 1590
Mother-of-pearl and silver gilt
H. 7¾ in. (19.7 cm.)
68.141.120a, b

The luminous quality of the shell is admirably complemented by the brilliance of the silver-gilt mounts. The restraint, exceptional for the period, may express the goldsmith's own taste. This view is supported by the equally quiet character of a later

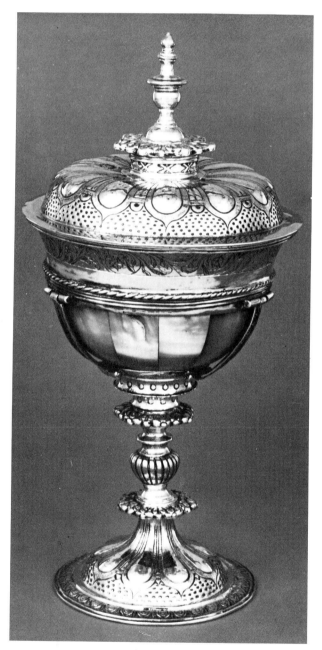

work by him in the Untermyer Collection, a silver-gilt wine cup of 1614 (1974.28.153). Both cups show an unusual harmony between basic form and flat surface decoration; they attest, moreover, to the master's acquaintance with Venetian glass prototypes.

EX COLL. F. J. Holdsworth; George A. Locket.
REFERENCES: *Apollo,* LXXX, 1960, p. 77, fig. 6; R. Came, *Silver,* London, 1961, p. 39, fig. 26; Untermyer *Silver,* 1969, no. 5, ill.; Clayton, 1971, p. 186, fig. 370.

11.

Pair of flagons

Maker's mark: branch in shield
London: 1597
Silver gilt
H. 12¼ in. (31.2 cm.)
Heraldry: (pricked in, inside hinges of covers) arms of Sir Edward Coke, Chief Justice of England, and his first wife, Bridget (d. 1598), daughter of John Paston of Huntingfield Hall, Suffolk. Dates 1597 and 1598 also pricked in. Crest of Leason, Earl of Miltown, 1763 (on handles)
68.141.142, 143

Made for Coke and his first wife. When she died in childbirth and Coke remarried, the flagons and other Paston treasures were secured by lawsuit for the firstborn child. The treasures were returned to the Paston family by about 1666 when they were made the subject of a painting (Untermyer *Silver,* 1969, fig. 3). The decorative motifs of cockleshells and dolphins demonstrate the Elizabethan orientation toward the sea and the concern with the trade routes that promised commercial expansion and prosperity. The frieze on the foot of dolphins sporting with barrels alludes to the old belief that barrels thrown overboard would amuse these animals and dissuade them from rocking or overturning a ship.

EX COLL. Sir Edward Coke and his wife, Bridget Paston, 1598; Paston family: Sir William Paston, 1663; Sir Robert Paston, created Earl of Yarmouth in 1679; Leason, Earl of Miltown, 1763; Col. R. W. Chandos-Pole (Christie's, 1 July 1914, lot 51, ill.); John Wells, New York, 1923; W. R. Hearst (Parke-Bernet, 7 January 1939, lot 278, ill.).
EXHIBITED: Parke-Bernet, New York, 1955, *Art Treasures Exhibition,* no. 200, ill.; Victoria and Albert Museum, London, 1964, *The Orange and the Rose: Holland and Great Britain in the Age of Observation 1600–1750,* p. 45, no. 80.
REFERENCES: Jackson, 1911, II, pp. 753–754, fig. 982; E. Wenham, *International Studio,* LXXXVII, 1927, p. 40, ill.; H. Honour in *The Tudor Period: 1500–1603,* Connoisseur Period Guides, I, New York, 1957–58, pl. 40C; Untermyer *Silver,* 1969, no. 16, ill.; *Notable Acquisitions: 1965–1975,* The Metropolitan Museum of Art, New York, 1975, p. 268, ill.

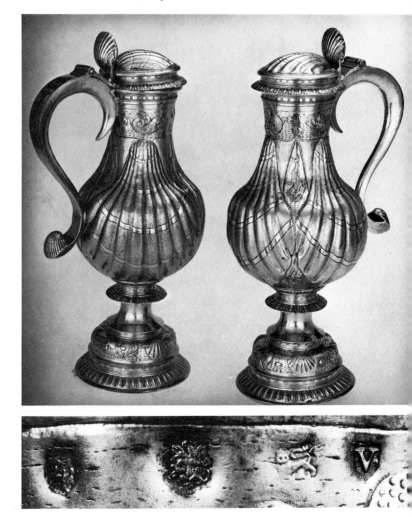

12.

Bell salt

Maker's mark: TS in monogram (three times)
London: 1600
Silver gilt
H. 8 in. (20.3 cm.)
68.141.92

With its three containers, the lower two for salt, the caster at the top for pepper, the bell salt was a late Elizabethan and Jacobean design. No such salt occurs later, anywhere. Our example has typical strapwork and foliage on a ground roughened by regular strikes with a small round punch. Comparable salts by this maker are in the Victoria and Albert Museum, 1594 (M.283.1893), and in the Munro collection, Henry E. Huntington Library and Art Gallery, San Marino, Calif., 1603. Another, 1607, was in the W. R. Hearst collection (Christie's, 14 December 1938, lot 99, ill.).

EX COLL. J. Dunn-Gardner, (Christie's, 29–30 April 1902, lot 129); Sydney Loder, (Sotheby's, 23 June 1931, lot 150); W. R. Hearst (Christie's, 14 December 1938, lot 98); David E. Nicholson (Sotheby's, 12 January 1961, lot 148, frontispiece).

EXHIBITED: Seaford House, London, 1929, *Queen Charlotte's Loan Exhibition of Old English, Irish and Scottish . . . Silver*, no. 89.

REFERENCES: R. Came, *Silver*, London, 1961, p. 44, fig. 31; Untermyer *Silver*, 1969, no. 21, ill.

13.

Spice box

Maker's mark: WR (on box and cover)
London: 1602
L. 5⅜ in. (13.7 cm.)
68.141.277

Only one earlier shell-shaped spice box is known; it too has a hinged escallop-shell cover and rests on four shell-shaped feet. That box, which bears London marks of 1598, was presented by Viscount Rothermere in 1924 to the Honourable Society of the Middle Temple. Such spice boxes were introduced during the late Elizabethan period, in response to the overseas trade in exotic spices. Once these supply routes were established, the spice box, with its interior partitions, became a favorite addition to the well-set table. Various examples dating from the reign of James I survive, among them one of 1612, illustrated by J. Banister (*English Silver*, New York, 1965, pl. 10). An example from 1613 was sold at Sotheby Parke-Bernet, New York (27 April 1973, lot 163, ill.). A box of 1615 with feet in the form of snails is in the Munro collection at the Henry E. Huntington Library and Art Gallery, San Marino, Calif. (*Connoisseur*, CLIV, 1963, p. 60, fig. 4). A box of 1619 was formerly in the collection of Sir Andrew Noble (Christie's, 24 November 1943, lot 57). A box of 1621, formerly in the Untermyer Collection (Untermyer *Silver*, 1963, no. 29, ill.), is now in the Minneapolis Institute of Arts (*Bulletin*, LVII, 1968, p. 88, ill.).

REFERENCES: Untermyer *Silver*, 1969, no. 22, ill.; see also L. Clowes, *Connoisseur*, CXXXIX, 1957, p. 31, fig. 10; Clayton, 1971, p. 271, fig. 546 (spice box of Middle Temple).

14.

Steeple cup

Maker's mark: AB conjoined (on cup and cover)
London: 1608
Silver gilt
H. 10⅞ in. (27.7 cm.)
Heraldry: (probably added later) arms of the
Tongrey family
68.141.227

The steeple cup, rarely found in this relatively small
size, is typically English. The steeple (also referred to
as an obelisk, pyramid, or pinnacle) rises from
bracket supports on the cover; pointing heaven-
ward, it symbolizes power and greatness. During
the last years of Queen Elizabeth, it was considered
an emblem of her long and glorious reign. In
Geoffrey Whitney's *A Choice of Emblems* (Leyden,
1586) the obelisk appears on the first page with a
legend obviously alluding to Queen Elizabeth: "A
Mightie Spyre, whose toppe dothe pierce the skie
. . . The Piller great our gratious Princes is." The
Untermyer Collection contains further examples of
Jacobean plate with steeples, including a magnifi-
cent double salt with maker's mark RP, escallop
between pellets (68.141.94a, b). By the maker of 14
is a steeple cup of 1602 in the Lee of Fareham
collection in the Royal Ontario Museum (*English
Silver,* exhib. cat., Royal Ontario Museum, To-
ronto, 1958, p. 15, B.20, cover ill.); an almost
identical cup without cover, London, 1605, was
sold at Sotheby Parke-Bernet (1 February 1973, lot
140); and a cup without cover, London, 1612, is in
the Assheton Bennett collection in the City Art
Gallery, Manchester (*Catalogue of Silver,* 1965, no.
7, pl. 4).

EX COLL. Rex Beaumont (Christie's, 2 December 1964,
lot 29, ill.).

REFERENCE: Untermyer *Silver,* 1969, no. 24, ill.

15.

Steeple cup

Maker's mark: IE, bow and three pellets below (on
bowl and cover)
London: 1608
Silver gilt
H. 18½ in. (47 cm.)
68.141.124

The gourd-shaped cup rising from a twisted tree
trunk on which a woodchopper is depicted is of
German origin. Compare the similar silver-gilt
cups surmounted by the arms of Rehlinger and
Imhoff, by Melchior Königsmüller, Nuremberg,
before 1611, in the Germanisches Nationalmuseum,
Nuremberg (Untermyer *Silver,* 1969, p. xvi, fig. 5).
The steeple of the present cup, on the other hand,
occurs nowhere in German silver: it is typically
English. Yet the cup itself is so German that we
cannot help feeling it originated in Nuremberg and
was brought to London by a Protestant silversmith.
Such imported works were usually stamped with
the mark of the maker-dealer who sponsored for-
eigners before their admittance to the freedom of
Goldsmiths' Hall. On the other hand, a German
refugee artist may have executed the cup in London
and added the steeple to conform to English taste.
Pieter Myers of the Museum's Research Laboratory
tested the cup to determine the elemental composi-
tion of its silver. Samples taken from the steeple,
bowl, and foot showed that the silver used for the
steeple is different from the rest, a result consistent
with the theory that the cup was made in southern
Germany (Nuremberg), the steeple in London.

EX COLL. Lt.-Col. A. C. Campbell (Sotheby's, 5 July
1956, lot 112, ill.).

REFERENCES: N. M. Penzer, *Proceedings of the Society of
Silver Collectors,* London, n.d., p. 1; Untermyer *Silver,*
1969, no. 23, ill.

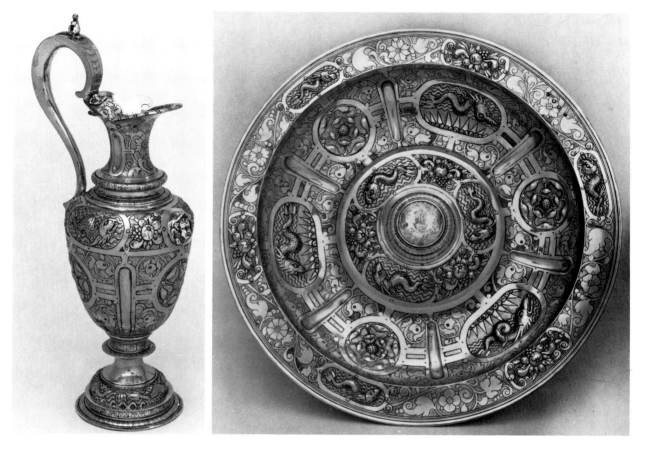

16.

Ewer and basin

Simon Owen
London: 1610
Silver gilt
H. 15¾, D. 19⅝ in. (40, 49.8 cm.)
Heraldry: (on basin) badge of Henry Frederick,
 Prince of Wales (1610–12); (on ewer and basin)
 arms of a member of the Sneyd family of Staf-
 fordshire, about 1750
68.141.135, 136

Made for Henry Frederick, eldest son of James I of
England (earlier James VI of Scotland), to honor his

becoming Prince of Wales. A. G. Grimwade identi-
fied the maker's mark as that of Simon Owen.
Owen, who began his apprenticeship in London in
1595, made a similar set for Goldsmiths' Hall in
1611. Its arms were obliterated when this set was
sold in 1637, but Grimwade recently recognized it
in the collection of Lord Petre. Another set, made
by Owen in 1610, was purchased three years later
by Eton College; still another, of 1614, belonging
to the Earl of Ancaster, was exhibited in 1926 at the
Burlington Fine Arts Club, London (*Late Eliza-
bethan Art,* pp. 66–67, no. 1). Although Owen was
not the only London maker to produce such large
sets, he seems to have specialized in tall pear-shaped
ewers with domed feet that fit neatly over the cen-
tral boss of their matching basins. When not in use,
his gilt sets were displayed on sideboards or buffets.
Here, the taste for marine subjects is obvious: large
Tudor roses alternate with dolphins in rippling
waters, each enclosed in a medallion. See 11 for

comment on the frieze of dolphins and barrels on the ewer's foot.

EX COLL. Henry Frederick, Prince of Wales; Sneyd family, Keele Hall, Staffs., 1750–1924 (Christie's, 24 June 1924, lot 87, ill.); W. R. Hearst.

REFERENCES: Untermyer *Silver,* 1969, no. 25, ill.; see also C. C. Oman, *Connoisseur,* CLXXVII, 1971, pp. 102–104, fig. 4.

17.
Circular dish

Maker's mark: IA
London: 1616
Silver gilt
D. 14¾ in. (37.5 cm.)
Heraldry: (around rim) arms of Archduke Albert of Austria, Governor of the Netherlands, with, in pretense, arms of his wife, the Infanta of Spain, to whom he was married by proxy in 1598; Cecil quartering four others and impaling Drury, for Viscount Wimbledon and his second wife, Diana, daughter of Sir William Drury of Halstede, Suffolk; Cecil quartering Neville for Viscount Wimbledon; Drury quartering four others, for Diana, second wife of Viscount Wimbledon; (at center) Cecil impaling Zouche, for Viscount Wimbledon and his third wife, Sophia, daughter of Sir Edward Zouche
Inscription: The Dishes of the Archduke gotten at the Battell of Newporte. Taken by the Lord Vicount Wimbaldon in the year 1600

68.141.193

This historic dish was made of silver captured from Archduke Albert of Austria at the Battle of Newport, 2 July 1600. Sir Edward Cecil, to become the original owner of the dish, led the decisive charge

to recapture Dunkirk from the Spanish—part of the English assistance to the house of Nassau in its struggle for survival. Sir Edward, third son of Sir Thomas Cecil, first Earl of Exeter, and grandson of William Cecil, Lord Burghley, the great chancellor, was created Viscount Wimbledon in 1626. Although the arms in the center of the dish record his marriage to Sophia in 1636, the style indicates that these arms were added somewhat later in the century. When the Viscount died, lacking an heir, his titles became extinct.

EX COLL. Maj. Hon. Rowland Winn, M. C. (Christie's, 19 December 1956, lot. 143, ill. frontispiece).

EXHIBITED: Victoria and Albert Museum (South Kensington), London, 1862, *International Exhibition of 1862,* no. 5780; Victoria and Albert Museum, London, 1962, *International Art Treasures Exhibition,* no. 83, pl. 178.

REFERENCE: Untermyer *Silver,* 1969, no. 27, ill.

18.
Sweetmeat dish

Maker's mark: S over W
London: 1627
L. 7¾ in. (19.7 cm.)
1974.28.154

After the Elizabethan great hall was abandoned in favor of less formal dining rooms, a need was felt for smaller domestic plate. This fluted, boat-shaped dish, with sparing decoration and simple cast scroll handles, is a typical example; it shows not only the considerable originality of the early Puritan style but also its characteristic lightness. Less resistant, therefore, to frequent handling, few comparable examples of Charles I domestic plate have survived.

EX COLL. H. O. N. Shaw (Sotheby's, 5 July 1956, lot 56, ill.); Fay Plohn, New York (Sotheby's, 16 July 1970, lot 25, ill.).

19.

Dish

> William Maundy
> London: 1631
> Silver gilt
> D. 7⅞ in. (19.7 cm.)
> 68.141.75

During the reign of Charles I the production of domestic plate diminished considerably; moreover, the elaboration of ornamental detail gave way to a striking plainness and lightness, dictated by economic conditions. The master whose work is most representative of these changes is William Maundy. His shallow dishes fitted with two shell handles are decorated with simplified embossed and punched floral designs, applied without much variety or sophistication. Maundy's son Thomas continued his father's style during the later years of Charles I and throughout the Commonwealth period.

EX COLL. Arthur M. Nowak, New York (American Art Association, New York, 17 March 1934, lot 57, ill.).
REFERENCE: Untermyer *Silver,* 1969, no. 32, ill.

20

Communion cup and paten

> Maker's mark: VS over fleur-de-lis (three times)
> London: about 1635
> H. 10⅛ in. (25.7 cm.)
> 1974.28.152a, b

Of rare distinction, this shows in form and decora-

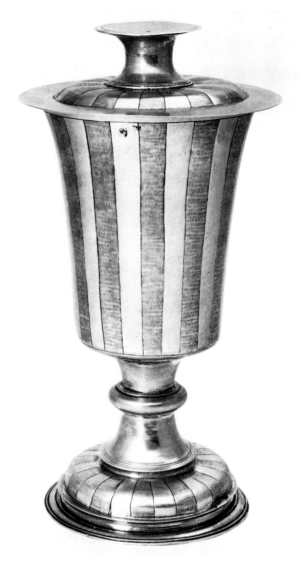

tion a subtle departure from Elizabethan tradition. While the style of the bowl is changed only slightly, the foot has a broad, cushioned section. The paten cover, when reversed, fits with its foot inside the cup. The lightly engraved decoration of vertical stripes on the body, and radiating from the centers of the foot and cover, is unique. The maker

would seem to have been a London silversmith, according to Jackson, who had observed his mark on a communion cup of 1631–32 (C. J. Jackson, *English Goldsmiths and Their Marks,* London, 1921, p. 118).

EX COLL. The Vicar and Churchwardens of St. Mary's Church, Rickmansworth (Christie's, 15 March 1972, lot 112, ill.).

21

Basket

Maker's mark: PG, rose below
London: 1641
D. 10¼ in. (26 cm.)
68.141.60

The imaginative piercing that forms the principal decoration of this basket allows the maker the continued use of heavy silver, silver at that time having become scarce. Virtuosity of technique and well-balanced proportions render this an outstanding example of Charles I domestic plate, of which almost none of equal excellence has survived.

EX COLL. Col. W. Fearon Tipping (Christie's, 15 May 1911, lot 43, ill.); E. G. Raphael.
EXHIBITED: Residence of Sir Philip Sassoon, London, 1929, *Loan Exhibition of Old English Plate and Decorations and Orders, for the Benefit of the Royal Northern Hospital,* no. 125, pl. 5; Victoria and Albert Museum, London, 1968, *The British Antique Dealers' Association Golden Jubilee Exhibition,* no. 39, pl. 29.
REFERENCES: Jackson, 1911, I, pl. 216, fig. 229; Untermyer *Silver,* 1969, no. 24, ill.; Clayton, 1971, p. 22, fig. 9.

22.

Tankard

Maker's mark: bird with branch (on tankard and cover)
London: 1646
H. 4⅛ in. (10.5 cm.)
68.141.196

The only known globular example, this small tankard has been described by Oman as intended for a child. The stylized, rather barren floral decoration is typical of decorative engraving and chasing on silver during the later reign of Charles I, when economic stringencies constrained artistic enterprise.

EXHIBITED: Parke-Bernet, New York, 1967, *Art Treasures Exhibition,* no. 211, ill.
REFERENCES: Untermyer *Silver,* 1969, no. 33; Oman, 1970, fig. 26A; Clayton, 1971, p. 293, fig. 599.

23.

Pair of flagons

Maker's mark: hound sejant (on flagons and covers)
London: 1646
H. 14 in. (35.5 cm.)
68.141.200, 201

The hound-sejant maker was, without doubt, the greatest English silversmith of his period. His mark was almost certainly derived from his crest, suggesting that he was a member of an armigerous family. His customers included royalists who wished to equip their private chapels with plate manifesting their resistance to Anglican convictions.

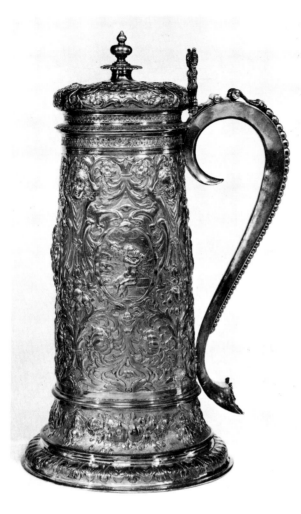

signs by Daniel Rabel in *Cartouches de differentes inventions* (Tavernier, Paris, 1632). Although the basic form had been adopted for church plate, these flagons were made for secular use. The original owner of our pair is unknown; the other pair, formerly at Thirkleby church in West Riding, was owned by Francis Tyssen, a London merchant of Dutch extraction.

REFERENCES: Untermyer *Silver*, 1969, no. 35, ill.; Oman, 1970, p. 28, pl. 31B; J. D. Davis, *English Silver at Williamsburg*, Williamsburg, Va., 1976, no. 44, ill.

24

Two-handled bowl

Maker's mark: TG in dotted oval
London: 1654
Silver gilt
D. 4¾ in. (12.1 cm.)
Heraldry: (added later) (1) Pinkney and (2) Fynte impaling Wye
68.141.66

With crudely cast serpent handles and chased and punched surface decoration, this Commonwealth bowl is typical of a period of sparing and unsophisticated production. Matted medallions alternate with dots and flutes of striking simplicity but pleasing clarity. Such useful bowls appear to have en-

Whether the hound-sejant maker was a practicing silversmith only, or whether he also engaged in selling work finished by others, is uncertain. Probably the latter, which would account for the great differences between some of his plain and embossed plate. He may have employed Dutch masters who had not been granted independent status in England. His surviving work extends from 1646 to 1666: from the reign of Charles I through the Commonwealth period to the reign of Charles II. In the work of few other seventeenth-century silversmiths can changes of style be so clearly observed. This pair of flagons, and another pair of the same year, now divided between the Victoria and Albert Museum (M. 537-1956) and Temple Newsam House, Leeds, are his earliest works known. They are decorated with embossed and chased floral ornament and auricular cartouches with figures, and resemble de-

joyed a considerable vogue, but only one other, among several, originated from this maker in 1654: the covered bowl in the Wadsworth Atheneum, Hartford, Conn. (*Elizabeth B. Miles Collection of English Silver,* 1976, no. 27, ill.).

REFERENCES: *Connoisseur,* CXL, 1957, p. 113, no. 13, ill.; Untermyer *Silver,* 1969, no. 41, ill.

25.

Flagon and pair of communion cups

Maker's marks: (flagon) RF, (cups) WH
London: 1660
Silver gilt
H. flagon 12½, cups 6¾ in. (31.7, 17.2 cm.)
Heraldry: royal arms and cipher of William and Mary, as used between 13 February 1689 and their acceptance by the Scottish Convention Parliament 11 April 1689

68.141.116, 117, 118

This set belonged to the Royal Jewel House, since, like all other royal plate, the pieces are marked on the bottom in ounces and quarters instead of the customary ounces and pennyweights. The present arms have replaced those of Charles II. The heavy spherical cups on baluster stems are typical neither of English communion cups nor coronation banquet cups—and had they been made for the coronation of the yet unmarried Charles, one cup would have sufficed. According to Charles Oman, the cups resemble Scottish communion cups of the second quarter of the seventeenth century. On Charles II's

return to England in 1660, England reverted to the Episcopal church, Scotland remaining under Presbyterian rule. Determined to install his own bishops in Scotland, Charles brought leading Scottish ministers to England; after their conversion, most returned to Scotland as Anglicans. Our cup and flagons are relics of this period, Oman believes, since it may have been thought tactful to provide the visitors with plate of a familiar type. Presumably these cups had patens, and there was a flagon for each; thus, these are probably parts of a set. An altar dish with identical date letter and armorials but the mark of another maker belongs to the Crown (H. D. W. Sitwell, *The Crown Jewels,* London, 1953, pl. XXIX).

EX COLL. Royal Jewel House, 1808; Earl of Bridgewater, 1810; Sophia Hume and the Earl of Brownlow and their descendants, Belton House, Grantham; George A. Crawley (Sotheby's, 10 May 1927, lot 141, frontispiece); W. R. Hearst, 1938.

EXHIBITED: Texas University Art Museum, Fort Worth, 1969, *One Hundred Years of English Silver: 1600–1760,* nos. 1, 2, ill. (and mentioned in the introduction).

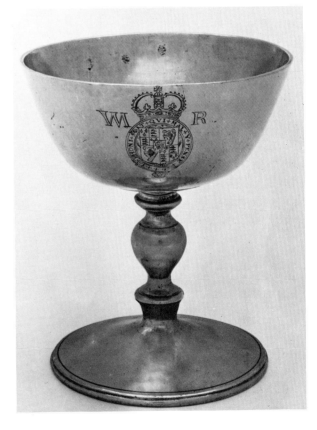

Flagon

Cup

REFERENCES: *Antiques,* LXXX, 1961, p. 328, ill.; D. Cooper, ed., *Great Private Collections,* New York, 1963, p. 141, ill.; *Connoisseur,* CLV, 1964, p. 167, fig. 2 (one cup); Untermyer *Silver,* 1969, no. 193, ill.

26.

Two-handled cup and cover

Francis Leake
London: 1660
Silver gilt
H. 8 in. (20.3 cm.)
68.141.254a, b

Such cups were sometimes accompanied by a matching footed salver. The embossed decoration repeated on the cover, featuring prancing animals among outsize flowers, is typical of Dutch influence in England after the Restoration. The cast caryatid handles, however, are of traditional English design. Charles Oman (1970, p. 29) believes that Francis Leake sponsored work by foreign goldsmiths, employing some in his workshop whose work he stamped with his own mark. This may explain the origin of our cup and that of a similar covered cup with footed salver made by Leake in 1658 (Sotheby's, 17 June 1971, lot 178, ill.). Oman's theory is strengthened by the appearance of a tankard of 1678 by Leake in the collection (1970.131.12).

Of plain, typically English character, it is encircled simply by a broad matted band produced by small punches.

REFERENCE: Untermyer *Silver,* 1969, no. 49, ill. See entry in this catalogue, 27.

27.

Tankard

Henry Greenway
London: 1661
Silver gilt
H. 8 in. (20.3 cm.)
Heraldry: arms of Wilmot impaling Jervoise
Inscription: The gift of Mrs. Wilmot to the Parish of Lambourn Late wife of Sir William Willmot Esqr. Churchworns Richard Berry Will Runnaker 1701
1970.131.7

The Lambourn church accounts for 1702 include an item concerning this tankard: "Pd. ye Goldsmith for engraving ye Church Plate 10 s." Charles Oman (1970, pp. 34, 26) mentions Greenway, whose mark was HG between two mullets and four pellets. Greenway obtained the freedom of Goldsmiths' Hall in 1648. Thereafter his mark, like that of Francis Leake, is occasionally seen on the work of

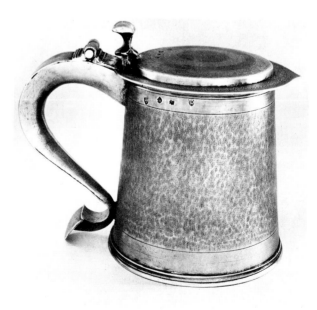

foreigners, the Zurich-born Wolfgang Howzer for one. Greenway and Leake seem to have shared a workshop, both being employed by the royal gold-smith Sir Richard Viner, who distributed impor-tant commissions. The Lambourn tankard is encir-cled by a broad matted band produced by repeated strikes with a small round-headed punch. Such a plain decoration, which had greatly appealed to Puritan patrons of the Commonwealth period, con-tinued in favor for some time thereafter. An almost identical though smaller tankard in the Untermyer Collection (1970.131.12) bears Francis Leake's mark, London, 1678, as does the even smaller, very similar example of 1671 included in Christie's sale 23 June 1976, lot 124, ill.

EX COLL. The Vicar and Churchwardens of St. Mi-chael's Church, Lambourn, Berks. (Christie's, 25 June 1969, lot 147, frontispiece).
REFERENCE: Y. Hackenbroch, *Connoisseur,* CLXXX, 1972, pp. 120–121, fig. 8.

28.

Salts, set of six

Maker's mark: CS (Christopher Shaw?)
London: 1662
L. (of each) 4 in. (10.2 cm.)
Inscription: (on each) James Heames his Guift (top); 12 of theis the Guift of James Heames twice Warden 1662 (bottom)
68.141.181–186

The original set of twelve quatrefoil salts was pre-sented to the Company of Painter Stainers and re-mained in its possession until recently. Heames also gave to his company, in October 1662, a dozen silver wine cups with the same inscription and the arms of the company. In October 1671 he presented brass andirons and fender and fire tools similarly engraved. Heames became master of the company in 1664.

REFERENCES: Jackson, 1911, II, p. 780 (one of a set); Untermyer *Silver,* 1969, no. 45, ill.; Oman, 1970, p. 49, fig. 500.

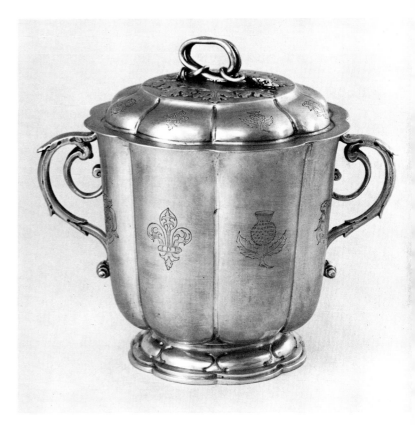

29.

Cup and cover

Unmarked
London: 1664
H. 6⅝ in. (16.8 cm.)
Inscription: (under foot) ANTHO L$^{\text{d}}$ ASHLEY CHAN-CELLER OF HIS MA$^{\text{ties}}$ EXCHEQUER 1664
68.141.304a, b

Anthony Ashley Cooper (1621–83), created Baron Ashley 20 April 1661, succeeded the Earl of Clarendon as Chancellor of the Exchequer 20 May 1661 and remained in the post until he was created Earl of Shaftesbury 23 April 1672. Holders of such high office were allowed to retain the old seal on the death of a sovereign or on the changing of the seal, and they usually converted it into a commemorative cup or salver. Our cup bears the national emblems of England, France, Scotland, and Ireland, which suggests the possibility that it was made from an obsolete Commonwealth seal. On the other hand, such cups were also a favorite form of New Year's gifts; that this one is unmarked might indicate that the King himself had awarded the cup to Lord Ashley in recognition of his services; plate commissioned by royalty was duty free and not submitted to Goldsmiths' Hall for hallmarking. The fluted shape and cast double-scroll handles are so close to the established work of the hound-sejant maker as to suggest his authorship. The imaginative and innovative embossed vine leaf decoration encircling the snake finial on the cover forecasts the cut-card motifs of the French Huguenots; the effect is similar, though the technique is different.

EX COLL. Earl of Shaftesbury, St. Giles House, Wimborne, Dorset (Christie's, 14 December 1966, lot 89, ill.).
REFERENCES: Untermyer *Silver,* 1969, no. 46, ill.; Oman, 1970, pp. 19, 40, pl. 14a.

30.

Pair of dishes

Silver gilt
Maker's mark: AF with mullet and two pellets
London: 1664
D. 18 in. (45.7 cm.)
Heraldry: Brownlow impaling Pulteney for Sir John Brownlow, Bt. 1641, and his wife, Alice, daughter of Sir John Pulteney
68.141.79, .80

A similar dish of Portuguese origin is in the Museu de Arte Sacra de São Roque, Lisbon (*Exposiçao de ourivesaria Portuguesa e Francesca,* Lisbon, 1955, pl. 65). The Portuguese influence on English silver was first observed by Oman; it resulted from the close ties between the countries created by the marriage of Charles II to Catherine of Braganza in 1662. These splendid dishes, of generous proportions with fluted borders and scalloped edges, display the original owner's armorials within a mantling of large ostrich plumes crossed below the shield, a device that became characteristic of the Caroline period. The arms refer to Sir John Brownlow (1594–1686), who in 1685 built Belton House at Grantham, Lincolnshire.

EX COLL. Sir John Brownlow, Belton; Lord Brownlow, Belton House, Grantham (Christie's, 13 March 1929, lot 58, ill.); James Robinson, New York; W. R. Hearst (Parke-Bernet, 7 January 1939, lot 303, ill.).
REFERENCES: E. Wenham, *Domestic Silver of Great Britain and Ireland,* New York, 1931, pl. 10; C. C. Oman, *Apollo,* LI, 1950, p. 164, fig. 10; Untermyer *Silver,* 1969, no. 50, ill.; Oman, 1970, p. 51, pl. 57A.

31.

Tankard

Maker's mark: IN, a mullet below, in heart (on tankard and cover)
London: 1668
Silver gilt
H. 7½ in. (19 cm.)
Heraldry: Holles impaling Pierrepont, ensigned by earl's coronet for Gilbert Holles (1633–89), third Earl of Clare, and his wife, Grace, daughter of William Pierrepont of Thorsby, Nottinghamshire
68.141.144

The masculine appeal of this capacious tankard is greatly enhanced by its three lion couchant feet, the lion thumbpiece, and the bold treatment of the armorial achievements that include yet another lion as supporting animal. The remarkable handle, con-

ceived as a knotted branch with lobed foliage, is a motif following engraved designs of the Van Vianen family of Utrecht. The mellow quality of the original gilding harmonizes pleasantly with the engraver's rendering of the impressive heraldry. A similar

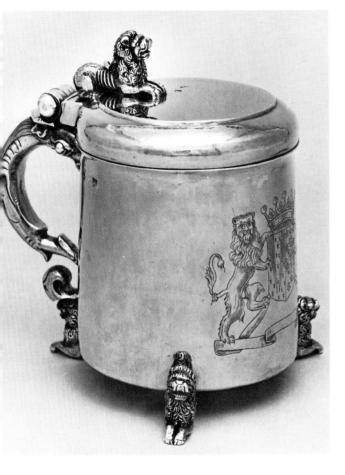

tankard, maker's mark RG, London, 1674, is in the Archibald A. Hutchison collection, Fogg Art Museum, Cambridge, Mass. (114.36).

EX COLL. Duke of Newcastle (Christie's, 7 July 1921, lot 66, ill.); W. R. Hearst (Parke-Bernet, 7 January 1939, lot 302, ill.).

EXHIBITED: St. James's Court, London, 1903, *Old Silver-*

work Chiefly English from the XVth to the XVIIIth Centuries, Loan Exhibition in Aid of the Children's Hospital, no. D. 31, pl. 72.

REFERENCES: Jackson, 1911, I, p. 231, fig. 241; Untermyer *Silver,* 1969, no. 51, ill.

32.

Snuffers and tray

> Maker's mark: WC over escallop (William Commyns?) (on snuffers and tray)
> London: 1670
> L. 9⅞ in. (25.1 cm.)
> Heraldry: arms of Marow of Berkeswell, Warwickshire, impaling Clespesby; crest of Marow on handle
> 68.141.55, 56

Snuffers were widely used when candlewicks were not consumed by their flames. During the post-Restoration period they were placed upon a tray of matching outline, though this was rarely made by the same silversmith, contrary to the case here. Snuffers were more frequently assigned to specialists. The Untermyer Collection includes later examples: 1690 (68.141.54a, b) and 1700 (68.141.57, 58); these show the later fashion of providing a stand fitted with a snuffer, rather than a tray.

REFERENCE: Untermyer *Silver,* 1969, no. 53, ill.

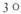

the three scroll feet, and engraving with a repeat of the elephant crest in a plumed mantling. Then, the cup's total weight was 51 oz., considerably more than its present weight of 46 oz. 5 dwt. The maker's mark, T. I. between escallops, was once believed to be that of Thomas Issod; it is here correctly noted as the mark of Thomas Jenkins as a result of study by A. G. Grimwade and Judith Banister. For other works in the collection by this important and prolific London maker, see 36 and 45.

EX COLL. Reginald Astley, Weir House, Alresford, Hants. (Christie's, 10 April 1929, lot 94, ill.).
EXHIBITED: Lansdowne House, London, 1929, *Loan Exhibition of English Decorative Art, in Aid of the Invalid Children's Aid Association*, no. 102, pl. 29.
REFERENCE: Untermyer *Silver*, 1969, no. 52, ill.

33.

Two-handled cup and cover

Thomas Jenkins (marked on cup and cover)
London: 1672
Silver gilt
H. 7 in. (17.8 cm.)
Heraldry: Corbet impaling Bridgman for Capt. Richard Corbet (d. 1718) of Moreton Corbet and his wife, Judith, daughter of Sir John Bridgman, Bt.; (other side) crest of Corbet family
68.141.65a, b

Characteristically English in form. Notable, in addition to the prominent armorials, is the early cut-card decoration around the base, a decoration that was to be typical of Huguenot silver in England. The cover has three scroll feet that render it reversible; such covers would be supplanted by salvers before the turn of the century. Marked with London hallmarks of 1672 but lacking the maker's mark, this is a replacement cover for the original, which was last seen illustrated in the Hearst sale catalogue, 1939. That cover had matching cut-card decoration, a central knob or finial in addition to

34.

Sugar box

Maker's mark: SB in monogram
London: 1673
L. 8 in. (20.3 cm.)
68.141.161

Sugar boxes or caskets existed long before the introduction of casters during the later seventeenth century. The typical form, developed during the reign of Charles II, is oval, supported by four feet, with a hinged cover often decorated with a coiled snake finial, and a hasp for closing. Our example has cast lion-paw feet, with an early form of cut-card decoration above.

EX COLL. Sir Edward Barron, London (Knight, Frank & Rutley, London, 20 March 1947, lot 81, ill.).
EXHIBITED: Seaford House, London, 1929, *Queen Charlotte's Loan Exhibition of Old English, Irish and Scottish . . . Silver*, no. 292, ill.
REFERENCES: J. Banister, *English Silver*, New York, 1965, pl. 18; Untermyer *Silver*, 1969, no. 54; Oman, 1970, p. 49, pl. 52A.

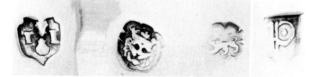

35.
Incense burner

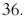

Maker's mark: TL, escallop below
English: about 1675
H. 17¾ in. (45.1 cm.)
Heraldry: arms of Sir John Bankes of Aylesford, Kent, created baronet in 1661, and his wife, Elizabeth, daughter of Sir John Dethick, Lord Mayor of London, 1655–56
68.141.232

Double-gourd-shaped incense burners of pierced foliage design supported on three scroll feet had a sudden, brief vogue about 1675–85. Among several similar examples is one belonging to the Duke of Rutland, 1677 (Jackson, 1911, I, fig. 255); another is in the State Hermitage Museum, Leningrad. Two unmarked examples appeared in recent London sales: Sotheby's (17 June 1971, lot 164, ill.); Christie's (27 June 1973, lot 24, ill.); see also Oman, 1970, p. 59, pl. 74 (a similar example).

REFERENCES: Clayton, 1971, pp. 197–198, fig. 397.

36.
Pair of beaker vases

Thomas Jenkins (marked on lips and bases)
London: about 1675
H. 17¾ in. (45.1 cm.)
68.141.241, 242

Such tall beakers were usually intended for display with bulbous covered vases known as ginger jars, though these were too large for that purpose. Both kinds derive from Chinese prototypes or Delft copies of them. Introduced after the Restoration to decorate mantelpieces, these *garnitures de cheminées* were rarely found after the turn of the century. A similar pair by Jenkins, London, 1680, is in the collection of the Duke of Rutland. For the recent identification of Thomas Jenkins' mark, see 33.

EX COLL. Earl of Home (Christie's, 17 June 1919, lot 28, ill.); Earl of Harewood (Christie's, 30 June 1965, lot 133, ill.).

REFERENCES: Untermyer *Silver,* 1969, no. 58; Oman, 1970, p. 59, pl. 79; Clayton, 1971, p. 333, fig. 707 (together with a taller, unmarked center vase).

37.
Set of six candlesticks

Maker's mark: JC conjoined in script below coronet (on four)
London: 1675
H. 12 in. (30.5 cm.)
Heraldry: (later addition) Marjoribanks impaling Hogg ensigned with baron's coronet for Dudley Coutts Marjoribanks (1820–94), created baronet 1866, elevated to the peerage as first Baron Tweedmouth 1881, and his wife, Isabella Hogg
1968.141.36–41

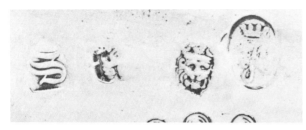

To the best of our knowledge, the earliest surviving set of recusant candlesticks. Such sets were made for private services in Catholic recusant chapels, which played a vital part in English religious life of the post-Reformation period. To manifest the worshiper's continued allegiance to the Church of Rome, the candlesticks recalled the baroque shapes of those seen in Catholic churches on the Continent: that is, with a triangular base and baluster stem. The utter simplicity of our set, with cable moldings and plain ball feet, is insular and expressive of the serious purpose they served.

EX COLL. Lady Tweedmouth (Sotheby's, 7 June 1945, lot 153, both ill.); Lady Baron (Sotheby's 5 July 1956, lot 119, ill.).
REFERENCES: C. C. Oman, *English Church Plate,* London, 1957, p. 275, pl. 173; Untermyer *Silver,* 1969, no. 195, ill.

38.
Fire irons and bellows

Unmarked
English: about 1675
Silver, iron, leather, wood
L. bellows, without ring handle, 27¾ in. (70.5 cm.); shovel 35⅛ in. (89.3 cm.); tongs 32¹¹⁄₁₆ in. (83 cm.); poker 34¼ in. (87 cm.)
Monogram: DL ensigned with duke's coronet for Elizabeth Murray (d. 1698), Countess of Dysart and Duchess of Lauderdale
68.141.156–159

Elizabeth Murray, Countess of Dysart in her own right, married as her second husband John Maitland, created Duke of Lauderdale 1672. The pair to this set, with identical monogram, is in the collection of the Earl of Dysart (P. Macquoid, *The Age of Walnut,* London—New York, 1905, p. 85, fig. 78).

Similar sets are in Ham House, and an almost identical pair of bellows, with arms of Sir Joseph Williamson, from Chobham Hall, Kent, is in the Farrer Collection at the Ashmolean Museum, Oxford (E. A. Jones, *Catalogue of the Collection of Old Plate of William Francis Farrer,* London, 1924, pl. 3).

EX COLL. Duke of Northumberland (?); Princess Harzfeldt, Foli-John Park, Sussex; Claude Leigh.
REFERENCES: Untermyer *Silver,* 1969, no. 55, ill.; Clayton, 1971, p. 25.

39.
Pair of beakers

Maker's mark: EG
London: 1678
H. 6¼ in. (15.9 cm.)
Heraldry: arms of Mrs. Honoria Thompson
1974.28.160, 161

Plain beakers with gently tapering bodies were the traditional drinking vessel till well after the general introduction of glass. An Elizabethan example in the collection, engraved with arabesques and strapwork, has a spreading foot stamped with ovolos (68.141.115). The maker of this exceptional pair of Charles II beakers, or perhaps his client, renounced all flourishes to direct attention to the armorials. These show the full splendor of feathered mantlings around a widow's lozenge. Such pronounced preference for plain form is typically English—a preference that tends to reassert itself after periods of intense foreign influence, like the one brought about by those Dutch masters who had followed Charles II upon his return from Holland in 1660. An entry in the church minute book of Wattisford

in Suffolk of the "8th month 1678," reads: "About this time Mrs. Honoria Thompson Widow gave to the Church as a token of her great affection and respect two large silver beakers with her Arms theron to continue for the use of the Church at the Lords Table."

REFERENCES: *Apollo,* XCIV, 1971, p. 529, fig. 12; Y. Hackenbroch, *Connoisseur,* CLXXX, 1972, pp. 120–121, fig. 9 (one).

40.
Two-handled cup and cover

 Unmarked
 England: about 1680
 Parcel gilt
 H. 7½ in. (19 cm.)
 68.141.281a, b

"Cagework cups" such as this, in which a plain silver-gilt body is sheathed with a casing of pierced and chased silver, appeared suddenly after the Restoration. No continental prototypes are known, and those cups that are marked usually bear maker's marks only. It would seem that this rare technique was pursued by only a few specialists who belonged to the same London workshop. Their designs were based on Dutch engravings such as those in *Novae Florum Icones* (Amsterdam, Justus Danckerts, 1664–66).

REFERENCE: Untermyer *Silver,* 1969, no. 61, ill.

41.
Covered bowl on stand

 Maker's mark: F$_S$S beneath crown (on bowl, cover, stand)
 England: about 1680
 Silver gilt
 H. 3½ in. (8.9 cm.), D. 5¼ in. (13.3 cm.)
 68.141.69a, b, c

This maker, whose mark occurs on a cordial cup in the collection (68.141.194), produced domestic plate that was frequently enhanced by ornamental engraving of rare sensitivity. Although the engravings were almost untouched by Huguenot influence, he adopted the Huguenots' cut-card decoration, seen here on the cover. Typical of his small-scale plate, the bowl is exquisitely engraved with decorations rooted in the Elizabethan tradition, although slightly influenced by Dutch seventeenth-century realism. The closest comparison is a silver-gilt teapot engraved with hunting scenes, Museum of Fine Arts, Boston.

REFERENCES: Y. Hackenbroch, *Connoisseur,* CLXVIII, 1968, p. 140, fig. 7; Untermyer *Silver,* 1969, no. 82, ill.

42.
Oval canteen with cover

 Unmarked
 London: about 1680
 Silver gilt
 H. 3⅜ in. (8.6 cm.)
 Heraldry: arms of Mordaunt impaling O'Brien ensigned with earl's coronet; (other side) monogram PM for Penelope, wife of Henry Mordaunt, second Earl of Peterborough, and daughter of Barnabas O'Brien, sixth Earl of Thomond, Ireland. The Countess was groom of the Stole to Mary of Modena, Queen of James II
 1970.131.13a, b

The form suggests that this was part of a canteen or traveling set, of the kind usually fitted into a leather case. Few such cups had covers. Made before the fashion was established, 42 is one of the earliest examples. The sensitive engraving and the cut-card decoration on the cover, applied with admirable lightness of touch, add greatly to the cup's appeal.

p. 195, ill.; Y. Hackenbroch, *Metropolitan Museum of Art Bulletin*, May 1968, p. 386, fig. 11; Untermyer *Silver*, 1969, no. 48, ill.; Oman, 1970, fig. 21A.

43.

Pair of wager cups

Maker's mark: IA conjoined, marked on larger and smaller cups; Dutch eighteenth-century import mark on one
English (London): about 1680
H. (of each) 6⅛ in. (5.5 cm.)
Inscription: (around rims of smaller cups)
 WHEN RICHES FAILE FRIENDS GROE SCANT
 NO GUTT TO UNKINDNESS NO WOE TO WANT
 (on aprons)
 HANDS OF I PRAY YOU HANDLE NOT ME
 FOR I AM BLIND AND YOU CAN SEE
 IF YOU LOVE ME LEND ME NOT
 FOR FEAR OF BREAKING BEND ME NOT
68.141.302, 303

This type of cup originated in Nuremberg during the late sixteenth century. The stiff skirt of the lady served as principal cup; the smaller cup pivots between her hands. The name wager cup originated from the convivial entertainment of attempting to drink out of both cups without spilling the wine. Such cups were also called wedding cups, following a custom according to which the groom offered the small cup filled with wine to his bride, thereafter draining the larger one to toast her. In England wager cups were rare. An almost identical, slightly larger cup, maker's mark TA, is in the Vintner's Company. Another, marked WF conjoined, London, 1682, was sold at Christie's, 19 June 1946, lot 107.

EX COLL. Lady Sophia Des Voeux, 1862; Mrs. Milligan, 1910; Sir John Noble (Christie's, 12 December 1951, lot 134).
EXHIBITED: Victoria and Albert Museum (South Kensington), London, 1862, *International Exhibition of 1862*, no. 5859; Residence of Sir Philip Sassoon, London, 1932, *The Age of Walnut, Loan Exhibition in Aid of the Royal Northern Hospital*, no. 341.
REFERENCES: R. H. Cocks, *Connoisseur*, IV, 1904, pp. 233–236; C. R. Grundy, *Connoisseur*, LXXXIX, 1932,

44.

Punch bowl

Maker's mark: EG
London: 1680
Diam. 12 in. (30.5 cm.)
Inscription: SIVE EDITIS, SIVE BIBITIS, SIVE QUID FACITIS, OMNIA AD GLORIAM DEI FACITE (Whether you eat, or whether you drink, whatever you do, do to the glory of God); Ecce quam bonum e quam jucundum habitare fratres, in unum (Behold, how good and how pleasant it is for brethren to dwell together in unity—Psalm 133:1); Collegis Suis Posterisq. Dicavit Richardus Cox Custos 1680 (So said Richard Cox, Treasurer [?], to his colleagues, present and future, 1680)
68.141.68

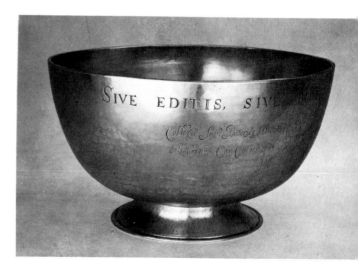

Usually punch bowls were of a more elaborate character, enriched with applied or engraved decoration. While of impressive weight, this bowl from Hereford is appealingly simple. The spirit of dedication expressed in the inscription is confirmed by the figure of Charity engraved inside.

EXHIBITED: Parke-Bernet, New York, 1955, *Art Treasures Exhibition,* no. 204, ill.

REFERENCE: Untermyer *Silver,* 1969, no. 60, ill.

45.

Two-handled cup with cover

Thomas Jenkins (marked on cup and cover)
London: about 1682
Silver gilt
H. 7¼ in. (18.4 cm.)
Heraldry: crest and motto of Spencer ensigned by a marquis' coronet borne upon an imperial eagle ensigned by a prince's coronet, probably for George, Marquis of Blandford, son of Charles, fourth Duke of Marlborough and great grandson of the illustrious John Churchill, first Duke of Marlborough, created a prince of the Holy Roman Empire by Emperor Leopold, 1704
1974.28.184a, b

Stand

Thomas Jenkins
London: 1682
Silver gilt
D. 12¾ in. (32.4 cm.)
68.141.203

These were probably made as companion pieces. Their outlines complement one another, the gilding has the same warm tonality, and the flat-chased chinoiserie decoration seems to be of identical in-

vention and execution. It is possible that this fanciful decoration, which had its greatest vogue between 1680 and 1690, originated in a single London workshop, where commissions from various makers or clients were filled. The cup serves as playground for exotic birds beneath tall trees; the stand shows a setting of Chinese and Western architectural elements that form the stage for Europeans in Chinese fancy dress. A nine-piece toilet set by the same maker, including a mirror marked AH, London, 1681, has a similar decoration; it is in the Sterling and Francine Clark Art Institute, Williamstown,

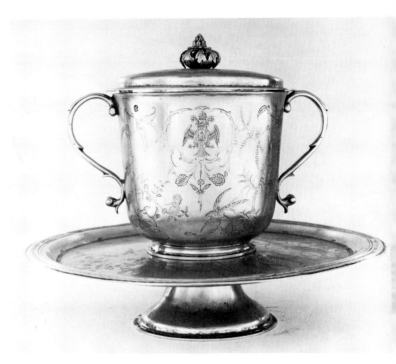

Mass. The Untermyer Collection includes a silver-gilt ewer with harp-shaped handle, maker's mark PA, London, 1685 (68.141.139) that is similarly decorated. Further examples of Thomas Jenkins' work in the collection are a splendid two-handled covered cup, 33, and a pair of boldly embossed tall beaker vases, 36. Both predate the London fashion for chinoiserie decoration on silver.

EX COLL. Duke of Cambridge, before 1911; George Dunn (stand).

REFERENCES: (stand) Jackson, 1911, II, p. 806, ill.; C. C. Dauterman, *Metropolitan Museum of Art Bulletin,* Summer 1964, p. 15, fig. 5; Y. Hackenbroch, *Connoisseur,* CLXXX, 1972, p. 122, fig. 12.

46.

Casters, set of three

Anthony Nelme
London: 1684 (marked on casters and tops)
H. 7 and 4⅞ in. (17.8, 12.5 cm.)
68.141.238–240

The earliest examples of Nelme's work in the collection. He entered his first mark in 1679/80, rose to the honor of being elected Warden of Goldsmiths' Hall in 1717, trained his son Francis to succeed him, and died before February 1723. When allowed to register his mark, 20 March 1722, Francis decided to use the one his father had held ready (but had not used) for conversion to the old sterling silver standard, restored in 1720. The casters' cylindrical shape and their pierced and domed circular bases repeat those of Nelme's 1683 set in the Assheton Bennett Collection, City Art Gallery, Manchester (*Catalogue of Silver,* 1965, no. 107, pl. XI). Their straight-sided form is typical of the insular tradition, antedating the graceful baluster shape introduced by Huguenot masters (78). Yet, in its unsophisticated simplicity, the native form has a special appeal. All the same, we can readily understand why even a successful maker like Nelme feared the foreign competition and lent his name to the petition of 11 August 1697 fighting it. He realized, no doubt, that some traditional English shapes were in danger of being considered old-fashioned, unless native masters swallowed their pride and accepted Huguenot form and fashion, as Nelme eventually did.

REFERENCE: Untermyer *Silver,* 1969, no. 89, ill.

47.

Porringer

Maker's mark: TC in monogram
London: 1685

D. 4½ in. (11.5 cm.)
68.141.262

Circular porringers with convex sides and a single pierced handle, made of silver or pewter, originated during the reign of Charles I. Known also as bleeding bowls, we nevertheless associate them with the enjoyment of food. The Puritans subsequently introduced them into North America, where they had a far longer vogue than in the Old Country. The form changed only in such minor details as the pierced design of the handle, which, as in this example, served for the pricking or engraving of initials. Since no example seems to be known with armorials or a crest, it appears that porringers were primarily used in affluent middle-class households. A double cup by the same maker, same year, is in the collection (68.141.251).

REFERENCE: Untermyer *Silver,* 1969, no. 73, ill.

48.

Double cup

Maker's mark: TC in monogram (on each cup)
London: 1685
H. 5¼ in. (13.3 cm.)
68.141.251

Among similar cups are two marked RN with mullet below. One, London, 1672, is in the Munro Collection at the Henry E. Huntington Library and Art Gallery, San Marino, Calif. (Sotheby's, 15 May 1963, lot 100, ill.; *English Domestic Silver,* exhib. cat., Huntington Library, 1963, no. 39, ill.); the other, London, 1674, with the monogram of Henry Mordaunt, second Earl of Peterborough, was formerly in the collection of Colonel Sackville. Two

further examples are noteworthy, one marked OS above a trefoil, London, 1671 or 1673 (?), at the Inner Temple, London (Oman, 1970, fig. 22A), the other, marked IN over a flower, London, about 1680, in the Francis E. Fowler Jr. Museum, Beverly Hills, Calif. (*Connoisseur*, CLXXVIII, 1971, p. 119, fig. 5d). These various models of the double cup, originating from 1672 to 1685, demonstrate the rapid changes in fashion that affected London silversmiths. After enjoying a brief, intense vogue, the double cup became almost obsolete.

REFERENCE: Untermyer *Silver,* 1969, no. 72, ill.

49.

Nest of six tumblers and cover

> Maker's mark: RH in dentate reserve (on each
> tumbler and cover)
> London: 1688
> Silver gilt; shagreen case
> H. 3 in. (7.6 cm.)
> 68.141.308

Nests of tumblers were rare in England. They recall the German sixteenth-century sets of *Monatsbecher,* decorated with scenes of the Labors of the Months. These were cups, however, whereas ours are tumblers with rounded bottoms, a type popular in England from the reigns of Charles II to George II, though earlier examples exist. Alternating bands of polished and matted silver-gilt form the decoration, the matted effect being obtained by closely spaced strikes of a small round punch. A similar nest, formerly owned by the Earl of Home, is now

owned by Colonial Williamsburg (Davis, 1976, no. 40, pp. 51–52, ill.). Without its shagreen case, it includes a cover with three cast bun feet to form a stand, whereas our cover has a vase-shaped finial. The decoration of the Williamsburg tumblers also relies on the contrast of polished and matted surfaces, though it is differently organized. Our previous reading of the maker's mark was PH; the Williamsburg set is marked RH. Both marks are in the same dentate reserve. We conclude that the maker of both nests was RH.

REFERENCES: Untermyer *Silver,* 1969, no. 74, ill.; J. D. Davis, *English Silver at Williamsburg,* Williamsburg, Va., 1976, pp. 52–53.

50.

Snuffbox

> Unmarked
> England: about 1690
> Silver and oak
> L. 3¼ in. (8.3 cm.)
> 1970.131.14

The commemorative scene on the cover shows the future Charles II hiding in the Boscobel Oak, with an angel in flight offering him the crowns of the three kingdoms: England, Scotland, and Ireland. Two armed riders search for Charles below the tree. Such boxes circulated among royalists as a sign of loyalty to the cause of the young Pretender. Oak was used with silver to symbolize that famous tree. Broadsheets and pamphlets account for the popularity of this scene. However great the disparity between the sacred and the profane, one cannot help thinking in this connection of those countless splinters of the True Cross brought by crusaders from the Holy Land, to be sealed and displayed in reliquaries or monstrances. Similar boxes were included in three recent sales (Sotheby's, 3 February 1972, lot 147, ill; Sotheby's at Gleneagles Hotel, Scotland, 28–29 August 1975, lot 60, ill.; Sotheby's, 26 February 1976, lot 170, ill).

REFERENCE: E. Delieb, *Silver Boxes,* New York, 1968, p. 47, ill.

51.

Pair of pilgrim bottles

Unmarked
England: about 1690
Silver gilt
H. 16¾ in. (42.5 cm.)
Heraldry: arms of Pierrepont ensigned by earl's
 coronet for Evelyn, fifth Earl of Kingston-
 upon-Hull, later created Marquess of Dorchester
 (1706) and Duke of Kingston-upon-Hull (1715)
68.141.225, 226

Among the earliest and most resplendent examples
of Huguenot silver in the collection. The traditional
form, with screw top and heavy chains to facilitate
submersion in a stream, originated in the late Mid-
dle Ages, when the bottles were made of leather,

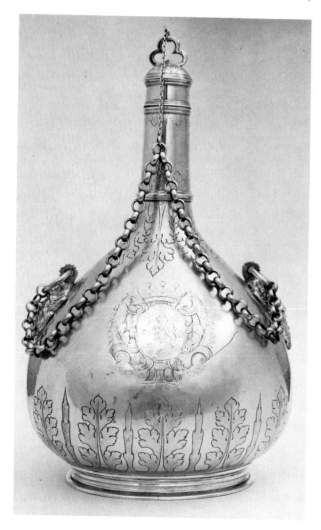

pottery, or metal. After the Revocation of the Edict
of Nantes, Huguenot silversmiths introduced the
form in Holland, Germany, and England. Each of
our bottles has a molded satyr's mask on the shoul-
ders to hold the chains, by now purely decorative.
Matted acanthus foliage is engraved around the
bases and necks, stressing the nobility of the simple
form.

REFERENCES: Untermyer *Silver,* 1969, no. 78, ill.; Clayton,
 1971, p. 199.

52.

Toilet mirror

Anthony Nelme (marked on crest and beneath each
 member of frame)
London: 1691
H. 30¼ in. (77 cm.)
Heraldry: arms of Taylor quartering Gee, for un-
 married lady of the Taylor family of Walling-
 wells, Yorkshire
68.141.190

It is evident in this and in two later examples of
Nelme's work in the collection that he gradually
yielded to elements of the Huguenot style. A
chamberstick of 1699 (68.141.264), entirely plain
and serviceable, has gadrooned borders of Huguenot
derivation. A spherical sponge box of 1713 with
pierced top (68.141.264) repeats a hitherto un-
known form of Huguenot domestic plate. Also part
of a toilet service, our mirror frame is fashioned of
gadroons and surmounted by a crest with putti,
floral vases, swags, and lambrequins that owe much
to the engraved designs of Jean Bérain, published in
Paris, and Daniel Marot, published in The Hague.
Nelme made several similar mirrors. They must
have had a considerable vogue, combining as they
do basically simple forms with Huguenot ornament.
The occurrence of an almost identical toilet mirror
of 1694 by Benjamin Pyne, formerly in the collec-
tion of the Princess Royal (Christie's, 6 July 1966,
lot 109), leads us to believe that these two masters
combined efforts, upholding the high standards of
English goldsmiths yet remaining sensitive to the
contributions of their French competitors.

53.

Pair of covered toilet boxes

Peter Harache
London: 1692
Silver gilt
D. 4½ in. (11.4 cm.)
Heraldry: (added later) Smyth impaling Atkyns, with badge of Ulster, possibly for Jarrit Smyth of Ashton, Somerset, created baronet 1763, and his wife, a lady of the Atkyns family
68.141.279a, b, 280a, b

The first Huguenot master to arrive in England was Peter Harache, "lately [1681] come from France to avoid persecution and live quietly," as was stated in the certificate declaring him and his family free denizens. After his admittance to the freedom of Goldsmiths' Hall a year later, he produced some of the finest English domestic silver in the French style ever made, including commissions for William III. These toilet boxes show Harache's astonishing virtuosity in combining various techniques and forms of decoration, notably the pierced, detachable strapwork around the calyx, which is of his own invention. The gadrooned borders encircling base and cover, on the other hand, are typical of Huguenot silver.

REFERENCE: Untermyer *Silver,* 1969, no. 79, ill.

54.

Ecuelle with cover

Daniel Garnier
London: dated 1694
Silver gilt
D. 6½ in. (16.5 cm.)
68.141.274

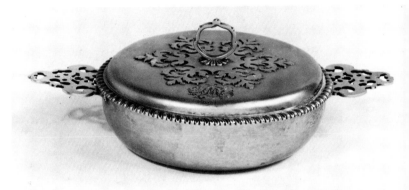

Garnier, a goldsmith from Caen in Normandy, arrived in England fully trained and was admitted to Goldsmiths' Hall in 1698. This ecuelle, its shape typically French, is one of his earliest pieces. In France, such covered dishes with matching stands were presented to a mother after childbirth. Ecuelles never belonged to the repertory of English masters, who tended to prefer the porringer with neither cover nor stand, and only one handle. The Huguenot shape lent itself admirably to being rendered in porcelain, and as the age of western European porcelain was near at hand, similar dishes were soon made in Continental, and subsequently English, porcelain. These circumstances render our beautiful ecuelle, with its distinctive cut-card decoration around the finial, a rare object. Also by Garnier is the standish, 57.

EX COLL. Sir Michael Noble (Christie's, 13 December 1967, lot 29, ill.).
REFERENCE: Untermyer *Silver,* 1969, no. 83, ill.

55.

Two-handled cup with cover

Thomas Boulton (marked on cup and cover)
Dublin: 1696
H. 7¾ in. (19.7 cm.)
Heraldry: arms of a gentleman of the Calvert family, the best known of whom is George Calvert, Baron Baltimore, absolute lord and proprietor of Maryland and Avalon (Newfoundland) in America
68.141.235a, b

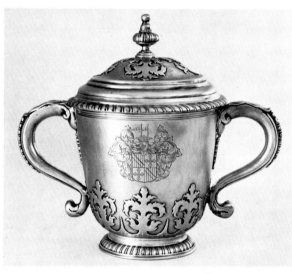

This shows both the high skill of Dublin silversmiths and their awareness of the latest trends in London workshops. The cut-card decoration applied around the cup and cover is almost identical with that on Daniel Garnier's silver-gilt ecuelle of 1694 (54), reconfirming the availability of such decorative elements in London shops, produced by specialists to fill the needs of practicing goldsmiths. A comparable cup by Boulton, 1694, was in the G. W. Panter collection (Sotheby's, 18 July 1929, lot 61, ill.); another, 1693–95, is in the Museum of Fine Arts, Boston (30.112).

REFERENCE: Untermyer *Silver,* 1969, no. 101, ill.

56.

Pair of andirons

Benjamin Pyne
London: 1697 (Britannia standard)
Silver and iron
H. 21⅜ in. (54.3 cm.)
68.141.155a, b

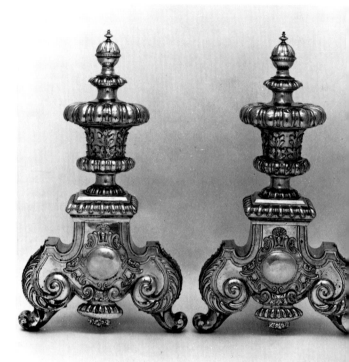

Andirons were usually made of brass or bronze. The few surviving silver examples were usually made of heavy sheets applied to a metal core that was linked by slots to the iron log rests at the rear. Purely decorative details, such as the vase-shaped finials on our pair, were cast. Benjamin Pyne entered his first mark in 1676. He was named a largeworker in 1697 when a new register was compiled after the introduction of the Britannia standard. (Coinage and silver plate had hitherto been made of the same sterling standard, which had led to the clipping and melting of coins for plate. To protect the official coinage, the Mint ordered the old sterling standard retained for coinage and the standard for silver plate increased. Compulsory new marks were introduced to show the difference.) Pyne, one of the foremost goldsmiths, belonged to the generation that felt

most strongly the effect of the Huguenot artisans, whose arrival in England was linked to the Revocation of the Edict of Nantes by Louis XIV in 1685. Pyne expressed his resentment by signing the petition against the work of "aliens or foreigners" in 1697; nonetheless, with the ease of the great master that he was, he merged English and French tastes. The design of our firedogs may have been based on extant Huguenot prototypes, or it may have been adapted from French engraved patterns for the silversmith, such as those in the *Nouveaux livre de Chenest* (C. Cotelle, Paris, about 1700).

EX COLL. Sir Giles Sebright (Christie's, 5 May 1937, lot 97, ill.).
REFERENCE: Untermyer *Silver,* 1969, no. 86, ill.

57.
Standish

Daniel Garnier (marked on cover, drawer, and twice on base)
London: 1697 (Britannia standard)
L. 9½ in. (24.1 cm.)
Heraldry: crest of Upton, ensigned by baron's coronet, probably for John Henry, second Baron Templetown (1771–1846) before being created first Viscount Templetown (1806)
68.141.168a–d

With tapering sides and gadrooned borders, this standish is fitted with compartments for ink, pounce, and, beneath the hinged cover, seal. A drawer below provides space for pens. A similar standish was recently added to the Elizabeth B. Miles collection at the Wadsworth Atheneum, Hartford, Conn. (*Elizabeth B. Miles Collection of English Silver,* 1976, p. 138, fig. 175); it is marked by William Lukin, who attained the freedom of Goldsmiths' Hall in 1699. How is one to explain two versions of the same model with different marks? Garnier was a Huguenot, Lukin an Englishman who petitioned against the assaying of work by foreigners. We can only assume that Lukin over-

marked and sold a standish that Garnier had executed before registering his own mark.

EXHIBITED: Victoria and Albert Museum, London, 1968, *The British Antique Dealers' Association Golden Jubilee Exhibition,* no. 41, pl. 12.
REFERENCE: Untermyer *Silver,* 1969, no. 84, ill.

58.
Pair of perfume bottles

John Bodington
London: 1700 (Britannia standard)
Silver gilt
H. 7¼ in. (18.4 cm.)
Heraldry: Master impaling Legh, for Sir Streynsham Master, Codnor Castle, County Derby, Governor of Fort St. George, East Indies, and his second wife, Elizabeth, daughter of Richard Legh of Lyme, County Chester
1970.131.15

Part of a large toilet service of twenty-one pieces by four specialist makers. The service was dispersed after 1929. In 1703 Bodington was a signer of the petition to the Goldsmiths' Company against the marking of foreigners' work. But however much he may have resented the competition, he certainly did not escape Huguenot influence, as shown by the gadrooned edges and finials of these bottles. They also indicate how congenial this predominantly provincial French style must have been to English makers and their patrons, whose preference for plain, serviceable form manifested itself periodically throughout the long and glorious history of English plate. Two circular bowls from the same service, also by Bodington, London, 1699, were lot 48 in Christie's sale catalogue, 24 November 1971, ill.

EX COLL. Faith Moore, London.
EXHIBITED: Residence of Sir Philip Sassoon, London, 1929, *Loan Exhibition of Old English Plate and Decorations and Orders, for the Benefit of the Royal Northern Hospital,* no. 345, pl. 56 (as part of the toilet service).

59.

Pocket canteen with original shagreen case and plug fitted to hold dining utensils

Charles Overing (cup)
Marks: flatware, T·T beneath crown; marrow
 spoon, EH with pellet below
London: 1700 (Britannia standard)
H. cup 3½ in. (8.9 cm.)
68.141.256

The cooperation of several specialists was customary in the production of such traveling canteens. The flatware, made in London about 1700, was often supplied by the maker T·T beneath crown. The hunting scenes engraved on the cup strike a popular note and may have been derived from contemporary book illustrations.

EX COLL. Sir John Noble (Christie's, 12 December 1951, lot 100, ill.).
REFERENCES: C. J. Jackson, *English Goldsmiths and Their Marks,* London, 1921, p. 154; Y. Hackenbroch, *Connoisseur,* CLXVIII, 1968, p. 140, fig. 4; Untermyer *Silver,* 1969, no. 95, ill.

60.

Pair of salvers on foot

Andrew Moore (marked on salvers and feet)
London: 1703 (Britannia standard)
Silver gilt
D. 15 in. (38.1 cm.)
Heraldry: Methuen family arms
68.141.233, 234

Moore's fame rests solidly on his set of royal silver furniture presented about 1690 by the City of Lon-

don to William III, now at Windsor Castle. These magnificent salvers were made for Sir John Methuen (1650–1706), the negotiator of a commercial treaty, known as the Methuen Treaty, with Portugal in 1703. The genius of Moore lies in his conception of generous form. These salvers are vehicles for the display of family arms. Each armorial appears within a cartouche of superbly organized foliage, calculated to enhance the plain surface, encircled by a threaded and gadrooned border. With admirable restraint Moore applied his simple cut-card decoration underneath only, around the detachable foot.

EX COLL. Methuen family (Christie's, 20 February 1920, part of lot 62, which included a pair of double-handled cups with covers, eight smaller salvers, and twenty-four plates by Andrew Moore and John Gibbons, 1703); W. R. Hearst, 1965.
REFERENCE: Untermyer *Silver,* 1969, no. 99, ill.

61.

Oval canteen cup

John Smith
London: 1703 (Britannia standard)
Silver gilt
H. 4 in. (10.2 cm.)
Heraldry: unidentified arms within widow's lozenge
68.141.252

Probably part of a traveling set, this shows the happy combination of a typically English form and superb Huguenot engraving in the style of Simon Gribelin, a member of a well-known family of watchmakers from Blois who came to London in 1680. There he published *A Book of Severall Ornaments* (London, 1682), followed by patternbooks primarily for watchmakers and silversmiths. A Huguenot master appears to have engraved the designs of 61.

62.

Chocolate pot

Robert Cooper (marked on pot and cover)
London: 1705 (Britannia standard)
H. 10⅛ in. (25.7 cm.)
68.141.86

The shape of this tapered, cylindrical pot—inter-changeable with that used for coffee except for the aperture in the cover to permit stirring the choco-late—is typically English, predating the Huguenot influence that was felt during the reign of Queen Anne. Robert Cooper appears in the account books of the banker Richard Hoare as a supplier of do-mestic plate to Samuel Pepys. His style was shared by several prominent London silversmiths of his generation. Similar pots were made in 1701 by Anthony Nelme (Sterling and Francine Clark Art Institute, Williamstown, Mass.), in 1702 by Wil-liam Lukin (Burrel Collection, Glasgow Art Gal-lery and Museum), in 1703 by William Charnel-house (Minneapolis Institute of Arts). Typical features include: flamelike cut-card motifs applied around the base of the curved spout with hinged cap, the spout set at right angles to a handle with matching cut-card decoration masking the joints, and a matching strap along the entire length of the handle. The hinged cover displays parallel flutings and a matted scalloped border. This, then, describes the London-made chocolate pot fashionable around the turn of the century until the early years of Queen Anne's reign.

63.

Coffeepot

Francis Garthorne (marked on pot and cover)
London: 1705 (Britannia standard)
H. 8⅞ in. (22.5 cm.)
68.141.258

Among the least conventional of coffeepots is this one by a largeworker who signed the petition against the work of "aliens or foreigners" in 1697 as "working goldsmiths." The style shows clearly that Garthorne belonged to the circle of tradition-bound native masters who chose their decorative motifs from English furniture rather than from Huguenot silver. The curving spout terminating in an eagle's head reminds us of the curved armrests of Queen Anne chairs. The motif is all the more effec-tive because it is the only one used.

64.

Chocolate pot

Richard Syng
London: 1706 (Britannia standard)
H. 8½ in. (21.6 cm.)
1974.28.168

In 1706, this must have been considered slightly old-fashioned. Syng, a free master in 1687, was no longer young, and obviously deeply rooted in the artistic conventions of the William and Mary pe-riod. At that time, narrow scalloped bands or flutings and punched motifs had been the height of fashion; in 1706 they were dated. Also harking back to an earlier tradition is the chased, rather stiff foliage forming vertical bands. The pear-shaped body has a plain spout with hinged cap, and a wooden handle set at right angles to it. As usual, the domed cover has a removable finial that allows the use of a stirring rod; the hinges terminate in a large bifurcated thumbpiece, more usually found on Caroline tankards. The style explains, at least in

part, why Syng's name is found on the petition against foreign workmen of 1 October 1703. He probably felt too old to modify his style, even though he was aware of the changes brought about by the Huguenot masters. The style followed by Syng lived on in the New World in a chocolate pot by Edward Winslow made in Boston during the first quarter of the eighteenth century (Metropolitan Museum 33.120.22).

REFERENCE: Y. Hackenbroch, *Connoisseur,* CLXXX, 1972, p. 123, fig. 15.

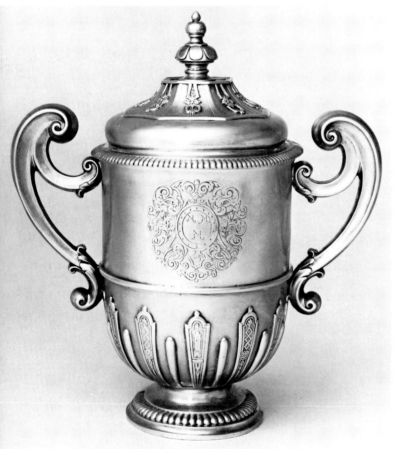

65.
Two-handled oval cup with cover

Pierre Platel (marked on cup and cover)
London: 1707 (Britannia standard)
H. 9¾ in. (14.8 cm.)
Heraldry: arms and crest of the Bridges family, Goodnestone Lodge, Kent
68.141.293a, b

Platel, whose family came from Lille, entered his mark as largeworker in 1699. One of the great Huguenot masters, he passed his high standards of excellence on to Paul de Lamerie, his apprentice from 1703 to 1713. Platel was among the few goldsmiths to be entrusted with large amounts of gold, and two commissions in gold for the Duke of Dev-

onshire survive at Chatsworth: the celebrated ewer and basin of 1701 and the covered cup of 1717. Platel made several double-handled covered cups; they had become fashionable as presentation pieces and table centerpieces. Splendid examples by Platel exist from 1702 (Clayton, 1971, fig. 265) and 1705, the latter in the Ashmolean Museum, Oxford (Hayward, 1959, fig. 6). Our cup is unique in its oval shape. The harp-shaped handles, gadrooned borders, and applied decoration are Huguenot features. The style of the engraved designs derives from the work of Simon Gribelin. For combined taste and excellence of workmanship, this cup is almost without a rival. A teapot in the collection by Platel, of utter simplicity, also shows the sure hand of a great master (68.141.311).

EX COLL. Mrs. J. G. Protheroe-Beynon (Christie's, 15 February 1967, lot 124, frontispiece).
REFERENCE: Untermyer *Silver,* 1969, no. 111, ill.

66.
Tumbler cup

Joseph Ward
London: 1708 (Britannia standard)
Interior gilded
H. 4 in. (10.2 cm.)
Heraldry: arms of Staple Inn, London
Inscription: (on bottom) Laurentius Agar. (hac de Societate, 1664&c)/Serviens ad legem, 12°Gu:3.1700/hoc dat amice, 1709./Lau.ᵇˡⁱ Societati Hospitij vulgo vocati/Staple Inn: LASAL. [Laurence Agar (of this Society, 1664 etc.)/Serjeant-at-law, 12th June (?), 1700/gives

this in friendship, 1709/to the Worshipful Society of the Hostel commonly called/Staple Inn: LASAL (possibly standing for Laurance Agar, Serjeant-at-law).]
68.141.195

In the Gray's Inn Register for 1677 is mentioned "Laurence Agar, late of Staple Inn, Gent."; and again, 1705, "Laurence Agar, Gent., third son of William Agar, late Earswick, Yorkshire, Gent., deceased." Staple Inn was bought from the Staplers in 1529 by the Benchers of Gray's Inn, to provide accommodation for law students. This tumbler, although larger than most examples, has been raised and beaten from a circular sheet of silver. Such tumblers offered splendid opportunities for the display of armorials. The cartouche resembles designs seen in Jean Tijou's *A New Booke of Drawings* (London, 1693). A similar tumbler by Samuel Dell, London 1692, is in the Museum of Fine Arts, Boston (33.81), and an oval one, with the mark T·T beneath a crown, undated, is in the Metropolitan Museum's collection (33.120.39).

REFERENCE: Untermyer *Silver* 1969, no. 104, ill.

67.

Censer, incense boat, spoon

Benjamin Pyne (marked on censer and incense boat)
Maker's mark, spoon: DV, rayed sun above
London: 1708 (Britannia standard)
H. censer 8⅞ in. (22.7 cm.); L. incense boat 4 in. (10.2 cm.), spoon 2½ in. (6.4 cm.)
68.141.259, 260

Post-medieval censers are rare. This example is interesting in that it resembles a sugar caster, while the incense container, originally boat-shaped, now looks like a spice box with hinged double cover. However conservative the then relatively old Ben-

jamin Pyne's attitude toward foreign influence had been (see 56), he modified the form of recusant plate, used by English Catholics, to harmonize with current styles.

EX COLL. Lord Clifford of Chudleigh (Christie's, 15 June 1966, lot 81, ill.).
REFERENCES: Untermyer *Silver,* 1969, no. 196, ill.; Clayton, 1971, p. 58, fig. 110.

68.

Chocolate pot

Nathaniel Lock (marked on pot and cover)
London: 1708 (Britannia standard)
H. 10¼ in. (26 cm.)
Heraldry: arms of Bickford impaling Tremayne for William Bickford of Dunsland, Devon, and his wife, Bridget Tremayne (m. 1708), of Sydenham, Devon
68.141.85

Lock, who entered his first mark as a smallworker in 1687, became a largeworker ten years later. In

1697 he was another of the petitioners against the competition of "aliens and foreigners." We can understand some of his fears after examining 68, for he was obviously deeply rooted in the artistic conventions of the previous age. He placed his pot on three lion sejant feet, of the kind seen on Charles II tankards, even though the lions' masculine prowess was better suited to the character of ale and beer than that of sweet chocolate. We assume that Lock used existing molds for these solidly cast lions. The swan-neck spout, provided with a hinged cap, has a plain rim around the socket. The handle is set at right angles to the spout, which was then the usual form. The hinged, flanged cover has the customary aperture for the insertion of a stirring rod. Lock was obviously harking back to traditional form rather than looking forward to the latest Huguenot trends. His attitude was, at least in part, indicative of his generation, but it also shows the personal taste of a goldsmith who chose to create domestic plate of enticing simplicity and robust character.

EXHIBITED: Parke-Bernet, New York, 1967, *Art Treasures Exhibition*, no. 210, ill.

REFERENCES: Untermyer *Silver*, 1969, no. 115, ill.; Clayton, 1971, p. 130, fig. 130.

styles, as illustrated by these boxes, which repeat models Willaume may have seen in Metz as his father's apprentice. An additional circular compartment, lodged between the hinges of the cover, is a detail not often seen. The tight organization of these boxes, or double salts, with chamfered corners, follows the Louis XIV period preference for compact form, a preference that gradually gave way to flowing oval outlines. Willaume's superb skill can be fully appreciated when one closes the covers of these boxes and hears the air escape—a sound associated with precious French gold snuffboxes. A bullet-shaped teapot of 1718 in the collection (68.141.253) shows the aging Willaume adopting a typically English form of domestic plate; so, too, does his large decafoil salver, 85.

EXHIBITED: Victoria and Albert Museum, London, 1968, *The British Antique Dealers' Golden Jubilee Exhibition*, no. 43, pl. 14 (one).

REFERENCE: Untermyer *Silver*, 1969, no. 120, ill.

69.

Pair of spice boxes

David Willaume
London: 1709 (Britannia standard)
Interiors gilded
L. 4¼ in. (10.8 cm.)
Heraldry: arms of George Pochin of Bourne, Lincolnshire, and his wife, Eleanor Frances, daughter of Sir Wolstan Dixie of Market Bosworth, Leicestershire
68.141.162, 163

The son of a goldsmith from Metz, Willaume gained the freedom of Goldsmiths' Hall in 1693/94, entering his first mark as largeworker in 1693. His wife was a sister of the goldsmith Lewis Mettayer, and his sister-in-law married the engraver Simon Gribelin. His son David continued his workshop. Willaume's early plate followed current French

70.

Pair of sconces

Isaac Liger (marked on sconces, backplates, clips, branches, drip pans)
London: 1709 (Britannia standard)
Silver gilt
H. 8¼ in. (21 cm.)
Heraldry: a fret over a cipher (unidentified)
68.141.218, 219

Made usually in pairs or sets, sconces were designed to magnify and reflect candlelight. The candles were placed in sockets—always with a drip pan—at the end of fixed or movable branches. This pair, with

fixed bracket-shaped arms, has a remarkably crisp surface, attained through precise modeling and tooling. Liger struck a happy balance between traditional form with semiarchitectural elements such as bold scrollwork, and decorative elements such as masks and swags. These he organized to frame oval fields, on which, about 1810, Robert Hennell III engraved an owner's ciphers. Liger was among the most accomplished silversmiths of his period, and from 1708 to his death in 1730 he supplied one of the most discriminating of English silver collectors, George Booth, second Earl of Warrington.

REFERENCES: Hayward, 1959, fig. 72B (one); Untermyer *Silver,* 1969, no. 106, ill.

71.

Cistern

Lewis Mettayer
London: 1709 (Britannia standard)
L. 32 in. (81.3 cm.)
Heraldry: (added later) Grenville with Pitt in pretense ensigned by baron's coronet, with supporters and motto REPETENS EXEMPLAR SUORUM, for William-Wyndham Grenville of Wotton-under-Bernewood, created Baron Grenville 1790, and his wife, Anne (m. 1792), daughter and eventual heiress of Thomas Pitt, first Lord Camelford
68.141.132

Used to cool bottled wine or, less often, to rinse glasses and plates, cisterns were placed within easy reach of dining tables or buffets. Usually of impos-

ing size, they often had figural bails that alluded to the owner's crest or armorial supporters. The original significance of the half-horse shapes is lost. Mettayer, who entered his first mark as largeworker in 1700, is well represented in the Untermyer Collection. One of the three key figures among the London Huguenot goldsmiths, his family ties linked him to Pierre Harache and David Willaume, and these three even interchanged patterns or molds. For example, 71 is encircled by applied, pierced strapwork identical with that seen on Harache's domestic plate, in particular his cistern of 1697 in the Barber-Surgeons' Company, London (Hayward, 1959, fig. 21). And similar half-horse handles are on Willaume's cistern of 1708 from the Cumberland Plate (Hayward, fig. 23). In spite of these borrowings, the extraordinary quality of such plate has rarely been surpassed.

EX COLL. W. R. Hearst.
EXHIBITED: Grafton Galleries, London, 1928, *Exhibition of Art Treasures, under the Auspices of the British Antique Dealers' Association,* no. 961, ill. p. 124.
REFERENCES: N. M. Penzer, *Apollo,* LXVI, 1957, pp. 39–46; Untermyer *Silver,* 1969, no. 131, ill.; Grimwade, 1976, p. 596.

72.

Snuffbox

England (London): about 1710
Gold
L. 3¼ in. (8.3 cm.)
Heraldry: unidentified arms, probably of a Continental family
1970.131.20

In England, the art of engraving on silver and gold had a sudden flowering through the contribution of Simon Gribelin, the Huguenot designer whose patternbooks were published after 1682. On rare occasions Gribelin engraved directly on plate, but since he did not sign his work, attributions to him must be tentative. The armorials in the elaborate cartouche on the cover of 72 are fitted admirably into the space, with a fluency of line that suggests the master's own touch. Such artistic excellence was

not reached again until William Hogarth applied himself briefly to engraving on plate, having been apprenticed to the London goldsmith Ellis Gamble in 1712.

REFERENCE: Y. Hachenbroch, *Connoisseur*, CLXXX, 1972, p. 124, fig. 18.

73.

Pair of tapersticks

Thomas Merry
London: 1710 (Britannia standard)
H. 4½ in. (11.5 cm.)
Heraldry: arms of Ridler family of Gloucestershire within lozenge for unmarried lady
68.141.44, 45

Merry had been apprenticed to the candlestick-maker John Laughton from 1695 to 1701 when he entered his own mark as smallworker. He continued that specialization and became London's leading maker of cast tapersticks, candlesticks, and snuffers. The Untermyer Collection includes another pair of his tapersticks, 1716 (68.141.50, 51), and a pair of his candlesticks, 1713 (68.141.245, 246). Comparing them, one can see how receptive Merry was to subtle changes of style. In fact, they suggest that he introduced the changes himself. He seems to have been the first, in 1710, to adopt baluster stems for candlesticks, and first again, in 1713, to place candlesticks on square molded bases with cut corners and central depressions, a form that Lamerie was to use throughout his career. We may wonder whether his specialty allowed Merry to support himself, for he was among the petitioners in 1711 who complained of the competition of "necessitous strangers." Had he been in more comfortable circumstances, perhaps he would have felt otherwise and offered able Huguenots employment in his own workshop.

EX COLL. Sir George Holford, Glos.; Arthur M. Nowak, New York (American Art Association, Anderson Galleries, New York, 17 March 1934, lot 51, ill.)
REFERENCES: Untermyer *Silver*, 1969, no. 107, ill.; S. T. B. Percival, *Connoisseur*, CLXXIV, 1970, pp. 270–274.

74.

Sugar basin and cover

Ebenezer Roe (marked on basin and cover)
London: 1711 (Britannia standard)
L. 2⅞ in. (7.3 cm.)
Heraldry: unidentified crest and motto, possibly of a branch of the Stewart family
1974.28.170a, b

This hexagonal box is exhibited not merely because of its unusual shape, but to show that even a now obscure master produced domestic silver of unusual appeal. The stepped base and cover have architec-

tural qualities that have been translated successfully into the medium of silver, and adapted to the proportions of the tea table.

75.

Pair of trembleuse stands

Paul de Lamerie
London: 1713 (Britannia standard)
Silver gilt
D. 6 in. (15.2 cm.)
68.141.222, 223

This pair is among Lamerie's earliest work, made the year he terminated his apprenticeship with

Pierre Platel. Lamerie was worthy of his great master, who taught him to appreciate simplicity of form. He never forgot the lessons of his youth, and throughout his long and productive life he would return to his earlier, plainer style, as if to pause temporarily in his fanciful flights into rococo imagery. The term trembleuse refers to saucers with stands or frames that hold handleless cups. Initially these were made of blanc de chine, subsequently of French soft-paste or German hard-paste porcelain. The present cups are of Doccia soft-paste porcelain

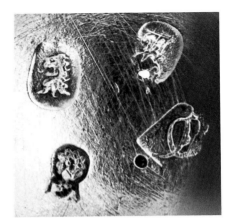

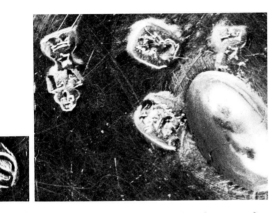

with the fine tin glaze often used at this factory after 1765.

REFERENCE: Untermyer *Silver*, 1969, no. 171, ill.

76.

Pair of covered jugs

> Simon Pantin (marked on jugs and covers)
> London: 1713 (Britannia standard)
> Silver gilt
> H. 11⅝ in. (29.5 cm.)
> Heraldry: (engraved after 1801) arms of Frederick Augustus (1763–1827), second son of King George III, Duke of York and Albany (1784), and his wife (m. 1791), Frederica Charlotte Ulrica Catherine, Princess Royal of Prussia
> 68.141.137, 138

The earliest example of Pantin's work in the collection. From Rouen, Pantin was probably apprenticed to Peter Harache before he entered his first mark as largeworker in 1701. The jugs are remarkable for

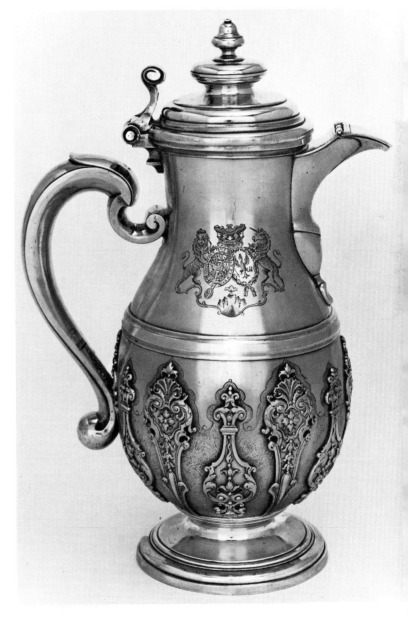

their generous weight, perfect proportions, and ornamental refinement. Below the molded rib that encircles the pear-shaped body are straps of alternating husk and shell design applied to a matted ground. Straps from the same molds were used on a two-handled covered cup of 1732 by Thomas Farren, in the Untermyer Collection (68.141.127a, b). Their occurrence on this later piece indicates the ready availability of such details, produced in the London workshops of specialists.

EX COLL. Lord Brownlow (Christie's, 13 March 1929, lot 56, ill.); E. Permain; W. R. Hearst (Christie's, 14 December 1938, lot 45, ill.).
EXHIBITED: Philadelphia Museum of Art, 1946, *Period Silver in Period Settings;* Parke-Bernet, New York, 1967, *Art Treasures Exhibition,* no. 213.
REFERENCES: C. R. Beard, *Connoisseur,* CII, 1938, p. 295, fig. 15; E. Wenham, *Antique Collector,* 16, January–February 1945, p. 59, fig. 2; Untermyer *Silver,* 1969, no. 137, ill.; Grimwade, 1976, p. 613.

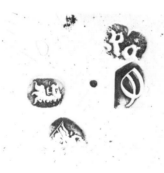

77.

Octagonal teapot on stand with lamp

Maker: John Rand (marked on teapot, stand, and lamp)
London: 1713 (teapot), 1707 (stand and lamp) (Britannia standard)
H. teapot 6½ in. (16.5 cm.)
1974.28.171

Little is known of Rand, whose life was short. His surviving work epitomizes the highly developed sensibilities of the Queen Anne style. The small size of this pot is linked to the then high price of tea. Octagonal shapes enjoyed a great vogue and were frequently adopted for items in the service of tea or coffee. The faceted swan-neck spout with duck-head terminal was also popular.

78.

Set of three casters

Lewis Mettayer
London: 1714 (Britannia standard)
Silver gilt
H. 8¾, 6¾ in. (22.2, 17.1 cm.)
Heraldry: (on each caster) royal arms, motto, and cipher of George I
68.141.71–73

Made when Sir Paul Methuen (1672–1757) was ambassador to Spain and Morocco, these formed part of his ambassadorial plate, as did five silver-gilt dishes by the same maker, 79. Such plate was issued by the Crown to officers of state and ambassadors, both in England and abroad. At the end of a mission the plate ordinarily had to be returned to the Royal Jewel House. In the case of Sir Paul, most of his plate, including these casters, was presented to him as a token of gratitude for his distinguished service. Ambassadorial plate was always engraved with the cipher of the ruling monarch, the cipher being altered when the plate was reissued in a subsequent reign. Most of the Methuen plate remained in the family until 1920. The casters are a perfect example of Mettayer's noble, elegant style. Typical of Huguenot conventions are the baluster-shaped containers, replacing the cylindrical shape of the Charles II and subsequent periods. The larger caster was intended for sugar. One of the smaller pair has its perforations blinded, making it suitable for mustard.

EX COLL. Methuen family (Christie's, 25 February 1920, lot 78, ill.); H. H. Mulliner (Christie's, 9 July 1924, lot 41, ill.); Viscount Lee of Fareham.
REFERENCES: H. H. Mulliner, *The Decorative Arts in England: 1660–1780,* London [1924], fig. 103; W. W. Watts, *Works of Art in Silver and Other Metals Belonging to Viscount and Viscountess Lee of Fareham,* London, 1936, pl. 32; *Antiques,* LIII, 1948, p. 115, ill.; Untermyer *Silver,* 1969, no. 132, ill.

79.

Set of five dishes

Lewis Mettayer
London: 1714 (Britannia standard)
Silver gilt
L. 13½ in. (34.3 cm.)
Heraldry: (on each dish) royal arms, motto, and
cipher of George I
68.141.288–292

The fan shape, an unusual one, may have been influenced by Chinese porcelain. Twelve dishes of the original large set, including four large circular and four fan-shaped ones, are in the royal collection at Buckingham Palace, presented 6 May 1935 by the Lord Mayor and Corporation of London to George V and Queen Mary on the occasion of their Silver Jubilee. Another outstanding example of Mettayer's work is in the Untermyer Collection, a large kettle on lampstand of 1708 (68.141.83).

EXHIBITED: Residence of Sir Philip Sassoon, London, 1929, *Loan Exhibition of Old English Plate and Decorations and Orders, for the Benefit of the Royal Northern Hospital*, no. 65, pls. 45, 46 (as part of a larger set).
REFERENCE: Untermyer *Silver*, 1969, no. 133, ill.

80.

Pair of wine coolers

William Lukin
London: 1716 (Britannia standard)
H. 8¼ in. (21 cm.)
Heraldry: arms of Sir Robert Walpole (1676–1745), created Earl of Orford in 1742, impaling those of his wife, Catherine, daughter of Sir John

Shorter of Bybrook, Kent, Lord Mayor of London
68.141.128, 129

Made for Sir Robert Walpole, Prime Minister of England, these were inherited by his son Horace and were described in the 1842 sale catalogue of Strawberry Hill as "A pair of splendid octagon WINE COOLERS, chased rose flower tablets, arabesque borders and scroll handles." The French character of the coolers suggests that Lukin must have either employed Huguenot silversmiths or submitted and sold their work as his own. The chased and engraved ornament is organized within well-defined fields, without any indication of the overflow of asymmetrical form that was to be an element of the coming age of rococo. The coolers represent the Louis XIV style in English silver. The closest comparable coolers are a pair made of gilt metal, formerly in the Puiforcat collection (Galerie Charpentier, Paris, December 1955, lot 98, pl. XXI), now in the Louvre (*Catalogue de l'orfèvrerie du XVII^e,*

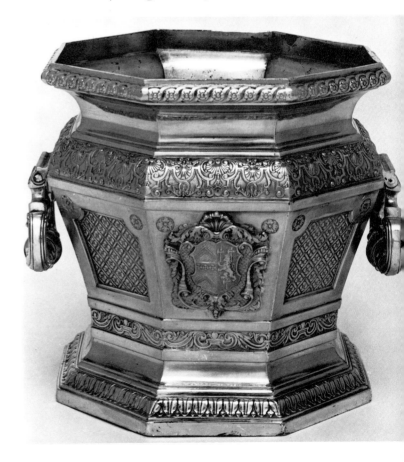

XVIII^e et du XIX^e siècle, Paris, 1958, no. 24, pl. VIII, described as "Paris, end of the seventeenth century"). A similar pair, of attenuated octagonal shape, is in the Philadelphia Museum of Art, one with the mark of Pierre Platel, 1703, the other with that of his pupil, Paul de Lamerie, London, 1716. A comparable cooler with the mark of David Willaume, London, 1718, was exhibited in London in 1929 (*Queen Charlotte's Loan Exhibition of Old Silver,* Seaford House, London, 1929, no. 461, pl. 69). Another example of Lukin's work in the Untermyer Collection is a kettle on lampstand of 1710 (68.141.82), with circular pear-shaped body and faceted swan-neck spout with hinged cap, the stand with simple bun feet.

EX COLL. Robert Walpole, Lord Orford; Horace Walpole (*Sale Catalogue of the Contents of Strawberry Hill,* 6 May 1842, lot 127, p. 122); Bertram, fifth Earl of Ashburnham (Christie's, 24 March 1914, lot 59, ill.); Marchioness of Cholmondeley, Houghton Hall, King's Lynn (Sotheby's, 2 November 1950, lot 150, ill.).

EXHIBITED: Residence of Sir Philip Sassoon, London, 1929, *Loan Exhibition of Old English Plate and Decorations and Orders, for the Benefit of the Royal Northern Hospital,* no. 760, pl. 55; 45 Park Lane, London, 1938, *The "Old London" Exhibition, in Aid of the Royal Northern Hospital,* no. 141; Mallett's Galleries, London, 1950, *Three Centuries of British Silver, Loan Exhibition in Aid of the Citizens' Advice Bureaux,* no. 85.

REFERENCES: W. W. Watts, *Apollo,* XXVII, April 1938, p. 189, ill.; A. G. Grimwade, *Apollo,* LII, 1950, p. 45, fig. VIII; R. Came, *Silver,* London, 1961, p. 80, fig. 60; Untermyer *Silver,* 1969, no. 125, ill.; Clayton, 1971, p. 341, fig. 724.

81.

Covered jug

James Fraillon (marked on jug and cover)
London: 1717 (Britannia standard)

H. 6⅛ in (15.5 cm.)
Heraldry: unidentified arms
68.141.312

Fraillon belonged to the first generation of Huguenot silversmiths born in England. His uneventful life left few traces, and he might be forgotten were it not for the excellence of a few pieces of domestic silver that bear his mark. A masterpiece of quiet refinement, 81 was probably made to serve hot milk or water. The octagonal molded foot is raised to keep the heat off the table surface; the handle is made of wood to render it cool to the touch. The octagonal baluster body is executed with such apparent ease that it belies the technical difficulties in raising and shaping a flat piece of metal, and following through that pleasing shape from the separately cast base to the finial. Other examples of Fraillon's work in the collection are a silver-gilt casket of 1716 (68.141.160) and an inkstand on spread eagles with claw-and-ball feet of 1723–24 (68.141.169).

REFERENCE: Untermyer *Silver,* 1969, no. 142, ill.

82.

Charger

Lewis Mettayer
London: 1717 (Britannia standard)
D. 27 in. (68.6 cm.)
Heraldry: royal arms of George I
1972.169

Chargers—large dishes—of predominantly cere-

monial character were often displayed on sideboards. Those fitted with a central boss presumably formed a set with matching ewer for table use. The

extraordinary size and weight of 82 renders table use unlikely, however. The arms displayed at the center form an effective contrast to the swirling gadroons around the border; these are combined with applied ornament on a matted ground with lobed outlines. Conveying an impression of royal splendor, the charger testifies to the high standards maintained by those who supplied the court.

EX COLL. Lord Brownlow (Christie's, 29 May 1963, lot 12, ill.); seventh Earl of Radnor (Christie's, 24 November 1971, lot 84, ill.).
REFERENCE: Grimwade, 1976, p. 596.

83.

Ewer and basin

Samuel Margas (ewer)
London: about 1720
Silver gilt
H. ewer 14$\frac{1}{2}$ (36.9 cm.); D. basin 27 in. (68.6 cm.)
Heraldry: badge of the Order of St. Andrew (founded by Peter the Great, 28 November 1689)
Inscription: (in Cyrillic letters, bottom of ewer, bottom of basin) English, No. 1; English, No. 2
68.141.133, 134

Of imposing dimensions, this ceremonial set is representative of the Huguenot silversmith's repertory in England. A handle similar to Margas' bold scroll, supported by a scroll bracket terminating in a grotesque mask, was used by Paul de Lamerie in 1737 (P. A. S. Phillips, Paul de Lamerie, London, 1935, pl. 115), suggesting that it may have been cast from an existing mold supplied by one of the specialists in Moulders' Lane. The set was not submitted for hall-marking—a royal prerogative—and the only

mark is that of Margas on the ewer. A largeworker who entered his mark in 1715, Margas may have stamped the work of a Huguenot master, not admitted to the Hall, whom he sponsored and whose works he sold. This appears likely when one examines a typically plain English teapot in the Untermyer Collection (68.141.211), made by Margas in 1716. The identity of the original owner of the ewer and basin is unknown. The added Russian armorials are embossed rather than engraved or cast, as was customary in England. Moreover, their punched ground is coarser than that of the basin's border decoration, and the color of the gilding does not match. It may be that these armorials hide those of the original owner, and that this set was an ambassadorial gift from a member of the British royal family to a member of the Russian imperial family who was a Grand Master of the Order of St. Andrew.

EX COLL. Russian Imperial family (until 1917); Harry Clifton; Arthur Bradshaw, Oxford.
EXHIBITED: State Hermitage Museum, Leningrad.
REFERENCES: A. de Foelkersam, Inventaire de l'argenterie des Palais Impériaux, St. Petersburg, 1907, pls. 20, 21; E. A. Jones, The Old English Plate of the Emperor of Russia, London, 1909, p. 68, pl. 34; Hayward, 1959, p. 11; Untermyer Silver, 1969, no. 145, ill.; Grimwade, 1976, p. 591.

84.

Pair of salvers on foot

Paul de Lamerie
London: 1720 (Britannia standard)
D. 5$\frac{1}{4}$ in. (13.4 cm.)
Heraldry: arms of Treby quartering Grance, for the Rt. Hon. George Treby, M. P. for Plympton, 1708, and for Dartmouth, 1722, appointed Secretary of War, 1718, Chancellor of the Exchequer, 1724
68.141.100, 101

Part of a set of six made for Treby by Lamerie, the invoice for which (Library of the Victoria and Albert Museum) is dated 25 April 1721: "Delivered 6 Little Salvers weighing 78 ozs, 5 dwts., £ 24 15s. 7d. fashion 18d, per oz., £5 17s. engraving £1 10s." Other silver made for Treby by Lamerie includes a toilet set of 1724, ordered as a wedding present for his wife, Charity Hele, elder daughter and coheir of Roger Hele of Halwell South Pool and Fardel Cornwood, Devon; the set is in The Ashmolean Museum, Oxford (E. A. Jones, *Catalogue of the Collection of Old Plate of William Francis Farrer*, London, 1924, pls. 37–41). A large basin, centering the arms of Treby, London, 1723, is in the British Museum (Hayward, 1959, pls. 62, 63); a covered cup with the arms of Treby, London, 1720, is in the collection of Queen Elizabeth II (A. G. Grimwade, *The Queen's Silver*, London, 1953, p. 64, pl. 8).

EX COLL. Miss L. Coats, Fernethy House, Perth., Scotland.

REFERENCES: W. Chaffers, *Gilda Aurifaborum*, London, 1883, pp. 241–243; P. A. S. Phillips, *Paul de Lamerie*, London, 1935, fig. 12 (invoice); Untermyer *Silver*, 1969, no. 172, ill.

85.

Decafoil salver

David Willaume
London: 1722
D. 22 in. (55.9 cm.)
Heraldry: Campbell with Pershall in pretense ensigned by earl's coronet for John, third Earl of Breadalbane, K. B., M. P. for Saltash 1727–41 and Oxford 1741–46, Minister at Copenhagen 1720, St. Petersburg 1731, Lord of the Admiralty 1741–42; and his second wife, Arabella Pershall (m. 1730), daughter and coheir of John Pershall of Great Sugnall, Staffordshire
1970.131.26

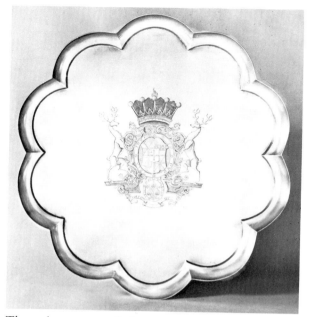

The salver, one of the most appealing forms of English silver, originated during the reign of George I. It is characterized by lobed outlines— hexafoil, octofoil, or decafoil—a molded, upcurved border cast with the salver, and separately cast bracket feet. The diameters vary considerably. Initially the surface was left plain, to show to best advantage the owner's coat of arms or crest within a cartouche. The Untermyer Collection includes a pair of smaller octofoil salvers by Simon Pantin, London, 1729 (68.141.102, 103) and a medium-sized octofoil salver by John Pero, London, 1718 (68.141.97). Willaume's salver, made in the last year of his life, is one of the most splendid examples of its kind as well as one of the largest. Willaume surmounted with apparent ease the technical difficulties confronting him and was able to harmonize quality with size. His son, David Jr., may have submitted this piece for hallmarking, having been granted permission to use his father's maker's mark. Originally, the salver was even larger, with a gadrooned border extending its diameter to 23 inches (Christie's, 24 April 1929, ill.) and increasing its weight from its present 118 ounces to 139.18 ounces. The removal of the outer border, the decision of a former owner, was done with great skill.

EX COLL. Mrs. Harry Rofe; Dr. Constable, Boston.
REFERENCES: Y. Hackenbroch, *Connoisseur*, CLXXX, 1972, p. 125, fig. 22.

86.

Tripod stand with kettle and lampstand

Simon Pantin (marked on each part)
London: 1724
H. stand 25¼, kettle and lamp 15½ in. (64.2, 39.4 cm.)
Heraldry: (on each part) Bowes with Verney in pretense for George Bowes (1701–60) of Streatlam Castle and Gibside, Durham, and his wife, Eleanor, daughter and sole heir of the Hon. Thomas Verney of Belton, Rutlandshire
68.141.81

Pantin's masterpiece, executed for the marriage of Bowes and Eleanor Verney, in which he used silver as a material that combines inherent strength with sensuous surface qualities. To emphasize the latter, he made a display of the splendidly engraved armorials, leaving them unrivaled by competing decoration. Such sets are rare; kettle and stand are usually separated if they survive at all. Pantin's set almost shared this fate but was reassembled before it was sold at public auction in 1955 (Christie's, 29 June 1955, lot 1, ill.). Also in the Untermyer Collection is a silver-gilt coffee service made by Pantin for George II (68.141.270–273a, b), 1727; the king's cipher is engraved on each item.

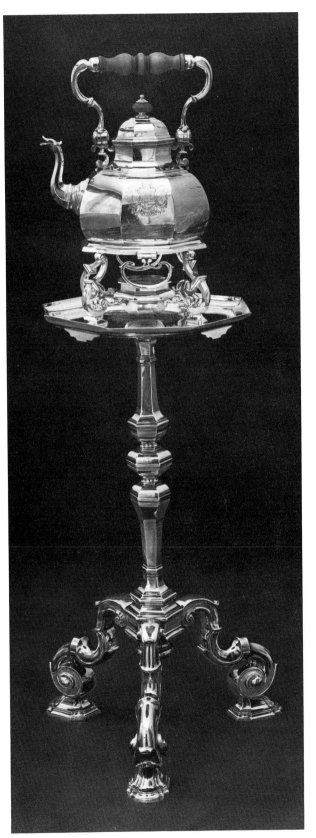

EX COLL. George Bowes; Earl of Strathmore and Kinghorne, Glamis Castle, Angus, from 1767 (Christie's, 8

December 1948, lot 127, ill. [tripod stand only]);
A. R. Tritton.
EXHIBITED: Residence of Sir Philip Sassoon, London,
1929, *Loan Exhibition of Old English Plate and Decora-
tions and Orders, for the Benefit of the Royal Northern
Hospital*, no. 251; Seaford House, London, 1929, *Queen
Charlotte's Loan Exhibition of Old English, Irish and Scot-
tish . . . Silver*, no. 568, pl. 43 (tripod stand only).
REFERENCES: C. C. Oman, *English Domestic Silver*, London,
1934, p. 152; *Antiques*, LXXI, 1957, pp. 534–535, ill.;
D. Cooper, ed., *Great Private Collections*, New York,
1963, p. 141, ill.; Untermyer *Silver*, 1969, no. 138, ill.;
Notable Acquisitions: 1965–1975, The Metropolitan Mu-
seum of Art, New York, 1975, p. 268, ill.; Clayton,
1971, p. 304, fig. 633; Grimwade, 1976, p. 613.

87.

Teapot and stand

Bowles Nash (marked on pot and stand)
London: 1725
H. teapot 4⅝ in. (11.8 cm.), L. tray 5¼ in. (13.4
cm.)
Heraldry: arms of Shapleigh
68.141.90, 91

Of the several teapots in the collection, this is the
only one that has retained its original stand. The
globular pot is of the kind raised from a single sheet
of silver. Added to the plain body are a molded foot
and a straight tapering spout. The stand, resting on
bun feet, has a molded rim with incurved corners.
In all, a typically English form, without foreign
influence. Nash entered his first mark in 1721,
having finished his apprenticeship to the London
silversmith Gabriel Sleath. Teapots with matching
stands were later characteristic of Copenhagen
silver.

REFERENCE: Untermyer *Silver*, 1969, no. 153, ill.

88.

Shaving set

William Fawdery (marked on basin, jug, and cover)
London: 1725
L. basin 12¼ in. (31.2 cm.), H. jug 7⅝ in. (19.3
cm.)
Heraldry: arms of (possibly) a branch of the Hirst
family
68.141.261a, b

The semicircular cut in the rim of the oval basin
accommodated the neck of the gentleman being
shaved. The covered jug of flattened oval form was
suitable for traveling. Fawdery, who had gained his
freedom as a silversmith in 1694, may have seen
similar sets made in France, but here he created in
the English manner. Simplicity and a perfect sense
of proportion are the distinguishing features, ren-
dering the set ideal for the display of the owner's
arms. In this instance, the arms were engraved a
generation later, for the cartouches incorporate
rocaille elements.

EX COLL. Maj. Gen. Sir Allan Adair, Bt. (Christie's, 5
June 1966, lot 154, ill.).
REFERENCE: Untermyer *Silver*, 1969, no. 151, ill.

89.

Pair of tea caddies

Augustine Courtauld (marked on caddies and cov-
ers)
London: 1726 (Britannia standard)
H. 4½ in. (11.4 cm.)
Heraldry: arms and crest of a branch of the Still
family
68.141.268, 269

The lifelong preference of this Huguenot silver-
smith for simple form is based, at least in part, upon
his apprenticeship to Simon Pantin, which lasted
until 1708. The allure of these caddies, the only pair
in the collection, depends greatly upon the molded

lines that set off the bases and hinged covers, as well as on the skillfully engraved armorials and foliage borders; these designs show the influence of fellow Huguenot Simon Gribelin. Tea caddies were frequently made in pairs, since hostesses liked to mix different leaves to please their guests.

EX COLL. James Donahue, New York (Parke-Bernet, 2 November 1967, lot 10, ill.).
REFERENCES: Y. Hackenbroch, *Connoisseur,* CLXVIII, 1968, pp. 142–143, fig. 15; Untermyer *Silver,* 1969, no. 156, ill.

90.

Inkstand on salver

Samuel Lea (marked on inset of salver)
London: 1726
L. inkstand 5⅜, salver 6¼ in. (13.7, 15.9 cm.)
Heraldry: arms and motto of the Onslow family
1974.28.186a–c

The rectangular stand with high molded foot is fitted with three covered receptacles, each topped by an acorn finial; apertures in the interspaces held the quills. The inkstand is placed upon a square salver with incurving corners and bracket feet; the salver is fitted with a rectangular box-shaped sunken center that is entirely covered by the inkstand. Lea must have used an unmarked salver, made earlier and not submitted for hallmarking. The dissonance between the curve-rimmed salver and the rectangular outline of the inkstand confirms that they were not originally intended for one another. In

order to avoid paying the full silver tax, assessed by weight, Lea used part of a smaller, fully marked box for his inset rather than submit the entire ensemble. A comparable combination of square salver with incurvate corners supporting a rectangular inkstand is in the Ashmolean Museum, Oxford (E. A. Jones, *Catalogue of the Collection of Old Plate of William Francis Farrer,* London, 1924, p. 72, pl. 36). This salver and inkstand are both by John White, London, 1730, but they bear different armorials, indicating once again that the combination was an afterthought.

91.

Basket

John Le Sage
London: 1730
L. 14 in. (35.5 cm.)
Heraldry: arms of Carthew family (probably)
68.141.61

The pierced and chased trelliswork represents basket weave. The oval foot and everted border are also pierced. A similar basket, owned by Horace Walpole, was described in the sale catalogue of Strawberry Hill, (lot 130): "A handsome 13 inch oblong bread basket, open basket pattern and twisted handles."

REFERENCE: Untermyer *Silver,* 1969, no. 163, ill.

92.

Salver

Augustine Courtauld
London: 1730
D. 15¼ in. (38.8 cm.)
Heraldry: arms of Hardy impaling D'Aeth
1974.28.178

Here one sees the influence of contemporary mahogany furniture. The shaped and molded rim resembles the piecrust borders of tripod tables, on which salvers were often placed. A particularly attractive cartouche surrounds the coat of arms. The frieze running around it has undulating outlines that very closely follow the salver's molded, raised border. The style and linear fluency of the execution suggest that the engraving was designed by a follower of Simon Gribelin.

REFERENCE: Y. Hackenbroch, *Connoisseur,* CLXXX, 1972, p. 128, fig. 28.

93.

Faceted jug with cover

Pezé Pilleau
London: 1730
H. 6½ in. (16.5 cm.)
Heraldry: arms of Lee with unidentified quartered
 arms in pretense
68.141.149

Pilleau is the only English maker known to have executed domestic plate with faceted surfaces. The son of a goldsmith of the same name, he was apprenticed to John Chartier, a master represented in the collection by a covered jug of particular grace (68.141.150). Pilleau married his master's daughter and became a free goldsmith in 1724. His jug can be compared to his slightly larger coffeepot of 1731 (A. Grimwade, *Rococo Silver,* London, 1974, pl. 61a) that also displays vertical facets meeting in the center to form a chevron line. However, we know of no precedent for the treatment of the tightly hinged cover of 93, fitted with a hemispherical inset to help maintain the temperature of the contents.

REFERENCE: Untermyer *Silver,* 1969, no. 164, ill.

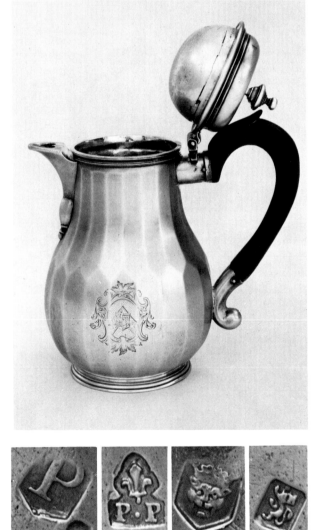

94.

Tray

Paul de Lamerie
London: 1732
L. 10 in. (25.4 cm.)
Heraldry: unidentified crest
68.141.74

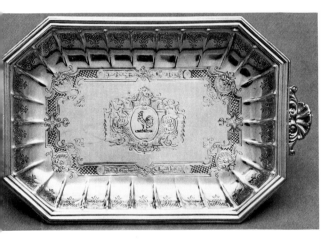

A most original application of fluting to a rectangular field with chamfered corners. Flutes are more usually seen on circular dishes or saucers, such as Lamerie's trembleuse stands, 75. The tray, which may have held spoons, is surrounded by a threaded border, fitted with cast foliage and shell handles at either end. The harmony between the basic shape and the engraved decoration is especially appealing. The crest at the center, for instance, is placed within a shaped rectangular cartouche that repeats the outlines of the tray. The surrounding frieze of trelliswork alternating with foliage has shell motifs that flatten the corners to correspond to the shape of the threaded border. Near the tops of the flutes are vignettes of alternating trellis- and shellwork, repeating the motifs again. Rarely have silversmith

and engraver complemented one another more gracefully.

EX COLL. Hon. Mrs. A. M. Holman (Sotheby's, 10 March 1960, lot 153, ill.).
REFERENCE: Untermyer *Silver,* 1969, no. 175, ill.

95.

Pair of sauceboats

Gabriel Sleath
London: 1732
L. 8¼ in. (21 cm.)
Heraldry: apparently unrecorded arms with badge of Ulster, motto QUA POTET LUCET
68.141.97, 98

These double-lipped boats on oval molded feet have molded rims and double scroll handles. The form, developed during the early reign of George I, was soon replaced by sauceboats with only one lip, handle at opposite end. The plain character of Sleath's boats suited the formal, dark, paneled dining rooms of that period, just as later examples with fanciful decoration and figural handles, 103, suited the lighter mood of English rococo.

EX COLL. Elbert H. Gary and Emma T. Gary (American Art Association, New York, 8 December 1934, lot 294, ill.).
REFERENCE: Untermyer *Silver,* 1969, no. 158, ill.

96.

Pair of candlesticks

Paul de Lamerie
London: 1734 (Britannia standard)
H. 9 in. (22.8 cm.)
1968.141.42, 43

With baluster stems and octagonal bases, these are of a form unchanged since its introduction a generation earlier: Lamerie responded readily to the Eng-

lish patrons' characteristic preference for simple form. Another pair by Lamerie, also 1734, identical save for their engraved arms, is in the Archibald A. Hutchinson collection, Fogg Art Museum, Cambridge, Mass. (114.9). Also in the Untermyer Collection is a set of four candlesticks by Lamerie, similar but smaller, 1728 (68.141.46–49).

EX COLL. Pamela Woolworth.
EXHIBITED: Museum of Fine Arts, Houston, Tex., 1956, *Paul de Lamerie*, no. 23, ill. (one).
REFERENCE: Untermyer *Silver*, 1969, no. 179, ill.

97.

Teakettle stand

> Augustine Courtauld
> London: 1735 (Britannia standard)
> L. 10½ in. (26.7 cm.)
> Heraldry: unidentified (possibly unmatriculated) arms impaling Markham
> 1974.28.187

The triangular form, not unprecedented, is rare. It is designed to harmonize with a tripod lampstand. The shaped and molded rim, showing a considerable change in Courtauld's style, offers us his response to playful rococo form. The rim is intersected with shell and floral motifs that add movement to its outlines; the motifs are echoed by the engraved frieze within. Although some traditional trelliswork is retained, the assymetrical rocaille framework displays the full impact of ro-

coco decoration. The engraver was no longer guided by the patternbooks of Bérain or Gribelin; he followed later masters, perhaps Bernard Picart, whose illustrations and vignettes were published about 1728, or, more likely, Hubert Gravelot, who came to London in 1733. The asymetrical cartouche enclosing the coat of arms at the center shows an even greater devotion to the new style. A similar stand by Robert Abercromby, London, 1735, is illustrated in Clayton, 1971, p. 304, fig. 635.

98.

Brazier

> Charles (Frederick) Kandler
> London: 1735–39
> D. 6¾ in. (17.2 cm.)
> 1974.28.179

Rococo form in all its boldness and freedom is realized in the sculptural melon-shaped bowl supported by three winged griffins, their hinged tails extendible to support a dish. Kandler, presumably of German origin, was a close relative of J. J. Kaendler, the master modeler of the Meissen factory, whose style he emulated. He changed his maker's mark in 1739, dropping the C for Charles and replacing it with F for Frederick. The modeling of the griffins recalls similar creatures in Meissen

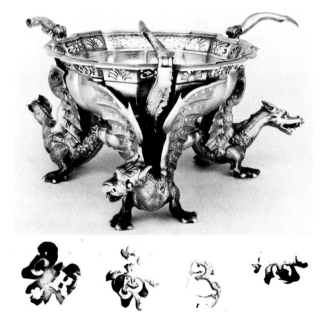

porcelain. Their surface treatment is reminiscent of painted decoration on porcelain, where patterns are more variable than the matting, chasing, and engraving techniques provide in silver. Kandler aimed at combining the best of two worlds, and succeeded with astonishing virtuosity. For another example by Kandler, see 103.

REFERENCE: Y. Hackenbroch, *Connoisseur*, CLXXX, 1972, p. 128, fig. 29.

99.

Shaving jug

John Williamson (marked on jug and cover)
Dublin: 1736
H. 7½ in. (19 cm.)
68.141.205

Although of traditional shape, there are subtle and original touches, notably the mask covering the spout and the chased and engraved decoration on the oval cover. By 1736, the fashion for cut-card decoration had run its course, and the Irish engraver applied his ingenuity in finding alternative solutions for the embellishment of the joints between the body and the handle.

EX COLL. Lord Swaythling, Townhill Park, Southampton (Christie's, 17 July 1946, lot 85, ill.); Capt. H. D. Clark (Sotheby's, 26 November 1953, lot 153, frontispiece).

REFERENCE: Untermyer *Silver,* 1969, no. 167, ill.

100.

Coffeepot

Phillip Kinnersly (marked on body and cover)
Dublin: 1736
H. 8½ in. (21.6 cm.)
1974.28.180

Irish silversmiths closely followed London fashions, so it comes as no surprise that Kinnersly adopted the shape of Lamerie's coffeepots of 1725, 1728 (both Sterling and Francine Clark Art Institute, Williamstown, Mass.), and 1730 (Folger Coffee Company, Kansas City, Mo.). Like nearly all flat-based pots, the body of 100 was made of a sheet of silver, shaped into a cone and then soldered along a line hidden in part by the handle, after which the bottom was soldered in place. Kinnersly's spout is the same as Lamerie's model, with facets on the lower half and a single leaf scrolling along the otherwise plain top. Were such parts as spouts and handles purchased from London mold makers in clay or in silver? Pieter Meyers, of the Museum's Research Laboratory, found that the silver of the spout is significantly different in composition from the rest, suggesting that Kinnersly could have bought the spout, already cast, from another workshop, after which the engraver matched its decoration to that on the pot. In 1737 the same spout was used by another Dublin silversmith, John Williamson, for his coffeepot with the arms of John Bourke, first Earl of Mayo, County Kildare, in the collection of the Folger Coffee Company. A notable feature of these Irish productions is the unity of style of the handsome engraving. Among the motifs most frequently used are strapwork with cameolike portrait busts in oval medallions, and foliage arranged symmetrically.

101.

Set of three casters

Paul de Lamerie
London: 1740
H. 10½, 9½ in. (26.7, 24.2 cm.)
Heraldry: arms of Yorke impaling Cocks ensigned by baron's coronet for Philip Yorke (1690–1764), Lord Chief Justice of England, created Baron Hardwicke of Hardwicke, 1733 (advanced to Viscounty and Earldom 1754), and his wife, Margaret, daughter of C. Cocks, M.P. for City of Worcester
68.141.229–231

Here we see the decorative repertory of Lamerie's later years. Children's heads, fierce lion masks, and

swags and bunches of fruits and flowers are lavishly distributed, though well organized. The elongated tops have pierced panels of suspended foliage and flowers, and finials in the form of pine cones. The size and weight of the set are impressive, and so, doubtless, was its price. Such heavy sets were rarely made, therefore, particularly at a time when less expensive alternatives in porcelain were catching the imagination of fashionable society.

EX COLL. W. R. Hearst, 1965.
EXHIBITED: Parke-Bernet, New York, 1967, *Art Treasures Exhibition,* no. 212, ill.
REFERENCE: Untermyer *Silver,* 1969, no. 181, ill.

102.

Covered bowl

Attributed to James Shruder
London: about 1740
Silver gilt
H. 6 in. (15.3 cm.)
1974.28.185a, b

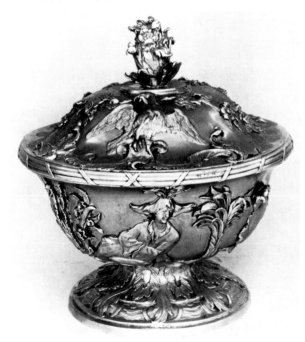

A false bottom, probably taken from a smaller or damaged object struck with the hallmarks of James Shruder, London, 1737, is soldered into this bowl, apparently to avoid the tax levied on unmarked

plate. Rather than submit the bowl to Goldsmiths' Hall as required by law, the maker may have resorted to this procedure out of economic desperation. To the best of our knowledge, no London silversmith other than Shruder pursued the difficult technique of applying chinoserie and foliage decoration. The sources of his designs were French engravings, of the kind based on Boucher's inventions or the *Cartouches chinois* and *Trophies de fleurs chinois* published by Gabriel Huquier. Such designs rarely attracted English silversmiths; they found greater response among the modelers of soft-paste porcelain at Chelsea, Bow, and Derby. Another of Shruder's characteristics is the reeded border of the cover, on which diagonal bands act as ties. A similar border, tied with small leaves, is on the ecuelle he made in 1738 (A. Grimwade, *Rococo Silver,* London, 1974, fig. 30b). Shruder's trade card, signed "J. Shruder Inv.," shows that he was capable of designing decorative cartouches and foliage that could easily be transposed into silver. His painstaking technique may have been too time-consuming in relation to the market value of London silver—perhaps explaining why no other maker followed him and why he went bankrupt in 1749.

EX COLL. Violet Trefusis, Florence.

103.

Sauceboat

Charles (Frederick) Kandler
London: 1742
L. including handle 9¼ in. (23.5 cm.)
Heraldry: unidentified arms and crest
1974.28.181

Among the most successful of rococo fantasies in silver, in which utilitarian and decorative elements merge, this boat is supported by three winged mermaids with entwined double tails, resting on a shaped base of shells and crustacea. The imagery is

strikingly similar to that of the Swan Service that J. J. Kaendler created at the same time at Meissen. On the other hand, the griffin-shaped handles occur not only in Meissen porcelain by Kaendler but in Paris ormolu by Charles Cressent. Besides figural motifs, the boat is covered with swags of fruit, laurel branches, and cartouches that harmonize with the undulating outlines. In spite of its crowded surface, the basic form is distinctly defined and its usefulness is apparent.

104.

Bowl

Paul de Lamerie
London: 1744
D. 7¾ in. (19.8 cm.)
Heraldry: arms of Franks impaling Evans for David
 Franks (1720–93) of Philadelphia and his wife,
 Margaret Evans
68.141.64

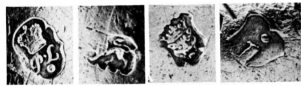

These arms occur on other components of a dispersed tea set by Lamerie once owned by David Franks of Philadelphia and his wife Margaret Evans, whom he married in 1743: a pair of tea caddies, London, 1742 (Sotheby's, 2 May 1963, lot 138, ill.), a circular salver, London, 1742 (Donald S. Morrison collection, on loan to Brooklyn Museum of Art), and a kettle with lampstand and a basket, London, 1744 (Metropolitan Museum, 58.7.17, 66.158.1). The decorative motifs on the bowl are from the rich vocabulary of Lamerie's later years, with one additional feature: the foot rim of foliage, flowers, shells, scrollwork, and lionmasks is designed to touch ground at irregular intervals. The movements of these motifs reflect the restless, inventive genius of Lamerie in his attempts to modify conventional form.

EX COLL. Mrs. John E. Rovensky (Parke-Bernet, 25
 January 1957, pt. II, lot 542, ill.).
EXHIBITED: Victoria and Albert Museum, London, 1968,

The British Antique Dealers' Association Golden Jubilee Exhibition, no. 40, pl. 15.
REFERENCES: J. McN. Dennis, *Metropolitan Museum of Art Bulletin,* December 1967, p. 176, fig. 3; Untermyer *Silver,* 1969, no. 184, ill.

105.

Basket

Paul de Lamerie
London: 1744
L. 16 in. (40.6 cm.)
68.141.188

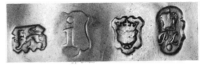

Lamerie's art found its most exuberant expression in this shell basket with pierced border and lacelike edge of shells and seaweed, fitted with a cast handle terminating in a female half-figure and supported on cast dolphin feet. The raised dolphin tails are entwined in naturalistic shell formations. Only a superlative craftsman could combine these various motifs and techniques to happy effect, or would dare make the attempt.

REFERENCE: Untermyer *Silver,* 1969, no. 183, ill.

106.

Bowl

George Wickes
London: 1744
Silver gilt
D. 6½ in. (16.5 cm.)
Heraldry: arms of Capel for William Anne, fourth
 Earl of Essex
1970.131.33

Wickes's mark includes the Prince of Wales feathers, indicating that Frederick, Prince of Wales, was among his many aristocratic clients. For Wickes, the rococo style was equivalent to movement, expressed in the swirling flutes of 106. It stands on a circular foot covered with fully developed rocaille ornament. The exterior is unadorned. Within, the

swirling movement is accentuated by applied shell and crustacean ornament reaching from the lobed border to the flutes. This applied decoration is so close to details on sauceboats by Nicholas Sprimont that one is tempted to believe that Wickes took decorative embellishments from Sprimont's existing models. The bowl itself was so admired that Wickes's design was revived in the 1820s. A similar, larger, silver-gilt bowl with royal arms, made by John Bridge, London, 1826, was sold recently (Sothey Park-Bernet, New York, 16 December 1976, lot 45, ill.), and four more bowls by Bridge, London, 1828, also similar, are at Windsor Castle (E. A. Jones, *The Gold and Silver of Windsor Castle,* Letchworth, 1911, p. 217, ill.).

EX COLL. Neville Hamwee (Christie's, 18 May 1966, lot 65, ill.).

REFERENCES: A. Grimwade, *Rococo Silver,* London, 1974, p. 54, fig. 69a; Clayton, 1971, p. 33, fig. 46.

107.

Ewer and basin

Abraham Portal
London: 1755
Silver gilt
H. ewer 16 in. (40.6 cm.)
Heraldry: royal arms and initials of George II (on ewer and basin)
68.141.316, 317

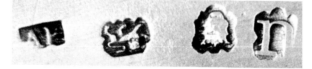

This flamboyant example of English rococo, free of its more typical excesses, has a special appeal. The asymmetrical applied foliage cartouche on the vase-shaped ewer is of singular strength, concentrating on form rather than on detail; it may have derived from *The 4th Book of Ornaments by* DE LA COUR (London, 1743). The reeded, undulating borders of the ewer and basin are overlaid with sprigs of flowers, skillfully proportioned and applied to harmonize with the boldness of the plate. This set is probably the "Gilt Basin and Ewer, wt. 244 ozs 9 dwts" that formed part of the ambassadorial plate

issued to Sir Charles Hanbury Williams on his appointment as ambassador to St. Petersburg in 1756; at any rate, it is the only such set in the Jewel Office accounts for that year. In 1922 the set was presented to Princess Mary, as stated in the inscription under the basin's foot: TO HRH THE PRINCESS MARY FROM THE DIPLOMATIC CORPS AT THE COURT OF ST. JAMES'S 28TH FEBRUARY 1922. Few works by Portal are known. He apprenticed 1740–49 with Paul de Lamerie, and 107 does honor to both, allowing the pupil to take his place among the great London silversmiths working in the rococo style. Portal spent some of his later years writing plays for the Drury Lane Theatre.

EX COLL. Queen Mary; the Princess Royal (Christie's, 6 July 1966, lot 115, ill.).

REFERENCES: Jackson, 1911, II, p. 586, figs. 807, 808; Untermyer *Silver,* 1969, no. 185, ill.

108.

Cheese stand

John Parker and Edward Wakelin
London: 1764
L. 14½ in. (36.8 cm.)
68.141.257

Wakelin introduced the cradle form in 1760—example now in the Victoria and Albert Museum. It accommodates an entire cheese wheel, and, for the convenience of the diners, it rolls along the table on castors. An almost identical stand with the arms of the ninth Earl of Exeter (Clayton, 1971, p. 64, fig. 121) has the same marks as ours. Parker and Wakelin entered into partnership shortly after 1760, although the date of joint mark registration is unknown. Quite apart from the originality and practicality of their stand's design, it offers a splendid example of piercing from a period when the English rococo style was waning.

EX COLL. The Princess Royal (Christie's, 6 July 1966, lot 93, ill.).

REFERENCES: A. G. Grimwade, *Proceedings of the Society of Silver Collectors,* London, 1961; Untermyer *Silver,* 1969, no. 186, ill.

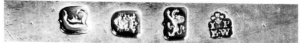

FURNITURE

The entries are by
WILLIAM P. RIEDER,
Assistant Curator, Department of Western European Arts.

Abbreviations

Chippendale, *Director, 1754; 1762*	Thomas Chippendale, *The Gentleman and Cabinet-maker's Director*, 1st ed., London, 1754; 3rd ed., 1762
Coleridge, 1968	A. Coleridge, *Chippendale Furniture*, London, 1968
DEF, 1954	P. Macquoid and R. Edwards, *The Dictionary of English Furniture*, rev. ed., 3 vols., London, 1954
Macquoid, *Mahogany*, 1906 Macquoid, *Satinwood*, 1908	P. Macquoid, *A History of English Furniture*, 4 vols., London, 1905–08; III, *Mahogany*; IV, *Satinwood*
Mulliner, 1924	H. H. Mulliner, *The Decorative Arts in England: 1660–1780*, London [1924]
Untermyer *Furniture*, 1958	Y. Hackenbroch, *English Furniture with Some Furniture of Other Countries in the Irwin Untermyer Collection*, introduction by J. Gloag, Cambridge, Mass., 1958
Untermyer *Needlework*, 1960	_____ , *English and Other Needlework, Tapestries, and Textiles in the Irwin Untermyer Collection*, Cambridge, Mass., 1960

109.

Tester bed

English: late 16th century with subsequent altera-
tions
Oak, carved and inlaid with walnut, ebony, ash
bole, English yew, elder
103½ x 105½ x 84½ in.; (262.9 x 268 x 214.6 cm.)
53.1

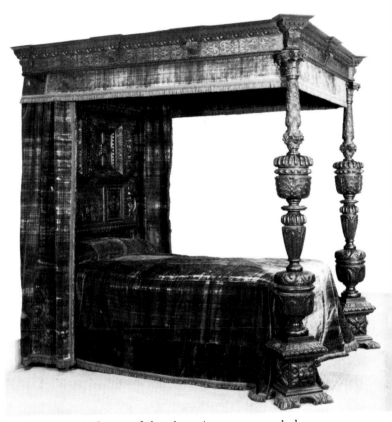

The architect Charles James Richardson (1806–71)
made an engraving of this bed in 1842, entitling it
"Oak Bedstead from Cumner Place, Berkshire."
Subsequently known as the Cumnor Bed, the piece
gained popularity by association with Robert Dud-
ley, Earl of Leicester (1532?–88), whose wife, Amy
Robsart, was allegedly murdered at Cumnor Place
in 1560. There are, however, several problems.
Richardson himself was not confident about the
provenance ("Whether this Bedstead formed part of
the furniture of Cumner-Place, at the period when
Sir Walter Scott has celebrated it, in his novel of
'Kenilworth,' the Author will not take upon him-
self to state." [Richardson, 1842, p. 9]), and history
argues against it. In 1560 Cumnor was owned by
Robert Dudley's treasurer, Anthony Forster, who
died in 1572, after which the house remained un-
tenanted and unfurnished for more than a century.
During this time it acquired the name Dudley Cas-
tle. It was later turned into tenements and demol-
ished about 1810 by the Earl of Abingdon. Most of
the bed dates stylistically in the late sixteenth cen-
tury, a period when Cumnor was unoccupied.
Richardson recognized that parts of it are later
("some part of it appears to be of the reign of
Elizabeth, another portion of the time of James I,
and part of it comparatively modern"): exactly
which are of what date is a question still being
studied. The headboard includes three low relief
scenes of St. Mark, St. John, and the Baptism of
Christ. These are without parallel in English beds of
the period and are not carved by the same hand as
the surrounding caryatid figures. The decorated
arches at the base of the headboard are a common
element in early English beds, but not in this posi-
tion, an area generally left plain, as the bolster and
pillows would have covered any carving (*DEF*,

1954, I, p. 42). Some of the alterations are revealed
by physical evidence (for example, the hidden
compartment containing a crucifix behind the cen-
tral caryatid cannot be original, since the dowel
marks on the caryatid indicate that it was not origi-
nally hinged). Comparison with the engraving
shows that there have also been changes since 1842
(removal of a carved seated profile figure from each
side of the headboard at the top, new inlaid panels
substituted between them, and removal of four
fluted panels separating the arches at the base of the
headboard, with probable recarving of the side
arches). At some date after 1837 the bed was ac-
quired by John and William Dent for Sudeley Cas-
tle in Gloucestershire, which they began restoring
and furnishing in that year. Whether it was in their
possession when engraved by Richardson is not
known.

EX COLL. John and William Dent and by family descent
to J. H. Dent-Brocklehurst, Sudeley Castle, Glos.;
W. R. Hearst, St. Donat's Castle, Glam., Wales.
REFERENCES: C. J. Richardson, *Studies from Old English
Mansions, Their Furniture, Gold and Silver*, 2nd ser.,
London, 1842, p. 9 and unnumbered pl.; idem, *Frag-*

ments and Details of Architecture, Decoration and Furniture of the Elizabethan Period, New York, n.d., pl. 38; H. G. Fell, *Connoisseur*, XCVIII, 1936, p. 111; *Connoisseur*, XCVIII, September 1936, p. vii, ill.; J. G. Phillips, *Metropolitan Museum of Art Bulletin*, February 1954, pp. 148, 166; Untermyer *Furniture*, 1958, pp. 13–14, pls. 23–24, figs. 41–43; G. Wills, *English Furniture, 1550–1760*, Enfield, Mx., 1971, p. 27, fig. 23; M. Schwartz and B. Wade, *The New York Times Book of Antiques*, New York, 1972, p. 30, ill.

110.

Court cupboard

English: late 16th century
Oak and walnut inlaid with sycamore and holly
48½ x 54 x 19 in. (123.2 x 137 x 48.3 cm.)
64.101.1134

The term "court cupboard" was applied both to the type with a splay-fronted section above the middle shelf (as here) and to the type with open tiers, 113 (R. W. Symonds, *Connoisseur*, CXIII, 1944, pp. 11–17). Beneath the middle shelf of 110 is a single wide drawer with gadrooned and leaf-carved front. The Tudor rose is inlaid in the center and corners of the frieze and the bases of the paired columns flanking the door. Kirk has proposed that this motif

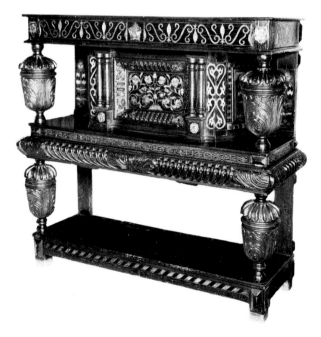

was used primarily in Derbyshire, southern Lancashire and, to a lesser extent, Lincolnshire (J. Kirk, *Antiques*, LXXXVIII, 1965, pp. 792–795), but it may have been more widely employed; the combination of motifs here does not suggest any specific region. The door has been rehinged, its original handle on the left side removed (the brass handle to right of center is a modren replacement), and there are minor restorations throughout.

EX COLL. F. C. Harper, England; W. R. Hearst.
REFERENCES: *Antiques*, LIII, 1948, p. 115, ill.; *DEF*, 1954, II, pp. 188, 192, fig. 6; Untermyer *Furniture*, 1958, p. 64, pl. 269, fig. 311.

111.

Food cupboard

English: about 1600
Oak inlaid with box, bog oak, holly
33½ x 36¼ x 9¾ in. (85 x 92 x 25 cm.)
1974.28.26

The checker pattern of box and holly is frequently found in English cupboards of this period. Edwards notes: "Here the balusters are of early character, and the traditional method of ventilation survives in the perforated scrollwork below the door transoms. The plinth is divided by pilasters of a type often introduced in Elizabethan woodwork, and the central panel opens with a key, forming what is called a 'close cupboard' in contemporary inventories" (*DEF*, 1954, II, p. 186). 111 was photographed before 1924 when in the collection of Francis Mallett (ibid., fig. 6); minor restorations have since been made to the top and left door.

EX COLL. Francis Mallett, London.
REFERENCE: *DEF*, 1954, II, p. 186, fig. 6.

112.

Side table

English: about 1600–20
Oak
33¼ x 45⅜ x 21¾ in. (84.5 x 115.3 x 55.4 cm.)
1974.28.33

The terms "side table" and "sideboard table" occur in early seventeenth-century inventories, but few such pieces have survived from this period. Several are known of slightly later date, about 1650 (*DEF*, 1954, III, p. 276, figs. 4, 5), and these have stretchers connecting the legs. The lower shelf and frieze on three sides of this table and the flat, decorated stiles that serve as rear legs indicate that it was originally either the upper half or lower half of a court cupboard. The carving of the balusters and the frieze motifs suggest an East Anglian origin.

113.

Court cupboard

> English: first quarter 17th century
> Oak
> 46½ x 49 x 16 in. (118 x 124.5 x 40.6 cm.)
> 64.101.1133

Symonds proposed an East Anglian origin for this (Symonds, 1944, p. 15). It is related in the shape of its balusters and presence of a dentilled cornice to a cupboard dated 1633 in the Victoria and Albert Museum (R. W. Symonds, *Connoisseur*, CXXXIX, 1957, pp. 226–227, figs. 11, 12).

REFERENCES: R. W. Symonds, *Connoisseur*, CXIII, 1944, p. 15, fig. IX; Untermyer *Furniture*, 1958, p. 64, pl. 268, fig. 310.

114.

Court cupboard

> English: first quarter 17th century
> Oak
> 50 x 47 x 17¾ in. (127 x 119.4 x 45.1 cm.)
> 1974.28.30

Several furniture historians have reservations about this, based on the inconsistency of style among the griffins, caryatid figures, and relief carving on frieze and drawer front. Oak cupboards incorporating griffin supports were widely popular in England in the 1920s and 30s as sideboards for the display of silver and pewter, and large numbers of them were made up from old fragments or entirely faked. No serious study has yet been made of these cupboards to establish which are authentic; until this is done, judgments must remain tentative. Griffins of similar form, although of more sophisticated carving, are on a cupboard in the Victoria and Albert Museum (W. 61–1950; J. Rogers, *English Furniture*, Feltham, Mx., 1967, p. 53, fig. 30) and another in the Ashmolean Museum (*DEF*, 1954, II, p. 179, fig. 3). No parallel is known for the scrolled brackets extending from the sides of the upper section of this cupboard.

115.

Court cupboard

> English: about 1620–40
> Oak
> 50½ x 48 x 20 in. (128.3 x 122 x 50.8 cm.)
> 1974.28.76

This has been criticized for the flat and symmetrical carving of the back panels, the gadrooned moldings beneath the middle and lower shelves (which are upside down in contrast to the conventional use of this motif in seventeenth-century court cupboards), and the carved edge of the top, a treatment rarely found in objects of this type. Certain parts appear to be old, such as the four balusters; others are unquestionably new, such as the drawer linings. Whether this is a seventeenth-century cupboard extensively altered in the nineteenth century or one made up from old and new elements is still unsettled. An East Anglian origin has been proposed.

116.

Table

> English: first half 17th century
> Oak
> 31¾ x 128 x 36½ in. (80.6 x 325 x 92.7 cm.)
> 64.101.1065

Tables of this form are traditionally thought to have been made early in the seventeenth century, but a similar example in the Treasurer's House in York is dated 1686 (*DEF*, 1954, III, p. 217, fig. 19). Baluster supports with gadrooning on both upper and lower sections, as present both here and on the York table, are rare in English furniture. For a related six-support table, with balusters ornamented with both gadroons and leafage, see H. Cescinsky, *English Furniture from Gothic to Sheraton*, New York, 1968, p. 92.

REFERENCE: Untermyer *Furniture*, 1958, p. 44, pl. 179, fig. 216.

117.

Armchair

English: mid-17th century
Oak, initials IC-UB carved on crest rail
45¾ x 28¾ x 21 in. (116.2 x 73 x 53.3 cm.)
64.101.898a, b

This belongs to a group of chairs made in the early and mid-seventeenth century with a scrolled cresting on the top and a double scrolled bracket on either side of the back. Among related examples are a chair in the Victoria and Albert Museum (M. Tomlin, *English Furniture*, London, 1972, p. 33, pl. 13) and one in a private collection with initials at the top and dated 1661 (G. Wills, *English Furniture, 1550–1760*, Enfield, Mx., 1971, p. 69, fig. 56). Benno M. Forman (written communication) notes the fine quality of the turned arms and legs, with some northern European influence in their proportions. Stretchers on chairs of this type almost invariably are one to three inches above the floor; it appears that the legs have been cut at the bottom, bringing the stretchers flush with the floor.

REFERENCE: Untermyer *Furniture*, 1958, p. 16, pl. 33, fig. 55.

118.

Cupboard

English (West Yorkshire): dated 1659

Oak inlaid with various woods, initials ISG inlaid on central panel of lower section with date
54½ x 74½ x 23¼ in. (138.5 x 189.2 x 59 cm.)
64.101.1135

The panels of marquetry are similar to those on a splay-fronted cupboard from Farnley Hall, near Leeds (G. Wills, *English Furniture, 1550–1760*, Enfield, Mx., 1971, p. 63, pl. 8, incorrectly stated to be at Temple Newsam House) and another, location unknown (*DEF*, 1954, II, p. 192, fig. 7). Christopher Gilbert notes (written communication) that West Yorkshire provides many precedents for the obliquely checkered border surrounding the marquetry panels, the vine trail ornament, and the stiles enriched with upright fronds headed by balls.

REFERENCE: Untermyer *Furniture*, 1958, pp. 64–65, pl. 270, fig. 312.

119.

Armorial panel

English: 1660–88
Limewood, parcel-silver and gilt
35 x 35 x 12½ in. (89 x 89 x 31.8 cm.)
64.101.1210

These are the arms borne by the Stuart sovereigns, James I, Charles I, Charles II, James II. On heraldic grounds this establishes terminal dates of 1603–88 (excepting the Protectorate of Cromwell, 1653–59). Stylistically, the panel dates from the second half of the seventeenth century and it must therefore have been executed between 1660 (beginning of the reign of Charles II) and 1688 (end of the reign of James II). The arms are described heraldically as: quarterly 1 and 4, quarterly i and iiii France, ii and iii England; 2 Scotland; 3 Ireland.

EX COLL. Castle Gould, Long Island, N.Y. (Castle Gould, sale cat., 28 May 1940, lot 392).

REFERENCE: Untermyer *Furniture*, 1958, p. 77, pl. 331, fig. 381.

120.

Pair of sconces

English: about 1690
Gilded gesso on pine; brass candle sockets
25 x 4 x 10½ in. (63.5 x 10 x 26.7 cm.)
64.101.1029, 1030

Bramshill, an early Jacobean house in Hampshire, passed through several owners in the seventeenth century before being sold in 1699 to Sir John Cope, by which date none of the original furniture remained. It was furnished by Sir John and his heirs with some late seventeenth- and early eighteenth-century and much mid-eighteenth-century furniture. These sconces were first recorded in the Chapel Room by Hussey (16 June 1923), but it is not known when they entered the house. They were attributed by Hussey (2 June 1923) to Daniel Marot, but while the candle branches, Ionic capitals, and baldachins with pendant tassels are somewhat influenced by Marot, the attribution is no longer acceptable. The pelican may be the crest of the family for which they were originally made. Hanging in the same room in Bramshill was a pair of contemporary sconces of related style bearing the crest of the Earls of Radnor (Hussey, 2 June 1923, p. 799, fig. 2).

EX COLL. Capt. Denzil Cope, Bramshill, Hants.

EXHIBITED: Residence of Sir Philip Sassoon, London, 1932, *The Age of Walnut, Loan Exhibition in Aid of the Royal Northern Hospital*, p. 21, fig. 443.

REFERENCES: C. Hussey, *Country Life,* LIII, 2 June 1923, pp. 799–801, fig. 1; idem, *Country Life,* LIII, 16 June 1923, p. 857, fig. 10; M. Jourdain, *Country Life,* LIX, 6 March 1926, p. xxxix; H. A. Tipping, *English Homes,* London, 1927, period 3, II, p. 299, figs. 377, 378; R. W. Symonds, *Antiques,* XXII, 1932, p. 140, fig. 8; *DEF,* 1954, III, p. 48; Untermyer *Furniture,* 1958, pp. 39–40, pl. 155, fig. 187.

121.

Wing chair

English: about 1700

Walnut upholstered in contemporary needlework of colored worsted and silk tent stitch on canvas
54¼ x 26 x 23 in. (138 x 66 x 58.5 cm.)
64.101.913

The scene on the back shows the "Baptism of the Eunuch of Ethiopia by the Apostle Philip" (Acts 8:26–39). Swain has identified the source of the chariot in the background and the two attendants on the right as an illustration by Matthew Merian of Basel in the edition of the New Testament published in Frankfort in 1627 (Swain, 1975, fig. 165). On the right wing is a Harlequin derived from an engraving by Jean Dolivar after J. Le Pautre published in Paris about 1670 (ibid., fig. 168). Swain suggests that this may be a replacement because it bears so little relation to the biblical subject. However, the pastoral scenes with strolling figures and amorous couples elsewhere on the wings, sides, and seat are stylistically consistent with each other and the back, and all of this needlework appears to be original.

EX COLL. Robert Tritton, England.

EXHIBITED: Grafton Galleries, London, 1928, *Exhibition of Art Treasures, under the Auspices of the British Antique Dealers' Association,* p. 9, no. 31.

REFERENCES: Untermyer *Furniture,* 1958, p. 19, pls. 47–48, figs. 70, 71; M. Swain, *Furniture History,* XI, 1975, pp. 77, 78, figs. 164–166, 168.

122.

Armchair

English: about 1700–10
Legs and stretchers of walnut, framework of beech (except later crest rail of birch), upholstered in contemporary English needlework of polychrome silk and wool tent stitch (gros point and petit point) on canvas
52 x 34¼ x 24 in. (132 x 87 x 61 cm.)
55.8.2a, b

The scene on the back represents David before King Saul. On the inside of each wing is a parrot; the remaining areas are covered with flowers, birds, butterflies, and a series of hillocks. The needlework is not original to the chair; it is first recorded on it

in 1932, when the chair was lent by Lionel Harris, Jr., to the Christie's *Art Treasures Exhibition*. The high curved shape of the back is most unusual in English armchairs of this period; the crest rail beneath the upholstery was probably added to show as much as possible of the needlework.

EX COLL. Lionel Harris, Jr., London.

EXHIBITED: British Antique Dealers' Association, Christie's, London, 1932, *Art Treasures Exhibition*, no. 51, ill.; The Metropolitan Museum of Art, New York, 1971–72, *In Quest of Comfort: The Easy Chair in America*, no. 15.

REFERENCES: M. Jourdain, *Apollo*, XXXIV, 1941, pp. 81–82, fig. 11; H. Comstock, *Antiques*, LXVII, 1955, p. 398, fig. 1; Untermyer *Furniture*, 1958, p. 21, pl. 56, fig. 79.

123.
Fire screen

English: about 1715
Gilded gesso on beech, contemporary needlework panel (slightly cut down and much restored) in silk and wool tent stitch on bast tabby
49 x 23½ x 18 in. (124.5 x 59.7 x 45.7 cm.)
1974.28.75

The high quality of the gesso work was noted by R. W. Symonds (Symonds, 1929, p. xiii). The needlework panel, the figures in which represent the five senses, is a recent replacement. When the screen was in the collection of Percival D. Griffiths, about 1920–38, it contained a scene painted on canvas in imitation of tapestry (ibid., p. 289, fig. 234). A similar screen, from Bretby Hill, Derby., is in the Victoria and Albert Museum (A. Gonzalez-Palacios, *Inghilterra*, I, Il Mobile nei Secoli, VII, Milan, 1969, p. 37, fig. 40).

EX COLL. Percival D. Griffiths, Sandridgebury, near St. Albans.

REFERENCES: R. W. Symonds, *English Furniture from Charles II to George II*, London, 1929, pp. xiii, 289, figs. 2, 234; idem, *Antiques*, XIX, 1931, p. 194; idem, *Antique Collector*, XVIII, 1947, p. 119, fig. 6.

124.
Toilet mirror

English: about 1710–20
Oak and pine; japanned variously red and gold (much restored); drawer linings of maple
33 x 16½ x 10¾ in. (84 x 42 x 27.3 cm.)
64.101.1015

The block-front drawer originally contained several dividers, creating compartments for toiletries. As was often the case with English toilet mirrors of this date, the stand is a miniature bureau, with small drawers and pigeonholes behind the slanted front. Mirrors of similar form are in the Victoria and Albert Museum (*DEF*, 1954, II, p. 361, figs. 11, 12), Colonial Williamsburg, and the Cooper-Hewitt Museum, New York (H. Huth, *Lacquer of the West*, Chicago, 1971, pls. 76, 77).

REFERENCE: Untermyer *Furniture*, 1958, p. 38, pl. 149, fig. 180.

125.
Pair of sconces

English: about 1720
Gilded gesso on pine inset with contemporary needlework in colored silk and wool tent and cross-stitch on canvas (some restoration); candle branches of brass
23 x 15¼ in. (58.5 x 38.7 cm.)
64.101.1011–1012

Brass arms decorated with Indian heads are found on sconces of the Queen Anne and George I periods, which, as Symonds (1958) noted, suggests that they were the stock pattern of a brass foundry.

EX COLL. Percival D. Griffiths, Sandridgebury, near St. Albans; Geoffrey Hart.

EXHIBITED: Ormeley Lodge, Ham Common, 1954, *Loan Exhibition of Masterpieces of British Art and Craftsmanship*.

REFERENCES: R. W. Symonds, *Antiques*, XXII, 1932, p. 140, fig. 5; idem, *Masterpieces of English Furniture and Clocks*, London, 1940, p. 72; idem, *Country Life Annual*, 1958, pp. 94–95, fig. 9; Untermyer *Furniture*, 1958, p. 37, pl. 147, fig. 178; Untermyer *Needlework*, 1960, p. 48, pl. 111, fig. 149.

126.

Mirror

English: about 1720–25
Gilded gesso on pine
71 x 36 in. (180.5 x 91.5 cm.)
46.116

Attributed to the London cabinetmaker John Belchier (active about 1722–53) on the basis of two similar mirrors at Erthig Park, Denb. (R. Edwards and M. Jourdain, *Georgian Cabinet-makers,* London, 1955, p. 137, figs. 35, 36). The first of these is a

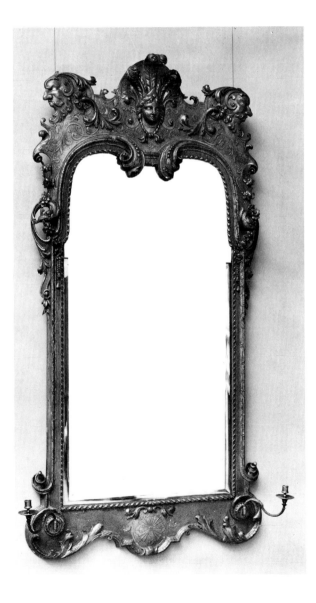

silvered gesso mirror that has been identified with a bill dated 1723; the plumed mask carved on its crest is similar to that on the present mirror. The second mirror in carved and gilded gesso was supplied for the State Bedroom in 1726 (J. Hardy, *A State Bed from Erthig,* Victoria and Albert Museum Brochure 2, London, 1972, pp. 2, 4, 9 note 10, pl. 4) and displays grotesque heads in profile at the top and eagle's heads at the sides, relating it closely to the present example. Belchier's account for furniture delivered to Erthig between 1722 and 1726 is quoted in full by Edwards and Jourdain, pp. 116–117, where this mirror is mistakenly attributed to James Moore, the carver, gilder, and cabinetmaker who provided gilded gesso furniture to the Royal Palaces in George I's reign. A comparable mirror is in the Detroit Institute of Arts (*European Decorative Arts in the Eighteenth Century,* Detroit, 1961, fig. 1) and another, present whereabouts unknown, was with the firm of Moss Harris & Sons (*A Catalogue and Index of Old Furniture and Works of Decorative Art,* London [about 1932], pt. 1, p. 90, no. F 23060).

EX COLL. H. H. Mulliner.

REFERENCES: H. Cescinsky, *The Gentle Art of Faking Furniture,* London, 1931, pl. 267, no. 1; R. W. Symonds, *Connoisseur,* XCVIII, 1936, p. 13, no. VIII; P. Remington, *Metropolitan Museum of Art Bulletin,* November 1954, pp. 69, 112; Untermyer *Furniture,* 1958, pp. 34–35, pl. 137, fig. 166.

127.

Pair of chandeliers

English: about 1725
Carved wood and gilded gesso; ormolu candle sockets
37 x 39 in. (94 x 99 cm.)
1970.148.1, 2

These were recently cleaned, uncovering the original gilding. Such features as the pendant pomegranate, flame finial, and branches carved with leaves and flowers in high relief were often seen in English gilt chandeliers of the period. An example from Hamilton Palace incorporating these same motifs

into a design of strong French character is in the Victoria and Albert Museum (D. Fitz-Gerald, *Georgian Furniture,* London, 1969, pl. 17).

EX COLL. Mrs. A. H. Stevens (Sotheby's, 12 February 1965, lot 136, ill.)
REFERENCE: *Ivory Hammer 3,* Sotheby and Co., London, 1965, p. 281, ill.

128.

Two side chairs

English: 1724–36
Walnut and walnut veneer, partially gilt; lead mounts on knees and front rail; coat of arms in *verre eglomisé* on each splat; upholstered with contemporary needlework, tent stitch on canvas; numbered respectively on front seat rail X, I
41 x 23 x 22 in. (104 x 58.5 x 56 cm.)
64.101.936, 937

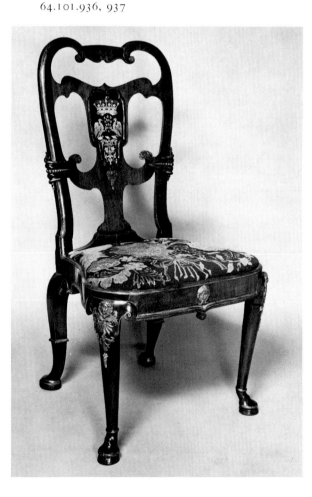

The original set included at least twelve side chairs, two settees, and two pedestals. Sets of this composition were rare in English eighteenth-century furniture, and the importance of the present one is increased by its narrow date range, its lead mounts, and the coat of arms in *verre eglomisé*. Nicholas, fourth and last Earl of Scarsdale, on whose death in 1736 the peerage became extinct, commenced the rebuilding and refurnishing of Sutton Scarsdale in Derbyshire in 1724. Stylistically the chairs cannot predate 1720, and the Scarsdale coat of arms establishes the *terminus ad quem.* They were probably provided for Sutton Scarsdale in or shortly after 1724. For none of the pieces in this set is the provenance known prior to the present century. Other chairs *en suite* are in the Frick Collection and the Cooper-Hewitt Museum, and numerous copies exist. The Metropolitan Museum possesses one of the pedestals (26.260.98) with an identical *eglomisé* panel.

EX COLL. Annie C. Kane, New York.
REFERENCES: *DEF,* 1954, I, pp. 254–256, fig. 93; Untermyer *Furniture,* 1958, pp. 21–22, pls. 64, 65, figs. 87, 88; F. Hinckley, *A Directory of Queen Anne, Early Georgian and Chippendale Furniture,* New York, 1971, p. 63, fig. 64; M.D. Murray, *Connoisseur,* CLXXX, 1972, pp. 202–203, 209.

129.

Stool

English: about 1725–35
Gilded gesso on walnut, upholstered in 18th-century Soho tapestry
20 x 22½ x 16 in. (51 x 57 x 40.6 cm.)
64.101.957

Part of a large set of gilded gesso furniture, including settees, side chairs, and tables, traditionally thought to have been in the collection of the Dukes of Buckingham and Chandos at Stowe House, Bucks. Other pieces from the set are in Windsor Castle; Upton House, War.; Parham Park, Sussex; and in the Metropolitan Museum. The contents of Stowe, comprising some 5000 lots, were sold in 1848 (Christie's, 15 August–7 October), but because the entries were both brief and vague (for

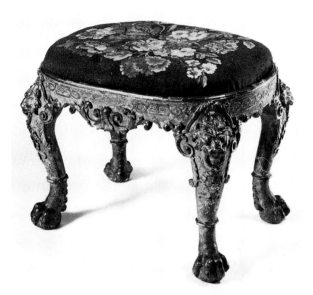

example, "A noble pier table"), individual pieces and even sets of furniture are today difficult to identify. A study of the previous owners of the extant pieces of this set and those who acquired furniture at the sale suggests that this traditional provenance may not be correct. R. Edwards and M. Jourdain (1955, p. 43) attribute it to the London cabinetmaker James Moore (active about 1708–26) by comparison with his authenticated pieces, particularly a signed table at Buckingham Palace and a table, formerly at Stowe, now in the Victoria and Albert Museum, that can be dated 1714–1718 by the presence of the crest and coronet of Richard Temple, Lord Cobham. However, this attribution is questionable, since there are considerable differences in style and technique between these tables and the known pieces of this set.

EX COLL. Dukes of Buckingham and Chandos, Stowe House, Bucks. (?); H. H. Mulliner (Christie's, 10 July 1924, lot 111); Lady Evelyn Beauchamp (Christie's, 12 May 1955, lot 106, ill.).

REFERENCES: Mulliner, 1924, fig. 58; H. Cescinsky, *English Furniture from Gothic to Sheraton*, New York, 1968, p. 251; H. Comstock, *American Collector*, XV, September 1946, pp. 12, 14, fig. 3; Sir Owen Morshead, *Windsor Castle*, London, 1951, fig. 38; *DEF*, 1954, I, pp. 270–271, fig. 138; P. Remington, *Metropolitan Museum of Art Bulletin*, November 1954, pp. 69, 114; R. Edwards and M. Jourdain, *Georgian Cabinet-makers*, London, 1955, pp. 43, 136, fig. 32; R. W. Symonds, *Antique Collector*, XXVII, 1956, pp. 140–141, figs.

8–10; idem, *Country Life*, CXXIII, 12 June 1958, p. 1283, fig. 4; Untermyer *Furniture*, 1958, p. 25, pl. 85, fig. 111; G. B. Hughes, *Country Life*, CXXVII, 9 June 1960, p. 1335, fig. 5; P. Whitfield, *Apollo*, XCVII, 1973, p. 601, fig. 6.

130.

Two side chairs

English: about 1725–35
Gilded gesso on walnut, upholstered in modern damask
42½ x 24 x 26½ in. (108 x 61 x 67.4 cm.)
1974.28.214, 215

Dolphins are a frequent motif on eighteenth-century English furniture, but the extent of the marine imagery on these chairs suggests that they may have been specially commissioned. They form part of a large set. Two more are in the Untermyer Collec-

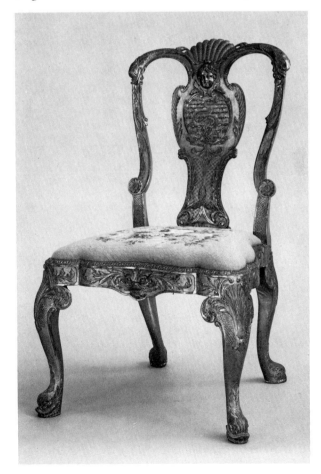

tion (1974.28.216, 217), three belong to the Ashmolean Museum (one on loan to the Victoria and Albert Museum), two are in a Baltimore private collection, two are in a Chicago private collection, and two were sold Sotheby's, 3 June 1977, lot 93A, ill. Most are incised with roman numerals inside the seat rails, the highest number being XX. The Ashmolean chairs belonged to Col. Claude Lowther (1872–1929), who installed them at Herstmonceaux Castle, Sussex, between 1913 and 1929 (sold Christie's, 5 November 1929, lot 134). Little is known about the history of the other chairs. The one at the Victoria and Albert is described as "one of the most magnificent chairs of its date" by Fitz-Gerald, who relates it to examples at the Lady Lever Art Gallery, Port Sunlight, Ches. (P. Macquoid, *English Furniture . . . in the Lady Lever Art Gallery,* London, 1928, fig. 89) and Beningbrough Hall, York. (H. A. Tipping, *Country Life,* LXII, 3 December 1927, p. 823, fig. 6). Gonzalez-Palacios notes the stylistic similarities to certain furniture made in Lucca.

EX COLL. John J. McAllister, San Francisco.
REFERENCES: *Annual Report,* Ashmolean Museum, Oxford, 1934, p. 22; K. T. Parker, *The Times,* London, 2 June 1934, p. 15; *The Times,* London, 10 March 1945; *Antiques,* LXXXVII, 1965, p. 537; *101 Chairs,* exhib. cat., Furniture History Society, Oxford, 1968, no. 22; D. Fitz-Gerald, *Georgian Furniture,* London, 1969, no. 16; A. Gonzalez-Palacios, *Inghilterra,* I, Il Mobile nei Secoli, VII, Milan, 1969, p. 41, figs. 45, 46; H. D. Molesworth and J. Kenworthy-Browne, *Three Centuries of Furniture in Colour,* London, 1972, p. 116, fig. 191.

131.

Pair of sconces

English: about 1730
Gilded gesso on pine, inset with later panel (about 1750–70) of moiré silk rep, embroidered in 18th-century polychrome silk and gold and silver thread (metal strips wrapped on white silk)
28 x 10½ in. (71 x 26.7 cm.)
1974.28.65, 66

The circular punching on gesso ground continues

beneath the sockets of the candle branches, possibly indicating that these were added later. The Prince of Wales feathers at the top suggested to Mulliner that the sconces may have belonged to George II's son, Frederick, created Prince of Wales in 1729; however, they were a fairly common decorative motif in the second quarter of the eighteenth century.

EX COLL. H. H. Mulliner (Christie's, 10 July 1924, lot 103); Humphrey W. Cook; Lady Hague; Mrs. Dorothy Hart (Christie's, 30 October 1969, lot 96, ill.).
REFERENCES: Mulliner, 1924, fig. 61; *DEF,* 1954, III, pp. 49–50, fig. 15; F. Davis, *Country Life,* CXXX, 24 August 1961, pp. 398–399, fig. 3; C. Musgrave, *Connoisseur,* CLIX, 1965, pp. 74–75, fig. 6.

132.

Bureau-cabinet

English: about 1730–40
Cabinet carcase of walnut, bureau carcase of oak, the whole veneered in walnut and burr walnut; architectural details in carved and gilded limewood; pilaster bases and capitals in bureau cupboard of gilt bronze
82½ x 29 x 21 in. (209 x 73.5 x 53.5 cm.)
64.101.1110

Percival Griffiths considered this the star piece in the collection that he formed in the first three decades of this century (R. W. Symonds, 1943). Its construction is fully explained and illustrated in photographs and measured drawings by Symonds (1929). The gilding on the pilasters, cornice, and broken pediment emphasizes its architectural character. The high quality, noted in every published reference, is best summarized in *DEF:* "The design and execution are alike exceptional, the narrow proportions and excellence of the carving producing an effect of remarkable elegance."

EX COLL. Capt. W. F. Dickinson; Percival D. Griffiths, Sandridgebury, near St. Albans.
EXHIBITED: Parke-Bernet, New York, 1942, *French and English Art Treasures of the XVIII Century,* no. 553; Parke-Bernet, New York, 1955, *Art Treasures Exhibition,* no. 225.
REFERENCES: R. W. Symonds, *Old English Walnut and Lacquer Furniture,* London, 1923, pp. 126–128, pl. XXV;

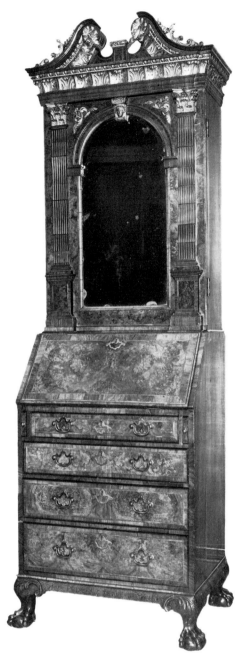

idem, *English Furniture from Charles II to George II,*
London, 1929, pp. 109, 111, 114–115, figs. 64–67,
diagrams 6–7; idem, *Connoisseur,* XC, 1932, p. 237,
no. VI; idem, *Antique Collector,* XIV, 1943, pp. 163,
165–166, fig. 1; idem, *Country Life,* CXI, 13 June
1952, pp. 1810–1812, fig. 2; *DEF,* 1954, I, pp. 138,
142–143, figs. 42, 43; Untermyer *Furniture,* 1958, p.
56, pls. 232–235, figs. 271–274; D. Molesworth in
Great Private Collections, ed. D. Cooper, New York,
1963, pp. 138–139.

133.

Cheval fire screen

English: about 1730–40
Walnut, parcel-gilt; English needlework panel
 (cut down) first quarter 18th century, silk and
 wool tent stitch on bast tabby
55¼ x 42 x 17¼ in. (140.5 x 106.7 x 44 cm.)
64.101.1154

The materials used for fire screens in the first three
quarters of the eighteenth century were, in order of
popularity: wicker, India paper, canvas, damask,
silk, needlework, and tapestry. Only needlework
screens have survived in appreciable numbers
(R. W. Symonds, *Antique Collector,* XVIII, 1947, p.
121). Having studied the Royal Wardrobe Ac-
counts, Symonds concludes that walnut was used for
the frames until about 1730, after which they were
mostly of mahogany. Though of walnut, 133 may
date as late as 1740. The perforated palmettes above
the legs are frequently found in the backs of walnut
chairs of this period (*DEF,* 1954, I, p. 275, fig. 154).

EX COLL. Lord Aberconway, London.
EXHIBITED: Burlington Fine Arts Club, London, 1934.
REFERENCE: Untermyer *Furniture,* 1958, p. 71, pls. 294–
 296, figs. 336–338.

134.

Chair

English: about 1735
Legs of mahogany with traces of parcel gilding; seat
 rails of walnut; upholstered with contemporary
 needlework in one continuous panel in colored
 wool and silk, tent stitch on canvas, details in
 satin and stem stitch
39 x 24 x 23¼ in. (99 x 61 x 59 cm.)
64.101.955

The scene on the back, representing the Rape of
Proserpine, derives from an engraving by François
Chauveau (1613–76) in *Les Metamorphoses d'Ovide
en rondeaux,* Paris, 1676, p. 136 (Swain, 1975, fig.
172). A chair *en suite,* formerly in the collection of
Sir George Donaldson, displays on the back Pyra-

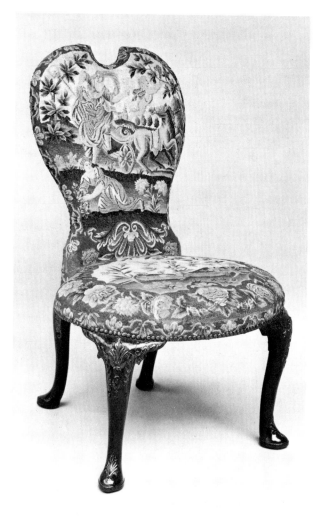

mus and Thisbe, from an unknown source; it was published by Percy Macquoid (*Country Life,* XLIII, 2 February 1918, p. 115, fig. 1) as "probably Scotch" and part of a set inherited by Lord Byron's mother. A pair of chairs from another set but of identical shape and with needlework of similar design was recently on the London market (*Connoisseur,* CLXXX, June 1972, p. 3, ill.). Herbert Cescinsky imaginatively proposed that such chairs were designed "to straddle across, horse-fashion, with the chin resting in the lunette in the back, to watch a 'main' of cock-fighting" (*English Furniture from Gothic to Sheraton,* New York, 1968, p. 262). More prosaically, the cupped depression of the back was probably intended to accommodate a periwig.

EX COLL. Percival D. Griffiths, Sandridgebury, near St. Albans.

EXHIBITED: Parke-Bernet, New York, 1942, *French and English Art Treasures of the XVIII Century,* no. 504; The Metropolitan Museum of Art, New York, 1945, *English Domestic Needlework of the XVI, XVII, and XVIII Centuries,* fig. 66.

REFERENCES: R. W. Symonds, *English Furniture from Charles II to George II,* London, 1929, opp. p. 3; H. Comstock, *American Collector,* XV, September 1946, pp. 13–14, fig. 4; R. W. Symonds, *Country Life,* CXI, 13 June 1952, p. 1810, fig. 1; Untermyer *Furniture,* 1958, p. 24, pl. 80, fig. 105; Untermyer *Needlework,* 1960, p. 46, pl. 104, fig. 142; M. Swain, *Furniture History,* XI, 1975, pp. 79, 82, figs. 171, 172.

135.

Side table

English: about 1735
Carcase and drawer linings of oak, walnut and burr walnut veneer; brass handles (modern replacements)
$28\frac{1}{4}$ x $37\frac{1}{2}$ x $21\frac{1}{2}$ in. (71.7 x 95.3 x 54.6 cm.)
64.101.1089

Legs of similar form appear on numerous contemporary tables and seat furniture and continued to be used through the mid-century. A walnut bookcase of about 1750 in the Untermyer Collection has nearly identical legs (Untermyer *Furniture,* 1958, pl. 244, fig. 285).

REFERENCE: Untermyer *Furniture,* 1958, p. 50, pl. 207, fig. 245.

136.

Two armchairs

English: about 1740
Mahogany, upholstered in modern damask
$37\frac{3}{4}$ x 32 x $30\frac{1}{2}$ in. (96 x 81.2 x 77.5 cm.)
64.101.978, 979

The number of pieces originally in this set is not known, nor has a provenance been established for

any of the surviving pieces before 1900. Symonds (1958) states that there were twelve armchairs, bought at auction by M. Harris and Sons just after the First World War and sold in ones and twos to individual collectors. In 1906 Macquoid attributed a settee and one chair (whereabouts now unknown) to Giles Grendey, but subsequent research on this cabinetmaker has not supported the attribution. The particularly high quality of carving has been noted in most references. Another of the armchairs is in the Philadelphia Museum of Art (47-20-3).

EX COLL. (64.101.978) Percival D. Griffiths, Sandridgebury, near St. Albans; (64.101.979) Dr. Lindley Marcroft Scott, Hornblotten House, Castle Cary.
EXHIBITED: Parke-Bernet, New York, 1942, *French and English Art Treasures of the XVIII Century* (one).
REFERENCES: Macquoid, *Mahogany*, 1906, p. 120, pl. IV; H. Cescinsky, *English Furniture of the 18th Century*, London, 1910, II, pp. 65–67, fig. 62; Mulliner, 1924, fig. 12; R. W. Symonds, *Connoisseur*, LXXIX, 1927, p. 231, no. XIV; *Loan Exhibition of English Decorative Art, in Aid of the Invalid Children's Aid Association*, Lansdowne House, London, 1929, no. 426, pl. XCI; *Exhibition of Chippendale Furniture for the Benefit of St. Luke's Hospital Social Service*, Frank Partridge, New York, 1929, no. 39; R. W. Symonds, *English Furniture from Charles II to George II*, London, 1929, pp. 41, 191, 209, figs. 20, 148, 168; *The English Chair*, Moss Harris & Sons, London, 1937, p. 107, pl. XXXVII; *Apollo*, XXIX, 1939, p. 319; *Connoisseur Year Book*, 1951, p. 89; *DEF*, 1954, I, p. 265, fig. 124; R. W. Symonds, *Antique Collector*, XXIX, 1958, pp. 97, 99, fig. 1; Untermyer *Furniture*, 1958, pp. 28–29, pls. 100–103, figs. 127–130; E. T. Joy, *The Country Life Book of Chairs*, London, 1967, p. 39, fig. 29.

137.

Mirror

English: about 1740–50
Mahogany; modern glass
38½ x 26½ in. (97.8 x 67.3 cm.)
64.101.1004

The carving of the fruit, flowers, and foliage recalls late seventeenth-century English mirror and picture

frames, while the restrained use of rocaille is typical of the 1740s and 50s. The combination is rare in a mirror of this period.

EX COLL. Mrs. Howard Eric, New York.
REFERENCE: Untermyer *Furniture*, 1958, p. 35, pl. 138, fig. 167.

138.

Console table

English: about 1740–50
Mahogany; marble top
33 x 50½ x 25¼ in. (84 x 128.3 x 64.2 cm.)
64.101.1092

Single-leg rococo mahogany console tables are rare in English furniture. This example combines a classical egg and dart molding with symmetrically disposed shells, scrolls, and leafage on a boldly curved serpentine carcase. It may have been carved *en suite* with a pier glass, but no matching mirror has been found. The hatched detail on the leg appears frequently on mid-eighteenth-century English chairs.

REFERENCE: Untermyer *Furniture*, 1958, pp. 50–51, pl. 210, fig. 249.

139.

Doorway (one of a pair)

English: about 1745–50
Pine
102 x 54 in. (260 x 137 cm.)
1974.28.85

Door frames that widen at the top to support a frieze and cornice are found in numerous mid-eighteenth-century English houses in the Palladian style, for example, those in the Entrance Hall at Saltram, Devon., about 1750 (H. A. Tipping, *English Homes*, London, 1926, period 6, I, p. 170, fig. 256). In 139, there is an assymetric rococo pierced shell-like motif in the center of the frieze.

140.

Settee and two side chairs

English: about 1750
Mahogany, upholstered in modern green damask
Settee 41¼ x 82 x 29½ in. (104.8 x 208 x 75 cm.)
Chairs 39⅝ x 26½ x 25¼ in. (100.6 x 67.4 x 64 cm.)
64.101.977; 64.101.965, 966

Part of a set that currently numbers sixteen chairs (fourteen of which are in the Metropolitan Museum: 51.186.1, 2, and 64.101.965–976; one in Hammond House, Annapolis, Md.; and one in the Victoria and Albert Museum: W. 24-1951) and two settees (MMA 51.186.3, 64.101.977). The set may have originally included two or more armchairs: one has been published (Macquoid, 1906, p. 195, fig. 171), but its present whereabouts is unknown and its authenticity is unverifiable. The scroll-back treatment of the top rail and the low-relief carving of these pieces suggested an Irish origin to Macquoid, but the current consensus is that they were made in England. They were first recorded, by Latham, in 1904 in Westwood Park, Worcs., a house acquired by the first Lord Doverdale in 1896. It was previously occupied by the Packington family, who built it in the seventeenth century. There is no known documentation of its eighteenth-century furnishings and thus, no reason to suggest that the set was made for Westwood. A set of six later copies (four side chairs and two armchairs, probably nineteenth century) was formerly at Clarendon Court, Newport (sold Anderson Galleries, New York, 29 January 1931, lot 467, ill.). A set of six chairs of similar form, differing in construction and details of carving, was in the collection of Mrs. Giles Whiting (sold Sotheby Parke-Bernet, New York, 15 April 1972, lot 371); whether this set was of American or English origin has been debated (Comstock, 1956).

EX COLL. Lord Doverdale, Westwood Park, Worcs.
REFERENCES: C. Latham, *In English Homes*, London, 1904, I, pp. 258–259; Macquoid, *Mahogany*, 1906, pp. 194–195; H. Cescinsky, *English Furniture of the 18th Century*, London, 1910, II, pp. 171–172, fig. 162; idem, *The Old World House*, London, 1924, p. 78, fig. 7; C. Hussey, *Country Life*, 21 July 1928, pp. 94–100, figs. 2, 3, 5, 8; P. Remington, *Metropolitan Museum of Art Bulletin*, November 1954, pp. 69, 116; H. Comstock, *Antiques*, LXVII, 1955, pp. 400–401; idem, *Antiques*, LXIX, 1956, pp. 229–230, fig. 3; *Untermyer Furniture*, 1958, pp. 27–28, pls. 96–99, figs. 123–126.

141.

Wall lantern

English: about 1750
Mahogany, partly gilded; glass panels; mahogany candlestick
24 x 12½ x 24 in. (61 x 31.7 x 61 cm.)
64.101.1020

From a set of four, two of which are in the Victoria and Albert Museum (W. 26-1954, formerly in the collections of Miss Gow, Hexham-on-Tyne, Northumb., and Brigadier W. E. Clark, London: both illustrated by Nickerson, where they are incorrectly dated 1725), and one formerly with H. M. Lee & Sons, London (*Connoisseur*, CV, July 1940, p. xiii, ill., present location unknown).

REFERENCES: *Untermyer Furniture*, 1958, p. 39, pl. 152, fig. 183. D. Nickerson, *English Furniture of the Eighteenth Century*, London, 1963, p. 27, fig. 26; D. Fitz-Gerald, *Georgian Furniture*, London, 1969, no. 53.

142.

Pair of brackets

English: about 1750 and later
Mahogany
16 x 10¼ x 7½ in. (40.7 x 26 x 19 cm.)
1974.28.35, 36

The female heads are carved from lighter-colored mahogany in a freer style than the tops, which are of high quality and were executed about 1750. The physiognomy of the heads and style of drapery suggest a later, probably nineteenth-century, date.

143.

Pair of brackets

English: about 1750
Gilded gesso on pine
15½ x 10 x 7¾ in. (39.4 x 25.5 x 19.7 cm.)
1974.28.61, 62

In the second quarter of the eighteenth century eagles became a popular motif as supports for English pier tables. Toward the middle of the century, they were adapted to the rococo style and were widely used in wall brackets. A similar eagle bracket was formerly in the collection of Percy B. Meyer (*DEF*, 1954, I, p. 119, fig. 12).

144.

Two armchairs

English: 1751–52
Mahogany upholstered with 18th-century Beauvais
 tapestry
44 x 32 x 28 in. (112 x 81.5 x 71 cm.)
64.101.987, 988

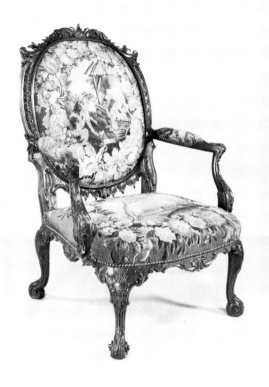

In the two years following his marriage in 1750, Peregrine, third Duke of Ancaster (1714–78) undertook considerable redecoration at Grimsthorpe Castle, Lincs.; it was probably then that these chairs were made. The original set consisted of six (four in the Metropolitan Museum, 64.101.987–990, and two presently on the New York art market) and two settees (one MMA 1971.236; whereabouts of second unknown). In an inventory of about 1813 still at Grimsthorpe, the set was described as being gilt and covered with Gobelins tapestry: "Lady Willoughby's Drawing Room: . . . Two mahogany and gilt carved Sofas, stuff'd backs and seats cover'd with Tapestry de Goblins and brass nailed. Six Arm Chairs exactly to correspond with D°." After Lady Willoughby's death in 1828, the set was put up for sale at Christie's (March 1829) and bought in by her eldest son and heir, Peter Robert, nineteenth Baron Willoughby de Eresby, and reinstated at Grimsthorpe. The chairs remained there until 1934. The Gobelins coverings of the backs represented a series entitled "Jeux d'Enfants" after designs by Boucher. Several similar series are known (Standen, pp. 279–281). The tapestry on the seats displayed scenes from the fables of La Fontaine. All are described in detail in an inventory of 1901–03 and illustrated in the Sotheby catalogue of 11 May 1934, lot 168, when the six chairs were sold by the second Earl of Ancaster. Subsequently, the chairs were stripped of their gilding and those acquired by Judge Untermyer were covered in their present eighteenth-century Beauvais tapestry.

EX COLL. Earls of Ancaster, Grimsthorpe Castle, Lincs.; Sir Edward Barron, London.

REFERENCES: C. Hussey, *Country Life,* LV, 26 April 1924, p. 653, fig. 7; H. A. Tipping, *English Homes,* London, 1928, period 4, II, pp. 316, 318, fig. 472; Untermyer *Furniture,* 1958, p. 31, pls. 116–120, figs. 143–147; E. A. Standen in *Decorative Art from the Samuel H. Kress Collection at the Metropolitan Museum of Art,* London, 1964, pp. 279–281; Coleridge, 1968, pp. 96, 192, pl. 182.

145.

Mirror

> English: about 1750–55
> Gessoed pine, partly gilded, partly painted gray
> 80 x 45 in. (203 x 114.3 cm.)
> 64.101.1007

This has been related to a drawing by Matthias Lock of about 1760 in the Victoria and Albert Museum (Untermyer *Furniture,* 1958, p. 36). However, it is heavier in proportion and more symmetrical than Lock's drawings for mirrors and may predate them by five to ten years.

EX COLL. Bernard Baruch, New York.

REFERENCES: Untermyer *Furniture,* 1958, p. 36, pl. 142, fig. 171; G. Wills, *English Looking-glasses,* London, 1965, p. 90, fig. 69.

146.

Chandelier

> English: about 1750–60
> Gilded gesso on lindenwood; ormolu candle sockets of later date.
> 40¾ x 65 in. (103.5 x 165 cm.)
> 50.82

There are eight detachable double scroll branches, each with a number at the base corresponding to a numbered groove in the stem. Each upper scroll is carved with acanthus leaves and a different flower, each lower scroll with oak leaves and acorn tendrils. Eight different blossoms ornament the topmost rim with four on the openwork section immediately below. The original gilding is almost intact. Although Comstock proposed an earlier date for it, 146 is a splendid example of the fully developed English rococo. When acquired by Judge Untermyer, it had no candle sockets; the present ones are from a French chandelier of about 1845 (ex coll. Maria Pia de Braganca, sold Parke-Bernet, 24 May 1951, lot 484).

REFERENCES: H. Comstock, *Antiques,* LXVII, 1955, pp. 400–401, fig. 5; Untermyer *Furniture,* 1958, p. 41, pl. 161, fig. 194; Coleridge, 1968, p. 203, pl. 298.

147.

Basin stand

> English: about 1750–60
> Mahogany; China trade porcelain bowl (bowl about 1775)
> H. 32¼, D. of top 12¾ in. (82.5, 32.5 cm.)
> 64.101.1047a, b

Beneath the soapbox in the center are two drawers for toilet articles. The circular depression on the base accomodated a ewer. The carving throughout is of particularly high quality. Several basin stands of similar form are illustrated in *DEF,* 1954, III, p. 367.

EX COLL. Genevieve Garvan Brady, Manhasset, N.Y.

EXHIBITED: Parke-Bernet, New York, 1942, *French and English Art Treasures of the XVIII Century,* no. 533.

REFERENCES: *DEF,* 1954, III, p. 367, fig. 7; Untermyer *Furniture,* 1958, p. 42, pl. 170, fig. 204.

148.

Bureau table

> English: about 1750–60
> Mahogany and mahogany veneer; carcase and drawer linings of oak; drawer pulls missing, their placement indicated by plugged holes
> 32 x 42 x 24 in. (81.2 x 106.7 x 61 cm.)
> 64.101.1111

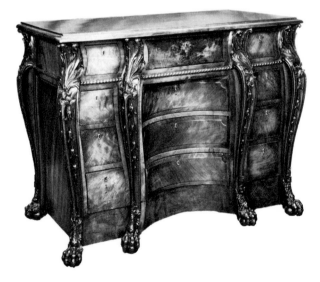

The vertical supports curve outward, away from the center, creating a rhythm echoed both by the drawer fronts and the concave middle section. The sides curve slightly forward in the center, in a reverse of the front plan. Among many refinements are the projecting, carved rear corners (so that the sides as well as front are symmetrical) and the drawer linings, which continue the varying curves of the drawer fronts. The body extends almost to the floor, rather than ending beneath the lowest drawers, as was customary in objects of this type. 148 has been associated with the furniture of William Vile, to which it is not related, and it has been compared to a pair of commodes formerly at Hampden House, Bucks. (one in R. W. Symonds, *Masterpieces of English Furniture and Clocks,* London, 1940, p. 35, fig. 26). While sharing a similar structure of four curved stiles above lion-paw feet, these do not display the same high level of carving or subtlety of design. Symonds notes the relationship of the commodes to a design by Chippendale (*Household Furniture in Genteel Taste for the Year 1760,* Society of Upholsterers, London, 1760, pl. 60), but neither they nor 148 can be attributed to him.

EX COLL. Alan P. Good, Glympton Park, Woodstock, Oxon. (Sotheby's, 2 July 1953, lot 283, ill.).
REFERENCES: T. P. Grieg, *Connoisseur,* CXXXII, 1953, pp. 124–125, ill.; Untermyer *Furniture,* 1958, pp. 56–57, pl. 236, fig. 275.

149.
Pair of brackets

English: about 1750–60
Mahogany
21½ x 16¾ x 11 in. (54.6 x 42.5 x 28 cm.)
64.101.1173

Based on a design in Chippendale's *Director* (1754, pl. CXXXI; 1762, pl. CLX), the drawing for which is in the Metropolitan Museum (20.40.1, leaf 80). Although Chippendale titled his plate "Brackets for Busts," they were also widely used to display porcelain.

EXHIBITED: National Gallery of Art, Washington, D.C., 1976, *The Eye of Thomas Jefferson,* p. 50, fig. 85.
REFERENCE: Untermyer *Furniture,* 1958, p. 73, pl. 310, fig. 354.

150.
Pair of standing shelves

English: 1753–54
Carcase of mahogany, fretwork panels of English walnut, the whole japanned black and gold with red interior
59 x 23 x 10½ in. (150 x 58.5 x 26.7 cm.)
64.101.1124, 1125

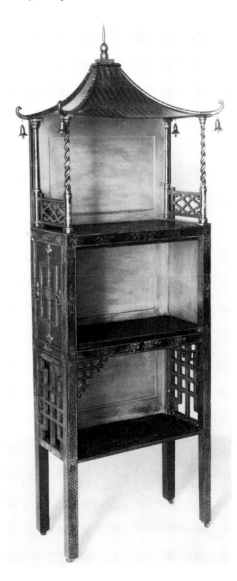

The fourth Duke of Beaufort refurnished his bed-room at Badminton House in the new Chinese taste in 1753 or early 1754. The furniture, often attrib-uted to Chippendale, has recently been shown by Hayward to have been executed by the London firm of William Linnell (about 1708–63), perhaps to designs by John Linnell (1737–96). The room was hung with Chinese wallpaper and contained a large set of japanned furniture including a bed, eight armchairs, two pairs of standing shelves, a com-mode, one or perhaps two kneehole dressing tables, and one or possibly two carved mirrors. Hayward (*Apollo,* 1969, fig. 1) illustrates a partial view of the room as it was arranged in 1908. The furniture was sold by the Duke of Beaufort in 1921. A similar set of standing shelves, with a door in the middle sec-tion, belonging to Alice, Countess of Gainsbor-ough, is on loan to the Leicester Museum (Cole-ridge, 1968, pl. 282).

EX COLL. Duke of Beaufort, Badminton House, Glos. (Christie's, 30 June 1921, lot 50 [51?] [one ill.]).

REFERENCES: Macquoid, *Satinwood,* 1908, pp. 17–18, 21, fig. 15; P. Macquoid, *English Furniture . . . in the Lady Lever Art Gallery,* London, 1928, no. 168, pl. 52; Un-termyer *Furniture,* 1958, p. 61, pl. 254, fig. 295; Cole-ridge, 1968, p. 201, pl. 281; H. Hayward, *Furniture History,* V, 1969, pp. 18, 83, 114; idem, *Apollo,* XC, 1969, pp. 134, 139, fig. 7; H. D. Molesworth and J. Kenworthy-Browne, *Three Centuries of Furniture in Colour,* London, 1972, p. 169, fig. 280.

151.
Armchair

English: about 1755
Mahogany; modern metal brace screwed to back; seat upholstered in contemporary English needle-work.
38 x 26½ x 20 in. (96.5 x 67.3 x 50.8 cm.)
64.101.991

The legs derive from a design in Chippendale's *Director* (1754, pl. XXV; 1762, pl. XXVIII), one in a series of nine designs for chairs in the Chinese manner, "very proper for a Lady's Dressing Room:

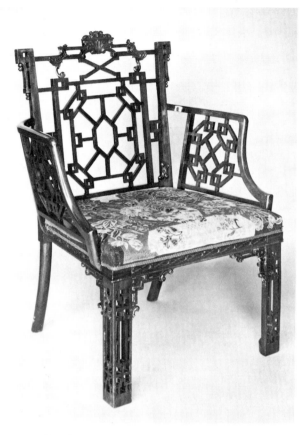

especially if it is hung with India Paper. They will likewise suit Chinese Temples. They have com-monly Cane-Bottoms, with loose Cushions, but, if required, may have stuffed Seats and Brass Nails." Based on the same design is a set of four side chairs and a settee *en suite* in the Lady Lever Art Gallery, Port Sunlight, Ches. (P. Macquoid, *English Furniture . . . in the Lady Lever Art Gallery,* London, 1928, nos. 157, 158, pl. 48 [settee], and Coleridge, 1968, p. 193, pl. 196 [chair]). Four armchairs also in the Lady Lever Art Gallery were thought by Macquoid to be from the same set (ibid., no. 157, pl. 47), but are now considered of later date (*Le Siècle de l'élégance,* 1959, no. 65). Their form is similar to that of 151 with the exception of the carved band on the seat rails, which continues above the front legs. It is not known whether 151 was originally *en suite* with the side chairs and settee.

REFERENCES: Untermyer *Furniture,* 1958, p. 31, pl. 121, fig. 148; *Le Siècle de l'élégance, la demeure anglaise au XVIIIe siècle,* exhib. cat., Musée des Arts Décoratifs, Paris, 1959, no. 65; Coleridge, 1968, p. 193, no. 196.

152.

Fire screen

English: about 1755
Mahogany; panel of carpet pile
52½ x 37½ x 26¼ in. (133.3 x 95.2 x 66.7 cm.)
64.101.1155

St. Giles's House in Dorset, the former location of 152, was refurnished in the mid-eighteenth century by the fourth Earl of Shaftsbury, whose first wife, Lady Susannah Noel (d. 1758) was among the subscribers to the first edition of Thomas Chippendale's *Director* (1754). The house still contains many pieces of rococo furniture in the *Director* tradition. The base of 152 displays some similarities with one of the *Director* designs (1754, pl. CXXVII), but they are insufficient to warrant an attribution. A mahogany fire screen at Dumfries House in Ayrshire, Scotland, supplied by Chippendale in 1759, while unrelated in carving to 152, contains a carpet-pile panel with the same pictorial composition; the panel

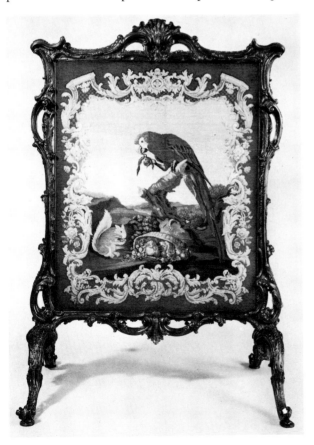

has been attributed to the London weaver Thomas Moore (Gilbert, 1969, p. 674, fig. 47). Other weavers of this type of fabric were Peter Parisot at Fulham, Claude Passavant at Exeter, and Thomas Whitty at Axminster; the last was patronized by the Countess of Shaftesbury. The design was apparently taken from a French Savonnerie panel of which three examples are known, one in the Metropolitan Museum.

EX COLL. Earl of Shaftesbury, St. Giles's House, Dorset.
REFERENCES: M. Jourdain, *Country Life,* XXXVII, 13 March 1915, p. 339, ill.; M. Jourdain and F. Rose, *English Furniture, the Georgian Period,* London, 1953, p. 195, fig. 167; Untermyer *Furniture,* 1958, frontispiece, p. 72, pls. 297–299, figs. 339–341; Untermyer *Needlework,* 1960, p. 49, pl. 113, fig. 151; D. Molesworth in *Great Private Collections,* ed. D. Cooper, New York, 1963, p. 146; C. Gilbert, *Burlington Magazine,* CXI, November 1969, p. 671 note 36.

153.

Tea caddy

English: about 1755
Mahogany; ormolu handle and escutcheon
6 x 11½ x 6½ in. (15.2 x 29.2 x 16.5 cm.)
64.101.1190

This shows many similarities with a design in Chippendale's *Director* (1754, pl. CXXIX, upper right; 1762, pl. CLIX), the drawing for which is in the Metropolitan Museum (20.40.1, leaf 89). Several of Chippandale's published "Tea Chests" are basically miniature *bombé* commodes. Because the carving of 153 is partly applied and partly cut from the solid (Pinto incorrectly states that it is entirely the latter), it has been much criticized, but the carving is consistent in style, the wood evenly matched in color, and there are no signs of later additions or restorations. It formed part of the collection of English furniture assembled by Fred Skull in High Wycombe, who noted, as did Pinto and Hughes, its fine quality (Skull, quoted in Untermyer *Furniture,* pp. 75–76).

EX COLL. Mr. Kelly, Shrewsbury, until about 1920; Harold Davis, London; Fred Skull, Bassetsbury

Manor, High Wycombe, Bucks. (Christie's, 23 April 1952, lot 245, ill.).

REFERENCES: C. Hussey, *Country Life*, LXXIV, 7 October 1933, p. 365, fig. 6; *DEF*, 1954, III, pp. 340–341, fig. 3; G. B. Hughes, *Country Life*, CXXII, 5 September 1957, p. 440, fig. 3; Untermyer *Furniture*, 1958, pp. 75–76, pl. 323, fig. 371; E. H. Pinto, *Treen*, London, 1969, p. 293, fig. 316.

154.

Doorway

English: about 1755
Pine; mahogany door not original
149 x 58½ x 10 in. (378.5 x 148.5 x 25.4 cm.)
64.101.1212

Norfolk House in St. James's Square, London, was built for the ninth Duke of Norfolk by Matthew Brettingham the Elder (1699–1769) between 1748 and 1752. The interior decoration, based largely on the designs of the Piedmontese architect Giovanni Battista Borra (1712–about 1786) was completed by February 1756. Fitz-Gerald notes that the house "bore the distinction of being one of the first extensive displays of French-inspired decoration in London" (1973, p. 5). This "monkey" door and its companion in the Victoria and Albert Museum (Fitz-Gerald, pl. 45), designed by Borra, were executed about 1755 by the London carver John Cuenot (d. 1762) for the Great Drawing Room, later known as the Ballroom. In 1845 two additional doors, copied in papier-mâché and plaster, were installed in the room. Following the demolition of Norfolk House in 1938, the four doors were sold at Christie's. Borra repeated the overdoor composition about 1755 in the Sala di Diana at the Palace of Racconigi near Turin, substituting putti for the monkeys and classical vases for the spirally fluted Norfolk ones (ibid., pl. 44). Fitz-Gerald notes the strong Piedmontese character of the quatrefoil grillwork or *treillage* within the pediments of the Great Drawing Room doors.

EX COLL. Duke of Norfolk, Norfolk House, London (Christie's, 7–9 February 1938, lot 286).

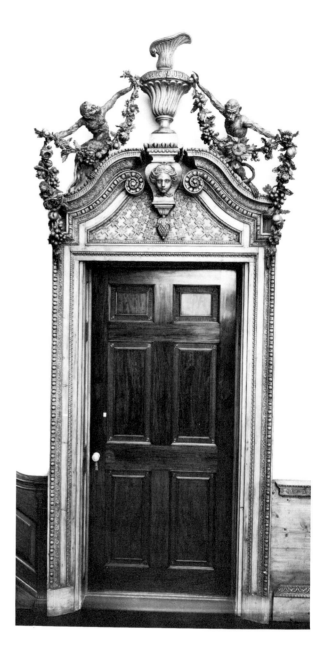

REFERENCES: E. B. Chancellor, *The Private Palaces of London*, London, 1908, pp. 313–323; A. Oswald, *Country Life*, LXXXII, 25 December 1937; H. Comstock, *Connoisseur*, CI, 1938, pp. 332–333; Untermyer *Furniture*, 1958, p. 77, figs. 384–385, pls. 334, 335; *Survey of London*, London County Council, 1960, XXIX, pp. 198–199; XXX, pls. 156b, 157a; D. Fitz-Gerald, *The Norfolk House Music Room*, London, 1973, pp. 14, 19, 45–46, 54–55, pls. 8, 43.

155.

Chair

English: about 1755–60
Mahogany; upholstered in later needlework, tent
 stitch on canvas
39½ x 23 x 19½ in. (100.3 x 58.5 x 49.5 cm.)
64.101.983

Chippendale published a plate showing three "ribband back chairs" in the *Director* (1754, pl. XVI), describing them as "the best I have ever seen (or perhaps have ever been made)." In the third edition (1762) this became plate XV with the note: "Several sets have been made, which have given entire satisfaction." They proved to be among the most popular of his designs, and large numbers of chairs were carved by numerous cabinetmakers following these patterns both in the eighteenth century and later. There has yet to be a consensus among furniture historians for criteria on which to date them. One of a pair, 155 was derived, with some variations, from the left design in Chippendale's plate and appears to be of mid-eighteenth-century workmanship. The carving is comparable to that of a set of four chairs and a settee in the Victoria and Albert Museum from the same design (Coleridge, 1968, pls. 173, 174).

EX COLL. Major J. C. Bulteel (Christie's, 7 May 1953, lot 23).
EXHIBITED: Rhode Island School of Design, Providence, 1954, *Chippendale and His Age*.
REFERENCE: Untermyer *Furniture*, 1958, p. 30, pls. 110, 111, figs. 137, 138.

156.

Armchair

English: about 1755–60
Mahogany; re-upholstered in 18th-century English
 needlework
39 x 27 x 22 in. (99 x 68.5 x 56 cm.)
64.101.992

An identical chair is in an English private collection, but without provenance or relation to published designs or documented pieces, neither can be attributed. A similar pair, without the apron and with small variations in the carving, was formerly in the H. James Yates Collection (R. W. Symonds, *Masterpieces of English Furniture and Clocks*, London, 1940, p. 15, fig. 8).

EXHIBITED: British Antique Dealers' Association, Christie's, London, 1932, *Art Treasures Exhibition*.
REFERENCES: *Connoisseur Year Book*, 1957, p. 111, fig. 17; Untermyer *Furniture*, 1958, pp. 31–32, pls. 122, 123, 125, figs. 149–151.

157.

Pair of wall lanterns

English: about 1755–60
Mahogany; mirror backs and platforms; mahogany
 candlesticks
34 x 17¾ x 11 in. (86 x 45 x 28 cm.)
64.101.1021, 1022

When sold by Christie's from the collection of the Hon. F. S. O'Grady in 1912, these were said to have come from Coventry House (now The St. James's Club, 106 Piccadilly). Bought by the sixth Earl of Coventry in 1765, the house was decorated and furnished from that year to 1769 after designs by Robert Adam. Given the Earl's interest in the new neoclassical style, it is unlikely that he would have introduced earlier rococo wall lanterns into his house. Coventry House changed ownership twice in the mid-nineteenth century before it was leased in 1868 to its present tenant, and it is not known when these lanterns were installed. Coleridge (p. 202) compares them with a design in the third edition of Chippendale's *Director* (1762, pl. CLIII), but the similarities do not warrant an attribution.

EX COLL. Coventry House, London; Hon. F. S. O'Grady, Duffield Park, Derby (Christie's, 25 April 1912, lot 87); Percival D. Griffiths, Sandridgebury, near St. Albans.
REFERENCES: H. A. Tipping, *English Furniture of the Cabriole Period*, London, 1922, p. 78, pl. XXXII, fig. 2; R. W. Symonds, *Antiques*, XXII, 1932, pp. 141–142, fig. 12; *DEF*, 1954, II, p. 283, fig. 6; Untermyer *Furniture*, 1958, p. 39, pl. 153, fig. 184; Coleridge, 1968, pp. 104, 202–203, pl. 296.

158.

China table

English: about 1755–60
Mahogany and mahogany veneer
28¼ x 37¾ x 26½ in. (71.8 x 96 x 67.4 cm.)
64.101.1099

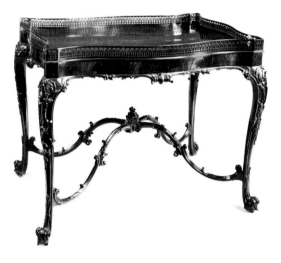

In *The Rise of the House of Duveen,* James Henry Duveen engagingly relates how he bought this, "the most exquisite Chippendale drawing-room table I have seen," at an auction at "Four Crosses" near Welshpool for £75. "I liked the table so much that I was thinking of not selling it at all," he wrote—and sold it almost immediately for £500 to the English dealer Sidney Letts, who sold it to the American collector Richard Canfield. The stretcher, cabriole legs, and serpentine top are related to (though not derived from) a design for "China Tables" in Chippendale's *Director* (1754, pl. XXXIIII; 1762, pl. LI), described by him as "Two designs for Tables for holding each a Set of China, and may be used as Tea-Tables." The carving is of particularly fine quality, although this does not, by itself, suggest an attribution to Chippendale. A table with a similar stretcher and serpentine top is presently on the New York art market (Coleridge, 1968, pl. 214).

EX COLL. James Duveen; Sidney Letts; Richard A. Canfield, by 1914; Marsden J. Perry (Anderson Galleries, New York, 4 April 1936, lot 246, ill.).

EXHIBITED: Parke-Bernet, New York, 1942, *French and English Art Treasures of the XVIII Century,* no. 544.
REFERENCES: L. V. Lockwood, *Colonial Furniture in America,* New York, 1913, II, p. 210, fig. 739; H. D. Eberlein and A. McClure, *The Practical Book of Period Furniture,* Philadelphia, 1914, pl. XIX; *Antiques* LIII, 1948, p. 115; J. H. Duveen, *The Rise of the House of Duveen,* New York, 1957, pp. 115–119; Y. Hackenbroch, *Antiques,* LXXIV, 1958, pp. 229–230, figs. 11, 12; Untermyer *Furniture,* 1958, pp. 52–53, pl. 218, fig. 257.

159.

Armchair

English: about 1760
Mahogany; upholstered with French 18th-century needlework (much restored)
51 x 33½ x 33 in. (129.5 x 85 x 84 cm.)
64.101.980

With its mate (exhibited in The Metropolitan Museum of Art, 1975, *The Grand Gallery,* p. 208, no.

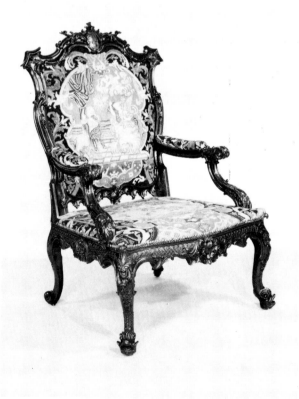

203, ill.), 159 is related to several designs in the *Director* (1762, pls. XX, XXI) entitled "French Chairs," but not directly derived from any one design. Their large size suggests that they may have been intended for ceremonial usage. Hayward compares them to a drawing by John Linnell (about 1737–96) in the Victoria and Albert Museum (E. 72-1929; Hayward, 1969, fig. 2) and notes the possibility that they may have been executed by the London firm of William Linnell (about 1708–63). The needlework is not original. Both chairs display on the crest at the center of the top rail the arms of the Barrington family as they existed subsequent to 1601 (not the arms of the Marquess of Abergavenny, as stated by Hackenbroch and Coleridge).

EX COLL. Richard A. Canfield, Providence, R. I.; Marsden A. Perry (Anderson Galleries, New York, 4 April 1936, lot 267, ill.); W. R. Hearst.

EXHIBITED: Baltimore Museum of Art, 1959, *Age of Elegance: The Rococo and Its Effect,* p. 78, no. 365, p. 84, fig. 365.

REFERENCES: L. V. Lockwood, *Colonial Furniture in America,* New York, 1913, II, p. 108, fig. 581; Untermyer *Furniture,* 1958, p. 29, pls. 104, 105, figs. 131, 132; Coleridge, 1968, pp. 96, 192, pl. 183; H. Hayward, *Furniture History,* V, 1969, pp. 78, 83.

160.
Mirror

English: about 1760
Stained pine
71 x 37¼ in. (180.5 x 94.6 cm.)
64.101.1006

The animals at the sides and top are related to those in mirror designs by Thomas Johnson (for example, pl. 4 in his collection of designs of 1758, H. Hayward, *Thomas Johnson and English Rococo,* London, 1964, pl. 13), but the mirror as a whole is not derived from any single Johnson engraving. The carving appears to be the work of a provincial, rather than a London, craftsman.

REFERENCE: Untermyer *Furniture,* 1958, p. 36, pls. 140, 141, figs. 169, 170.

161.
Overmantel mirror

English: about 1760
Pine, gessoed and water-gilt
71 x 66 in. (180.4 x 167.5 cm.)
64.101.1008

Several of similar form are known. One, formerly in the "Chinese" bedroom at Badminton House, Glos. (Macquoid, *Satinwood,* 1908, pp. 13–14, fig. 8), was probably supplied by William Linnell; it was sold by the Duke of Beaufort in 1921 and was on the London market in 1965 (*Connoisseur,* CLX, December 1965, p. LI, ill.). Another was in the collection of the Marquess of Bath, sold Sotheby's, 22 November 1940, lot 81, ill. Another is in the Cowley Bridge Hotel, Uxbridge, Mx. Still another, in the Victoria and Albert Museum (W. 65-1938), was once thought to be German (R. Edwards, *Apollo,* XXIX, 1939, pp. 130–131, ill.). Although they show numerous variations in details, these mirrors may all have a common origin in an engraved design.

REFERENCES: Y. Hackenbroch, *Antiques,* LXXIV, 1958, pp. 230–231, fig. 13; Untermyer *Furniture,* 1958, p. 36, pl. 143, fig. 172.

162.
Candlestand

English: about 1760
Mahogany
38¼ x 12½ in. (97.2 x 31.8 cm.)
64.101.1046

Based on a design in Chippendale's *Director* (1754, pl. CXXII; 1762, pl. CXLVI), the drawing for which is in the Metropolitan Museum (20.40.1, leaf 101). Of good though not exceptional quality, this piece could have been produced by any of a number of mid-eighteenth-century London carvers. Candlestands of this period usually had galleries or small rims around the tops. The present top appears to be a replacement.

REFERENCE: Untermyer *Furniture,* 1958, p. 42, pl. 169, fig. 203.

163.

Secretary-cabinet

English: about 1760
Mahogany and mahogany veneer; drawer linings of
 mahogany and oak
80 x 42 x 16½ in. (204 x 106.5 x 42 cm.)
64.101.1123

The central panel opens downward to create a writing flap; the other doors conceal drawers and cupboards. The canted sides result in a pentagonal plan, which suggests that the upper part was intended for the display of china rather than books, as was the usual case in the eighteenth-century secretary-cabinet. A combination of Chinese and Gothic motifs, such as present here, was not considered incongruous in the mid-eighteenth century. The individual elements can be found in Thomas Chippendale's *Director* (1762, pl. CXLII) and in William Ince's and John Mayhew's *Universal System of Household Furniture* ([London], 1762, pl. XLVI), but the cabinet is not derived from either volume. While both illustrate china cases and bookcases with pierced pagoda tops, such a feature is rare in extant furniture of this period, the present example the more so for being pierced in a deliberately asymmetrical, rustic manner. The use of mahogany drawer linings in the secretary compartment underlines the quality of the piece. The top in its present state appears somewhat truncated; originally there may have been an additional pagoda or other decorative terminal feature in the Chinese taste (compare the six designs for china cases in the *Director,* 1762, pls. CXXXII-CXXXVII). Smith notes that the screen and railing before the open shelves are based on the lattice designs from Canton illustrated in Sir William Chambers' *Designs of Chinese Buildings* of 1757, while the incurving scrolls of the feet imitate an authentic Chinese type of foot.

EX COLL. Cuthbertson, London; Bernard Baruch, New
 York.
REFERENCES: R. W. Symonds, *Connoisseur* (Souvenir of
 the Antique Dealers' Fair), June 1952, p. 11; *DEF,*
 1954, I, p. 150, fig. 56; Untermyer *Furniture,* 1958, p.
 60, pls. 252, 253, figs. 293, 294; Coleridge, 1968, pp.
 102, 200, pl. 272; R. C. Smith, *Antiques,* XCVI,
 1969, p. 552, fig. 1.

164.

Clothespress

English: about 1760
Mahogany; carcase of pine; drawer linings of oak;
 ormolu drawer handles
87 x 59 x 26¾ in. (221 x 150 x 68 cm.)
64.101.1139

Behind the doors in the upper section are two banks of five drawers each, with three long drawers in the lower section, an unusual arrangement. Clothes-

presses of this period commonly had sliding shelves covered with green baize behind two doors in the top area and three or four exposed drawers below for storing linen, as Chippendale noted in his *Director* (1754, pl. CXXIX). Gothic and Chinese elements are combined in the blind tracery applied to the doors with their pointed arches and simulated bamboo colonnettes. A similar treatment of Gothic decoration in tracery and openwork gallery is found in a drawing by the London cabinetmaker George Speer (1736–after 1802) (A. Coleridge, *Apollo,* XCII, 1970, p. 280, fig. 10), but this was a vocabulary of ornament used with variations by many cabinetmakers in the mid-eighteenth century. A nearly identical piece, one of a pair without gallery, was published by C. Simon (*English Furniture Designers of the Eighteenth Century,* Philadelphia, 1905, pp. 69–70, fig. XVIII) and described, probably errο-

neously, as a bookcase (present whereabouts unknown).

EX COLL. J. H. Hambro, Luton, Beds. (Christie's, 1 May 1947, lot 130, ill.).

REFERENCES: Untermyer *Furniture,* 1958, p. 66, pls. 276, 277, figs. 318, 319; D. Molesworth in *Great Private Collections,* ed. D. Cooper, New York, 1963, p. 139; Coleridge, 1968, pp. 89, 190, pl. 163; J. Gloag, *Antiques,* XLV, 1969, pp. 684–685, fig. 5.

165.

Commode

English: about 1760
Mahogany; carcase of pine; drawer linings of mahogany; ormolu handles and escutcheons
35 x 42 x 24¾ in. (89 x 106.6 x 61 cm.)
64.101.1142

In 1766, John Cobb (about 1710–78), upholsterer and cabinetmaker at 72 St. Martin's Lane, supplied to James West of Alscot Park, Warwickshire, a commode with identical ormolu handles, leaf plates and escutcheons, and a *bombé* shape on the front similar to that of this piece. It also has a similar apron and side profile and plain, rather than carved, corners (H. Honour, *Cabinet Makers and Furniture*

Designers, London, 1969, p. 112, ill.). A nearly identical commode was formerly at Malahide Castle, Co. Dublin (sold Sotheby's, 5 March 1971, lot 165, ill.). Closely related examples include commodes at Harewood, Adare Manor, Co. Limerick, St. Giles House, Dorset (*DEF,* 1954, II, p. 114, fig. 12) and two recently on the London market (the first ill. *Apollo,* LXXXIII, June 1966, p. xlix, and the second, sold Christie's, 21 May 1970, lot 110, ill.). Of these the latter are of particular interest, for the corner mounts repeat, with some variation, in ormolu the motifs carved on 165. These and the handles and escutcheons were apparently stock models supplied to many cabinetmakers: they occur on commodes otherwise unrelated to those in this group. An attribution of the group as a whole to John Cobb will require further detailed stylistic analysis and an examination of the construction of each commode.

EX COLL. Earl Howe, Penn House, Amersham, Bucks. (Christie's, 13 June 1928, lot. 30, ill.).

EXHIBITED: Parke-Bernet, New York, 1942, *French and English Art Treasures of the XVIII Century,* no. 566.

REFERENCES: *Christie's Season 1928,* London, 1928, pp. 328–329; R. W. Symonds, *Apollo,* XVII, 1933, pp. 61–62, 67, fig. 1; Untermyer *Furniture,* 1958, p. 67, pl. 280, fig. 322.

166.

Bracket

English: about 1760
Mahogany
17 x 17 x 9½ in. (43 x 43 x 24 cm.)
64.101.1172

The contrast in scale between the dentils of the platform and the bold scrolls and foliage at the bottom is a notable feature. A pair of similar brackets with a symmetrical floral pendant at the base was formerly in the collection of Sir Harry and Lady Hague (*DEF,* 1954, I, p. 118, fig. 10).

REFERENCE: Untermyer *Furniture,* 1958, p. 73, pl. 309, fig. 353.

167.

Bracket

English: about 1760
Gilded gesso on pine
23 x 16 x 10 in. (58.5 x 40.6 x 25.5 cm.)
1974.28.60

Wall brackets of gilded wood were popular in both England and France in the mid-eighteenth century. Louis-Antoine de Caraccioli wrote of them in 1768: "Il en faut dans un appartement, pour qu'il soit à la mode" (*Dictionnaire critique, pittoresque et sentencieux,* Lyon, 1768, I, p. 66). 167 is a particularly successful English interpretation of the rococo style.

REFERENCE: Untermyer *Furniture,* 1958, pl. 315, fig. 359.

168

168.

Pair of pedestals

English: about 1760
Pine; recently painted pale yellow and white
43½ x 11 x 11 in. (111 x 28 x 28 cm.)
1974.28.7, 8

Decorated on three sides with applied carving of flowers, fruit, and leafage, these pedestals were designed to stand against a wall. In the mid-eighteenth century, pedestals of this tall, tapering form supported busts, bronzes, vases, or candelabra. Chippendale included four designs of this type in the third edition of his *Director* (1762, pl. CXLVIII), describing them as "Terms for Busto's ec." William Ince and John Mayhew also showed four in their *Universal System of Household Furniture* [London], 1762, entitled "Therms for Busts or Lamps." Our pedestals exhibit some similarities in the carving on the large panels with the left design in Chippendale's plate, though they are not derived directly from it.

169.

Barometer

John Whitehurst
English: 1760
Mahogany case
Dial signed and dated: "Whitehurst/Derby/1760"
41½ x 14½ x 2¼ in. (105.4 x 37 x 5.6 cm.)
1974.28.49

Whitehurst (1713–88) established a workshop in Derby in 1736 and acquired a wide reputation for his turret and "tell-tale" clocks. In 1775 he moved to London, where he was appointed "Stamper of Money Weights" at the Mint. He published books on geology and time measurement and was elected Fellow of the Royal Society in 1779 (for further biographical details, N. Goodison, *English Barometers, 1680–1860*, New York, 1968, pp. 257–259). Whitehurst "is said to have ordered cases for his instruments from Chippendale" (Coleridge, 1968, p. 207), and 169 has been compared with a barom-

eter supplied by Chippendale in 1769 for Nostell Priory, York., (ibid., pp. 115–116, pl. 346). However, 169 cannot be attributed to him since neither in decorative motifs nor style of carving are they related. Although Coleridge states that the movements are identical (p. 207), that of the Nostell barometer is by Justin Vulliamy; it is described in detail by N. Goodison (*Furniture History*, II, 1966, pp. 19–21).

EX COLL. Marsden J. Perry, Providence, R.I. (American Art Association, Anderson Galleries, New York, 4 April 1936, lot 225); Arthur S. Vernay, New York; Walter P. Chrysler, Jr. (Parke-Bernet, 30 April 1960, lot 220, ill.).

REFERENCE: Coleridge, 1968, pp. 115–116, 207, pl. 347.

170.

Two armchairs

English: about 1765
Mahogany, except back seat rail of beech faced with mahogany; covered in contemporary English needlework
42 x 28 x 26 in. (106.7 x 71 x 66 cm.)
64.101.985, 986

Part of a set consisting of eight armchairs (one in the Victoria and Albert Museum: W. 47-1946; four sold at Sotheby's, 6 October 1967, lot 176, ill., now in a private collection; whereabouts of one chair unknown) and one settee (MMA 57.93). They correspond closely to a design for a "French Chair" first published in the third edition of Thomas Chippendale's *Director* (1762, pl. XXII, right), the drawing for which is dated 1759 (MMA 20.40.1, leaf 13). This does not, however, warrant an attribution to Chippendale: numerous cabinetmakers executed furniture to his designs. He states in the notes to the four plates of designs for "French Chairs" (pls. XX-XXIII):

> Some of them are intended to be open below at the Back: which make them very light, without having a bad Effect. The Dimensions are the same as in Plate XIX, only that the highest Part of the Back is two Feet, five Inches: But sometimes these Dimensions

vary, according to the Bigness of the Rooms they are intended for. [The backs of the present chairs are 27 inches high.] A skilful Workman may also lessen the Carving, without any Prejudice to the Design. Both the Backs and Seats must be covered with Tapestry, or other sort of Needlework.

Two provenances have been advanced for the present set of furniture: one that it was made for William Plumer of Gilston Park, Herts., the other that it was made for George, first Marquess Townshend (1724–1807), of Raynham Hall, Norfolk. It has not yet been established which, if either, is correct.

EX COLL. Lord Woolavington, Lavington Park, Sussex (Sotheby's, 20 November 1936, lot 100, ill.); Robert Tritton, England.

EXHIBITED: Burlington Fine Arts Club, London, 1938–39, *Winter Exhibition*, no. 75.

REFERENCES: *Connoisseur*, LXVIII, 1924, p. 110; *A Catalogue and Index of Old Furniture and Works of Decorative Art*, Moss Harris & Sons, London [about 1932], pt. II, p. 171, no. F 9165; *Country Life*, LXXX, 7 November 1936, cover; *The English Chair*, Moss Harris & Sons, London, 1937, p. 122, pls. LIIA, LIIB; *Apollo*, XXXVII, February 1943, back cover; *Antique Collector*, XVIII, March–April 1947; R. W. Symonds, *Antique Collector*, XXI, 1950, p. 145, fig. 3; *Connaissance des Arts*, 11, 15 January 1953, p. 31; *DEF*, 1954, I, p. 288, fig. 198; R. Edwards and M. Jourdain, *Georgian Cabinet-makers*, London, 1955, p. 178, figs. 108, 110; Y. Hackenbroch, *Antiques*, LXXIV, 1958, pl. opp. p. 225, pp. 228–229, figs. 7, 8; Untermyer *Furniture*, 1958, pp. 30–31, pls. 114, 115, figs. 141, 142; Untermyer *Needlework*, 1960, p. 49, pl. 114, fig. 152; R. Edwards, *English Chairs*, London, 1965, p. 23, no. 77, fig. 77; Coleridge, 1968, pp. 96, 192, 194, pls. 179, 205; D. Fitz-Gerald, *Georgian Furniture*, London, 1969, fig. 60; G. Wills, *English Furniture, 1760–1900*, Enfield, Mx., 1971, pp. 22–23, fig. 17; J. Gloag, *Guide to Furniture Styles*, New York, 1972, cover and p. 157.

171.

Chimneypiece

English: about 1770
White marble and yellow Siena marble
49 x 89 x 12 in. (124.5 x 226 x 30.5 cm.)
64.101.1215

Gloucester House in Park Lane, London, was built for William Henry, Duke of Gloucester (1743–1805), brother of George III. This chimneypiece was in the Dining Room, which with the adjacent Saloon overlooked the extensive gardens between Park Lane and Park Street. On Gloucester's death, the property was taken over by the second Earl Grosvenor and renamed, in 1806, Grosvenor House (for description of the house and collection, E. B. Chancellor, *The Private Palaces of London*, London, 1908, pp. 260–274). The house was demolished in the late 1920s, and the present Grosvenor House was built on the site in 1930.

EX COLL. Duke of Westminster, Grosvenor House, London.

REFERENCE: Untermyer *Furniture*, 1958, p. 78, pl. 338, fig. 388.

172.

Writing cabinet

English: about 1770–75
Pine and oak carcase veneered with mahogany and satinwood; marquetry panels of satinwood and other tinted woods; ormolu mounts and drawer handles; interior and drawer linings of mahogany
52 x 29 x 15½ in. (132 x 73.6 x 39.4 cm.)
64.101.1127

The paneled doors in the upper part enclose a mahogany interior of pigeonholes and nine small drawers. Separating this and the three large drawers below is a leather-covered writing slide. The chinoiserie marquetry scenes on the doors are derived from two engravings by Jean Pillement (1727–1808) representing September (left) and October (right), from a series of the months published in Paris in 1759 (D. Guilmard, *Les Maîtres ornemanistes*, Paris, 1880, pp. 188–189, no. 80:22; *L'Oeuvre de Jean Pillement*, Guérinet, Paris, n.d., I, pls. 63–64). The marqueteur has adapted the scenes by altering individual elements, creating compositionally balanced pendants. Pillement's engravings were used as sources for marquetry by Abraham and David

collection (Macquoid, *Satinwood,* 1908, p. 163, fig. 147). It has identical marquetry on the three drawers (the pattern reversed on the bottom) and framed panels on the sides. Replacing the Pillement scenes are a single classical Greek figure on each door and on both sides a vase, all derived from Sir William Hamilton's collection of Greek vases, first published by Pierre d'Hancarville in *Antiquités étrusques, grecques et romaines,* Naples, 1766–67.

EX COLL. Howard Reed, London (Christie's, 16 November 1955, lot 211, ill.).

REFERENCES: *Connoisseur,* CXXXVI, 1955, p. 113, fig. 4; Y. Hackenbroch, *Antiques,* LXXIV, 1958, pp. 230–231, figs. 15, 16; Untermyer *Furniture,* 1958, pp. 61–62, pls. 256–259, figs. 297–300.

173.

Pair of pedestals

> English: about 1775
> Carcase of pine, veneered with satinwood, mahogany, rosewood, and other woods
> 55 x 13 x 8 in. (140 x 33 x 20.3 cm.)
> 64.101.1054, 1055

The motif in the marquetry of interwoven strands of husks suspended from a tied ribbon is related to that in a drawing by John Linnell, dated 1778, for a pedestal (H. Hayward, *Furniture History,* V, 1969, pp. 74, 97, fig. 72). Another pair of pedestals (sold Sotheby's, 28 June 1974, lot 141, ill.) has been compared with this drawing, but the marquetry techniques of the two pairs are different and they do not appear to be from the same workshop. Musgrave notes that the ornament on 173 is typical of Robert Adam's middle period (Musgrave, 1966, p. 209).

REFERENCES: Untermyer *Furniture,* 1958, pl. 173, fig. 209a; C. Musgrave, *Adam and Hepplewhite and Other Neo-classical Furniture,* New York, 1966, pp. 142, 209, fig. 143.

Roentgen in their factory at Neuwied, Germany. However, a considerable stylistic difference exists between their elaborate pictorial marquetry and the panels of this cabinet, which are more simplified and combine the techniques of engraving and sand-scorching in a manner unrelated to the Roentgen's work. The apron and feet mounts are stock models frequently found on both English and French furniture of this period. The mount on the apron is somewhat large for the area and may be a later addition. A closely related writing cabinet from the same workshop is in an English private

174.

Doorway (one of a pair)

Probably designed by John Carr (1723–1807)
English: 1776
Door of mahogany; frame of pine painted gray, red,
 and blue and parcel-gilt
108 x 64 x 7 in. (274 x 162.5 x 17.8 cm.)
64.101.1213

Basildon Park in Berkshire was built in 1776 for Sir
Francis Sykes (1732–1804), Governor of Bengal, by
John Carr of York, who became the best-known
architect in the north of England. Like many of his
buildings, Basildon was in the Palladian tradition of
Lord Burlington and William Kent, with interior
decoration much influenced by the work of Robert
and James Adam. (For a summary of Carr's career
with bibliography and list of works, H. Colvin, *A
Biographical Dictionary of English Architects,* London,
1954, pp. 122–125.) The interior (including the
principal ceilings) was completed for a later owner,
James Morrison, by the architect J. B. Papworth in
1839–44. Before the house was demolished in 1930,
the plans, interior views, and details of doorways
and chimneypieces were published in *Architectural
Review,* LXVIII, September 1930, pp. 113–119,
where either this doorway or its mate is shown *in
situ* in the Dining Room (p. 116).

EX COLL. Sir Francis Sykes, Basildon Park, Pangbourne,
Berks.
REFERENCES: G. Richardson, *New Vitruvius Britannicus,* I,
1802, pls. 12–14; *Architectural Review,* LXVIII, Sep-
tember 1930, p. 116; Untermyer *Furniture,* 1958, p. 78,
pl. 337, fig. 387.

175.

Commode

English: about 1770–80
Carcase of pine; front and sides veneered with
 satinwood, kingwood, holly, rosewood, and other
 woods; drawer linings of oak; ormolu mounts;
 top of veined yellow marble
38 x 54 x 28 in. (96.5 x 137 x 71 cm.)
64.101.1145

Commodes with a single large marquetry panel on
the front are rare in English furniture of this period.
Access to the interior is gained by two marquetry-
decorated doors at the sides, each of which conceals
four mahogany drawers. The three marquetry pan-
els display the same distinctive technique; details are
rendered entirely by engraving, and the eccentricity
of the front, in both motifs and composition, sug-
gests the possibility of a Continental artist (though
not one working from the designs of Michelangelo
Pergolesi, as proposed by Mulliner). The only other
known example of the corner mounts on this com-
mode occurs on a pair of corner cupboards at
Burghley House in Northamptonshire, which to-
gether with a pair of commodes *en suite* were pro-
vided by the London firm of William Ince and John
Mayhew to the ninth Earl of Exeter in 1767–68 (H.
Hayward and E. Till, *Country Life,* CLIV, 7 June
1973, pp. 1605–1606, figs. 3–5). The commodes of
that set repeat the apron profile of 175, but because
they and the corner cupboards incorporate floral
marquetry taken from late seventeenth-century
Dutch or French cabinets previously in the house, a
comparison of the marquetry is pointless. Other
documented furniture from Ince and Mayhew fails
to show a consistent marquetry style, suggesting
that they may have acquired panels from independ-
ent marqueteurs. If the construction of 175 and the
Burghley pieces were found to be similar, an at-
tribution to Ince and Mayhew would be acceptable.
The fronts of a pair of commodes in the Philadel-
phia Museum of Art (1976–129–1, 2) display lions'

heads and draped swags closely related to the side panels of 175 and may prove to be from the same shop. On several occasions Ince and Mayhew obtained ormolu mounts from the firm of Boulton and Fothergill of Soho, Birmingham, most notably in 1774–75 for a cabinet made for the Duchess of Manchester (now in the Victoria and Albert Museum; N. Goodison, *Ormolu: The Work of Matthew Boulton,* London, 1974, pp. 133–134, pls. 52–59), but there is considerable difference between its jewellike quality and the good, though not exceptional, level of the corner mounts on 175.

EX COLL. First Lord Tweedmouth, Guisachan House, Inverness; Countess of Portsmouth, Hurstbourne Park, Whitchurch, Hants. (Christie's, 18 May 1922, lot 81, ill.); Col. H. H. Mulliner (Christie's, 10 July 1924, lot 70, ill.); Rufus Scott, New York.

EXHIBITED: Parke-Bernet, New York, 1942, *French and English Art Treasures of the XVIII Century,* no. 560.

REFERENCES: M. Jourdain, *English Decoration and Furniture of the Later XVIII Century,* London, 1922, pp. 193, 194A, fig. 303A; Mulliner, 1924, fig. 52; Untermyer *Furniture,* 1958, p. 69, pl. 284, fig. 326; D. Molesworth in *Great Private Collections,* ed. D. Cooper, New York, 1963, p. 140.

176.

Commode

> English: about 1770–80
> Carcase of pine veneered with harewood, crossbanded with rosewood; with oval panels of satinwood inlaid with sprays of flowers in tinted and engraved fruitwoods; drawer with compartments of mahogany; drawer lock with scratched initials WB-N
> 33½ x 39 x 22¾ in. (85 x 99 x 57.8 cm.)
> 1974.28.6

The drawer in the frieze contains a baize-lined slide beneath which are numerous compartments for writing materials. The area behind the two doors is divided into three by a central partition and a single shelf on the left. On the doors and top are floral sprays tied with a ribbon; these are similar in both

technique and composition to those on a group of commodes attributed to John Cobb (P. Thornton and W. Rieder, *Connoisseur,* CLXXIX, 1972, pp. 32, 34 note 16). However, all of these are *bombé* commodes in the French taste, with legs that continue the curve of the front corners (the legs of 176 are of a most unusual shape for furniture of this period), and none has a drawer at the top. Draped marquetry festoons create a trompe l'oeil effect as they pass before and behind the panel borders on the front of the drawer. Plugged holes on both sides indicate the former presence of handles.

177.

Cellaret (one of a pair)

> English: about 1780
> Mahogany and mahogany veneer; ormolu mounts
> 28 x 19 x 19 in. (71 x 48.2 x 48.2 cm.)
> 64.101.891

A cellaret of almost identical form, with rams' heads rather than anthemion mounts at the tops of the legs, was formerly at Balls Park, Hertford (*Country Life,* XXXI, 20 April 1912, p. 584, ill.).

EX COLL. Alfred H. Caspary, New York (Parke-Bernet, 30 April 1955, lot 276, ill.).

REFERENCE: Untermyer *Furniture,* 1958, pp. 15–16, pl. 29, fig. 49.

178.

Commode

English: about 1780

Carcase of pine and mahogany veneered with satin-
wood, harewood, tulip, and other woods; top
inlaid with these and mother of pearl and deco-
rated with twelve painted circular medallions;
front with a painted oval panel surrounded by a
parquetry ground; the whole with ormolu
mounts

32 x 80½ x 24 in. (81.3 x 204 x 61 cm.)

64.101.1152

The large central door, hinged on the right, opens
to reveal two shelves. Above them in the frieze is a
single drawer of the same width. There is no access
to either side compartment. All the ormolu mounts
on this English piece in the French taste are varia-
tions on those used by such Parisian *ébénistes* as
Jean-Henri Riesener, Martin Carlin, and Roger
Vandercruse; however, both their modeling and
gilding indicate English manufacture. The par-
quetry further establishes the overall French char-
acter. The oval painting of three nymphs adorning a
statue of Pan has been thought to derive from a
composition by Angelica Kauffmann, although a
specific source has not been found. This commode
suggested to Macquoid the work of the London
cabinetmaker George Seddon, an attribution un-
supported by subsequent research.

EX COLL. Hopkins, England; Patrick A. Valentine,
Chicago.

EXHIBITED: London, 1908, *The Franco-British Exhibition;*
Plaza Hotel, New York, 1910, *Furniture of Thomas
Chippendale,* no. 53.

REFERENCES: Macquoid, *Satinwood,* 1908, p. 181, figs.
162, 163; H. C. Marillier in *The Franco-British Exhibi-
tion Illustrated Review,* London, 1908, pp. 256–258; *The
Furniture of Thomas Chippendale,* Partridge, Lewis, and
Simmons, London [about 1910], no. 53, pls. XXVII,
XXVIIA; Untermyer *Furniture,* 1958, pp. 70–71, pls.
290, 291, figs. 332, 333.

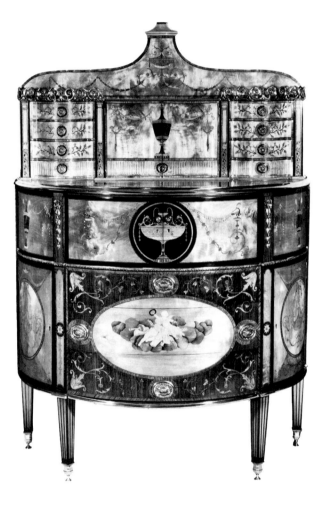

179.

Desk-cabinet

English: about 1785

Pine carcase veneered with satinwood, sycamore,
and rosewood; drawer linings of mahogany

70 x 47 x 24 in. (178 x 119.5 x 61 cm.)

64.101.1151

The two doors of the upper section conceal a fitted interior of pigeonholes and a drawer; the two doors in the curved central area slide apart to reveal a fitted writing compartment that slides forward. One of three very similar inlaid cabinets, all made in the same London workshop, maker unknown. One is at Luton Hoo (collection of Lady Zia Wernher), the other in a United States private collection (formerly J. Pierpont Morgan; Mrs. Charles Hirschhorn, New York [Parke-Bernet, 6 November 1971, lot 192, cover and pl. XLVII]). The oval panel of winged putti reclining on clouds, representing "La Poésie," derives from a composition by Boucher engraved by Gabriel Huquier. Stylistically related secretaries and cabinets were produced in both the eighteenth and nineteenth centuries; one of the cabinets is in the Victoria and Albert Museum (M. Tomlin, *English Furniture*, London, 1972, fig. 208).

EX COLL. Mrs. Eric Petterson (Sotheby's, 6 March 1964, lot 165, ill.).

EXHIBITED: Grosvenor House, London, 1953, *Antique Dealers' Fair*.

REFERENCES: F. S. Robinson, *English Furniture*, London, 1905, pl. CXLIX; T. P. Greig, *Connoisseur*, CXIII, 1944, p. 66; *Connoisseur*, CXXXVI, 1955, p. 146, fig. 5; E. H. Pinto, *Antique Collector*, XXVIII, 1957, pp. 193–196, figs. 1A, 1B; R. Fastnedge, *Sheraton Furniture*, London, 1962, p. 106, fig. 72; G. de Bellaigue, *Burlington Magazine*, CVII, May 1965, p. 249, note 42; I. Ickeringill, *New York Times*, 22 August 1968, p. 43, col. 1.

180.

Pair of candlestands

English: about 1780–90
Basswood with oval glass globes; ormolu mounts
48 x 18½ x 16 in. (122 x 47 x 40.6 cm.)
64.101.1058a, b; 1059a, b

One side of each base has been left uncarved, indicating that these were intended to stand in niches or against a wall, probably on triangular pedestals. The pale gray and light blue colors appear to be original. At the top, ormolu rams' heads and pendant festoons echo those carved in the center. The presence of

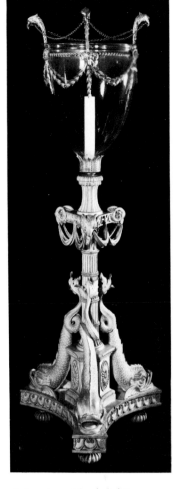

griffins' heads and rams' heads with dolphins suggests that the dolphins do not have specific symbolic significance. These motifs are similarly treated in the work of Robert Adam.

REFERENCE: Untermyer *Furniture*, 1958, p. 43, pl. 175, fig. 211.

181.

Secretary-bookcase

English: about 1790
Pine carcase with mahogany and satinwood veneer, bordered with lines of tulipwood and ebony; drawers of mahogany; eight panels on fronts and outer sides of four small pedestals at the top of lacquered glass simulating lapis lazuli
85¾ x 43½ x 22³⁄₁₆ in. (218 x 110.5 x 65 cm.)
56.169a, b

The drawer in the center constitutes a secretary; its front, which is hinged at the bottom, falls down to form the writing surface, revealing at the back small drawers and compartments. The lock, inscribed I BRAMAH, was made by the Yorkshire locksmith Joseph Bramah (1749–1814). Secretary-bookcases of similar form, varying in detail, were published by both A. Hepplewhite & Co. (*Cabinet-maker and Upholsterer's Guide,* London, 1788, pls. 42–44) and Thomas Sheraton (*Cabinet-maker and Upholsterer's Drawing-book,* London, 1793, pl. 28). The three grisaille figures on the center bookcase drawer represent Fortitude (the lion at her feet has been overpainted), Justice, and Temperance. They appear to have been made from engravings by John Boydell, published in 1782, of the West Window of the Chapel at New College, Oxford, the composition of which was based on oil sketches produced by Sir Joshua Reynolds between 1777 and 1780. The decoration of curved pediment and flanking spandrels was taken, somewhat eclectically, from Mi-

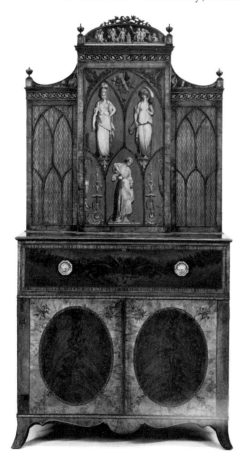

chelangelo Pergolesi's *Designs for Various Ornaments* (published as loose sheets, 1777–1801): the central four putti and goat from pl. LXXX, dated 1779, after a design by Giovanni Battista Cipriani; the remaining figures in the pediment were copied from the left and right sides of pl. XXX, dated 1780. The figures on the spandrels were adapted from pls. CLXXVII and CLXXXI, both dated 1781, to become emblematic of Science and Art. Pergolesi included numerous designs for bands of ornament; the band that runs along the front and sides at the top of the bookcase was derived from his pl. XLVI of 1778. A secretary-bookcase of similar form and dimensions, with glazed doors in the upper section, was sold at Parke-Bernet, 22 September 1972, lot 160, ill., catalogued as "George III style."

EX COLL. H. H. Mulliner; Viscount Leverhulme, London; Genevieve Garvan Brady, Manhasset, N.Y.

REFERENCES: M. Jourdain, *English Decoration and Furniture of the Later XVIII Century,* London, 1922, pp. 194B-195, fig. 303B; Mulliner, 1924, fig. 31; *Good Furniture Magazine,* June 1927, p. 122; H. Cescinsky and G. L. Hunter, *English and American Furniture,* Grand Rapids, Mich., 1929, p. 238; *DEF,* 1954, I, pp. 151, 153–154, fig. 68 (mistakenly said to be in the Lady Lever Art Gallery, Port Sunlight, Ches.); Untermyer *Furniture,* 1958, pp. 62–63, pl. 263, fig. 305.

182.

Dressing table

English: about 1790
Satinwood, mahogany, and rosewood veneer with painted decoration; silver and silver-plate mounts
30¾ x 21½ x 16½ in. (78 x 54.6 x 42 cm.)
64.101.1087

Beneath the hinged top is a large oval compartment lined with pleated silk, surrounded by numerous smaller compartments, several of which contain glass bottles and stops and ivory containers. Behind the two front doors are two drawers and four false drawer fronts. This was originally a dressing table (similar fittings are seen in two designs by Thomas Sheraton in his *Cabinet Dictionary,* London, 1803, II, pls. 40, 69) with an oval basin and a mirror attached

to the underside of the top. It appears to have been converted to a work table in the late nineteenth century, when the silk lining was added and mirror removed, leaving ratchet slots and several plugged holes indicated its position. When exhibited in 1937 the painted panels were attributed to Angelica Kauffman, but they are not related to her style and remain anonymous. The top and shelf between the legs are decorated with painted and inlaid Prince of Wales feathers. Marillier stated in 1908 (possibly because of this motif) that the table belonged to Princess Charlotte of Wales (1796–1817), daughter of George IV, but a search of her accounts as preserved in the Royal Archives has failed to identify the table, and it has no royal inventory or brand marks.

EX COLL. F. Hay-Newton; Mrs. K. Marlow (Christie's, 29 June 1937, lot 114, ill.); J. M. Botibol, London.

EXHIBITED: London, 1908, *The Franco-British Exhibition;* Grosvenor House, London, 1937, *The Fourth Antique Dealers' Fair,* p. 28, ill.

REFERENCES: H. C. Marillier in *The Franco-British Exhibition Illustrated Review,* London, 1908, p. 251; Untermyer *Furniture,* 1958, p. 49, pl. 204, fig. 242.

183.

Armchair (one of a pair)

English: about 1800
West Indian satinwood; seat rails of beech; seat
 covered in modern satin brocade
37¾ x 25½ x 21¾ in. (96 x 65 x 55.3 cm.)
64.101.996

The maker derived the design of the splat from Thomas Sheraton's *Cabinet-maker and Upholsterer's Drawing-book* (London, 1793, pl. 25), disregarding Sheraton's intention that the decoration be painted rather than carved, and using a shield-shaped back rather than the square back of the design. The use of rams' heads at the base of the armrests, not derived from Sheraton, is exceptional in English chairs of this period. These and other features, such as the back supports curving smoothly outward at the base and the canted rear legs with moldings at the top, result in a design of considerable originality. A

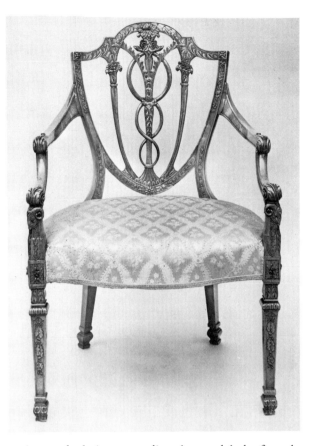

satinwood chair more directly modeled after the Sheraton design was once in the Scholfield collection (Macquoid, *Satinwood,* 1908, pl. VII).

EX COLL. John Hale, Manchester, England.

EXHIBITED: Parke-Bernet, New York, 1942, *French and English Art Treasures of the XVIII Century,* no. 496.

REFERENCES: Untermyer *Furniture,* 1958, p. 33, pls. 128–130, figs. 157–159; Y. Hackenbroch, *Antiques,* LXXIV, pp. 231–232, figs. 17, 18.

184.

Table

French: second quarter 17th century
Oak
33 x 102 x 33¾ in. (84 x 260 x 85.7 cm.)
1974.28.21

This was once thought to have been made in England about 1600, but the slender proportions of the columnar supports, the acorn pendants, and the

small scroll brackets suggest a French craftsman working slightly later. The simplicity of the decoration and use of angle braces at the ends to strengthen the base indicate a provincial, rather than Parisian, origin. Such elements as the central arcade, turned pendants, and scroll brackets also occur in designs for tables in Dutch pattern books of this period, for example in Paul Vredeman de Vries' *Verscheyden Schrynwerck*, Amsterdam, 1630 (S. Jervis, *Printed Furniture Designs before 1650*, London, 1974, pl. 352), but these engravings show tables more heavily proportioned and elaborately decorated.

185.

Mirror

Johannes Hannart
North Netherlandish: about 1680–1700
Boxwood and ebony; modern glass
Signed: Joh Hanat (beneath foot of left putto on
 oval plaque at base)
66 x 39 in. (167.7 x 99 cm.)
64.101.1223

The sculptor Johannes Hannart (or Jan Hanat) was born in Hamburg, became a master in 1683, and worked in Leyden and The Hague, where he died in 1709. The coat of arms (quarterly, 1 and 4, a sheep passant gardant, 2 and 3, three swans dismembered, two and one—no evidence of tinctures), formerly identified as that of the Courtaillon de Montdoré of Lorraine, quarterly with that of the Van Swanenburgh family of Leyden, is now being restudied. This frame is one of a pair intended for marriage portraits; the relief at the base of putti adorning a

sheep with a wreath and laurel garland has both a festive and armorial reference. The unsigned pendant, in the Rijksmuseum, Amsterdam (*Catalogus van Meubelen*, 1952, no. 342; *Album Rijksmuseum Amsterdam: 256 Meesterwerken*, n.d., no. 219, ill.), has, in place of the arms, a cipher once read as ACC. Similar carving and treatment of motifs, such as the leafage flanking a coronet, are found on a frame by Hannart surrounding a group portrait by Jan de Baen of magistrates from The Hague, 1682, in the collection of the Haags Gemeentemuseum.

EXHIBITED: British Antique Dealers' Association, Christie's, London, 1932, *Art Treasures Exhibition*, p. 19, no. 92.

REFERENCES: *Apollo*, XVI, 1932, p. 186; *Antique Collector*, VII, 1936, p. 193; *Catalogus van Meubelen*, Rijksmuseum, Amsterdam, 1952, pp. 262–263, no. 342; Untermyer *Furniture*, 1958, p. 79, pls. 344, 345, figs. 397–399.

PORCELAIN, FAIENCE, AND ENAMEL

The entries are by
YVONNE HACKENBROCH,
Consultative Curator, Department of Western European Arts.

Numbers 186–242 are grouped according to the starting dates of the factories producing hard-paste porcelain. These are followed by examples of soft-paste porcelain, faience, and a group of Berlin enamels, 243–252. Then follow English porcelains, 253–277, again grouped according to the starting dates of the factories.

Abbreviations

Untermyer *Meissen,* 1956 Y. Hackenbroch, *Meissen and Other Continental Porcelain, Faience, and Enamel in the Irwin Untermyer Collection,* Cambridge, Mass., 1956

Untermyer *Chelsea,* 1957 ————, *Chelsea and Other English Porcelain, Pottery, and Enamel in the Irwin Untermyer Collection,* Cambridge, Mass., 1957

186.

Pantaloon

German (Meissen): about 1710
Red Boettger ware
Unmarked
H. 8 in. (20.3 cm.)
64.101.86

The first attempt at original sculpture at Meissen, following the series of Chinese deities cast from blanc de chine figures in the Dresden collections, was a series of six Italian comedy figures in red Boettger ware. Their hands and faces are mat, their caps and gowns highly polished. The first of the series, Pantaloon, in typical pose, recalls an engraving by or after Jacques Callot. The other figures are more inventive and have cold color decoration (applied without a second firing), a somewhat later

process. This traditional representation of the long-nosed, long-legged Pantaloon was probably not modeled by a local sculptor working at the Saxon court, even though one such, Paul Heerman, was paid, 1 October 1708, for three theatrical figures.

EX COLL. Rothberger, Vienna.
EXHIBITED: The Metropolitan Museum of Art, New York, 1949, *Masterpieces of European Porcelain*, no. 262.
REFERENCES: Untermyer *Meissen*, 1956, pl. 43, fig. 63; see also G. Rudloff-Hille and H. Rakebrand, *Keramos*, 36, 1967, p. 17, note 28, figs. 7, 8 (similar example in the Schlossmuseum, Gotha).

187.

Two dwarfs

German (Meissen): 1715–19
Boettger porcelain
Unmarked
H. 5, 6 in. (12.7, 15.3 cm.)
64.101.122, 123

So-called Callot dwarfs were favorite subjects of early Meissen modelers as they sought alternatives for the repetitious Chinese deities and pagoda figures after blanc de chine models. Originally made of silver or gold and incorporating baroque pearls as parts of their quaint bodies, the dwarfs had been favorite *Kunstkammer* items, occuring in such selections as the Grünes Gewölbe in Dresden. Following the prevailing fashion, porcelain modelers used the reinventions after Jacques Callot's *Varie Figure Gobbi,* Florence, 1622. These were published in Amsterdam in 1716 (with Dutch and French captions), and appeared about the same time in Germany (with German captions). Both of our figures occur in these editions, one named Madame Palatinella, the other Nicolò Cantabella. In porcelain they are sparingly colored but show much gilding. The high, rectangular bases with chamfered corners are of the kind often seen carved in wood or ivory.

EX COLL. Robert von Hirsch, Basel.
REFERENCE: Untermyer *Meissen*, 1956, pl. 68, fig. 97.

188.

Pair of vases

German (Meissen): 1715–19
Boettger porcelain
Unmarked
H. 8⅝, 8⅜ in. (21.9, 21.3 cm.)
64.101.145, 146

These illustrate that fleeting moment in the history of the Meissen factory when models were furnished by a silversmith and outside decoration was executed by a glass painter. The gilt-applied foliage decoration and female maskaroons are in the style and technique of the Dresden silversmith J. J. Irminger. Invited by Augustus the Strong in 1710 to design porcelain wares, Irminger introduced shapes that emulate those he had used for silver. He probably also suggested the gilding that simulates applied decoration in precious metal, unaware as yet of the innate possibilities of porcelain. We may assume that these vases, only parcel gilt, were not immediately sold. Tides of fashion moved swiftly in the newly founded Meissen factory, and undecorated, out-of-date models were sold to outside decorators, or *Hausmaler.* The *schwarzlot* on our vases, a black camaïeu decoration touched with gilding, is in the style of Ignaz Preissler (1676–1729) or a member of his immediate family, Dutch artists active in Silesia. The decoration of naval engagements is of the kind frequently shown in Dutch paintings and engravings.

EXHIBITED: The Metropolitan Museum of Art, New York, 1949, *Masterpieces of European Porcelain,* no. 357.
REFERENCE: Untermyer *Meissen,* 1956, pl. 69, fig. 113.

189.

Set of three bottles

German (Meissen): about 1720
Hard-paste porcelain
Unmarked
Decorated in workshop of Johann Auffenwerth
H. 9¾, 7¼ in. (24.8, 18.5 cm.)
1974.28.126–128

These *Bouteillen,* as they are called in the Meissen records, are among the earliest porcelains made after

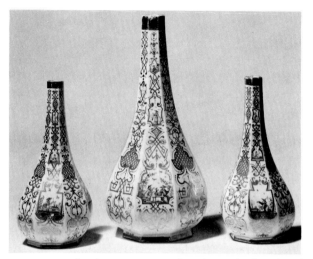

Boettger's death in 1719. The shape had existed earlier, and the bottles, initially made in brown Boettger ware, were left plain or had relief decoration. They were subsequently made in white Boettger porcelain and painted with oriental motifs. This set, one of the finest, was apparently sold off in white as out-of-date merchandise about ten years after it was made. It was decorated in the workshop of the independent Augsburg *Hausmaler* Johann Auffenwerth and his daughters Elisabeth and Sabine. The chinoiserie scenes within strapwork were based on the inventions of Augsburg ornamental engravers, such as those in J. J. Baumgartner's *Gantz Neu Inventiertes Laub und Bandelwerck* (Augsburg, 1727, 1730). The Auffenwerth palette included iron red, purple, and gold. It is difficult if not impossible to identify the different hands who painted such pieces, since the initials, when there are such, are usually well concealed. All these painters used the same patternbooks, including the chinoiseries published by Martin Engelbrecht.

EX COLL. Felix Kramarsky (Parke-Bernet, 9 January 1959, lot 598, ill.).

190.

Pair of ospreys mounted on ormolu

German (Meissen): 1720–25; ormolu French (Paris): about 1750
Hard-paste porcelain
Mark: crossed swords in underglaze blue (on each bird)
H. 12¾ in. (32.4 cm.)
64.101.18, 19

Early Meissen models feature individual figures. Their self-contained appearance and simplicity of outline remind us that initially most of the designers were trained in the carving of boxwood or ivory. Complex groups, such as these splendid ospreys on rockery, their plumage streaked with gilding, were often composites. The ormolu mounts of undulating rocaille design support the birds and their melon-shaped vases with elegant ease. The groups were ideally suited as ornaments for a mantel; their outlines may have been devised to harmonize with those of ormolu firedogs of a similar rocaille pattern.

EX COLL. Baron Ferdinand von Rothschild, London; Baronin Mathilde von Goldschmidt-Rothschild, Frankfort; Baron Erich von Goldschmidt-Rothschild, Berlin (Hermann Ball & Paul Graupe, Berlin, 16–21 March 1931, lot 198, pl. 48); Lionel de Rothschild, London (Christie's, 4 March 1946, lot 198).

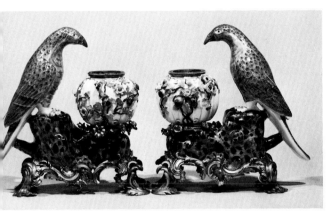

EXHIBITED: The Metropolitan Museum of Art, New York, 1949, *Masterpieces of European Porcelain,* no. 270 (one).

REFERENCE: Untermyer *Meissen,* 1956, color pl. 11, fig. 11.

191.

Bowl with turquoise ground

German (Meissen): about 1725
Hard-paste porcelain
Marks: crossed swords in underglaze blue; N-47.6 / W
incised and filled in black: inventory number of the Johanneum

D. 9 in. (22.8 cm.)
64.101.164

The development of ground colors and new shapes for them was the principal pursuit of Johann Gregorius Höroldt (1696–1775) during his early years at Meissen. Although Augustus the Strong was pleased with Höroldt's achievements, he preferred a more sparing use of color that showed the brilliant white glaze of Saxon porcelain to better advantage. 191 reflects the king's suggestion that modelers carefully study the Chinese and Japanese porcelain in his collections. Because it bears Augustus' inventory number for Meissen porcelain—the Johanneum mark—it can be traced back to early inventories, for one, the unpublished "Inventarien vom Chur Fürstl. Sächsischen Holländischen Palais zu Neustadt bey Dresden und zwar über Das Sächsische Porzellan," 1779, II, in which it figures among "Bowls, green with white reserves bordered in gold, with flowers, birds, and landscapes; inside, however, are small occasional flowers."

REFERENCE: Untermyer *Meissen,* 1956, pl. 81, fig. 121.

192.

Teapot

German (Meissen): about 1725
Hard-paste porcelain
Unmarked
Decorator: Abraham Seuter, Augsburg, about 1740
H. 4½ in. (11.4 cm.)
1974.28.122a, b

With its painted reserves and burnished gold ground, part of one of the most splendid Meissen services decorated by Augsburg *Hausmaler.* Until its dispersal in 1963, the service was complete, in its original case with a royal crown. Whether that crown represented Saxony-Poland or the Two Sicilies is uncertain, but the service was probably a present for Maria Amalia Christina of Saxony, daughter of Augustus the Strong, who married King Charles III of the Two Sicilies in 1738. The service was subsequently owned by Prince Murat, viceroy of Naples. In 1728, the Meissen authorities curtailed the sale of white porcelain to *Hausmaler,* as reported by Johann Georg Keyssler in 1730: "For a

year and a half it has been prohibited to sell entirely white porcelain, in order to earn in our country such profits as foreign artists make with gilding and decorating; to be able to do so, forty painters are being employed" (O. Walcha, *Meissner Porzellan*, Dresden, 1973, p. 166). The service of 192 is decorated with scenes from Molière as engraved by Gerard van der Gucht after drawings by Charles Antoine Coypel, published in French and English editions of the plays. The scenes on 192 are composites from the London edition by John Watts, 1739.

REFERENCES: H. Morley-Fletcher, *Meissen*, London, 1971, p. 100, color ill.; S. Ducret, *Meissner Porzellan bemalt in Augsburg, 1718 bis um 1750*, Brunswick, 1972, II, pp. 25–26, figs. 258, 262.

193.

Set of three covered vases

German (Meissen): about 1725
Hard-paste porcelain
Mark: crossed swords in overglaze blue
H. 12¼, 9½ in. (31.2, 24.2 cm.)
64.101.153a, b, 154a, b, 155a, b

Only a few examples of clair de lune (light blue) Meissen porcelain are known. They include two slender beaker vases in the Rijksmuseum, Amsterdam, that may have belonged to the present set, and a large tankard in Dresden, with the profile portrait

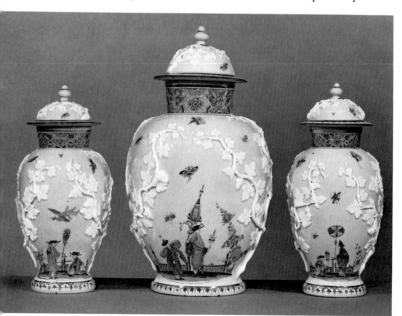

of Augustus the Strong in white relief. Although no documentation survives to explain the origin of this light blue paste, we tend to associate its discovery with the search for underglaze blue, conducted by David Köhler until his death in 1725. His experiments to prevent the blue from running during the firing could at one time have suggested a coloring of the entire paste. The vivid Kakiemon decoration of our set, with its branching grapevine in white relief, harmonizes with the colored porcelain.

EXHIBITED: The Metropolitan Museum of Art, New York, 1949, *Masterpieces of European Porcelain*, no. 334.
REFERENCE: Untermyer *Meissen*, 1956, color pl. 85, fig. 117.

194.

Pair of turtle-shaped boxes

German (Meissen): 1725–27
Hard-paste porcelain
Mark: crossed swords in underglaze blue (on each turtle)
L. 6⅛ in. (15.5 cm.)
64.101.171a, b, 172a, b

Such curious-looking turtles were popular with early porcelain and faience modelers, who intended them as containers to serve turtle broth or paté, yet in the Meissen records between 12 November and 19 December 1729 some are listed as butter dishes. They had a considerable tradition as *Kunstkammer* items, where the carapace was usually polished and mounted in precious or semiprecious material. The carapaces of these porcelain models were probably cast from life. The innate mystique of the creatures has been intensified by the use of bright colors, including the iridescent luster typical of the early Meissen palette.

REFERENCE: Untermyer *Meissen*, 1956, pl. 10, fig. 127.

195.

Pair of beaker vases with black ground

German (Meissen): 1725–30
Hard-paste porcelain
Mark: AR in underglaze blue; two dots in underglaze at rim of base (one each base)

Decorator: Johann Gregorius Höroldt
H. 11¼ in. (28.6 cm.)
64.101.133, 134

The popularity of large Chinese and Japanese vases, given impetus by the ornamental engravings of Daniel Marot, Jean Mariette, and Gilles Oppenort depicting vases in porcelain cabinets or as garnitures de cheminée, led to their imitation by Europeans in faience or silver. After porcelain was invented at Meissen, Augustus the Strong, already a collector of oriental vases, ordered similar sets from the new factory. From about 1723 until his death in 1733, most porcelain made for Augustus bore his AR mark. Höroldt arrived in Meissen from Vienna in 1720 and was appointed court painter in 1723. He experimented with various ground colors, including black, eventually achieving brilliant results. The gold decoration, despite S. Ducret's and W. de Sager's recent arguments that it was added by Abraham Seuter in Augsburg, is by Höroldt or his immediate circle, as stated in Untermyer *Meissen,* p. 121. To the best of our knowledge, only white porcelain was ever sold to dealers or *Hausmaler;* in any case, it is unlikely that porcelain bearing Augustus' AR mark would be sold. Although similar chinoiserie designs were used by Augsburg decorators, they were derived from Höroldt's own engraved designs. Stylistically, the sprawling gold and colored decorations on white grounds of the *Hausmaler* are unlike the more restrained decorations of the factory workers, who tended to complement the rare ground colors.

EX COLL. Count Tozzitta, Paris.
REFERENCES: Untermyer *Meissen,* 1956, pls. 70, 71, fig. 107; S. Ducret, *Meissner Porzellan bemalt in Augsburg, 1718 bis um 1750,* Brunswick, 1971, I, pl. 21, fig. 82; W. de Sager, *Antique Collector,* XXXXIII, 1972, pp. 240–248, fig. 10.

196.

Teapot

J. G. Kirchner
German (Meissen): about 1727
Hard-paste porcelain
Unidentified lustermark
Decorated in workshop of Johann Auffenwerth

H. 6⅜ in. (16.3 cm.)
1970.277.5

This grotesque form, a departure from Chinese prototypes, derives from an engraving after Jacques Stella (1596–1657) in *Livres de vases* (Paris, 1667). The handle, the spreading escallop-shaped base, the tight-fitting cover, and the dripless spout convert a seventeenth-century jug into a serviceable eighteenth-century teapot. Kirchner, a modeler at Meissen 1727–28 and then a master modeler 1730–31, took other designs from Stella for Augustus the Strong's monumental grotesque vases, made soon after 1727, at the height of the baroque style in

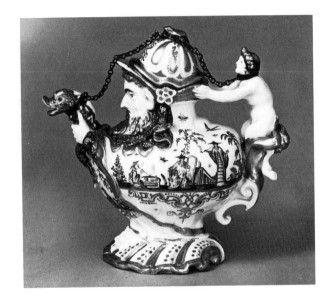

Germany. His teapot must have enjoyed considerable success, for a number of models have survived, including one decorated with *Goldchinesen* in the Metropolitan Museum (50.211.147a, b). 196 has the faint iridescent *Lüstermarke* sometimes found on early pieces, possibly referring to its distribution or sale. The heart-shaped mark containing the initials $\frac{PA}{B}$ is unrecorded. It cannot be that of a painter or decorator, since their rare signatures are always in one of the colors used on the piece. Nor can it be the mark of a goldworker, since their control numbers are always in gold. The generous use of gold identifies this as an early work.

EX COLL. Princess Schwarzburg-Sondershausen.
REFERENCE: Y. Hackenbroch, *Connoisseur,* CLXXVI, 1971, p. 266, fig. 2.

197.

Birds of paradise mounted on ormolu

J. J. Kaendler (1706–75)
German (Meissen): 1733
Hard-paste porcelain
Visible marks: crossed swords in underglaze blue at
rear of one, $\frac{No-315}{W}$ in black at base of other:
inventory number of the Johanneum
H. 11 in. (28 cm.)
64.101.25, 26

Kaendler modeled these after stuffed specimens in the Elector's collection, describing one in his working reports of January 1733 as "yet another small bird, the size of a finch, has 2 large wings and 2 small ones, a long beak, and the tail consists of 2 long feathers which change into a double ring at the end." Our two were once in the Elector's collection, housed originally in the Holländische Palais, later transferred to the Johanneum. The unpublished "Inventarien" of 1779 (II, no. 318) mentions "Four colorful birds of Paradise, upon high, decorated pedestals, all with damages."

EX COLL. Drach, Vienna.
EXHIBITED: The Metropolitan Museum of Art, New York, 1949, *Masterpieces of European Porcelain,* no. 271.
REFERENCES: *Sammlung für Kunst und Wissenschaft, Porzellan, Meissen . . . aus den sächsischen Staatsammlungen,* sale cat., Rudolph Lepke, Dresden, 7–8 October 1919, lots 115, 116, ill.; Untermyer *Meissen,* 1956, color pl. 12, fig. 15.

198.

Pair of vases with white ground

German (Meissen): 1734–36
Hard-paste porcelain
Mark: crossed swords in underglaze blue (on one vase)
Decorator: attributed to Adam Friedrich von Löwenfinck
H. 18, 18½ in (45.8, 47 cm.)
64.101.159, 160

Their shape derived from K'ang Hsi prototypes,

these are decorated in exotic and Kakiemon themes in the style of Löwenfinck (1714–54), who was apprenticed as a painter in 1727, specialized in "bunden Blumen" in 1731, and became a master in 1734. He fled Meissen in 1736 after disagreements, including his refusal to submit to Höroldt's style. His subsequent occasional signatures help to identify his early Meissen work. The compositions here are based, at least in part, on designs by Petrus Schenk the Younger, no. 34 in the Dresden Print Room.

REFERENCES: Untermyer *Meissen,* 1956, color pl. 64, fig. 114; A. L. Den Blaauwen, *Bulletin van het Rijksmuseum,* 12, no. 2, 1964, pp. 35–49 (reprinted in *Keramos,* 31, 1966, pp. 3–13).

199.

Golden orioles (pirols)

J. J. Kaendler, J. G. Ehder, and P. Reinicke
German (Meissen): 1734–40
Hard-paste porcelain
Marks: crossed swords in blue (on one bird); $\frac{N-315}{W}$ incised and filled in black: inventory mark of the Johanneum (on both birds)
H. 12 in. (30.5 cm.)
64.101.9, 10

The contrast between the brilliant yellow plumage and black wing and tail feathers is the outstanding feature here. The birds are first mentioned in Kaendler's working records of July 1733: "A medium-sized bird called golden oriole, mounted on a pedestal." Ehder's report of January 1740 cites "A golden oriole prepared in clay." Another example bearing the same inventory mark is in the Metropolitan Museum (1974.356.330).

REFERENCES: *Sammlung für Kunst und Wissenschaft, Porzellan, Meissen . . . aus den sächsischen Staatsammlungen,* sale cat., Rudolph Lepke, Dresden, 12–14 October 1920, lot 175; Untermyer *Meissen,* 1956, color pl. 6, fig. 5.

200.

Teapot in form of monkey with young

J. J. Kaendler

German (Meissen): 1735
Hard-paste porcelain
Unmarked
H. 7½ in. (19 cm.)
64.101.200

The form, with one small monkey serving as the spout, the other as the handle, was an ideal one for Kaendler to show his ability at naturalistic representation and his flair for the grotesque. The piece appears in his working records of May 1735: "A teapot in the form of a monkey, holding a young one on its back and another in its hands, from which the tea flows, modified and given its final shape, seated on a small plinth to which it is chained with a chain and padlock."

REFERENCE: Untermyer *Meissen,* 1956, pl. 91, fig. 146.

201.

Chinese and bird

J. J. Kaendler
German (Meissen): about 1735
Hard-paste porcelain
Mark: small crossed swords in underglaze blue, at back of base
L. 9¼ in. (23.5 cm.)
64.101.42

On the basis of its naive and fanciful quality, this has been consistently dated too early and attributed, for no obvious reason, to one of the earliest known

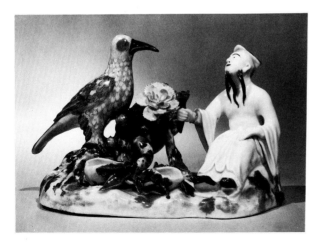

modelers at Meissen, Georg Fritzsche (1691–1727). Its present attribution to Kaendler is based on the description in his May 1735 working records of a similar group. The seated Chinese is intentionally somewhat stiff, in the manner of blanc de chine figures. The large bird perched on the flowering tree trunk identifies this as from Kaendler's early period, when he created his series of colorful birds.

REFERENCE: Untermyer *Meissen,* 1956, color pl. 19, fig. 24.

202.

Oriental seated in a bower

J. J. Kaendler
German (Meissen): about 1735
Hard-paste porcelain
Mark: crossed swords in underglaze blue, at back of base
H. 15¾ in. (40 cm.)
64.101.41

This and several comparable compositions, all of which include one or two somewhat primitive-looking Orientals, have hitherto been considered to be the work of Georg Fritzsche, one of the earliest modelers at Meissen. First mentioned in 1712 as an apprentice, "a Junge," his activities extended until about 1732. However, a description in Kaendler's working report of May 1735 matches an example sold recently in London as a work by J. G. Kirchner (Christie's, 2 December 1974, lot 208, color pl. opp.) now in the Victoria and Albert Museum: "An Indian arbor grown with many branches and large flowers, of such a kind that all sorts of sweetmeats can be placed in it and near the throne. . . . With it two figures fashioned in the Japanese manner, a man and a woman who are placed in the thrones and both figures are shown as they hold a shell on the head and one on the lap, on which likewise the sweetmeat could easily be placed." Accordingly, this entire group must now be given to Kaendler, about 1735.

EX COLL. Louis Jay, Frankfort; Richard Merton, Frankfort.

EXHIBITED: The Metropolitan Museum of Art, New York, 1949, *Masterpieces of European Porcelain*, no. 245.
REFERENCE: Untermyer *Meissen*, 1956, color pl. 13, fig. 23.

203.

Columbine and Pantaloon

J. J. Kaendler
German (Meissen): 1736
Hard-paste porcelain
Mark: crossed swords in blue
H. 6¼ in. (15.9 cm.)
64.101.92

Kaendler modeled this group again in 1741 (215). In this first model the mocking Columbine, in fashionable dress, was intended to hold a hand-mirror to Pantaloon's face, revealing his ugliness to him. The irregular slab base, left plain here, is adorned with flowers and foliage in the later model, and the costumes there are more extensively decorated with gold.

REFERENCE: Untermyer *Meissen*, 1956, pl. 50, fig. 69.

204.

The Thrown Kiss

J. J. Kaendler
German (Meissen): 1736
Hard-paste porcelain
Mark: crossed swords in underglaze blue (on lady)
H. 5⅝, 5½ in. (14.2, 14 cm.)
64.101.47, 48

The lady is Kaendler's earliest crinoline figure, and it is his joy of discovering porcelain as the brilliant material in which to portray fashionable society that enhances these examples. Both figures are found in Kaendler's working records for December 1736: "Yet another figure made for stock, in a loose over-blouse, holding a fan in her hands, and a gentleman, dressed up in his fur housecoat, approaching to speak into her ear." The figures are modeled after an engraving by Pierre Filloeul, *Le Baiser rendu,* based on a painting by Jean Baptiste Pater, and published in *Suite d'estampes nouvelles pour les contes*

de La Fontaine . . . (Nicolas de Larmessin, Paris, 1736). The figure of the gentleman has been separated from that of the lady, thus changing a kiss on the cheek into a thrown kiss. We tend to believe that Kaendler did this because he lacked as yet the courage to model a group of several figures, a difficulty he surmounted half a year later in his *Hand-kiss,* 207. The theme of the *Baiser rendu* recurred in hard paste at Höchst about 1755, example in the Untermyer Collection (64.101.281), and in soft paste at Bow about 1760, example in the Untermyer Collection (64.101.705).

EX COLL. Esders, Paris.
EXHIBITED: The Metropolitan Museum of Art, New York, 1949, *Masterpieces of European Porcelain*, no. 277.
REFERENCES: Untermyer *Meissen*, 1956, color pl. 20, fig. 27; G. Zick, *Keramos*, 53/54, 1971, pp. 97–107.

205.

Mustard pot adapted for oil

J. J. Kaendler
German (Meissen): 1737
Hard-paste porcelain
Mark: crossed swords in blue
H. 8¾ in. (22.3 cm.)
64.101.147

This and a sugar caster, 206, formed part of the Plat de Ménage that Kaendler made for Count Heinrich von Brühl in 1737, the year of Brühl's marriage. This service is Kaendler's gayest and most colorful creation, in which he gave free rein to his imagination as a sculptor, making only a few concessions to the practical needs of its users. The pot, like most other parts of the service, is described in Kaendler's working reports of September-October 1737: "A vessel for mustard, also belonging to the Plat de Ménage, made ready. It is in the form of an Indian hen, as a Japanese lady rides on it, holding at the same time a container in one hand from which the mustard can conveniently be taken."

EXHIBITED: The Metropolitan Museum of Art, New York, 1949, *Masterpieces of European Porcelain*, no. 323.
REFERENCE: Untermyer *Meissen*, 1956, color pl. 87, fig. 147.

206.

Sugar caster

J. J. Kaendler
German (Meissen): 1737
Hard-paste porcelain
Mark: crossed swords in blue
H. 7¾ in. (19.7 cm.)
64.101.176a, b

With the mustard pot (205), part of the service made for Count Heinrich von Brühl, described in Kaendler's working records of September–October 1737: "A sugar caster belonging to the Plat de Ménage, made in the shape of a pierced baldachin, through which the sugar is poured. Beneath this baldachin are two exotic figures of both sexes embracing. All these pieces that belong together caused some effort, because they all are figural."

EX COLL. R. W. M. Walker, London (Christie's, 25 July 1945, lot 8).
EXHIBITED: The Metropolitan Museum of Art, New York, 1949, *Masterpieces of European Porcelain*, no. 238.
REFERENCE: Untermyer *Meissen,* 1956, color pl. 86, fig. 131.

207.

The Handkiss

J. J. Kaendler
German (Meissen): 1737
Hard-paste porcelain
Mark: crossed swords in blue
H. 6 in. (15.3 cm.)
64.101.57

Kaendler's earliest crinoline group, with which he freed Western porcelain from the compelling imagery of oriental prototypes. Its success is manifested in its many repetitions and variations, including a model by Du Paquier, 231. Another of the Meissen models is in the Untermyer Collection (64.101.59). The model is described in Kaendler's records of April 1737: "A new group started from stock, representing a lady of quality seated on a reception chair, holding a cup of coffee in her right hand; her

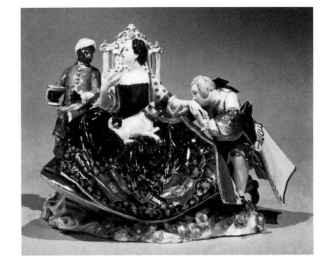

left, however, is kissed by a finely groomed gentleman; behind the lady stands a blackamoor serving with a porcelain tazza. . . ." The composition derives from an engraving by Laurent Cars after Boucher, published Paris, 1734, illustrating a scene in Molière's comedy *Le Sicilien ou l'amour peintre.* That 207 is an early example of the model is evident in the brilliant decoration. The lady's black crinoline skirt with floral border contrasts vividly with her kneeling companion's white and gold coat.

EX COLL. Cooper, England.
EXHIBITED: The Metropolitan Museum of Art, New York, 1949, *Masterpieces of European Porcelain,* no. 301.
REFERENCE: Untermyer *Meissen,* 1956, color pl. 30, fig. 35.

208.

Musicians on settee

J. J. Kaendler
German (Meissen): 1737
Hard-paste porcelain
Marks: crossed swords in blue; 45 twice impressed
W. 13¾ in. (35 cm.)
64.101.65

This early group, inspired by the engraving of Elias Nilson *Die Musik bei Hoff,* or *La Musique de chambre,* caused the modeler some difficulties. Although seated somewhat stiffly side by side, the figures are nonetheless elegantly attired and their hands and

instruments are in convincing positions. Kaendler described the group in 1737: "Two very ornate settees, on which two figures are seated, corrected in the clay. They are very difficult because both figures hold musical instruments in their hands, on which they play just as in reality." Six years later, Kaendler renewed the model, either by royal command or because the large group was too complex for repeated handling.

EX COLL. George Blumenthal, Paris (Galerie Georges Petit, Paris, 1–2 December 1932, pl. 35, fig. 66).

REFERENCE: Untermyer *Meissen,* 1956, color pl. 34, fig. 43.

209.

Joseph Fröhlich

> J. J. Kaendler
> German (Meissen): 1738
> Hard-paste porcelain
> Unmarked
> H. 9½ in. (24.2 cm.)
> 64.101.126

The few of Kaendler's models portraying real persons are easily recognizable. This likeness of the Dresden court jester was made after an engraving by C. F. Boetius, dated 1729 (F. H. Hofmann, *Das Porzellan,* Berlin, 1932, p. 318, fig. 317). An earlier Fröhlich, dated 1733, was lost in Dresden during World War II. Our model is described in Kaendler's working records for April 1737: "Also in Dresden the figure of Joseph . . . as he used to walk as majordomo with the keys, placed upon a postament, and is going to be finished only here in Meissen."

REFERENCE: Untermyer *Meissen,* 1956, color pl. 45, fig. 100.

210.

Dr. Boloardo

> J. J. Kaendler
> German (Meissen): about 1738
> Hard-paste porcelain

> Mark: crossed swords in blue
> H. 7¾ in. (19.7 cm.)
> 64.101.71

An intellectual who lays claim to learning he does not possess, Dr. Boloardo invites our laughter. He was born in the shadow of the University of Bologna, if not upon its doorsteps. As a friend of Pantaloon, he shared that worthy's miserly disposition and inclination for amorous adventures. Kaendler's figure wears the traditional mixture of academic and theatrical garb, including a broad-brimmed hat and voluminous coat. The eloquent gesture of this man, reputed to have spoken Latin with a Bolognese accent, is particularly effective: Kaendler knew how to make his hands more expressive than his speech could ever have been.

EX COLL. Roussel, Paris (Galerie Georges Petit, Paris, 26 March 1912, lot 213); Baron Max von Goldschmidt-Rothschild, Frankfort.

REFERENCES: H. E. Backer, *Keramik-Freunde der Schweiz. Mitteilungsblatt,* 26, December 1953, p. 27; Untermyer *Meissen,* 1956, color pl. 40, fig. 48.

211.

Tobacco box

> German (Meissen): about 1740
> Hard-paste porcelain
> Unmarked
> W. 6¾ in. (17.2 cm.)
> 1974.28.124

The figural scenes on this unusually large box are painted in purple camaïeu and organized in panels surrounded by gold lace borders. The peaceful figures in landscapes, in contemporary costumes, contrast with a battle scene in the style of Georg Philipp Rugendas. The interior of the box is gilded. The interior of the cover, in purple camaïeu, depicts five three-quarter figures seated around a table, smoking long Dutch clay pipes and being served coffee, the scene adapted from the *Piramide d'ailes et de cuisses de poulets,* designed by J. P. Pater, engraved 1733 by Lepicie, illustrating a novel by Paul Scarron. The porcelain painter, doubtless attached

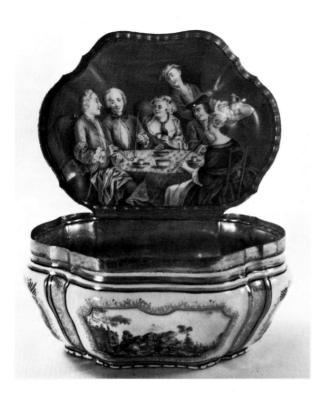

to the factory, converted Pater's dinner party into a smoking party, reduced the number of guests and servants, and showed them at less than full length. Though he copied the quiet pattern of the engraving's tablecloth, he set his table with easily recognizable Meissen coffee cups, saucers, and a bowl. The gilt-copper mounts, chased with foliage and scrolls, were added in Dresden.

EX COLL. Lord Rothschild (Sotheby's, 16 March 1970, lot 57, ill.).

212.

Bowl with gilt interior

German (Meissen): about 1740
Hard-paste porcelain
Mark: crossed swords in underglaze blue
D. 11 in. (28 cm.)
64.101.163

The individuality and high quality of these battle scenes, referred to in German inventories as *Batallien,* is astonishing, in view of the fact that

individual styles were persistently suppressed by the Meissen management. The names of outstanding specialists, such as J. G. Heintze, B. G. Hoyer (or Häuer) and Ch. F. Herold, are known mostly through documents relating to penalties imposed on them by the factory for outside work. Our bowl presented a splendid surface for decoration on a larger scale than most porcelain artists, usually confined to the dimensions of snuff boxes, were accustomed to. Although the point of departure was battle scenes by Georg Philipp Rugendas, these skirmishes are reinventions. Their vehemence is effectively contrasted by the conventional gilded cartouches surrounding them, with the full vocabulary of shells, latticework, foliage scrolls, and lace borders.

EX COLL. Katarina Schratt, Vienna; Albert Pollack, Amsterdam.
REFERENCES: Untermyer *Meissen,* 1956, pl. 80, fig. 120.

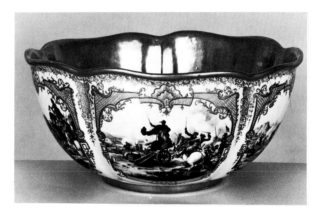

213.

Harlequin

J. J. Kaendler
German (Meissen): 1740–43
Hard-paste porcelain
Unmarked
H. 6 in. (15.3 cm.)
64.101.76

One of Kaendler's most colorful Italian comedy figures, molded to amuse and please polite court society. In his traditional patchwork costume, Harlequin greets his audience with a sweeping bow. He

is described early in Kaendler's *Taxa:* "A Harlequin with hat in hand bowing low." About 1790 J. M. Höckel copied the figure in Kelsterbach porcelain.

REFERENCE: Untermyer *Meissen,* 1965, color pl. 36, fig. 53.

214.

Rendevous at the Hunt

> J. J. Kaendler
> German (Meissen): 1740–44
> Hard-paste porcelain
> Unmarked
> H. 11 in. (28 cm.)
> 64.101.66

The lady's costume in this exceptionally large crinoline group is in the brilliant and difficult to produce lemon yellow known in Chinese porcelain as "imperial yellow." The large colorful floral sprays that complement the yellow ground are the skillful work of Meissen porcelain painters. This group is mentioned in Kaendler's *Taxa,* among models completed in 1744: "A group, for his Royal Highness, representing the hunt, with a lady holding a

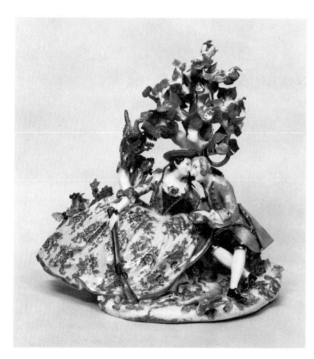

shotgun in her right hand, being offered a partridge by a gentleman." The composition is from an engraving after Carle van Loo's *La Halte de chasse,* of about 1737, now in the Louvre.

EX COLL. Count Tozzitta, Paris.
EXHIBITED: The Metropolitan Museum of Art, New York, 1949, *Masterpieces of European Porcelain,* no. 296.
REFERENCE: Untermyer *Meissen,* 1956, color frontispiece, fig. 44.

215.

Columbine and Pantaloon

> J. J. Kaendler
> German (Meissen): 1741
> Hard-paste porcelain
> Mark: crossed swords in blue
> H. 6¾ in. (17.2 cm.)
> 64.101.93

The later version of 203. Here, the figures are closer knit, and the festively dressed Columbine strokes her suitor's gray beard. The direct humor of the comedians in the earlier model is now replaced by the duplicity of court manners. The irregular slab base, left plain in 203, is studded with colorful flowers and foliage. Further, the figures' costumes are more extensively gilded. The group is mentioned in Kaendler's records for July 1741: "A group representing Pantaloon next to his lady friend completely renewed, finished in the most exacting way and rendered once more ready for use." A copy in Du Paquier porcelain, Vienna, about 1741–44, was in the Otto Blohm collection (R. Schmidt, *Early European Porcelain as Collected by Otto Blohm,* Munich, 1953, no. 97, color pl. 29).

REFERENCE: Untermyer *Meissen,* 1956, pl. 50, fig. 70.

216.

Lovers at Spinet

> J. J. Kaendler
> German (Meissen): 1741

Hard-paste porcelain
Unmarked
L. 9 in. (22.9 cm.)
64.101.63

A variation on the theme of polite society enjoying music and amorous play that Kaendler introduced to the world of porcelain. He worked overtime on this crinoline group, assisted by an apprentice ("mit Beihülffe eines Gesellens"). Kaendler described the composition in his *Taxa,* between 1740 and 1748: "One very difficult group, as a lady is seated on a chair playing a spinet, dressed in a loose jacket, fish bones, and skirt over it [crinoline], and in all details admirably attired, and is being kissed [by the gentleman]."

EXHIBITED: The Metropolitan Museum of Art, New York, 1949, *Masterpieces of European Porcelain,* no. 304.

REFERENCE: Untermyer *Meissen,* 1956, color pl. 33, fig. 41.

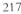

217

217.
Quack Doctor, Harlequin, and Monkey

J. J. Kaendler
German (Meissen): 1741
Hard-paste porcelain
Unmarked
8 in. (20.3 cm.)
64.101.100

Lampooning the medical profession, this expresses the young Kaendler's exuberant sense of humor. He describes it in his 1741 working records: "A dentist with a large wig, or a street crier offering his remedies, has a table standing beside him on which remedies are placed and a monkey holding medications as also a Harlequin in gay posture, his hat filled with herbs."

EX COLL. H. J. King, London (Christie's, 5 May 1914, lot 190, ill.); Mühsam, Vienna (Glückselig & Wärndorfer, Vienna, 19–30 April 1925, lot 61, ill.).

REFERENCE: Untermyer *Meissen,* 1965, color pl. 47, fig. 77.

218.
Mockery of Age

J. J. Kaendler
German (Meissen): 1741–42
Hard-paste porcelain
Unmarked
H. 7⅜ in. (18.6 cm.)
64.101.129

In the true spirit of the Italian comedy, this group mocks the failings of both age and youth. Kaendler lists it in his *Taxa* with work executed after 1740: "Group consisting of four figures, an old man seated in a fur housecoat holding a cane with a fur cap on his head, beside a young lady whom he wishes to embrace, and on whose lap a dog is lying; behind him stands a Harlequin who smilingly places a cock's feather in his cap, in front approaches a chap presenting him with celery." The group was copied in Vienna porcelain about 1749; a model in soft-paste Derby porcelain of about 1755 is in the Untermyer Collection (64.101.742)

EX COLL. Joseph E. Widener, Philadelphia (Samuel T. Freeman & Co., Philadelphia, 20–24 June 1944, lot 406, ill.).

REFERENCE: Untermyer *Meissen,* 1956, pl. 67, fig. 103.

219.

Impetuous Lover

> J. J. Kaendler
> German (Meissen): 1741–42
> Hard-paste porcelain
> Mark: crossed swords in blue
> H. 9½ in. (24.1 cm.)
> 64.101.128

Kaendler depicts a Harlequin mocking an ardent lover. Although somewhat similar in composition to Boucher's painting *Les Charmes de la vie champêtre,* it is unlikely that it influenced Kaendler since that work was apparently first engraved in 1757. He describes the group on page 5 of his *Taxa,* begun in 1740: "[A group] of four figures, with a shepherdess seated upon a lawn, joined by a finely dressed youth, full of amorous intentions but repudiated by her; above the youth is a Cupid holding him by his hair to hit him with his bow; a Harlequin standing nearby laughs at the youth." The group may have been planned with 218 to demonstrate the tribulations of young and old in the pursuit of love. By the time Franz Anton Bustelli, at Nymphenburg, modeled his group the Impetuous Lover, about 1760, Kaendler's robust humor had given way to a more sophisticated rococo style.

REFERENCES: Untermyer *Meissen,* 1956, pl. 66, fig. 102; G. Zick, *Keramos,* 29, 1965, p. 38, fig. 43; see also A. Ananoff, *François Boucher,* Lausanne—Paris, 1976, I, pp. 266–268, nos. 147, 148/1, figs. 490, 491.

220.

Two sconces

> J. J. Kaendler, assisted by J. F. Eberlein
> German (Meissen): 1742
> Hard-paste porcelain
> Unmarked
> H. 21¼ in. (54 cm.)
> 1970.277.12, 13

Count Brühl, director of the Meissen factory after 1733, ordered the Swan Service from Kaendler in 1737. It consisted of 2200 pieces. Before modeling it, Kaendler studied the shells in the natural history collections in Dresden, as noted in his working records of January 1738: "Spent three days in Dresden, where . . . I drew all sorts of shells and examined them closely, so that the . . . service could be realized in the most natural manner." In contrast to the colorful Plat de Ménage (205, 206), the Swan Service, decorated with figures of marine deities, dolphins, swans, seaweed, and shells, is in gold and white. Of the several Swan pieces in the Untermyer Collection, none display the joint arms of Brühl and his wife, Countess Franziska von Kolowrat-Krakowski, so it is evident that they were made for other clients. The rarest piece in the service is the sconce, and ours are probably the only examples to have survived the Second World War. Each has two candle arms and ormolu-mounted bobèches. The model for the sconce, which was ordered in 1742, shows the beginning of the rococo style in Meissen.

REFERENCE: Y. Hackenbroch, *Connoisseur,* CLXXVI, 1971, p. 269, color ill. p. 268 (one).

221.

Polish Handkiss

> J. J. Kaendler
> German (Meissen): 1743
> Hard-paste porcelain
> Unmarked
> H. 7¼ in. (18.4 cm.)
> 64.101.117

Polish themes appeared in Saxon art after Augustus the Strong, elector of Saxony, was crowned king of Poland in 1697. They were popular not only for reasons of national pride but because they gave artists the opportunity to depict colorful uniforms and ladies' fur-trimmed costumes. Kaendler mentions this group in his records for December 1743 ("A group where a Polish gentleman kisses a lady, cut in parts and gotten ready for molding") and again in his *Taxa* ("A group, a Polish lady in fur coat, seated in a meadow, joined by a well-dressed Pole who kisses her hand").

REFERENCE: Untermyer *Meissen,* 1956, color pl. 61, fig. 92.

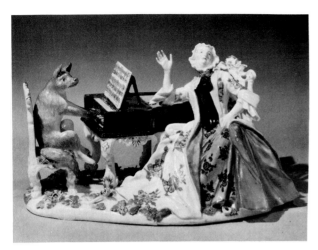

222.

Faustina Bordoni and the Fox

J. J. Kaendler
German (Meissen): 1743
Hard-paste porcelain
Unmarked
W. 10½ in. (26.6 cm.)
64.101.125

Among Kaendler's satirical groups few better convey the tone of Saxon court life than the one described in his records of 1743 as "A small group, showing a fox playing a harpsichord, and a lady seated upon a chair listening to him." At least two other models survive, but this is the only one to include the songsheet naming the opera whence it comes, thus identifying the lady. The sheet bears the title ANTIGONO and the names SG. BINDI and SG. HASSE, and an aria beginning "Ben che giusto a vendicarmi . . ." The opera, composed by Johann Adolph Hasse (1699–1783) for the Dresden Court Opera, was first performed at Schloss Hubertusburg, near Dresden, 10 October 1743. The composer's wife, Faustina Bordoni (1693–1783), was the leading mezzo-soprano; Giovanni Bindi (at the Dresden Opera after 1730) headed the male cast. As portrayed here, Faustina was no longer young, and the fox at the keyboard may well refer to her husband's sly methods in reserving the principal part for her. Those who knew Hasse's aria would know that the first word, when the fox turned the page, would be "viltà"—"misdeed."

223.

Harlequin and Columbine

J. J. Kaendler
German (Meissen): 1743
Hard-paste porcelain
Mark: crossed swords in blue
H. 6¼ in. (15.9 cm.)
64.101.96

This Harlequin conceals his roguish plans behind a mask. The group is described in Kaendler's factory records of January 1743 as an "Evening Work": "A group consisting of two figures, a Harlequin seated beside a lady, intending to caress her, but who is hitting him with the slapstick." The same description appears in Kaendler's *Taxa.*

224.

Cavalier and Lady

J. J. Kaendler
German (Meissen): 1744
Hard-paste porcelain
Mark: crossed swords in blue
W. 11 in. (28 cm.)
64.101.55

This rare group depicts a couple about to join a minuet. It is described in Kaendler's working records for June 1744: "A new group, divided and made ready for casting, which represents a cavalier with the star of an order on his chest, leading by the hand a well-dressed lady." The group is also described in the *Taxa*: "A group, with a cavalier

whose breast is decorated with a star and the Polish order, and who is also holding a snuffbox, who is leading by her hand a finely attired lady."

EX COLL. Hermine Feist, Berlin; Count Tozzitta, Paris.
REFERENCE: Untermyer *Meissen*, 1956, pl. 26, fig. 33.

225.

Oil pitcher

> J. F. Eberlein
> German (Meissen): 1744
> Hard-paste porcelain
> Mark: crossed swords in underglaze blue
> H. 8 in. (20.3 cm.)
> 1974.28.30a, b

From a service by Kaendler's closest associate, in the more restrained rococo style. Unlike earlier baroque dinner services, the sculptural elements are here confined to details such as handles or spouts. Two

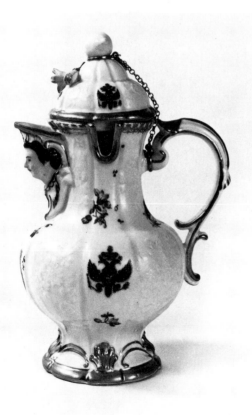

services, one made in 1741–44 for the Berlin merchant Johann Ernst Gotzkowsky, and an almost identical one made immediately after for Catherine of Russia, are decorated in Eberlein's favorite style: relief decoration with colorful Deutschen Blumen. Each item of the Russian set, of which this pitcher is part, bears the imperial Russian double-headed eagle with St. George in a shield, and the blue St. Andrew Cross with the letters SAPR (Sanctus Andreas Patronus Russiae), the Russian tsars and tsarinas being grand masters of that order. 225 is described in the Meissen records of 3 May 1744 and in a Russian record of 5 November 1745, soon after its arrival in St. Petersburg.

EX COLL. State Hermitage Museum, Leningrad.

226.

Lovers at a Sewing Table

> J. J. Kaendler
> German (Meissen): 1745
> Hard-paste porcelain
> Unmarked
> H. 7½ in. (19 cm.)
> 64.101.62

Since the electors of Saxony were grand masters of the Freemasons, themes linked to that society were occasionally represented in Meissen porcelain. Here, a lady sews a blue and white Freemason's apron for her approaching companion, who throws her a kiss. The lady's white crinoline is patterned with large floral sprays; her dress is bordered with the same blue ribbon as that on the apron. Kaendler calls it "A new Freemason group" in his working records of November 1744. In his *Taxa*, in which he noted his fees, he says that a pug dog was to be seated next to the lady.

EX COLL. Joseph E. Widener, Philadelphia (Samuel T. Freeman & Co., Philadelphia, 20–24 June 1944, lot 416); Mr. and Mrs. L. Sheafer, New York.
EXHIBITED: The Metropolitan Museum of Art, New York, 1949, *Masterpieces of European Porcelain*, no. 307.
REFERENCE: Untermyer *Meissen*, 1956, color pl. 33, fig. 40.

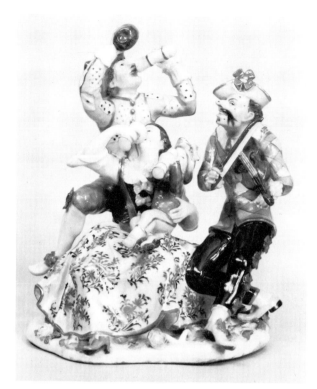

227.
Harlequin Family Drinking

J. J. Kaendler
German (Meissen): about 1745
Hard-paste porcelain
Unmarked
H. 7½ in. (19 cm.)
64.101.94

The gregarious humor of this Harlequin family is captivating. It would seem that their on-stage and off-stage performances were interchangeable. Comedy characters of Italian derivation have become familiar figures, whose customarily biting humor has been mellowed by the enjoyment of wine, the sound of music, and the comfort of family life in this group. Kaendler was at his best when featuring stage characters whose wit he appreciated and whose outlook on life matched his own.

EXHIBITED: The Metropolitan Museum of Art, New York, 1949, *Masterpieces of European Porcelain*, no. 294.
REFERENCE: Untermyer *Meissen*, 1956, color pl. 46, fig. 71.

228.
The Kiss

J. J. Kaendler
German (Meissen): 1746
Hard-paste porcelain
No mark visible
H. 4½ in. (11.5 cm.)
64.101.60

More elegant in style and more intimate in character than Kaendler's earlier, sometimes boisterous creations. He described it in his working records for January 1746: "A new group, with a well-dressed lady seated on the lap of a gentleman and they kiss one another." The porcelain is mounted as a candelabrum in eighteenth-century ormolu with soft-paste Mennecy flowers.

REFERENCE: Untermyer *Meissen*, 1956, pl. 32, fig. 38.

229.
Opera figure

J. J. Kaendler
German (Meissen): 1750–52
Hard-paste porcelain
Unmarked
H. 8¼ in. (21 cm.)
64.101.51

Once thought to represent Madame de Pompadour costumed for an amateur performance at Versailles, but in fact an anonymous theatrical personality in Paris attire of about 1750, this figure shows the impact of French art on the Meissen modeler. Kaendler spent time in France in 1749–50 when he delivered wedding presents for the marriage of Augustus II's daughter Maria Josepha to the Dauphin. No doubt he knew the work of Louis René Boquet (1717–1814), the king's costume designer for festivals, spectacles, and ceremonies. In 229 he followed Boquet's designs detail for detail—as he did for the male companion of 229, now in the Museum of Decorative Art, Copenhagen. Following his sojourn in Paris, Kaendler introduced rocaille bases height-

ened with gilding in his Meissen models, replacing the older slab bases with applied flowers.

EX COLL. Ole Olsen, Copenhagen; Mrs. Meyer Sassoon, London.

EXHIBITED: The Metropolitan Museum of Art, New York, 1949, *Masterpieces of European Porcelain,* no. 256.

REFERENCES: Untermyer *Meissen,* 1956, pls. 24, 25, fig. 30; see also A. Tessier, *La Revue de l'Art Ancien et Moderne,* 49, 1926, pp. 15–26, 89–100, 173–184; Fr. van Thienen in *Miscellanea I. Q. van Regteren Altena,* Amsterdam, 1969, pp. 198–203; Y. Hackenbroch, *Connoisseur,* CXCV, 1977.

painted in reserves surrounded by an iron red ground with silver stars. A bearded mask beneath the spout, molded and painted, introduces a touch of sophisticated humor. The foot, neck, and spout have protective gilt-metal rims.

EX COLL. Karl Mayer, Vienna (Glückselig & Wärndorfer, Vienna, 19–21 November 1928, lot 7, pl. 5).

REFERENCES: J. Folnesics and E. W. Braun, *Geschichte der K. K. Wiener Porzellan Manufaktur,* Vienna, 1907, no. 4, pl. 4; J. Folnesics, *Die Wiener Porzellan-Sammlung Karl Mayer,* Vienna, 1914, no. 3, color pl. 3; Untermyer *Meissen,* 1956, pl. 104, fig. 153.

230.
Coffeepot

Austrian (Vienna, Du Paquier): about 1720
Hard-paste porcelain and gilt metal
Unmarked
H. 7 in. (17.8 cm.)
64.101.236a, b

The hexagonal shape also occurs in domestic silver. The "Indian" decoration, of oriental derivation, is

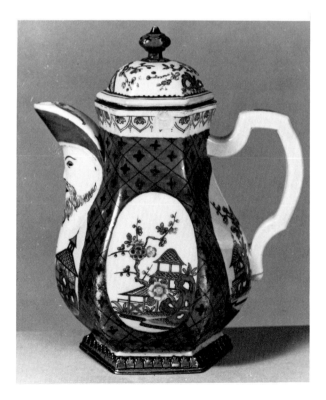

231.
Lady with Blackamoor

Austrian (Vienna, Du Paquier): about 1740
Hard-paste porcelain
Unmarked
W. 7¾ in. (19.7 cm.)
64.101.274

This free copy after Kaendler's *The Handkiss,* 207, was executed by Claudius Innocentius Du Paquier in his private factory (1718–44). Kaendler's graceful lady has been transformed into a stately matron

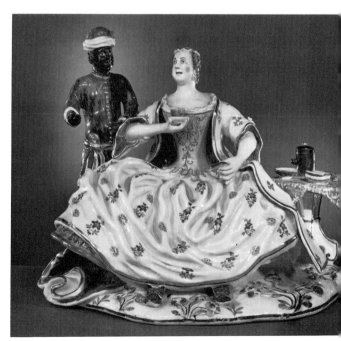

posing stiffly in fashionable attire. Although Du Paquier's modeling is not as precise as Kaendler's, his details are well defined, in the smooth manner of an artist more accustomed to working in faience than in hard-paste porcelain. The naive quality is indicative of Du Paquier's early response to the new material.

EX COLL. Anton Redlich, Vienna (Kende Galleries, New York, 30 March–6 April 1940, lot 47, pl. 1).

EXHIBITED: The Metropolitan Museum of Art, New York, 1949, *Masterpieces of European Porcelain,* no. 14.

REFERENCES: J. F. Hayward, *Viennese Porcelain of the Du Paquier Period,* London, 1952, p. 158, pl. 68; Untermyer *Meissen,* 1956, color pl. 105, fig. 165.

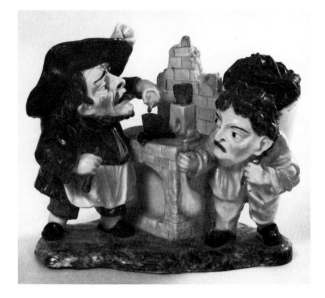

232.

Lawyers in Dispute, Alchemist

Austrian (Vienna) (?): 1744–49
Hard-paste porcelain
Unmarked
L. 8¼, 7¼ in. (21, 18.4 cm.)
64.101.344, 345

These two groups are based on engravings. The lawyers occur as single figures on pages 8 and 13 in *Il Callotto Resuscitato,* Amsterdam, 1716. Both groups, exactly as modeled in porcelain, appear in *de Narrenpoppen,* drawn by Anna Folkema (1695–1768), and published by Wilh. E. Koning, Amsterdam. These popular engravings circulated widely and therefore do not indicate the local origin of the groups. Before it had been firmly established that they are made of hard paste, they were thought to have come from Capodimonte. If of Italian origin (one or two Italian words are legible on the lawyer's scroll), the Venetian factory of Geminiano Cozzi (founded 1764) would be the likely one. However, we consider a Vienna origin more likely, immediately after the closing of Claude Du Paquier's private factory when, in 1744, the Austrian state took it over. At that time, a number of Callot dwarfs of similar character were modeled, some of which have the impressed Austrian arms (Bindenschild), a mark not strictly enforced before 1749. The themes of our groups could possibly have a bearing on the events of 1744: the lawyers might recall those who had settled the take-over, which involved Du Paquier's written disclosure of his secrets concerning paste, kiln construction, and firing methods. The alchemist, originally a gold seeker, now hoped to find at his brick furnace the secret of hard-paste porcelain; as such, he was an appropriate subject for a newly established porcelain factory.

EXHIBITED: The Metropolitan Museum of Art, New York, 1949, *Masterpieces of European Porcelain,* nos. 380, 381.

REFERENCE: Untermyer *Meissen,* 1956, color pl. 137, fig. 207.

233.

Minuet Dancers

Johann Friedrich Lück
German (Höchst): 1758
Hard-paste porcelain
Marks: wheel in iron red (lady); wheel and L in iron red (gentleman)
H. 7¼ in. (18.4 cm.)
64.101.286, 287

The Höchst factory (1746–96) produced both faience and porcelain. While its faience was among the finest in Germany, the fortunes of the factory depended primarily on the sale of its porcelain. Some of the faience models repeated those of Strasburg. The porcelain models, on the other hand, were more strongly influenced by graphic sources, for example, the *Baiser donné* and the *Baiser rendu* after Pater, both of which are in the Untermyer Collection (64.101.281, 282). Our lady and gentleman, most likely derived from an engraving by Nicolas de Larmessin after Nicolas Lancret, representing the dancer Mademoiselle Sallé, were executed between March and June, 1758, when J. F. Lück and his brother, Carl Gottlieb, originally from Meissen, worked in Höchst before moving to the Frankenthal factory.

EX COLL. (lady) A. Beckhardt, Frankfort; (gentleman) Ole Olsen, Copenhagen.

EXHIBITED: The Metropolitan Museum of Art, New York, 1949, *Masterpieces of European Porcelain*, no. 203.

REFERENCE: Untermyer *Meissen*, 1956, pl. 112, fig. 175.

234.
Lovers with a Birdcage

Ernst Heinrich Reichard
German (Berlin, Wilhelm Caspar Wegely): 1751–57
Hard-paste porcelain

Marks: *W* in underglaze blue; incised $\dfrac{\frac{2}{90}}{40}$

H. 6⅞ in. (17.5 cm.)
64.101.102

Although Meissen models were occasionally copied competitively, such imitations can also be interpreted as homages to Kaendler, the modeler who set the fashion for others to follow. 234 is based on a Kaendler model of 1741 (Untermyer Collection 64.101.102), described in Kaendler's *Taxa* as "A group of two figures embracing one another, whilst the girl holds a birdcage in her left hand." In 1751 Frederick the Great enabled W. C. Wegely to establish a porcelain factory in Berlin. It failed after six years. The principal modeler during the facto-

ry's life, E. H. Reichard, was better qualified to undertake reproductions than to create new models, for which reason his group lacks the special flair that Kaendler was able to impart to his figures.

EX COLL. Robert von Hirsch, Basel.

EXHIBITED: The Metropolitan Museum of Art, New York, 1949, *Masterpieces of European Porcelain*, no. 191.

REFERENCE: Untermyer *Meissen*, 1956, pl. 118, fig. 181.

235.
Crinoline Lady

Johann Paul Rupert Härtl (1715–92)
German (Neudeck-Nymphenburg): about 1754
Hard-paste porcelain
Mark: Bavarian shield, impressed on front of base
H. 6½ in. (16.5 cm.)
64.101.297

This somewhat stiffly modeled crinoline lady looks to her left, where her partner (not in the Collection) was to have followed her. She was modeled after an engraving by Johann Esaias Nilson, *Le Jardin magnifique,* published in Augsburg. The figure illustrates the style at Neudeck-Nymphenburg of about 1754, when Franz Anton Bustelli joined the factory. Until then, Härtl, to whom this figure is attributed, had been in charge. Bustelli initially assisted Härtl, but soon came into his own, transforming slighly pedestrian figures into the most beguiling personifications of rococo society ever to be created in porcelain.

EX COLL. Darmstaedter, Berlin (Rudolph Lepke, Berlin, 24–25 March 1925, lot 254, pl. 60).

EXHIBITED: The Metropolitan Museum of Art, New York, 1949, *Masterpieces of European Porcelain*, no. 339.

REFERENCE: Untermyer *Meissen*, 1956, pl. 120, fig. 183.

236.
Tea and coffee service

German (Nymphenburg): 1760–65
Hard-paste porcelain
Marks: Bavarian shield, impressed on each piece, beside impressed I or II

Decoration attributed to Cajetan Purtscher (1740–
 1813)
H. teapot 4¼ in. (10.8 cm), coffeepot 8¾ in.
 (22.2 cm.)
64.101.299a, b–320

After initial imitative rivalry with silver, porcelain
services were designed with molded and painted
decoration, as here, ideally suited for the new me-
dium. In 236 all traces of oriental influence have
disappeared, to be replaced by domestic scenes or
flowers. Bowl, cups, and saucers have a gold
ground, on which figures in landscapes are painted
in colors. These repeat inventions by Johann Esaias
Nilson, whose Augsburg engravings had become
favorite design sources. The porcelain painter
Cajetan Purtscher joined the Nymphenburg factory
6 February 1758.

EXHIBITED: The Metropolitan Museum of Art, New
 York, 1949, *Masterpieces of European Porcelain*, no. 344
 (part of the service).
REFERENCE: Untermyer *Meissen*, 1956, color pl. 123, pl.
 122, fig. 185.

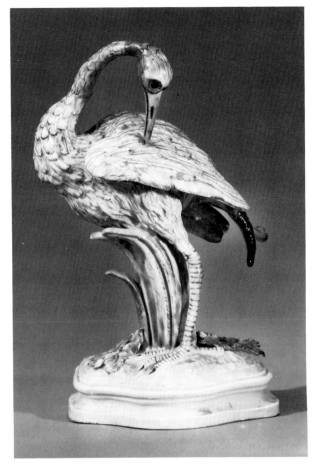

237.

Crane

Dominikus Auliczek the Elder (active 1763–97)
German (Nymphenburg): about 1767
Hard-paste porcelain
Marks: impressed shield; 43
H. 5⅞ in. (14.9 cm.)
1970.277.15

Since figures of birds are one of the glories of the
early Meissen models, it is difficult to account for
the fact that elsewhere on the Continent they made
only occasional appearances. The personal taste of a
Landesherr and the changing tides of fashion must
have played their part. At Nymphenburg, after the
period of Bustelli had run its spendid course, there
was a preference for animal groups in violent mo-
tion, pursued or attacked. This very rare "flamingo"
is mentioned in the price list of 1767 as standing
beside willow grass. Auliczek may have seen a Chi-
nese porcelain of the K'ang Hsi period, which, in
Nymphenburg, was called a flamingo.

EX COLL. Mrs. Edward Hutton, New York.
REFERENCES: Y. Hackenbroch, *Connoisseur*, CLXXVI,
 1971, pp. 270–271, fig. 8; see also F. H. Hofmann,
 Geschichte der Porzellan-Manufaktur Nymphenburg, Leip-
 zig, 1923, III, p. 488.

238.

Harlequin and Columbine

Johann Friedrich Kaendler (active 1758–?)
German (Ansbach): about 1762
Hard-paste porcelain
Unmarked
H. 8½ in. (21.6 cm.)
64.101.324

The Ansbach factory, founded in 1758, secured the
services of J. F. Kaendler, a cousin of the Meissen
Kaendler. The younger master, who left Saxony for
Franconia at the outbreak of the Seven Years' War,

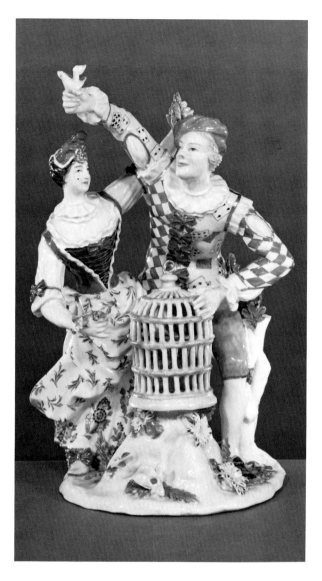

239.

The Coiffure; The Large Bow

Gottlieb Friedrich Riedel (1724–84)
German (Ludwigsburg): 1770–79
Hard-paste porcelain
Marks: crossed Cs in underglaze blue, H‴ in black,
 I. P. 3 N. F. incised (lady); crossed Cs in under-
 glaze blue, H in black (gentleman)
H. 5, 4 in. (15.2, 12.2 cm.)
64.101.326, 327

Satirical subjects entered the porcelain modeler's repertoire at Meissen in the early Boettger period (187). The Ludwigsburg factory, operating after 1758, produced miniature groups that mocked aspects of German fashions. Witness this gentleman, whose wig, terminating in a straight tail or *Zopf,* is tied with an oversize bow, or this lady, having her hair dressed to a staggering height. Such groups are thought to be inventions of G. F. Riedel (1724–84), a technician and painter from Dresden who, via Höchst (1757) and Frankenthal (1757–59), went to Ludwigsburg, and worked there until 1779. The fact that similar groups, though not of miniature size, occur wherever Riedel worked strengthens the attribution.

EX COLL. Sir Bernard Eckstein, Bt. (Sotheby's, 30 May
 1949, lot 111, pl. XIX, lady as by Jean Louis).
REFERENCE: Untermyer *Meissen,* 1956, pl. 127, figs. 191,
 192.

was under the spell of his famous cousin and copied his models. J. J. Kaendler's model for this couple (Untermyer Collection 64.101.124) is described in his *Taxa,* 1741: "Group . . . representing a male stage figure holding a birdcage in his left hand, in it a parrot being given cherries to eat [by a lady] who places feathers on her companion's head; he in turn presents her with a titmouse." The Ansbach repetition is larger than the original, the facial expressions are different, and we see narrow eyes and sharply modeled noses—typical Ansbach features.

EX COLL. Fritz Buckardt, Berlin (P. Cassirer & H. Helb-
 ing, Berlin, 8–9 December 192[?], lot 5, ill. p. 6).
REFERENCE: Untermyer *Meissen,* 1956, color pl. 124, fig.
 189; for the Meissen group see ibid., pl. 51, fig. 98.

240.

Maria Immaculata

Wenzel Neu (about 1708–74)
German (Fulda): about 1770
Hard-paste porcelain
Mark: cross in underglaze blue (at back of pedestal)
H. 14⅜ in. (36.5 cm.)
64.101.331

The only religious figure modeled at Fulda, a factory founded by Fürstbischof Heinrich von Bibra in 1764; it is one of the finest figures made at Fulda. It has the sculptural quality of the large stone figures placed on columns in southern Germany, Austria, and Bohemia. Known as "Maria-Hilf" or

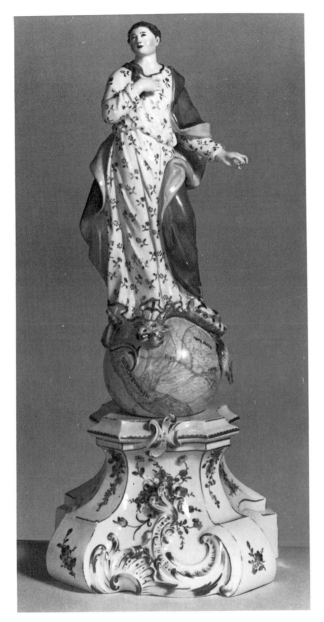

241.

Cane handle

Wenzel Neu
German (Kloster Veilsdorf): 1763–67
Hard-paste porcelain
Unmarked
L. 5½ in. (14 cm.)
64.101.353

The bearded-Turk form was derived from the full-length figure of *Le Turc amoureux* engraved by C. F. Schmidt after a painting by Lancret. Though once thought to have come from the porcelain factory at Buen Retiro, the handle is noted in the records of the Kloster Veilsdorf factory in Thuringia: "Chacan mit Türkenkopf." The same model is in the Hermitage Museum, Leningrad, and an ivory model is in the Bavarian National Museum, Munich.

REFERENCES: Untermyer *Meissen,* 1956, pl. 131, fig. 214;
E. Kramer, *Keramos,* 53/54, 1971, pp. 77–96, fig. 26;
see also R. S. Soloweitschick, *Thüringer Porzellan des 18. und Beginn des 19. Jahrhunderts in der Sammlung der Ermitage,* Leningrad, 1975, p. 86, no. 113, ill.

242.

Effendi, a Turkish Lawyer in His Study

Wenzel Neu
German (Kloster Veilsdorf): 1763–67
Hard-paste porcelain
Unmarked
H. 4¼ in. (10.8 cm.)
64.101.275

Although Chinese motifs and forms dominated in early European porcelain, Turkish themes gave the modeler the opportunity to depict pleasant social gatherings and exotically garbed figures from another region. This example was once thought to be from Du Paquier's Vienna factory, since Turkish figures were common in Viennese art of the period. However, fitting the local conceptions of the Turks, the Viennese representations were always military

"Pestsäulen," these were erected in gratitude for dangers averted. Neu's Madonna stands on a globe encircled by a serpent with an apple in its jaws, symbolizing her intercession for the redemption of man. Indicated on the globe are regions of Neu's native "Siebenbuirgen" in Bohemia. The figure was an ex voto offering ordered by von Bibra after he was able to rebuild his factory in 1770, following its destruction by fire.

EXHIBITED: The Metropolitan Museum of Art, New York, 1949, *Masterpieces of European Porcelain,* no. 196, pl. 128.

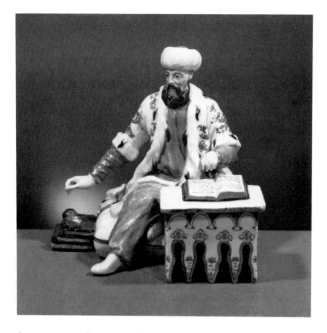

in nature. This peaceful scholar is, instead, a product of Kloster Veilsdorf, where Wenzel Neu modeled other Turkish characters (241). The source for the model was an engraving by Weigel of Augsburg in De Ferriol's *Nations de Levant* (Paris, 1714).

EX COLL. Robert von Hirsch, Basel.
EXHIBITED: The Metropolitan Museum of Art, New York, 1949, *Masterpieces of European Porcelain*, no. 11.
REFERENCES: J. F. Hayward, *Viennese Porcelain of the Du Paquier Period*, London, 1952, p. 157, pl. 69d; Untermyer *Meissen*, 1956, color pl. 109, fig. 166; E. Kramer, *Keramos*, 53/54, 1971, p. 77; S. Ducret, *Keramik und Graphik*, Brunswick, 1973, no. 307, ill.

243.

Bowl with relief decoration

> Italian (Doccia): 1750–55
> Hybrid porcelain
> Mark: three stars in line above fleur-de-lis, in underglaze red
> D. 6½ in. (16.5 cm.)
> 64.101.340

An outstanding example of relief decoration. Such decoration was frequently derived from casts of Medici silver, such as those made by the goldsmith

Piero Paolo Bini in 1746. Other reliefs were derived from engravings such as Picart's illustrations in the 1732 Amsterdam edition of Ovid's *Metamorphoses*. The scenes on the exterior of women preparing to bathe in a river are brightly colored, whereas the painted chinoiserie scene inside is in gold with touches of red, like similar decorations on Meissen and Du Paquier porcelain. The mark, found only on this bowl, is part of the Ginori arms; the fleur-de-lis is the *giglio* of Florence.

EX COLL. Count of Lichtenstein, Vienna.
REFERENCES: A. de Eisner Eisenhof, *Le Porcellane di Capodimonte*, Milan, 1925, p. 56, fig. 27; A. Lane, *Italian Porcelain*, London, 1954, p. 44, note 1; Untermyer *Chelsea*, 1957, pl. 136, fig. 203; L. Ginori Lisci, *La Porcellana di Doccia*, Milan, 1963, p. 56, fig. 27, p. 133, note 67.

244.

Dancing Girl

> Italian (Doccia): about 1770
> Hybrid porcelain
> Unmarked
> H. 6½ in. (16.5 cm.)
> 1974.28.116

Derived from a Kaendler figure of 1748–50 in Meissen porcelain, this figure retains the precise modeling characteristic of hard paste. The Doccia artists excelled at reinterpreting models originally executed elsewhere and even in other materials, such as ivory, terra cotta, bronze, silver, and occasionally marble.

REFERENCE: *Notable Acquisitions: 1965–1975*, The Metropolitan Museum of Art, New York, 1975, p. 288, ill. (with the original Meissen model [Metropolitan Museum 1974.232.1]).

245.

The Ladies' Tailor

> Giuseppe Gricci (d. 1770)
> Italian (Capodimonte): about 1744

Soft-paste porcelain
Unmarked
H. 8⅛ in. (20.6 cm.)
1970.277.25

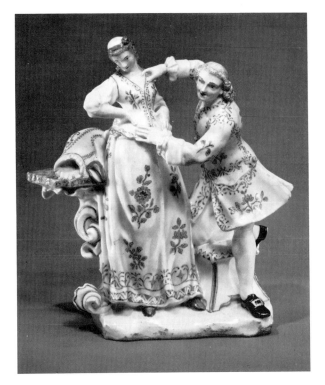

Gricci worked at Capodimonte 1743–59. In this, one of his earliest productions, the paste still contains impurities and the colors are not yet properly fused into the creamy glaze. The red and gold floral decoration is of Japanese derivation; the blue borders of the costumes imitate the blue "a stampino" decoration of contemporary Ginori services. The early date is further supported by the fact that Gricci closely followed an engraving by Charles Nicholas Cochin le Jeune, *Le Tailleur pour femme,* published in Paris, 1737 (Y. Hackenbroch, *Connoisseur,* CLXXVI, 1971, pp. 271–273, figs. 9, 10 [Cochin's engraving]). Gricci's later works were more original and exhibited a predilection for local types.

REFERENCES: F. Stazzi, *Porcellane italiane,* Milan, 1964, p. 101, fig. 78; *Notable Acquisitions: 1965–1975,* The Metropolitan Museum of Art, New York, 1975, p. 283, ill.

246.

Apple Stealer

Giuseppe Gricci
Italian (Capodimonte): 1747–49
Soft-paste porcelain
Unmarked
H. 8½ in. (21.6 cm.)
64.101.342

The mature Gricci's three- and four-figure groups were designed to be viewed in the round. The relationship of the characters in the group is subtly and rhythmically expressed through, for example, the inclination of a head or the extension of an arm. Here, the young apple stealer is attacked by a watchdog, while his two lady companions try to rescue him: one pulls the dog's tail, the other threatens the beast with her garden tool. Gricci's sentiment is tinged with humor.

EX COLL. Darmstaedter, Berlin (Rudolph Lepke, Berlin, 24–26 March 1925, lot 568, pl. 123).
REFERENCE: Untermyer *Meissen,* 1956, pls. 134, 135, fig. 205.

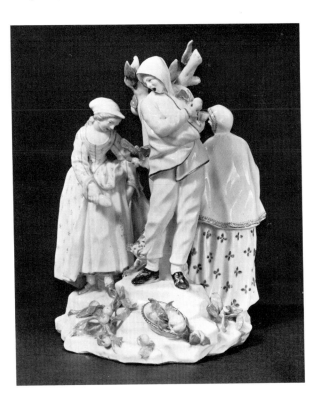

247.

Spaghetti Eaters

Giuseppe Gricci
Italian (Capodimonte): about 1750
Soft-paste porcelain
Mark: fleur-de-lis in blue
H. 5½ in. (14 cm.)
64.101.350

The masked, bald Pulcinella, his pointed hat lying on the ground, eats spaghetti from a caldron; Columbine, holding a cooking utensil, tenderly embraces him. The sentimental, idyllic domestic scene is like the paintings of Italian comedy scenes by Gricci's Florentine contemporary, Gian Domenico Ferretti.

EXHIBITED: The Metropolitan Museum of Art, New York, 1949, *Masterpieces of European Porcelain*, no. 361.
REFERENCES: Untermyer *Meissen*, 1956, pl. 142, fig. 211; H. Jedding, *Porzellan aus der Sammlung Blohm*, Hamburg, 1968, p. 30.

248.

Hexagonal covered vase

German (Plaue an der Havel): about 1715
Red stoneware
Unmarked
H. 21¾ in. (55.3 cm.)
64.101.383a, b

Boettger discovered this ware in 1707 and had considerable commercial success with it at the Leipzig Fair. Of the attempts to copy it the most successful was that of Plaue an der Havel (Kurbrandenburg), where Samuel Kempe of Meissen began producing in 1713. Yet the Plaue stoneware never attained the hardness, hence the sharpness of modeling, of Boettger's work. A typical Plaue form, 248 is decorated in relief with hand-molded, entirely unconventional figures of dancers and musicians. The Prussian eagle, wings spread, surmounts the domed cover. The foot is rimmed in plain brass.

EX COLL. Jacob Hecht, Berlin (Kende Galleries, New York, 9 March 1942, lot 84).
REFERENCE: Untermyer *Meissen*, 1956, pl. 151, fig. 226.

249.

Tankard mounted in silver gilt

German (Nuremberg): about 1720
Faience
Unmarked
Decorator: Mathias Schmid, signed MS
H. 9¼ in. (23.5 cm.)
64.101.385

Before becoming a faience painter with a penchant for battle and hunting scenes, Schmid, it is thought, was a military man. His broad manner led him to prefer capacious tankards as vehicles for his work. His battle scenes show some relationship to those engraved by G. P. Rugendas. Schmid heightened the drama of his military actions with clouds resembling cannon smoke and with fallen soldiers and wounded horses. His landscapes with tall trees are painted in shades of green or occasionally in purple camaïeu. In the center of the cover of 249 is a *Glockenthaler*, a coin issued in 1643 for August the Younger of Wolfenbuettel (1635–66).

EX COLL. Georg Tillmann, Hamburg; Baron Rudolph von Goldschmidt-Rothschild, Frankfort.
REFERENCE: Untermyer *Meissen,* 1956, pl. 153, fig. 228.

250.

The Captain

Joseph Hackl (active 1748–68)
German (Göggingen): 1748–53
Faience
H. 11¾ in. (29.9 cm.)
64.101.384

This rare Italian comedy figure, once thought to be from the faience factory in Brunswick, can now safely be attributed to the short-lived factory of Göggingen, near Augsburg. The few known Göggingen figures, all attributable to Joseph Hackl,

include Orientals (Germanische Nationalmuseum, Nuremberg) and at least two more Italian comedy characters of the same size as 250. All stand on thin rectangular slab bases that show, beneath, the fine-grained yellow gray Göggingen clay and, above, a muddy earth color applied in small brushstrokes.

REFERENCES: Untermyer *Meissen,* 1956, pl. 152, fig. 227; see also H. Müller, *Gögginger Faiencen,* Augsburg, 1975, pp. 300–301.

251.

Dwarf Musicians

French (Strasbourg): about 1750
Faience
Unmarked
H. 5⅝, 5¾ in. (14.4, 14.6 cm.)
1974.28.112, 113

Since they often convey the modeler's style rather than that of the factory, faience figures are difficult to attribute. Moreover, marks and signatures are unusual. Chompret located this pair among the first faience figures produced in Niderviller, though without pointing out close comparisons. We tend nevertheless to seek the origin of these highly sophisticated figures in Strasbourg, during the flourishing period under Paul Hannong. The reddish

color of the clay is typical of Strasbourg, as are the intricate textile patterns, and the individualized, somewhat grotesque facial expressions bear no resemblance to the even, aimable features distinguishing Niderviller figures. A few comparable musicians, apparently from the same series, include a white hurdy-gurdy player in the Kunstgewerbemuseum, Cologne, identical with ours except that he wears a hat. The figure, without a hat, derives from an engraving by Jacques Callot, one of his series of *Varie Figure Gobbi,* Florence, 1622 (Lieure 424). But as this series was repeatedly copied, reinterpreted, and re-engraved, it is difficult to find the direct link between Callot's work and our musicians. They show a strange combination of popular art and sophistication, notably in their finely tailored and patterned costumes and their expressive faces.

EX COLL. A. M. E. Akar.

EXHIBITED: Musée du Louvre, Paris, 1932, *La Faïence française de 1525 à 1820,* no. 2615.

REFERENCES: J. Chompret, ed., *Répertoire de la faïence française,* Paris, 1933–35, pl. 1c; see also ibid., p. 178 (notes by H. Haug on Niderviller).

252.

Cup and saucer, pair of stem cups, plaque

German (Berlin, House of Fromery): 1720–30
Enamel on copper with gold relief, cups and saucer lined with silver gilt
Enameler: Christian Friedrich Herold (1700–79); plaque (from a snuffbox) signed C. F. Herold F. H. cup and saucer 1¾ in. (4.5 cm.); stem cups 5⅝ in. (14.3 cm.); L. plaque 2⅝ in. (6.7 cm.)
64.101.393–397

The Berlin factory founded by Pierre Fromery, a Huguenot from Sedan, produced small articles of copper coated with white enamel and painted in colors and gilding. Relief decoration was added in gold. When Herold, Fromery's principal enameler, went to Dresden in 1726 to apply his gold-relief technique to porcelain, he continued to work occasionally for Fromery and independently. Enamel

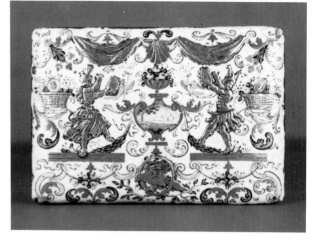

decoration on Meissen porcelain was forbidden outside the factory but permitted on copper. Herold's plight, until he was recognized as an outstanding porcelain painter, is clear in his petition to the Meissen management in 1739, accompanied with samples of his work: "I . . . do not believe that somebody at the factory could do my work, or could pride himself on having seen anything similar on porcelain, and this is the reason why . . . I would like to be called the only master of this art."

EX COLL. (cup and saucer) Bunal, 1857; Salomon, Dresden; Margarete Oppenheim, Berlin (J. Böhler, Munich, May 1936, lot 559, pl. 42).

REFERENCES: G. E. Pazaurek, *Deutsche Faience und Porzellan-Hausmalerei,* Leipzig, 1925, I (plaque) p. 155, fig. 125; H. Sauerland, *Der Kunstwanderer,* April 1926 (plaque) p. 315, fig. 5; W. Holzhausen, ibid., September 1930 (cup and saucer) p. 9, fig. 12, (stem cups) p. 11, fig. 17, (plaque) p. 8, fig. 10; Untermyer *Meissen,* 1956 (cup and saucer) color pl. 138, fig. 234, (stem cups) color pl. 138, fig. 235, (plaque) color pl. 236, fig. 397; see also O. Walcha, *Keramik-Freunde der Schweiz. Mitteilungsblatt,* no. 46, 1959 (plaque) p. 14 f.

253.

Vase

English (Chelsea): about 1748
Soft-paste porcelain
Mark: incised triangle (at base)
H. 4¾ in. (12.1 cm.)
64.101.412

Early Chelsea porcelain was primarily limited to utilitarian objects, since the factory lacked royal or princely patronage to guarantee the sale of luxury items. This rare vase bears the earliest Chelsea mark. The delightful decoration reproduces Kakiemon subjects, such as the well-known yellow tiger, plum tree in blossom, and "banded hedges." The tiger's paws resemble blue slippers. He stands in a field strewn with star-shaped flowers, his tail majestically upswept.

REFERENCE: Untermyer *Chelsea*, 1957, pls. 3, 144, fig. 5.

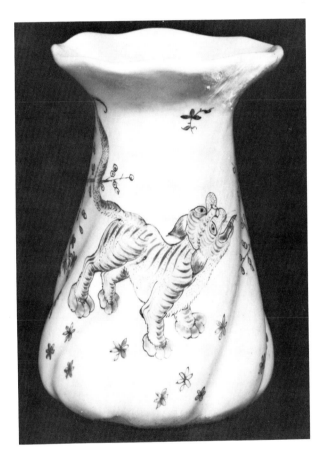

254.

Set of four shell-shaped dishes

English (Chelsea): about 1750
Soft-paste porcelain
Mark: raised anchor (on each dish)
L. 9⅝ (24.5 cm.)
64.101.441–444

Nicholas Sprimont, a silversmith from Liège, arrived in London in 1742 and registered his mark at Goldsmiths' Hall the following year. What prompted him in 1749 to become the director and eventual sole owner of the porcelain works at Chelsea? The challenge of a new commercial enterprise may have been compelling, also the opportunity to recast some of his silver models in a new medium. These dishes, which he had previously executed in silver, show a most successful translation. The colored decoration introduced yet another dimension to Sprimont's distinctive early English rococo forms. The scenes, depicting incidents in Turkish battles, were derived from engraved designs by Stefano della Bella (1610–64).

EXHIBITED: Detroit Institute of Arts, 1954, *English Pottery and Porcelain, 1300–1850*, p. 50, nos. 132–135.
REFERENCE: Untermyer *Chelsea*, 1957, pls. 14, 15, fig. 25.

255.

Tea service

English (Chelsea): 1750–52
Soft-paste porcelain
Mark: raised anchor
H. teapot 5 in. (12.7 cm.); D. saucers 4¼ in. (10.8 cm.)
64.101.445a, b–452

The oldest known advertisement of the newly founded Chelsea factory appeared in February 1749, offering for sale "Tea and Coffee Pots, Cups and Saucers of various Forms." Initially, most of the Chelsea services repeated forms and decorations of Chinese derivation, the exception being Sprimont's silver shapes, which he now adopted for soft-paste porcelain. The Fable Service was first produced during the Raised Anchor period (1750–52). The illustrations are derived from Francis Barlow's engravings in his folio edition of *Aesop's Fables* (London, 1665). The scenes, although unsigned, are applied with infinite care and artistic judgment. Comparison with signed work presenting similar wooded landscapes and floral sprays makes it seem possible that this decoration is the work of Jeffereys Hamett O'Neale, the principal Chelsea painter.

EX COLL. Bellamy Gardner (Sotheby's, 12 June 1941, lot 51, ill.).

EXHIBITED: Chelsea Town Hall, London, 1924, *Loan Exhibition in Aid of the Cheyne Hospital for Children: Chelsea China and Pottery* (catalogue by R. Blunt), no. 164, pl. 6; The Metropolitan Museum of Art, New York, 1949, *Masterpieces of European Porcelain,* no. 77.

REFERENCES: H. Bellamy Gardner, *English Ceramic Circle, Transactions,* 2, 1934, pp. 17–21, pl. 8 (one cup); W. H. Tapp, *Jeffereys Hamett O'Neale,* London, 1938, pl. 17, fig. 41 (bowl); Untermyer *Chelsea,* 1957, p. 16, fig. 26; see also J. C. Austin, *Chelsea Porcelain at Williamsburg,* Charlottesville, Va., 1977, no. 54, pp. 70 ff. (other fable services illustrated and discussed).

256.
Dr. Boloardo

> English (Chelsea): 1750–52
> Soft-paste porcelain
> Mark: raised anchor
> H. 7⅛ in. (18.1 cm.)
> 64.101.422

Some of the best Chelsea figures were produced during the Raised Anchor period (about 1749–52); most of them show the compelling influence of Meissen models. Not all of them escaped the hazards inherent in soft-paste porcelain. The rare Italian comedy figure of Dr. Boloardo, identified by his broad-brimmed hat and voluminous coat, collapsed slightly in the kiln, emerging bowlegged and bending forward more than intended. The fact that the soft paste does not pick up sharp detail, unlike the hard-paste Meissen model by Peter Reinicke of 1743–44, allows the figure's sweeping movements to become even more impressive. The Chelsea Sale Catalogue, 20 March 1755, mentions "Three figures of an Italian doctor."

EX COLL. Mrs. Radford, Lested Lodge, Well Walk, Hampstead (Sotheby's, 3–5 November 1943, lot 114, ill.).

EXHIBITED: Parke-Bernet, New York, 1955, *Art Treasures Exhibition,* no. 214.

REFERENCES: W. King, *English Porcelain Figures of the Eighteenth Century,* London, 1925, pl. 13, fig. 2; H. E. Backer, *Keramik-Freunde der Schweiz. Mitteilungsblatt,*

no. 26, December 1953, fig. 33; Untermyer *Chelsea,* 1957, color pl. 39, fig. 14.

257.
Pair of partridges

> English (Chelsea): 1750–53
> Soft-paste porcelain
> Mark: raised anchor (on each bird)
> H. 6 in. (15.3 cm.)
> 64.101.437, 438

An extraordinary sequence of birds was produced at Chelsea during the Raised Anchor period. Unlike the Meissen custom of modeling from life or from stuffed specimens, Chelsea birds were usually derived from the color plates of George Edwards' *Natural History of Uncommon Birds* (London, 1743–47). Our partridges were modeled after Edwards' *Little Partridges* (II, pl. 72). William Duesbury (1725–85), an independent decorator, was employed for the adaptations, and his London Account Book of 1751–53 repeatedly mentions "Chellsey" or "Chelsay" birds. Our birds are cited in the Chelsea Sale Catalogue, 12 March 1755: "2 partridges with wheat."

REFERENCE: Untermyer *Chelsea,* 1957, pl. 7, fig. 23.

258.
Oval dish

> English (Chelsea): 1752–54
> Soft-paste porcelain
> Mark: red anchor
> L. 12¾ in. (32.4 cm.)
> 64.101.482

The painted design derives from a circular Meissen plate, made about 1745, part of the large service Augustus III presented in 1747 to the British Minister in Dresden, Sir Charles Hanbury Williams. The Meissen service, now owned by the Duke of Northumberland, is at Alnwick Castle. In 1751, Sir

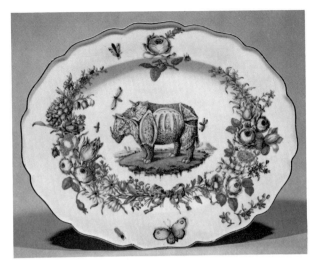

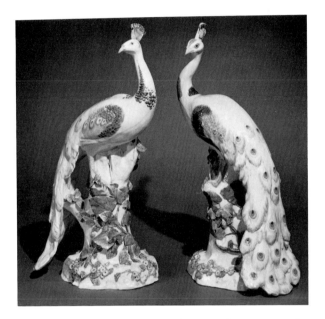

handling it, these are the only known large Chelsea birds. Unlike the earlier Meissen peacocks, which display their tail feathers as a magnificent wheel, the Chelsea birds pose with their tail feathers descending like regal robes. Reinforcing the naturally attenuated form, the modeler made the feathers and the supporting tree trunk into a solid unit designed to withstand the hazards of firing, particularly distortion. The clear even glaze received a colored decoration that changes from faint hues for part of the plumage to bright ones for others, including such highlights as the blue crests and the markings on the tails.

Charles lent much of his Meissen porcelain, then stored in Holland House in London, to the recently established Chelsea factory, where much of it was copied. The pictorial source for the rhinoceros is Albrecht Dürer's famous woodcut of 1515, known as the "Panzernashorn." Although a live rhinoceros was exhibited in London in December 1751, the Chelsea painter did not depart essentially from the time-honored and much copied Dürer woodcut, which he painted, surrounded by a floral wreath and butterflies, exactly as seen on the Meissen plate.

EXHIBITED: The Metropolitan Museum of Art, New York, 1949, *Masterpieces of European Porcelain*, no. 74.
REFERENCES: Untermyer *Chelsea*, 1957, pl. 17, fig. 48; T. C. Clarke, *Keramos*, 70, 1975, pp. 9–92, fig. 4, p. 12; idem, *Keramik-Freunde der Schweiz. Mitteilungsblatt*, no. 89, November 1976, no. 10, pl. 4, and p. 6.

EX COLL. Sir Ivor Maxse (Sotheby's, 1 February 1946, lot 32, ill. p. 7.).
REFERENCE: Untermyer *Chelsea*, 1957, color pl. 12, fig. 47.

259.

Pair of peacocks

> English (Chelsea): about 1756
> Soft-paste porcelain
> Unmarked
> H. 19, 18¾ in. (48.3, 47.7 cm.)
> 64.101.480, 481

Created by a modeler who knew the possibilities of soft paste, and had developed a particular flair for

260.

Pantaloon and Columbine

> English (Chelsea): about 1753
> Soft-paste porcelain
> Mark: red anchor
> H. 6¾ in. (17.2 cm.)
> 64.101.462

Although Kaendler's Italian comedy themes were

used as prototypes at Chelsea, the differences between the Meissen and Chelsea figures is striking. Part of this is accounted for in the difference of the pastes. The English soft paste lacks sharpness, but it has a smoothness enhanced by a glaze that readily absorbs colored decoration. But beyond this, in the passage of less than twenty years the baroque exuberance of Kaendler's figures has given way to the gentler rococo style. Columbine is no longer the cruel young beauty who ridicules the aged Pantaloon. And he, in turn, realizing that his time for amorous adventure is over, is resigned to serving his lady as best he can. Listed in the Chelsea Sale Catalogue, 11 March 1755, lot 27.

EXHIBITED: The Metropolitan Museum of Art, New York, 1949, *Masterpieces of European Porcelain,* no. 67.
REFERENCES: W. King, *Chelsea Porcelain,* London, 1922, fig. 30; Untermyer *Chelsea,* 1957, color pl. 38, fig. 31.

261.

Virgin and Child

Joseph Willems
English (Chelsea): about 1755
Soft-paste porcelain
Mark: red anchor
H. 8¼ in. (21 cm.)
1974.28.139

This may well be the most successful religious group in porcelain produced in England. Nicholas Sprimont, the director of the Chelsea factory in 1749, engaged Willems, a gifted modeler from Brussels. The influence of van Dyck is strongly felt in the pictorial quality of his group, which, furthermore, shows none of the inherent fragility of the medium. The Chelsea Sale Catalogue for 1755 refers to "An exceeding fine figure of a Madonna and a Child with a cross in its hands."

EX COLL. Baron Dimsdale, England (Sotheby's, 22 February 1972, lot 25, pl. VI).

262.

Scent bottles: Girl, Harlequin, Monk

English (Chelsea): about 1755
Soft-paste porcelain
Unmarked
H. 2½, 3½ in. (6.4, 8.9 cm.)
64.101.616a, b; 64.101.609a, b; 64.101.591

Generally known in their time as Chelsea Toys, scent bottles, bodkin cases, and patchboxes were ideally suited as tokens of love and friendship, sentiments frequently confirmed through their French inscriptions. The fashion for such objects originated in Meissen; it culminated at Chelsea. The sleeping girl guarded by a dog, inscribed FIDELLE ME GARDE, has an appealing air of innocence. The head of the Harlequin serves as the bottle's stopper; his support is a patchbox with hinged cover. The *Monk as Provender of the Monastery* not only carries a basket of eggs and a duck but, hidden within a sheaf of wheat, only her face and feet visible, a woman. This

satirical subject originated from broadsheets of the Reformation.

EXHIBITED: (64.101.609a, b; 591) The Metropolitan Museum of Art, New York, 1949, *Masterpieces of European Porcelain*, no. 78.

REFERENCE: Untermyer *Chelsea*, 1957, color pl. 62, pls. 71, 67 (detail), figs. 168, 161, 142.

263.

Chinese Musicians

English (Chelsea): about 1755
Soft-paste porcelain
Mark: red anchor
H. 14½ in. (36.8 cm.)
64.101.474

Among the most remarkable creations of Chelsea's Red Anchor period (1753–57), for the technical accomplishment in firing so large a soft-paste group was considerable. The modeler succeeded in harmonizing his exotic figures with rococo ideals of beauty. Although François Boucher and Jean Pillement had already found comparable solutions elsewhere, the English master followed his own creative impulse. Offering satisfying views from all sides, his group is ideally suited as a table centerpiece. It is mentioned in the Chelsea Sale Catalogue

of 8 April 1758: "A most magnificent LUSTRE in the Chinese taste, beautifully ornamented with flowers, and a large group of Chinese figures playing on music."

EX COLL. W. E. Hurcomb, London; Mrs. Frank Garvin, New York.

EXHIBITED: Chelsea Town Hall, London, 1924, *Loan Exhibition in Aid of the Cheyne Hospital for Children: Chelsea China and Pottery*, (catalogue by R. Blunt), no. 3A, pl. 12A; The Metropolitan Museum of Art, New York, 1941, *The China Trade and Its Influences*, fig. 46; Parke-Bernet, New York, 1942, *French and English Art Treasures of the XVIII Century*, no. 591; The Metropolitan Museum of Art, New York, 1949, *Masterpieces of European Porcelain*, no. 61, pl. 18.

REFERENCES: W. King, *Chelsea Porcelain*, London, 1922, frontispiece; Untermyer *Chelsea*, 1957, color pls. 29, 30, 31, fig. 39.

264.

Allegorical Groups: Winter and Spring, Summer and Autumn

Joseph Willems
English (Chelsea): 1760–65
Soft-paste porcelain
Mark: gold anchor
H. 12¾, 13¼ in. (32.4, 33.7 cm.)
64.101.520; 1971.75.1

Reunited in the Untermyer Collection, these two groups represent the Four Seasons. The festively attired couples holding seasonal attributes have small heads with amiable though empty faces that seem pale in comparison to the elaborate, densely patterned costumes enriched with burnished gold. Furthermore, the figures seem isolated from one another. The bases are loaded with applied vegetation, solidly supported below by rocaille decoration with pierced scrolls highlighted with gilding. These groups are among the last that Willems modeled at Chelsea, during the period of Sprimont's recurrent illnesses. Splendid as they are, they represent a style that had run its course. Comparable groups of the Seasons (R. Blunt, *Loan Exhibition in Aid of the*

Cheyne Hospital for Children: Chelsea China and Pottery, Chelsea Town Hall, London, 1924, pl. 17, no. 238; Sotheby's, 11 April 1946, lot 103), show slightly variant individual figures thus assembled. They may have been executed during the last and most difficult period of the Chelsea factory's existence, when new creations and proper supervision were lacking, although the traditionally high standards of workmanship were maintained until the enterprise was sold to James Cox in 1769/70.

EX COLL. (Winter and Spring) Mrs. K. Marlow (Christie's, 29 June 1937, lot 56, ill.).
EXHIBITED: (Winter and Spring) The Metropolitan Museum of Art, New York, 1949, *Masterpieces of European Porcelain*, no. 64.
REFERENCE: Y. Hackenbroch, *Metropolitan Museum of Art Bulletin,* June 1971, pp. 410–411, fig. 11 (both groups).

265.

George III and Queen Charlotte

> English (Chelsea): about 1761
> Soft-paste porcelain
> Unmarked
> H. 14¼ in. (36.3 cm.)
> 64.101.493

Historical themes were familiar at Chelsea. All such pieces are in white, perhaps in imitation of marble portraits. Eighteenth-century porcelain modelers relied on both sculptural and pictorial sources. However, sculpture was less suited to the more colorful porcelain medium, and it was usually drawn on only for historical events or personalities. The present group, commemorating the royal wedding in 1761, reveals affinities with the paintings of John Zoffany, engraved by James McArdell. The king and queen are placed upon porcelain scrollwork imitating a French rococo ormolu base. By this means the factory avoided an expensive importation.

EX COLL. Cookson, England; Charles E. Dunlap, New York.
EXHIBITED: The Metropolitan Museum of Art, New York, 1949, *Masterpieces of European Porcelain*, no. 62.

REFERENCES: F. Severne Mackenna, *Chelsea Porcelain: The Gold Anchor Wares,* London, 1952, p. 23; *Untermyer Chelsea,* 1957, pl. 43, fig. 57; A. Lane, *English Porcelain Figures of the 18th Century,* London, 1961, p. 54.

266.

Pair of vases with claret ground

> English (Chelsea): 1761–64
> Soft-paste porcelain
> Mark: gold anchor (on each)
> H. 9½ in. (24.2 cm.)
> 64.101.504, 505

The highlights of Chelsea's Gold Anchor period (1758–70) are vases with colored grounds inspired by those produced at Sèvres. Some of the vases are

rococo, others are more restrained; all are lavishly gilded. The ground of this pair attempts to duplicate the rose Pompadour of Sèvres, first applied in 1757. Sprimont, the Chelsea director, announced the new colors in 1760. Horace Walpole, who owned our pair, called their color "claret" in his *Description of Strawberry Hill*, 1774. The Bacchanalian scenes, painted in colors, are in the style of Boucher.

EX COLL. Horace Walpole (*Sale Catalogue of the Contents of Strawberry Hill*, 6 May 1842, lot 96, p. 64); Earl of Cadogan, 1865; Sir Hugh Adair, 1903; J. P. Morgan (Christie's, 22 March 1944, lot 48, ill.); Maj. J. C. Bulteel, Leighton, Devon (Christie's, 10 November 1949, lot 83, ill.).

REFERENCES: Horace Walpole, *Description of Strawberry Hill*, 1774, p. 482; *A Description of the Villa of Mr. Horace Walpole at Strawberry Hill*, 1784, p. 64; J. Marryat, *A History of Pottery and Porcelain*, 3rd ed., London, 1868, p. 378; A. H. S. Bunford, *English Ceramic Circle, Transactions*, 5, 1937, pp. 24–25; Untermyer *Chelsea*, 1957, color pl. 60, fig. 64; for quotation of Chelsea catalogue see J. E. Nightingale, *Contributions towards the History of Early English Porcelain from Contemporary Sources*, Salisbury, 1881, pp. 18–19.

267.

The Music Lesson

Joseph Willems
English (Chelsea): 1762–65
Soft-paste porcelain
Marks: gold anchor and R
H. 15 in. (38.1 cm.)
64.101.519

Typical of the "breath-taking opulence" (Lane, p. 7) of the Gold Anchor productions is this bocage group, which Willems modeled after the engraving by R. Gaillard of François Boucher's painting *L'Agréable Leçon*, 1748. This favorite subject, recurring as painted decoration in Chelsea, was also modeled (though without the bocage) at Vincennes, Frankenthal, and Vienna. The bocage, a typically English feature that brings everything into a splendid frontal view, makes such groups ideally suited for the mantel. 267 was lot 41 in the *Last Sale*

Catalogue of the Chelsea Porcelain of Mr. N. Sprimont, 15 February 1770: "A very large and curious group of a shepherd teaching a shepherdess to play the flute."

EXHIBITED: Residence of Sir Philip Sassoon, London, 1934, *Porcelain through the Ages, Loan Exhibition in Aid of the Royal Northern Hospital*, no. 146; The Metropolitan Museum of Art, New York, 1949, *Masterpieces of European Porcelain*, no. 66, pl. 20.

REFERENCES: Untermyer *Chelsea*, 1957, color frontispiece, fig. 73; A. Lane, *English Porcelain Figures of the 18th Century*, London, 1961, pp. 7, 72, note 5.

268.

Mezzetin and Isabella

English (Bow): 1749–50
Soft-paste porcelain
Unmarked
H. 7⅛ in. (18.1 cm.)
64.101.689

Foremost among the few Italian comedy groups originating at Bow, where porcelain was first made in 1748/49. The modeler had probably seen a similar Meissen group that was derived from an engraving by C. N. Cochin le Jeune, after the painting by Watteau, *Belles, N'écoutez rien ou Arlequin amoureux*. The soft paste used at Bow was coarser and the glaze thicker than at Chelsea, leading to difficulty in details. Here, this is apparent in the robust features and heavy eyelids. The open base discloses the irregular surface of the thick-walled paste as it was pressed into the mold by hand. The general effect presents an intriguing contrast between experimental attitudes toward the new medium of soft paste, and the self-assurance derived from the use of a previously approved model.

EX COLL. E. S. McEuen (Sotheby's, 31 May 1945, lot 85, ill.).

EXHIBITED: The Metropolitan Museum of Art, New York, 1949, *Masterpieces of European Porcelain*, no. 33.

REFERENCES: W. King, *Chelsea Porcelain*, London, 1922, fig. 6; A. J. Toppin, *English Ceramic Circle, Transactions*, 10, vol. 2, 1948, pl. 103a, b; Untermyer *Chelsea*, 1957, color pls. 90, 91, fig. 240.

269.

Chinese Goddess and Worshipers

English (Bow): about 1750
Soft-paste porcelain
Unmarked
W. 11 in. (27.9 cm.)
64.101.694

The modelers at Bow used Meissen models and English or Continental engravings as sources for their designs. This group reinterprets one of Jean Aubert's thirty engravings of 1731 after Antoine Watteau's decorations for the château of La Muette in the Bois de Boulogne. The worshipers may represent members of the 1686 Siamese mission to Louis XIV. The Bow modeler departed only slightly from the engraved design. The long pointed hat of the worshiper on the right is replaced by headgear composed of foliage, and the man at left, bareheaded in the engraving, wears a red cap. The goddess, Ki Mao Sao, who in the engraving holds an umbrella and palms and is enthroned on a cloud bank, here sits above a rocaille base decorated with gilding and pseudo Chinese characters.

EX COLL. C. W. Heneage (Sotheby's, 3 May 1946, lot 30); S. N. Nyburg.
REFERENCES: A. J. Toppin, *English Ceramic Circle, Transactions,* 10, vol. 2, 1948, pl. 102 (together with engraving); Untermyer *Chelsea,* 1957, color pl. 80, fig. 243.

270.

Kitty Clive and Henry Woodward

English (Bow): 1750
Soft-paste porcelain
Unmarked. Date incised in Woodward
H. 9¾, 10¾ in. (24.8, 27.4 cm.)
64.101.690, 691

Kitty Clive (1711–85) and Henry Woodward (1717–77) played the roles of the Fine Lady and the Fine Gentleman in Garrick's farce *Lethe,* first performed in Drury Lane 15 April 1740. The vehicle was the actors' greatest success. The figure of Kitty

Clive was modeled from an engraving by Charles Mosley published 1750, based on a drawing by Thomas Worlidge. The figure of Henry Woodward was modeled after a mezzotint by James McArdell after a painting by Francis Hayman, both of 1750. In Horace Walpole's *Description of Strawberry Hill,* 1774, we find: "Mrs. Catherine Clive, the excellent comedian, in the character of FINE LADY IN LETHE; in water-colours by Worlidge." The actress was a close friend of Walpole's and spent her later years, after retirement from the stage, in a cottage on Walpole's estate. These popular figures were modeled in other English factories, and both exist decorated in colors.

EXHIBITED: The Metropolitan Museum of Art, New York,

1949, *Masterpieces of European Porcelain* (Kitty Clive) no. 24; (Henry Woodward) no. 25.
REFERENCES: Y. Hackenbroch, *Connoisseur*, CXXXVIII, 1956, pp. 109–110, figs. 16, 17 (Kitty Clive and engraving by Charles Mosley); Untermyer *Chelsea*, 1957, pls. 76, 77, 145, fig. 241.

271.
Charging Bulls

Andrew Planché (1727[?]–1805)
English (Derby): about 1750
Soft-paste porcelain
Unmarked
Decorator: William Duesbury (1725–85)
W. 6¼, 5¼ in. (15.9, 13.4 cm.)
64.101.748, 749

Derived from an engraving by Johann Elias Ridinger, in *Entwurff einiger Thiere*, pt. III, Augsburg, 1738, pl. 37, captioned "Auer Ochse im Zorn" (Bull in Rage). Planché, from London, was referred to as "China maker" in Derby about 1747–57. At this early period in the factory's history, he was undoubtedly its most gifted modeler. His figures, like so many at Derby, have a vent hole in the base, and dry edges around the lower base, where the glaze is either scanty or absent. The floral sprays and bouquets of 271, with pink and green predominating, resemble those painted by William Duesbury, an independent porcelain decorator in London. The bulls may have been either sent to London, or painted by Duesbury in Derby after 1756, when he became the new owner of the porcelain works.

EXHIBITED: The Metropolitan Museum of Art, New York, 1949, *Masterpieces of European Porcelain*, no. 85.
REFERENCE: Untermyer *Chelsea*, 1957, pl. 104, fig. 278.

272.
Taste, Sight

Andrew Planché
English (Derby): 1750–54
Soft-paste porcelain

Unmarked
H. 8, 7 in. (20.3, 17.8 cm.)
64.101.738, 739

Planché's vigorous style and highly individual manner are seen in his groups of slightly grotesque Orientals, striking exaggerated poses. They form a sequence of the senses. *Sight* originally had a bird in the lady's hand. *Smell,* in the Metropolitan Museum (51.1.3), is a lady with a boy holding flowers. The gay coloring of all these groups, with washes of pale colors dominated by bright iron red, would appear to be factory work. Typically these groups have a vent hole in the base and dry edges.

EX COLL. L. A. Harrison, England (Sotheby's, 28 July 1937, lots 35, 36).
EXHIBITED: Chelsea Town Hall, London, 1924, *Loan Exhibition in Aid of the Cheyne Hospital for Children: Chelsea China and Pottery* (catalogue by R. Blunt), no. 164, pl. 6; Parke-Bernet, New York, 1942, *French and English Art Treasures of the XVIII Century*, no. 589; The Metropolitan Museum of Art, New York, 1949, *Masterpieces of European Porcelain*, no. 88.
REFERENCE: Untermyer *Chelsea*, 1957, color pl. 100, pl. 145, figs. 269, 270.

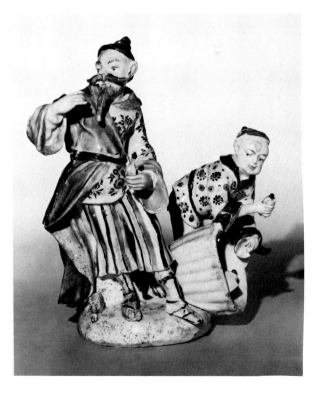

273.

Hercules and Omphale

English (Girl-in-a-Swing): 1751–54
Soft-paste porcelain
Unmarked
H. 8¾ in. (22.2 cm.)
1971.75.19

This factory derives its arbitrary name from one of about twenty-nine models, most of which are undecorated. A number of them are in the Untermyer Collection: a pair of white figural candlesticks representing Ganymede and the Eagle and the Rape of Europa (1971.75.20, 21), the candlesticks numbered

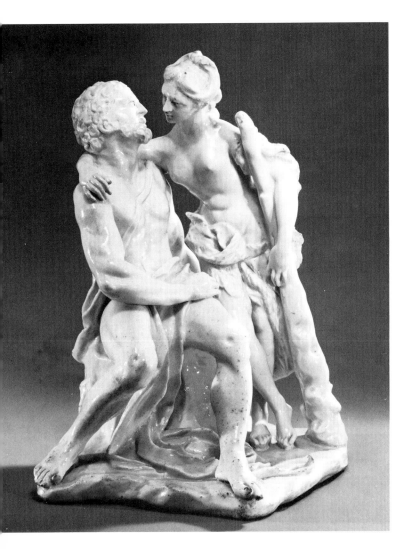

274, some scent bottles and seals enameled in colors, and *Britannia Mourning the Death of the Prince of Wales* (64.101.417). Since the prince died in 1751, we have an approximate date for all these productions. They seem to be the work of a single artist whose paste was white and fine-grained but unstable and subject to cracking in the kiln. His traces are lost about 1754, when scent bottles in his style were advertised for sale at Chelsea; these may have been the remaining stock of the Girl-in-a-Swing factory upon its closure. Some of the loveliest examples from this factory show the influence of French soft paste, particularly as handled at Vincennes. The theme of 273 occurs, in fact, in Vincennes soft paste (Metropolitan Museum 43.100.33), although the models show no direct dependence. Our group, less sophisticated than fashion-conscious French prototypes, derives from an engraving by Laurent Cars after a painting of 1724 by François Le Moyne. Technical considerations, such as the tightening of outlines to avoid breakages, imposed restraint. The figures' slender, tapering limbs, and their expression of tender intimacy are typical of the unknown master's manner.

REFERENCE: Y. Hackenbroch, *Metropolitan Museum of Art Bulletin,* June 1971, pp. 405–417, no. 6.

274.

Pair of figural candlesticks

English (Girl-in-a-Swing): 1751–54
Soft-paste porcelain
Unmarked
H. 7¾, 5½ in. (19.7, 14 cm.)
64.101.406, 407

Posing languidly, the slender figures are similar to those painted by the young Gainsborough. More directly, the girl depends upon an engraved illustration to the song "A Dying Nymph" in George Bickham the Younger's *Musical Entertainer,* 1739 (I, p. 43). Apparently the modeler was unacquainted with Meissen figures, but he may have known those of French soft paste. Indeed, the occasional decora-

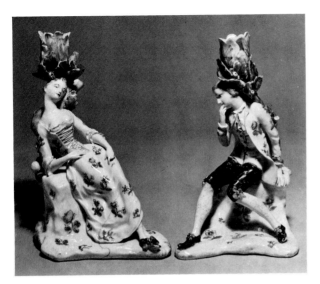

The earliest, short-lived porcelain works of Staffordshire were strongly influenced by local salt-glaze models in addition to those of Meissen and Chelsea. Models of considerable originality evolved in the 1750s. Local taste called for leaf, fruit, and floral forms—molded, applied, and painted—either on objects of use or decorative compositions. Typical are vases such as 275, with its allover decoration of applied flowers that climb to the top of the cone-shaped cover, on which a girl stands and birds nestle. The colors merge gently into the soft paste. Wisely, gilding was withheld, and the garden fantasy fits harmoniously into the life-style of Staffordshire's landed gentry.

REFERENCE: Untermyer *Chelsea*, 1957, pl. 119, fig. 305.

tion of roses and other floral sprigs is so closely related to the style of Mennecy that the painter may well have come from that factory. Such figures were fitted with candle sockets to encourage their purchase for domestic use, since the production of merely decorative objects, when not sponsored, was a precarious business for a porcelain factory.

EXHIBITED: Chelsea Town Hall, London, 1924, *Loan Exhibition in Aid of the Cheyne Hospital for Children: Chelsea China and Pottery* (catalogue by R. Blunt), no. 185, pl. 22; Parke-Bernet, New York, 1942, *French and English Art Treasures of the XVIII Century*, no. 586; The Metropolitan Museum of Art, New York, 1949, *Masterpieces of European Porcelain*, no. 42.

REFERENCES: O. Glendenning, *English Ceramic Circle, Transactions*, 8, vol. 2, 1942, pl. 57a; B. Gardner, *Connoisseur*, CIX, 1942, p. 39, ill.; F. Stoner, *Chelsea, Bow and Derby Porcelain Figures*, Newport, Mon., England, 1955, pl. 1; Untermyer *Chelsea*, 1957, color pl. 9, fig. 1.

275.

Pot-pourri vase

English (Longton Hall): 1754–57
Soft-paste porcelain
Unmarked
H. 16¼ in. (41.3 cm.)
64.101.791a, b

276.

Pair of covered vases

English (Worcester): 1768–72
Soft-paste porcelain
Mark: To (impressed on foot rim of each)
H. 15 in. (38.1 cm.)
64.101.784a, b, 785a, b

Worcester, established in 1751, produced only a few figures, concentrating instead on useful wares to assure the survival of the factory. Among its large early output were sets of splendid vases. Although almost contemporary with the Gold Anchor vases of Chelsea, they are less loaded with detail than those. Among the few eighteenth-century Worcester workers known by name, Tebo (presumably Thibaud anglicized) was active 1768–72, using the mark TO. His function as "repairer" allowed him to assemble decorative motifs and make them into a pleasing ensemble. This function of the "repairer" may account for two similar vases (ex coll. Gen. Sir Ivor Maxse, Sotheby's, 1 February 1946, lot 31), in which the bird finials have been exchanged for roses.

EX COLL. Berners; Humphrey W. Cook.

REFERENCE: Untermyer *Chelsea*, 1957, color pl. 116, fig. 300.

277.

Set of three vases

English (Bristol): about 1775
Hard-paste porcelain
Unmarked
H. 16½, 12½ in. (42, 31.8 cm.)
64.101.772a, b, 773, 774

Richard Champion's Bristol factory used hard paste
from Cornwall, patented 1774. The form here—
hexagonal, with narrow base swelling to broad
shoulder—and also the decoration are typical of
"Monsieur Saqui," an artist from Sèvres who later,
following the decline of Bristol, worked at Plym-
outh and Worcester. The decoration, alternating
predominantly blue and green panels of tall trees,
shows the quiet refinement that one expects of art-
ists initially trained at Sèvres. Two covered vases
belonging to this set, formerly in the Lord Fisher
collection, are now in the Fitzwilliam Museum,
Cambridge.

EX COLL. Mrs. Arthur James, Rugby, England.
REFERENCE: Untermyer *Chelsea,* 1957, pl. 112, fig. 294.

MEDIEVAL ART:
SCULPTURE AND
OTHER OBJECTS

The entries are by
CARMEN GÓMEZ-MORENO,
Curator-in-Charge, Department of Medieval Art,

except for 286, which is by
LAURENCE LIBIN,
Associate Curator in Charge, Department of Musical Instruments.

Abbreviations

Untermyer *Bronzes,* 1962

Y. Hackenbroch, *Bronzes and Other Metalwork and Sculpture in the Irwin Untermyer Collection,* New York, 1962

278.

St. James the Less, St. Phillip

German (lower Saxony): about 1350
Gilt bronze
H. 12½ in. (31.8 cm.)
64.101.1494, 1495

These appliqué figures are part of a series of apostles including St. Judas Thaddeus in the T. Flannery collection, Chicago, St. Bartholomew in the Art Institute of Chicago, St. Peter and St. Paul in the Detroit Institute of Arts, and St. John and St. James the Greater in the Kofler-Truniger collection, Lucerne. The Untermyer apostles are inscribed S. IACOBVS APLS and S. PHILIPPVS APLS. Although neither figure carries a symbol other than the book common to all the apostles, we know that the one called Jacobus is James the Less because the Jacobus in the Kofler-Truniger collection holds the pilgrim shell of James the Greater. The use of the twelve apostles in the predellas of altarpieces or in large shrines was popular in lower Saxony. There are also comparable wooden sculptures of apostles from lower Saxony.

EX COLL. Walter Tarnof, Berlin; Empress Frederick, Kronberg; Princess Margarete of Prussia; Landgraven of Hesse, Friedrichstal.
EXHIBITED: The Cloisters, New York, 1968–69, *Medieval Art from Private Collections,* nos. 104, 105.
REFERENCE: Untermyer *Bronzes,* 1962, pp. xxxviii, 25, pls. 94, 95, figs. 97, 98.

279.

Mourner from tomb of Fernando de Antequera, King of Aragon (d. 1416)

Pere Oller
Spanish (Catalonia): about 1417
Alabaster
H. 14¾ in. (37.5 cm.)
64.101.1496

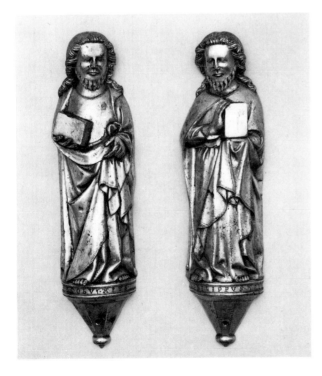

Commissioned by King Alfonso of Aragon, son of Fernando, the tomb and its series of mourning figures were carved by Pere Oller for the Abbey of Poblet. Most of the effigies of the royal pantheon were destroyed by Napoleon's forces. Although this was the only one of the royal tombs of Poblet executed by Pere, he carved other tombs, also with mourners around them, among them that of Bishop Berenguer de Anglesola in the Cathedral of Gerona. Not only does the concept of these tombs reflect contemporary French and Burgundian funerary customs that might also have been Spanish, but the style of Pere's figures is strongly influenced by the French and Burgundian schools. Yet his sculptures have a personality of their own. His realistic approach is revealed in his fondness for detail. Although his figures have squat proportions, they are treated with portraitlike naturalism. The excessively large heads and hands are balanced by the drapery spread around their feet. It is not known if Pere ever traveled outside Spain; the northern influence could have come to him through his master, Ca Anglada, a key figure in the transition from the pure Gothic style of the fourteenth century to the more naturalistic approach of the fifteenth.

EX COLL. Junyent, Barcelona.

EXHIBITED: The Cloisters, New York, 1968–69, *Medieval Art from Private Collections,* no. 41.

REFERENCE: Untermyer *Bronzes,* 1962, pp. xxxix, 26, pl. 96.

280.

Madonna and Child enthroned, crowned by angels and flanked by musical angels

> North Italian (Milan): about 1410
> Stone with traces of polychromy
> H. 32¼ in. (81.9 cm.)
> 1974.126.4

The International Style had a strong impact on artists working in and around the Cathedral of Milan about 1400, and that gigantic monument attracted many

artists not only from Italy but from other countries as well. The beauty and eclecticism characteristic of the Milanese workshop are seen in 280. The linear treatment of the drapery folds, the floating curls of the angels, and, above all, the elaborate architectural design of the throne bring to mind Austrian and Bohemian paintings and manuscript illuminations. The effect must have been even stronger when all the polychromy was present, since the scene was interpreted in a pictorial, two-dimensional way, with little sense of depth or volume. The relationship to, or derivation from, the painted media is not surprising, for there were several painters who made projects to be carried out in sculpture in the cathedral and, probably, in other monuments in Milan as well. While the original provenance of 280 is unknown, the lack of surface wear indicates that it was placed indoors in a church or private chapel.

REFERENCES: C. Freytag, *Metropolitan Museum Journal,* VII, 1973, p. 23, pl. 18; *Notable Acquisitions: 1965–1975,* The Metropolitan Museum of Art, New York, 1975, p. 152, ill.

281.

St. Mammès

Burgundian (Langres): late 15th century
Bronze
H. 13½ in. (34.3 cm.)
64.101.1497

Mammès was the patron saint of the town of Langres, and this is the chief reason for believing that this statuette comes from there. A native of Caesarea in Cappadocia, Mammès was thrown to the lions in Rome but remained unharmed. Later, he was disemboweled by order of Emperor Aurelius. Here, he holds his bowels and looks down at a lion sleeping at his feet. The elegance and restraint of the figure and its expression of serenity transcend the gruesome nature of the subject. The artist clothed Mammès not as a Roman, but within the style of fifteenth-century Burgundian sculptures representing contemporary people.

EXHIBITED: The Cloisters, New York, 1968–69, *Medieval Art from Private Collections,* no. 124; The Metropolitan Museum of Art, New York, 1974, *Saints and Their Legends,* no. 8.
REFERENCE: Untermyer *Bronzes,* 1962, pp. xxxix, 26, pl. 97.

282.

Flying angel

Probably Austrian (Styria): about 1490
Wood with polychromy and gilding on gesso
L. 18 in. (45.7 cm.)
1974.126.5

Delightful and lively, this must have belonged to one of the magnificent late Gothic retables that reached their apex of development during the second half of the fifteenth and first quarter of the sixteenth centuries. Angels of this type often flank the central theme of the retable, whether it be the Crucified Christ, the Savior in Glory, or God the Father with Christ Crucified, as in the *Gnadenstuhl.* Most often, such angels participate in the Crowning of the Virgin, a scene that was popularly presented either in the central part of the retable or in a superstructure. The position of the hands of 282, however, suggests that the figure held something other than a crown. The figure is carved in the round, and the back shows the same well-preserved polychromy and gilding as the rest; this suggests that the angel was placed in such a way that the back could be seen, perhaps in the superstructure of a retable, which is sometimes open.

EX COLL. W. R. Hearst.
REFERENCE: Untermyer *Bronzes,* 1962, p. 36, pl. 155, fig. 166.

283.

Pitcher with griffins and vine decoration in relief

Italian (Venice): about 1200
Bronze
H. 3¼ in. (8.3 cm.)
64.101.1406

The decorative motifs bear witness to the strong Byzantine influence in Venetian art. Because of the conservative character of Byzantine art, especially in its foreign adaptations, and of the long duration of its influence, the dating of Veneto-Byzantine objects like this one is difficult. Thus the date of this pitcher is only tentative.

EX COLL. A Castellani, Rome; Albert Figdor, Vienna (O. von Falke, *Sammlung Dr. Albert Figdor, Wien*, sale cat., Berlin, 1930, V, pt. 1, lot 462, ill.).
EXHIBITED: The Cloisters, New York, 1968–69, *Medieval Art from Private Collections*, no. 97.
REFERENCE: Untermyer *Bronzes*, 1962, pp. x, 5, pl. 1.

284.

Aquamanile in shape of a lion

North German: 13th century
Brass (dinanderie)
H. 7¾ in. (19.7 cm.)
64.101.1491

Romanesque aquamanilia are rare. They were produced in northern Germany, especially in Saxony, in the thirteenth century. This one has the vigor and originality of an early creation, since the lion is far from the tame, stereotyped lions found in the mass production that came later. The features are schematically rendered, drawing attention to what is most important: the ferocious eyes, sharp teeth, wild mane. Whether the vessel was made for secular or religious use cannot be established, but it was surely intended, like most aquamanilia, for the ceremonial washing of hands.

EX COLL. Oscar Hainauer, Berlin.
EXHIBITED: The Cloisters, New York, 1968–69, *Medieval Art from Private Collections*, no. 102.
REFERENCE: Untermyer *Bronzes*, 1962, p. 25, pl. 91.

285.

Aquamanile in shape of a unicorn

German (Saxony): about 1400
Brass (dinanderie)
H. 15¼ in. (38.8 cm.)
64.101.1493

First mentioned about 400 B.C. as a one-horned wild ass to be seen in India, the unicorn received his name from Pliny in the first century of our era. In the Middle Ages everyone believed in the existence of

the unicorn, and artists added their personal touches to his representations. Here, the head looks like a cross between a goat and a horse. The upturned flamelike tail curves to join the handle—an elongated catlike animal rather than the more usual dragon or basilisk. The front is fitted with a spigot. Though less vigorous than the beasts of earlier aquamanilia, the unicorn has a rather sophisticated outline in which curves lead the eye to the accent of the upthrust horn.

EXHIBITED: Museum of Fine Arts, Boston, 1940, *Arts of the Middle Ages*, no. 293; The Cloisters, New York, 1968–69, *Medieval Art from Private Collections*, no. 109.
REFERENCE: Untermyer *Bronzes*, 1962, p. 25, pl. 93.

286.

Mandora

North Italian: late 14th or early 15th century
Boxwood, spruce, rosewood
L. 14³⁄₁₆ in. (36.9 cm.)
64.101.1409

Since this has been altered from its original condition, we are uncertain whether it was meant to be plucked or bowed. The small one-piece body, integral neck (unfretted), and lateral pegs (absent), could suggest a plucked mandora or a bowed rebec. However, the pattern of wear on the inset spruce rosette, the figure of a girl plucking a similar instrument atop the pegbox, and other features of construction tend to favor the mandora. Perhaps a bridge once stood in the shallow groove across the lower portion of the belly. Five strings were tied through holes at the bottom, passed over the bridge and rosewood fingerboard, and fastened to tapered tuning pegs. Incorporating four tiny hearts in its design, a pierced rosette occupies most of the area of the flat top plate, where four circular inlays probably once filled depressions near the corners. Whatever its original form, the instrument, only about half an inch deep inside and hollow all the way up to the pegbox, is unlikely to have produced a robust tone. Full of nuptial symbolism, the deep-relief carving on the back shows a young falconer and his loose-tressed

tree, as it were in heaven, a saintly figure stands with unfurled scroll and left hand raised as though in blessing. Higher still a grotesque monster, his inlaid eye poked out, lurks ominously. Taken together with the performing girl and heart-inspired rosette on the front, these spirited carvings indicate that the instrument was intended as a betrothal or wedding gift for a young woman.

EX COLL. E. de Miller-Aichholz, Vienna; Albert Figdor, Vienna; Oscar Bondy, Vienna.

EXHIBITED: The Cloisters, New York, 1968–69, *Medieval Art from Private Collections*, no. 216, ill.; The Cloisters, New York, 1975, *The Secular Spirit*, no. 242, color pl. 13.

REFERENCES: O. von Falke, *Pantheon*, IV, 1929, p. 331, fig. 9; K. Geiringer, *Musical Instruments*, New York, 1945, no. 1, pl. 12; E. Winternitz, *Music Library Notes*, IX, June 1952, p. 398; Untermyer *Bronzes*, 1962, pp. xi, 6, pl. 5; E. Winternitz, *Musical Instruments of the Western World*, New York, 1967, pp. 48, 51, ill.; E. Melkus, *Die Violine*, 2nd ed., Bern, 1975, p. 18, ill.

287.

Mortar with arms of Froeschl of Martzoll

Austrian (Salzburg): 1451
Bell metal
H. 9¼ in. (23.5 cm.)
64.101.1540

A rare example of a medieval object with date (on base) and provenance clearly established. When it was made, the Froeschl family—the frog in the coat of arms stands for the name—lived in Reichenhall and Traunstein on profits from the salt mines in the Salzburg area. Two of the figures on the mortar are St. Rupert, who introduced the salt industry and made Salzburg wealthy, and St. Virgil (holding a geometric instrument), who founded the monastery of St. Peter and the Cathedral of Salzburg. Both saints are patrons of the town. Also represented are the Virgin and Child and St. Leonard, the patron saint of prisoners, much venerated in Austria and Bavaria. A mortar, possibly this one, is listed in a 1553 inventory of the Froeschl family. Related

mistress accompanied by their faithful dog, standing beneath a tree in which Cupid draws his bow. An alert stag leaps below the couple, while above the

examples with similar figures of the Virgin are in
the Musée des Arts Décoratifs, Paris (from the
Martin Le Roy collection), and the Victoria and
Albert Museum.

EXHIBITED: The Cloisters, New York, 1968–69, *Medieval
Art from Private Collections,* no. 118; The Cloisters, New
York, 1975, *The Secular Spirit,* pp. 34–35, no. 22.

REFERENCES: L. Kesteloot, *Jaarboeok van de Koninklijke
Oudheidkundige Kring van Antwerpen,* 1953–54, p. 8; Y.
Hackenbroch, *Connoisseur,* CXXXII, 1954, p. 171;
*Deutsche Bronzen der Renaissance: Collection Johannes
Jantzen,* Schloss Cappenberg, 1960, note to no. 58;
E. Meyer in *Festschrift Eberhard Hanfstaengl,* Munich,
1961, p. 21, fig. 10; Untermyer *Bronzes,* 1962, pp.
xlviii, 31, pls. 136, 137, figs. 147, 148.

288.

Plate with pelican in her piety

Netherlandish, Walloon (Dinant or Malines): about
 1480
Brass (dinanderie)
D. 20 in. (50.8 cm.)
64.101.1498

The pelican feeding her offspring with her own
blood is often represented on the cross, above the
rotulus, as a symbol of Christ's sacrifice for mankind.
Here, the subject is surrounded by a stylized grape
vine. It is exceptional to find this subject on a plate.
As the term "dinanderie" implies, the chief center of
the production of these works in bronze, brass, and
copper was originally Dinant. From the last quarter
of the fifteenth century through the first quarter of
the sixteenth, dinanderie plates were mass-produced
in the Netherlands and Germany, and certain rep-
resentations, religious or secular, animal or floral,
were repeated many times—but not this one. The
quality of the design and its execution are much
higher in 288 than usual in dinanderie plates. The
play of light and shade seems to have been taken into
account when the drawing was made on the metal.
When the artist had nearly finished his alternating
motifs in the wreath that was traditional on these
plates, he found that he would have to repeat one of
the motifs out of sequence. The interruption of the
design, beneath the pelican's feet, is an indication
that this is an original design, not a copy of an

existing one. Large dinanderie plates like this one
were probably made for secular use either in private
homes or monasteries.

EX COLL. Albert Figdor, Vienna (O. von Falke, *Sammlung
Dr. Albert Figdor, Wien,* sale cat., Berlin 1930, V, pt. 1,
lot 495, ill.).

EXHIBITED: The Cloisters, New York, 1968–69, *Medieval
Art from Private Collections,* no. 121.

REFERENCES: A. Walcher von Molthein, *Altes Kunsthand-
werk,* 1, I, 1927, p. 6, pl. 5, fig. 10; Untermyer *Bronzes,*
1962, pp. xliii, 26, pl. 98.

289.

Plate with wife triumphing over husband

South Netherlandish (Dinant or Malines): about
 1480
Brass
D. 20 in. (50.8 cm.)
64.101.1499

Hitherto, the subject was usually thought to illus-
trate the popular medieval legend of Aristotle being
ridden by Phyllis. Although the motif of the wife
astride her husband was probably derived from such
a representation, the scene here is now thought
simply to depict a woman's tyrannical rule over her
husband. The object to the left represents the method
of spinning wool by hand from a fixed distaff. The
yarn on the spindle had to be wound off with a
cross-reel such as that held by the man. Spinning was
usually considered woman's work; that a man could
be reduced to the task would suffice to express the
woman's rule. His position and the fact that she is
beating him, perhaps for not performing the task
correctly, leave no doubt as to the wife's supremacy.

EX COLL. Albert Figdor, Vienna (O. von Falke, *Sammlung
Dr. Albert Figdor, Wien,* sale cat., Berlin, 1930, V, pt. 1,
lot 496, pl. 180).

EXHIBITED: The Cloisters, New York, 1968–69, *Medieval
Art from Private Collections,* no. 122; The Cloisters, New
York, 1975, *The Secular Spirit,* no. 73.

REFERENCES: A. Walcher von Molthein, *Altes Kunsthand-
werk,* 1, I, 1927, pl. 1, fig. 2; Untermyer *Bronzes,* 1962,
pp. xliii, xliv, 26, pl. 99, fig. 102.

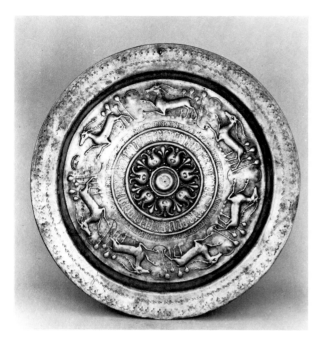

290.

Plate with running deer

German: end of 15th century
Brass (dinanderie)
D. 23¾ in. (60.4 cm.)
64.101.1508

Deer are among the most favored and successful of the many subjects on dinanderie plates. They appear in a great variety of numbers and postures. The simplest composition shows a single deer in the center surrounded by floral motifs. In others, deer encircle a central subject in pairs or in a double series. Here, a stylized floral motif in the center is encircled by two bands of embossed inscriptions, above which a line of deer races past clumps of trees. The design is vigorous and lively, and the play of low and high relief reveals a high degree of sophistication.

EX COLL. Albert Figdor, Vienna (O. von Falke, *Sammlung Dr. Albert Figdor, Wien,* sale cat., Berlin, 1930, V, pt. 1, lot 502, pl. 182).
EXHIBITED: The Cloisters, New York, 1968–69, *Medieval Art from Private Collections,* no. 125.
REFERENCE: Untermyer *Bronzes,* 1962, pp. xliv, 27, pl. 106, fig. 111.

291.

Flagon with mark of Villach

North German (Lüneburg): late 15th century
Pewter
H. 12 in. (30.5 cm.)
64.101.1542

The style is transitional between Gothic and Renaissance. The decorative motif of saints beneath arches occurs in early Gothic examples, but the arches here, less pure, behave more like capricious branches than architectural elements. The style and technique of the figures derive from the Master E. S. The handle, formed of tendrils twisted together and ending in dragonlike heads, contrasts sharply with the simplicity of the vessel's outline. The elegance of

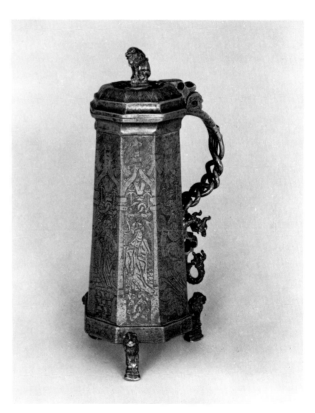

the shape and the elaborate decoration, together with the lack of wear, indicate that the flagon must have been intended for ceremonial or decorative, rather than everyday, use.

EX COLL. Frau Widmann-Lingg, Lindau; Albert Figdor, Vienna (O. von Falke, *Sammlung Dr. Albert Figdor,*

Wien, sale cat., Berlin, 1930, I, pt. 1, lot 305, pl. 62);
Oscar Bondy, Vienna.

EXHIBITED: The Cloisters, New York, 1968–69, *Medieval
Art from Private Collections,* no. 123.

REFERENCES: K. Berling, *Altes Zinn,* Leipzig, 1920, p. 69,
fig. 42; H. Herschel Cotterell, *Apollo,* XVIII, 1933,
p. 318; Untermyer *Bronzes,* 1962, pp. 1, 31–32, pl. 139,
fig. 150.

292.

Two candleholders: Fool and Jester

Attributed to Aert van Tricht
German (lower Rhenish): about 1500
Brass (dinanderie)
H. 11½, 12 in. (29.2, 30.5 cm.)
64.101.1534, 1535

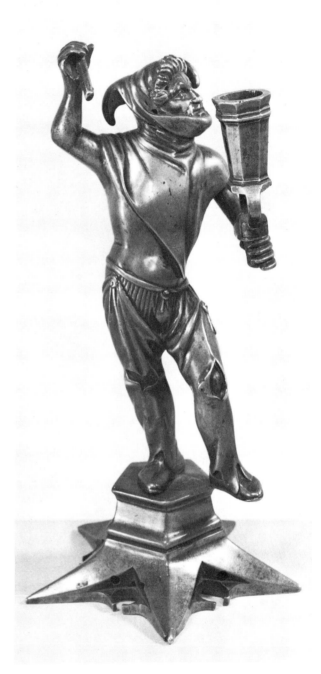

Yvonne Hackenbroch's attribution of these candle-
holders to Aert van Tricht is based on their similarity
to his other works. Nothing is known of his activity,
but he left his signature on two baptismal fonts, one
in the Church of Notre Dame in Maastricht, the
other in the Church of St. Jean in s'Hertogenbosch.
According to Hackenbroch, the figures crowning the
candle balustrade of the Cathedral of St. Victor in
Xanten, Rhineland, dated 1501, are very similar to
ours.

EX COLL. (Jester) Baron Thyssen, Lugano; (Fool) Count
Enzensberg, Enzensberg Castle; Richard von Kauf-
mann, Berlin (O. von Falke, *Sammlung Richard von
Kaufmann,* sale cat., Berlin, 1917, III, lot 461); Camilo
Castiglioni, Vienna; Jules Bache, New York (Kende
Galleries, New York, 19–20 April 1945, lot 476).

EXHIBITED: The Cloisters, New York, 1968–69, *Medieval
Art from Private Collections,* nos. 126, 127.

REFERENCES: L. Planiscig, *Sammlung Camilo Castiglioni: Die
Bronzestatuetten und Geraete,* Vienna, 1923, pl. 110;
E. Meyer in *Festschrift Hans R. Hahnloser,* Basel, 1961,
p. 178, fig. 28; (both figures) Y. Hackenbroch, *Con-
noisseur,* CXXXIX, 1957, p. 219; Untermyer *Bronzes,*
1962, pp. xlvi, 30, pls. 128, 129, figs. 139, 140.

SCULPTURE:
RENAISSANCE
AND LATER

The entries are by
JAMES DAVID DRAPER,
Associate Curator, Department of Western European Arts.

Abbreviations

Bode, 1908, I; 1912, III

W. Bode, *The Italian Bronze Statuettes of the Renaissance,* 3 vols., London, 1908–1912

Notable Acquisitions, 1975

Notable Acquisitions: 1965–1975, The Metropolitan Museum of Art, New York, 1975

Untermyer *Bronzes,* 1962

Y. Hackenbroch, *Bronzes and Other Metalwork and Sculpture in the Irwin Untermyer Collection,* New York, 1962

Weihrauch, 1967

H. R. Weihrauch, *Europäische Bronzestatuetten, 15.–18. Jahrhundert,* Brunswick, 1967

293.

Sleeping Hercules

Italian (Florentine): last quarter 15th century
Heavy hollow-cast dark reddish bronze; two small
 irregular holes in wall of cast by lion's tail; low
 arc cut from center of self-base
H. 5⅜ in. (13.7 cm.)
68.141.18

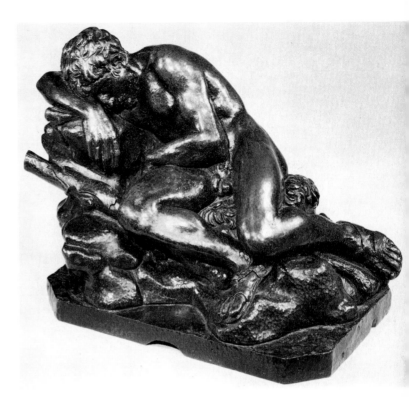

Yvonne Hackenbroch sees this as a work by Peter
Vischer the Younger of Nuremberg, calling atten-
tion to his training in a Paduan workshop in his
formative years. She relates it to German interest in
the subject of the young Hercules and his choice
between Virtue and Vice, which occurred to Her-
cules in a dream. In a forthcoming article for
Marsyas, Michael Mezzatesta will also specify the
subject as the Dream of Hercules. In *Notable Acqui-
sitions*, 1975, the present cataloguer characterized
the work as "about 1500, north Italian." Indeed, it
has a poetry that is related to Venetian painting. But
it is important to note that the cast is of a simple,
sturdy sort found in earlier Tuscan bronzes. It is
quite heavy, and the interior shows how the wax
has been mounded upon a shallow core and the
bronze cast then finished inside with perpendicular
chisel strokes. The metal, naturally patinated a rich
red brown, is particularly close to works cast in
Florence. The evident hammer strokes broadly but
expertly define the surfaces of the piece and indicate
an open delight in the varied textures they create.
Most significantly of all, the overlapping planes of
the angular figure are built up in a layered manner
typical of a man strongly influenced by Florentine
quattrocento reliefs in the wake of Donatello. In the
sharp features and expressive pose, there are echoes
of the figural style of Donatello's own reliefs for the
pulpits of S. Lorenzo, which were a training ground
for later fifteenth-century Florentine bronze sculp-
tors. Our artist has in a sense transferred the relief
principle to sculpture in the round, for the statuette
was designed to be seen from above. Truly satisfac-
tory comparisons are wanting, but a Florentine
Hercules struggling with a lion, in the Victoria and
Albert Museum (ascribed by Bode to Bertoldo and,
in the 1961–62 *Meesters van het brons* exhibition at

the Rijksmusem, no. 20, to Giovanni Francesco
Rustici), presents limited similarities of facture and
compositional purpose. 293 is by a more assured
hand. A derivative bronze in the Ca'd'Oro in Ven-
ice has an old but incorrect attribution to Tiziano
Aspetti. It represents a sleeping youth (no longer
Hercules), nude but for his shoes. It is a relatively
light cast, hammered all over but much less articu-
lately.

REFERENCES: *Notable Acquisitions* 1975, p. 238; Y. Hack-
 enbroch, *Jahrbuch der Hamburger Kunstsammlungen*,
 XXI, 1976, pp. 43–54.

294.

Nymph and Satyr

Zaccaria Zacchi (1473–1544)
Italian (Tuscan): 1506
White marble with dark intrusions of mica; satyr's
 head broken and restored at neck; signed and
 dated around the base: ZACCARIAE.ZACCHII.VOLAT-
 ERRANI.OPUS.AN.SAL.MDVI.
H. 21½ in. (54.5 cm.)
64.101.1443

Zacchi was born in Arezzo of a Volterran family. According to Vasari he became a close friend of the Florentine sculptor Baccio da Montelupo and "borrowed many things from him." Although he was not a major talent, Zacchi was much employed on large-scale decorative schemes farther north, especially in Bologna and Trent. 294 is his earliest known work. While the satyr's body is inert, the nymph's is tremulous and expressive. Its awkward but charmingly earnest qualities place the group at the very heart of the early Renaissance struggle to comprehend classical form.

EX COLL. Oscar Huldschinsky, Berlin.

REFERENCES: W. Bode, *Die Sammlung Oscar Huldschinsky,* Frankfort, 1909, pp. 13 and 43, no. 64; N. Rasmo in U. Thieme and F. Becker, *Allgemeines Lexikon der bildenden Künstler,* Leipzig, 1947, XXVI, p. 374; Untermyer *Bronzes,* 1962, pp. xxiv, 16, fig. 49.

295.

Satyress with Urn and Lyre; Satyr with Urn and Pipes

> Andrea Briosco, called Riccio (d. 1532)
> Italian (Paduan): about 1510–20
> Light hollow casts of reddish bronze; remains of dark brown lacquer; satyr formerly ithyphallic; points of horns of satyr and right horn of satyress broken; top left arm of satyress' lyre broken; satyr's right hand and handle of vase broken and replaced by modern parts
> H. 9½ in. (24 cm.) and 9⅞ in. (25 cm.)
> 64.101.1415, 1416

Classical satyrs, those enigmatic beings between men and brutes, were a frequent theme of the north Italian Renaissance, and Riccio and his shop specialized in them. While satyrs in Greco-Roman art go about their business as a time-honored matter of course, those of the classical revival sometimes appear to exert themselves to gain sympathy, and these two are especially appealing in their dim but painful awareness of inhabiting another world. The thin figures and taut facture are extremely impressive, like the figures in the best of Riccio's reliefs, but it is notoriously difficult to date his statuettes with any

precision in the context of documented reliefs. The closest comparison is perhaps with an undated relief of Christ in Limbo in the Louvre, where the elongated nudes and tightly organized, delicately hammered surfaces are virtually identical and produce similarly elegiac effects. The standing satyress is the

sole survivor of her kind among Riccio's statuettes, but there is an upright satyr with shorter horns in the Museo Correr, Venice, of lower quality than 295 but identical in stance except for a raised left arm (G. Mariacher, *Bronzetti veneti del rinascimento*, Vicenza, 1971, fig. 76).

EX COLL. Richard von Kaufmann, Berlin; private collection, Budapest.

EXHIBITED: Königliche Akademie der Künste, Berlin, 1914, *Ausstellung von Werken alter Kunst aus dem Privatbesitz von Mitgliedern des Kaiser Friedrich-Museums-Vereins*, p. 59, nos. 270, 271; Smith College Museum of Art, Northampton, Mass., 1964, *Renaissance Bronzes in American Collections*, no. 10; The Metropolitan Museum of Art, New York, 1973, *Early Renaissance Sculpture from Northern Italy*, nos. 34, 35.

REFERENCES: L. Planiscig, *Andrea Riccio*, Vienna, 1927, pp. 356–357, figs. 435, 436; Untermyer *Bronzes*, 1962, pp. xvi, 8, figs. 12, 13.

296

296.
Seated Satyr with Pipes and Shell-lamp

Model by Andrea Briosco, called Riccio (d. 1532)
Italian (Paduan): about 1510–20
Hollow-cast yellowish bronze, cast through opening in figure's seat; remains of dark brown lacquer; eyes silvered; both legs broken and restored at shins
H. 9¼ in. (23.4 cm.)
64.101.1417

Riccio cannot himself have been entirely responsible for all the statuettes and reliefs that poured from his very successful shop. As strongly as one feels that the models of both 295 and this seated satyr are by Riccio's hand, one is forced to concede that the manner of finishing is very different, this being more closely chased but losing ultimately in surface excitement. In this case, as in others, he may have modeled the figure but left the casting and chasing to assistants. The anatomy, with short, rather weak arms, shallow but delineated pectorals and shoulder blades, and long, strong legs, is consistent with Riccio's documented relief style, as is the upturned, wistful head with short curly hair and goaty whiskers in thin strands. The silvered eyes are a rare but not unique usage for Riccio; they occur in a beautiful Seated Pan in the Ashmolean Museum, Oxford. An X ray of the cast shows that the figure was first modeled in wax upon an hourglass-shaped clay core and that the pipes and shell-lamp were cast in one with the figure. Thus it is a unique cast, though closely related in composition to other seated satyrs with varying attributes (L. Planiscig, *Andrea Riccio*, Vienna, 1927, figs. 430, 433, and Bardini sale cat., Christie's, 5 June 1899, no. 28), each of which was newly modeled upon one of the stock of clay cores. Judging from photographs, 296 surpasses the others in quality, with the possible exception of the former Bardini statuette.

EX COLL. von Pannwitz, Berlin.

REFERENCES: O. von Falke, *Die Kunstsammlung von Pannwitz*, Munich, 1925, II, no. 4; Untermyer *Bronzes*, 1962, pp. xvi, 8, 9, figs. 14, 15; *Notable Acquisitions*, 1975, p. 231.

297.

Rearing Horse

Italian (possibly Venetian): about 1500
Heavy hollow-cast bronze; grainy surface; dark
 brown patina
H. 7⅛ in. (18 cm.)
64.101.1413

Known in several examples, some of which (those
in Venice, Paris, Berlin, and the Heinz Schneider
collection, Lakewood, Ohio) have riders on their
backs, which would help to explain the animal's
lunging movement; however, none of the riders
looks particularly as if he belonged with the horse
originally. While this is a fair cast, the best of all is
that in the Ca'd'Oro, Venice, in which details of
hair and hooves have exceptional clarity. The
present model has usually been attributed to Bar-
tolommeo Bellano on the basis of his realistic,
crowded Old Testament scenes in bronze in the
Santo, Padua (1480s), but Bellano's relief style is
much more rectilinear than this. A more apt
attribution is that to Severo da Ravenna, proposed
by Bertrand Jestaz. The Severo workshop replicated
models prolifically, as in the case of this horse, but it
must be asked whether the example in the Ca'd'Oro
does not speak for a more gifted modeler. The
semiheraldic type surely originated in the Veneto,
where horses with a similar horizontal pose between
rearing and galloping are a recurrent device. A
masterpiece of the type in painting is the horse in
Carpaccio's St. George Killing the Dragon, in the
Scuola di S. Giorgio degli Schiavoni, Venice.

REFERENCES: Untermyer *Bronzes*, 1962, pp. xiii, 7, fig. 10;
 B. Jestaz in *La Revue du Louvre et des Musées de France*,
 XXII, 1972, p. 76; W. D. Wixom, *Renaissance Bronzes
 from Ohio Collections*, exhib. cat., Cleveland, 1975, no.
 77.

298.

St. Christopher

Attributed to Severo da Ravenna
Italian (school of Ravenna): about 1500
Hollow-cast yellowish bronze, remains of black

lacquer; casting hole in bottom of tunic; two
broken fingers in left hand; lead repairs in both
legs.
H. 10¼ in. (26 cm.)
64.101.1410

Two other casts are known, in Berlin-Dahlem and
in the Louvre; 298 is slightly nearer the Berlin cast.
The Louvre example is missing the circular clasp on
the right shoulder, and the hair and features are not
quite as well chased. The model was regularly at-
tributed to Bartolommeo Bellano until Bertrand
Jestaz noted similarities to statuettes of Neptune by
Severo da Ravenna, whose workshop was in Ra-
venna but who kept in close touch with styles in
Venice and Padua. If it is indeed by Severo, the
closely studied contrapposto and sweeping move-
ment are unusually successful for him. The figure
has frequently been identified as Atlas; Jestaz ob-
served that the Louvre cast has a hole in the left
hand and that a seated Christ Child in the National
Gallery, Washington, D.C. (Kress collection) is a
perfect fit for this hand; the Louvre St. Christopher
and Washington Christ Child were then reunited to
form a complete composition. Apparently no other
example of the Christ Child exists.

EX COLL. Alphonse Kann, Paris; John Simon, New York.
EXHIBITED: Detroit Institute of Arts, 1958–59, *Decorative
 Arts of the Italian Renaissance, 1400–1600*, no. 228.
REFERENCES: Bode, 1908, I, p. 21, pl. XXI; H. Landais, *Les
 Bronzes italiens de la Renaissance*, Paris, 1958, p. 40;
 Untermyer *Bronzes*, 1962, pp. xiii, 6, figs. 6, 7; *Bild-
 werke der Christlichen Epochen von der Spätantike bis zum
 Klassizismus*, Staatliche Museen, Berlin, 1966, p. 100,
 no. 555; B. Jestaz in *La Revue du Louvre et des Musées de
 France*, XXII, 1972, pp. 67–68.

299.

Cleopatra

Attributed to Severo da Ravenna
Italian (school of Ravenna): first quarter 16th cen-
 tury
Hollow-cast reddish bronze, traces of black lacquer;
 open mouth, large hole in seat plugged with wax;
 matched squarish bronze plugs on back of hips
H. 10¼ in. (26 cm.)
64.101.1433

By examining the casting techniques with X rays, Richard E. Stone has convincingly demonstrated that this and a large body of statuettes derive from Severo da Ravenna, whose workshop was in fact in Ravenna and not Padua, as is commonly believed. With her peculiarly low center of gravity, this Cleopatra is one of Severo's poorest compositions from an anatomical point of view, but there is a degree of success in her expression as she reacts to the sting of the asp. Several examples exist, including one in the Metropolitan (10.9.2), cast identically but with a different mottled brown and green patina.

EX COLL. Mrs. Benjamin Stern, New York.

REFERENCES: L. Planiscig, *Andrea Riccio*, Vienna, 1927, p. 86, fig. 75; Untermyer *Bronzes*, 1962, pp. xx, 14, fig. 35.

300.

Seated Pan

Italian (Paduan or Venetian): about 1510–20
Heavy hollow-cast bronze; remains of dark brown lacquer; right arm broken at wrist
H. 11¼ in. (28.6 cm.)
64.101.1418

This is a clever assimilation of the Riccio style. It is properly lyrical and rather painterly in its hammered surfaces, but the anatomy is too inert and the facture finally too slack to permit the old attribution to Riccio. Peter Meller in conversation tentatively suggested the name of Alessandro Leopardi, founder of the great flagpole stands in the Piazza S. Marco in Venice (1501–05). Leopardi is not presently known as a maker of statuettes, but there is a certain correspondence, especially between the dry, angular ornament of the flagpole reliefs and the sharply modeled goatskin and head on the peculiar bell-shaped base of the Pan.

EX COLL. Bruno Kern, Vienna.

EXHIBITED: Kunsthistorisches Museum, Vienna, 1936, *Kleinkunst der italienischen Frührenaissance*, p. 136; Detroit Institute of Arts, 1958–59, *Decorative Arts of the Italian Renaissance, 1400–1600*, no. 245; Museum of Fine Arts, Houston, Tex., 1960, *The Lively Arts of the Renaissance*, no. 113.

REFERENCES: L. Planiscig, *Zeitschrift für bildende Kunst*, LXIII, 1929, pp. 168–172; idem, *Dedalo*, XII, 1932, p. 920; L. Fröhlich-Bum, *Pantheon*, XVIII, 1936, p. 287; W. Born, *Burlington Magazine*, LXIX, 1936, p. 136; Untermyer *Bronzes*, 1962, pp. xvi, 9, figs. 16, 17.

301.

Spinario

North Italian: about 1500–20
Hollow-cast bronze; remains of dark brown lacquer
H. 7½ in. (19 cm.)
68.141.9

The antique Spinario in the Capitoline Museum, a dreamy youth pulling a thorn from his foot, is a genre figure that particularly excited the interest of Renaissance artists. And judging from the mass of replicas it spurred (which by their very number generally defy attribution), it found its way into a good many Renaissance rooms. This is a nicely spirited reduction, with a delicate, ornamental, springing quality enhanced by the generous tooling of the muscles in arcs and by the arbitrary placement of a goat's head in full relief on the rear of the tree stump.

EX COLL. von Pannwitz, Berlin.

REFERENCE: O. von Falke, *Die Kunstsammlung von Pannwitz*, Munich 1925, II, p. 2, no. 14.

302.

Horse and Rider Startled by a Snake

North Italian (probably Paduan): about 1500–20
Hollow-cast in separate parts of golden reddish bronze; largely intact dark brown lacquer patina; base has open bottom, horse and snake attached by solder; rider has open seat and opening in mouth; steadied on horse by horn-shaped protuberance on horse's neck; horse has opening in mouth, missing plug on top of head, plug and small hole on left flank
H. 10 in. (25.4 cm.)
64.101.1419

The old attribution of this splendid bronze to Riccio is belied by the thin cast, smooth contours, and refined, crisp details of chasing. It is likely that the artist had seen Riccio's Shouting Warrior (Victoria and Albert Museum), but this is an imaginative reworking of the theme that far exceeds imitation. It has luckily survived with its original base and the offending serpent intact, and thus depicts some real or imagined event of Roman antiquity. The scene derives ultimately from an antique gem (S. Reinach, *Pierres gravées,* Paris, 1895, pl. 61, no. 57[3]; A. Furtwängler, *Die antiken Gemmen,* Leipzig—Berlin, 1900, I, no. 56, pl. XIX, no. 35, pl. XX). A closely related rider whose horse is lost is in the Kunsthistorisches Museum, Vienna; according to Manfred Leithe-Jasper it is superior to 302. It is well made, but in fact it is a different conception entirely, with older features and a coarser expression. Weak copies of the Vienna rider, mounted on horses derived from one of the ancient horses on the façade of S. Marco, Venice, exist at Klosterneuburg, in the Frick Collection, and in the Robert Lehman Collection. Our artist, like Riccio, has been greatly influenced by the expressive realism of Mantegna, with his grimacing facial types and taut, active poses, and by the lyric, streamlining influences of classical antiquity as well. His touch is so very

precise that one suspects he may have been a goldsmith and that his model was one of wood. The style is close to that of Francesco da Sant'Agata, whose signed boxwood Hercules in the Wallace Collection is a rare combination of supple movement and hard surfaces. Whoever our artist was, he or his immediate circle produced a number of unique statuettes, thinly cast and minutely chased, in marked contrast to the looser methods of Riccio. All have smooth contours and anguished Mantegnesque features. The figures are small and compressed, and when clad, have crisp, angular drapery folds. The related works, all superb, include the Hercules and Antaeus in the National Gallery, Washington, D.C. (Widener collection), usually attributed to Francesco da Sant'Agata; the Susanna in the Frick Collection, N.Y., often attributed to Riccio; the Europa in the Budapest Museum of Fine Arts; and the Prudence in Berlin-Dahlem. The rectilinear drapery folds of the last two have led them to be attributed to Bartolommeo Bellano, but they are much sharper, lighter, and more energetic works than Bellano could have managed. Each of the related bronzes gives an impression of rigidity, yet of infinite grace, and they all are intensely pictorial creations.

EX COLL. Count Donà dalle Rose, Venice; John Simon, New York.

REFERENCES: L. Planiscig, *Dedalo,* XII, 1932, p. 915; idem, *Katalog der Kunstsammlungen im Stifte Klosterneuburg,* Vienna, 1942, III, p. 8, no. 4; Untermyer *Bronzes,* 1962, pp. XVII, 9–10, figs. 18–20; J. Pope-Hennessy, *The Frick Collection,* New York, 1970, III, p. 114; *Notable Acquisitions,* 1975, p. 231; M. Leithe-Jasper in *Italienische Kleinplastik . . . der Renaissance,* exhib. cat., Schloss Schallaburg, Vienna, 1976, pp. 75–76, no. 47.

303.

Triumph of Neptune

North Italian: about 1515–25

Bronze relief, solid cast with a flat back, the background tooled with a punch except for the rim, which was covered by a frame; four holes in rim now filled; warm brown natural patina

D. 9¾ in. (24.8 cm.)

64.101.1426

The punched background of this beautiful tondo provides a foil for the sleek, crisply detailed figures and is a clue for relating it to Venetian reliefs of the early sixteenth century, such as those by the Master of the Barbarigo Reliefs and Vittore Camelio, but here the figures are more gracefully evolved. The best point of departure for the dramatic little composition may be the marble mythological reliefs that Antonio Lombardo executed in Ferrara for Alfonso d'Este, now in the Hermitage, Leningrad. Contrary to the Kress catalogue, it can be stated categorically that the Untermyer piece is better than those in the Louvre and Kress collection. Both of these are smaller (22 and 21.6 cm.). The Kress example is similar in many respects, but the facial features are blunted and the background is not tooled. The background of the Louvre example is coarsely punched with a rayed effect, the anatomy of the figures is weaker and the males are bearded. An example in the Bischoffsheim collection, later de Noailles collection (J.-B. Giraud, *Les Arts du métal,* Paris, 1881, pl. xx), is further reduced (18 cm.) and lacks a punched ground, but the figures may approach those of the Untermyer relief in quality.

REFERENCES: Y. Hackenbroch, *Connoisseur,* CXLIX, 1962, pp. 18–23; Untermyer *Bronzes,* 1962, pp. xviii, 12, fig. 28; J. Pope-Hennessy, *Renaissance Bronzes from the Samuel H. Kress Collection,* London, 1965, p. 95, no. 339.

304.

Hercules

North Italian (Venetian?): mid-16th century
Hollow-cast bronze except for arms, legs, and club, which are cast solid and finely joined; rectangular plug in back visible only in X ray; remains of dark brown lacquer patina
H. 8½ in. (21.6 cm.)
64.101.1545

The pose of this figure must seem rather eccentric, unless viewed in profile, where his lurking movement makes it clear that he was engaged with another figure, now lost, in one of the deeds of Hercules. The pose and facture (the figure is much

hammered except in the small of his back in a flattened area around the plug) have given rise to considerable speculation as to the figure's origin, suggested as north Italian, Florentine, or German. To date, the most satisfactory suggestion has been Planiscig's attribution to the Venetian Camelio (d. 1537), whose two signed reliefs in the Ca'd'Oro, Venice, contain energetic nudes angularly poised, as well as thoroughly roughened surfaces. But one stops short of an outright attribution. For one thing, the style is far from identical; for another, Camelio's role as a maker of statuettes remains unclear, and the statuettes attributed to him generally show a more sophisticated understanding of anatomy than is manifest in the reliefs.

EX COLL. von Pannwitz, Berlin; Henry Oppenheimer, London.
EXHIBITED: Burlington Fine Arts Club, London, 1912, *Italian Sculpture,* no. 63, pl. XXXII; Royal Academy of Arts, London, 1930, *Italian Art 1200–1900,* p. 449D.
REFERENCES: Bode, 1912, III, pl. 240; idem, *Die italienischen Bronzestatuetten der Renaissance,* Berlin, 1922, pl. 72; M. H. Longhurst, *Burlington Magazine,* LVI, 1930, p. 10; L. Planiscig, *Piccoli bronzi italiani del Rinascimento,* Milan, 1930, pl. 133, no. 233; Untermyer *Bronzes,* 1962, p. 32, fig. 153.

305.

Bust of the young St. John the Baptist

After a model attributed to Antonio Lombardo (about 1458–about 1516)
Italian (Venetian): probably 16th century
Hollow-cast reddish bronze; remains of black lacquer; small hole in right ear
H. 5¾ in. (14.5 cm.)
68.141.10

There are casts of this Giovannino in the museums of Florence (Bargello), Berlin, and Houston. L. Planiscig (*Jahrbuch der Kunsthistorischen Sammlungen in Wien,* IX, 1937, p. 114) illustrated the example now in Houston to show the closeness of the model to the head of the Christ Child belonging to Antonio Lombardo's bronze Madonna in the Zen Chapel of S. Marco, Venice. Bode (1908, I, pl. III) believed

it to be the work of the Florentine Vittorio
Ghiberti, continuator of the style of his famous
father, Lorenzo. The cast closest in appearance to
Antonio Lombardo's Christ Child is the one in the
Bargello, where the head shares a gentle softness of
contours. The other examples, not least 305, are by
a relatively heavy hand, and the features are as a
result both hard and saccharine. However, the inte-
rior of the cast is briskly tooled in a way seen in
good early bronzes.

EX COLL. von Pannwitz, Berlin.

EXHIBITED: The Metropolitan Museum of Art, New
York, 1973, *Early Renaissance Sculpture from Northern
Italy,* no. 19.

REFERENCES: O. von Falke, *Die Kunstsammlung von Pann-
witz,* Munich, 1925, II, no. 11, pl. VI; W. von Bode,
Bildwerke des Kaiser-Friedrich-Museums, Berlin, 1930, II,
p. 3, no. 9.

306.

Bust of a Roman

> North Italian: mid-16th century
> Hollow-cast reddish bronze; dark brown lacquer
> patina; traces of gilding on mantle; occasional fine
> cracks (as on forehead and neck) and small holes
> (as in corner of left eye)
> H. 21¾ in. (55.2 cm.)
> 68.141.22

Copies and careful adaptations after the antique
were a fundamental part of the sixteenth-century
sculptor's repertory. The exact prototype of this
bust remains to be discovered, but the facial type is
probably Roman, of the third century A.D. The
artist was a north Italian of the generation after the
Mantuan Antico (d. 1528), that most precious of
classical revivalists. There are certain parallels with
the bust of an emperor in the Liechtenstein coll-
ection signed by Ludovico Lombardi (about 1507–
75), a sculptor and founder active in Rome, Recana-
ti, and Loreto; however, 306 has a more lapidary
hardness and polish. In the Metropolitan Museum is
a bust of Antoninus Pius by Antico (65.202), its
pendant when in the collection of Mme. d'Yvon
(dispersed 1892).

EX COLL. Mme. d'Yvon, Paris.

EXHIBITED: The Metropolitan Museum of Art, New
York, 1973, *Early Renaissance Sculpture from Northern
Italy,* no. 15.

307.

Jupiter

> After a model by Benvenuto Cellini (1500–71)
> Possibly cast by Pietro da Barga (active 1574–88)
> Italian (Florentine): about 1580
> Light hollow-cast bronze; arms cast separately at
> shoulders; green and brown patina (bronze has
> probably been resurfaced); traces of black lacquer
> H. 12⅜ in. (31.4 cm.)
> 64.101.1446

One of the tasks required of Cellini at the court of
Francis I, as described in his *Autobiography,* was to
produce twelve lifesize statues of the gods in silver,
to serve as candelabra for the royal dining room at
Fontainebleau. Only one, the Jupiter, was cast be-
tween 1540 and 1544, and it survives only in the

form of bronze reductions. Other examples are in the Detroit Institute of Arts, the Museo Arqueológico in Madrid, the collection of Perry T. Rathbone, and Hamburg, Museum für Kunst und Gewerbe. The Juno of the series is known from Cellini's preliminary drawing in the Louvre as well as by a bronze reduction in the Niarchos collection, Paris. None of the bronzes is sufficiently well cast or tooled to be considered autograph. Even so, they provide precious evidence of Cellini's French period. The compositions, with raised arms and svelte contrapposto, were developed further in Cellini's

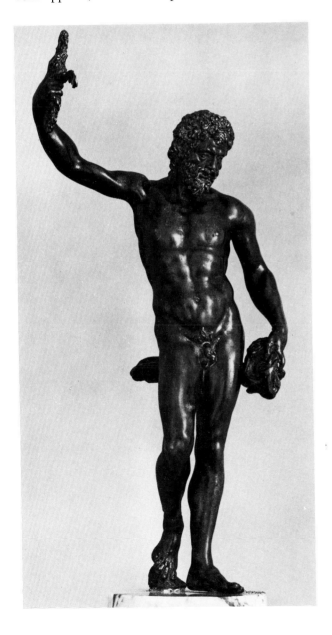

later statuettes of the gods on the base of his Perseus in the Loggia dei Lanzi, made upon his return to Florence. Cellini mentions that the silver Jupiter held a torch in his right hand and in his left a "ball signifying the world." A just inference is that Cellini returned to Italy with a model of the Jupiter, which was subsequently altered so that the identifying attribute became a raised thunderbolt rather than a lowered globe, as the functional torch of the statue no longer made sense in terms of a statuette. The undulating but flaccid body and the overdrawn, beefy features of 307 are reminiscent of the style of Pietro da Barga, who made bronze reductions after the antique and Michelangelo for Cardinal Ferdinando de' Medici between 1574 and 1588, most of which survive in the Bargello (G. de Nicola, *Burlington Magazine,* XXIX, 1916, pp. 363–371, especially figs. F, G, N). This resemblance is greater in 307, which is probably the best of the Jupiter reductions, but it is also visible in the head of the Madrid cast.

EX COLL. J. Porges, Paris; Samuel Untermyer, Yonkers.
REFERENCES: W. R. Valentiner, *Art Quarterly,* II, 1939, pp. 35–49; *W. R. Valentiner Memorial Exhibition: Masterpieces of Art,* North Carolina Museum of Art, Raleigh, 1959, p. 23, no. 16; Untermyer *Bronzes,* 1962, pp. xxvi, 18, figs. 55, 56; Weihrauch, 1967, pp. 180, 505 note 232; J. Hayward, *Arte illustrata,* 58, 1974, pp. 157, 162 note 5.

308.

Farnese Hercules

> Cast after the antique by Pietro da Barga (active 1574–88)
> Italian (Florentine): about 1576
> Light hollow-cast bronze, gilt (gilding absent on back below shoulders); circular plugs on abdomen and thighs
> H. 9 in. (22.9 cm.)
> 64.101.1462

An entry in the inventory of Cardinal Ferdinando de' Medici, dated 6 November 1576, states that a bronze Hercules made by Pietro da Barga was "said

by him to be the portrait of the one belonging to Cardinal Farnese." The Farnese Hercules, now in the Museo Nazionale in Naples, was one of the grandest antiquities unearthed in Rome in the Renaissance (1540). Its swagger pose engendered countless copies. Yvonne Hackenbroch observed the identity of style between this gilt copy and an ungilt one by Pietro da Barga still in Florence, in the Bargello (G. de Nicola, *Burlington Magazine*, XXIX, December 1916, fig. F opp. p. 363). The warm gilding of the front is impressive; its absence on the back indicates that the bronze was used decoratively or architecturally and not meant to be handled.

REFERENCE: Untermyer *Bronzes*, 1962, pp. xxxi, 22, fig. 73.

309.

Venus Drying Herself

After a model by Giovanni Bologna (1529–1608)
Italian (Florentine): about 1590–1620
Hollow-cast bronze; remains of transparent brown
 lacquer
H. 10¼ in. (26 cm.)
68.141.25

A speciality of Giovanni Bologna was the *figura serpentinata*, in which the figure is arranged in delicate curves and triangulations leading one into the next so that the eye travels swiftly over and around the piece. The elegant crouching Venus has this continual movement, expressed tautly and with a jeweler's refinement. It and other compositions helped spread the reputation of Giovanni Bologna as the greatest, most sophisticated Florentine sculptor of his generation. In fact, he seized upon the bronze statuette as the vehicle of his fame. For Giovanni Bologna's original wax model of this composition, a date in the early 1570s is suggested by the extreme but perfectly evolved serpentine pose, similar in its ambition to those realized on a larger scale in his later versions of the Mercury and the Apollo in the Studiolo of Palazzo Vecchio. The earliest mention of a bronze, however, is in the

1584 inventory of Cardinal Ferdinando de' Medici. Another in the 1609 inventory of Lorenzo Salviati is said to be "by the hand of Antonio Susini." In the Bargello, Florence, is perhaps the finest surviving example, the drapery of which is quite crisp. Others, including those in the museums of Berlin, Dresden, Brussels, Frankfort, and the Louvre, as well as one in the Metropolitan Museum (24.212.15), are the work of skilled workers in a mass-production situation, perhaps supervised by Antonio Susini; 309 belongs to this somewhat later group.

EX COLL. Prince Nicholas of Rumania.

310.

Geometry

After a model by Giovanni Bologna (1529–1608)
Italian (Florentine): about 1590–1610
Bronze cast solid except for base; golden metal with
 light brown lacquer patina; occasional small
 round plugs
H. 15¾ in. (40 cm.)
64.101.1450

The pose is a reworking of Giovanni Bologna's Venus of the Grotticella in the Boboli Gardens, Florence, of the early 1570s. He planned the pose to mirror the composition of his Apollo in the Studiolo of Palazzo Vecchio. The serpentine formation of limbs is made elegant as well as manneristically unstable by the radical reduction of the base to a very small area. The signed gilt example in the Kunsthistorisches Museum, Vienna, is so splendid that it must be considered the only autograph bronze of the composition. Among the many replicas, this one is distinguished by the extreme heaviness of the metal and the pleasing, light brown patina. The chasing is rather broad and not of the very precise sort usually seen in Giovanni Bologna's immediate successors.

REFERENCE: Untermyer *Bronzes*, 1962, pp. xxix, 19, fig. 60.

311.

The Dwarf Morgante

> After a model attributed to Giovanni Bologna
> (1529–1608)
> Italian (Florentine): about 1600
> Hollow-cast bronze; yellowish brown natural pat-
> ina with traces of transparent lacquer; both square
> and round plugs
> H. 5⅛ in. (13 cm.)
> 64.101.1452

Morgante was the favorite dwarf of Cosimo I de' Medici, Grand Duke of Tuscany. Many casts with slightly varying attributes exist, proving that this was a very popular bronze. Here Morgante pretends to be Bacchus, with goblet and grapes. In fact, the swagger pose is a parody of a format usually reserved for exhorting rulers (such as statues by Giovanni Bologna of Cosimo I and Ferdinando I). Although this is a mediocre example, one can appreciate the minutely studied checks and balances of the contrapposto system.

EX COLL. Enrico Caruso, New York.
REFERENCE: Untermyer *Bronzes*, 1962, p. 20, fig. 62.

312.

Rape of a Sabine

> After Giovanni Bologna (1529–1608)
> Italian (Florentine): about 1675–1700
> Hollow-cast bronze of golden red color; remains of
> black opaque lacquer
> H. 23½ in. (59.5 cm.)
> 1970.315

By 1579, Giovanni Bologna produced a large statuette of a two-figure nude group involved in a balletic abduction scene. He declined to give the pair a precise significance, calling it simply a Rape. Bronzes after this model are in Naples, Vienna, and the Metropolitan Museum (63.197). Between 1579 and 1583, the sculptor added a crouching elder male nude at the base. The marble three-figure group in the Loggia dei Lanzi, Florence, was the heroic re-

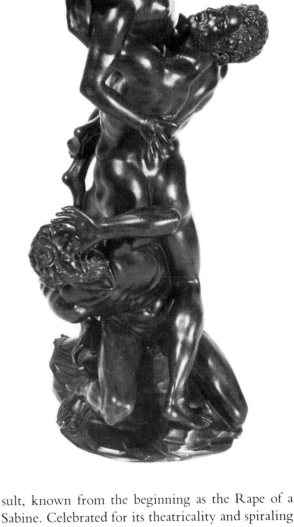

sult, known from the beginning as the Rape of a Sabine. Celebrated for its theatricality and spiraling twists and turns, the group inspired a stream of copies. Possibly the finest of the bronze reductions is

that in the Bayerisches Nationalmuseum, Munich. 312 appears identical to it in most points but does not match its brilliant chasing. From a distance, the grainy dark lacquer has a dull satiny look. It is of a type much in use in late seventeenth-century Florentine workshops, notably in that of Massimiliano Soldani. These shops maintained the Florentine standards of casting that lasted from the days of Giovanni Bologna himself, and our example is proof of that continuing excellence.

313.

Architecture

> After Giovanni Bologna (1529–1608)
> Northern European: late 17th century
> Yellowish hollow-cast bronze; left arm cast separately; remains of dark reddish lacquer
> H. 14¼ in. (36.2 cm.)
> 64.101.1449

Giovanni Bologna made a marble figure of a seated woman with the instruments of architecture for Grand Duke Albrecht V of Bavaria. It is lost, but a second marble is in the Bargello. For the figure, Giovanni Bologna posed a compositional problem very different from his research into the *figura serpentinata,* for the Architecture is stable and comparatively reposeful. A bronze statuette of the composition in the Boston Museum of Fine Arts is signed and quite fine. Markus Zeh of Augsburg owned a cast in 1611, and two belonged to the French crown in 1684. The Untermyer cast is of a type represented in museums in Florence, Paris, Rotterdam, London (Wallace Collection), and Toledo, none of which are either early seventeenth-century or Florentine. The hard contours and cross-hatched tooling of the flesh speak in favor of the later seventeenth century, possibly in France or the Netherlands.

REFERENCES: Untermyer *Bronzes,* 1962, pp. xxix, 19, fig. 59; W. D. Wixom, *Renaissance Bronzes from Ohio Collections,* exhib. cat., Cleveland, 1975, no. 150.

314.

Arm (sconce)

> Italian (probably Tuscan): late 16th–early 17th century
> Hollow-cast reddish bronze; light brown patina with traces of transparent reddish brown lacquer and gilding; fitted with bronze pan for holding candle
> L. 17 in. (43.2 cm.)
> 64.101.1487

This noble torch-bearing arm, which once dramatically illuminated a palazzo, was previously catalogued as Venetian, second half of the seventeenth century. It is more likely a work produced at an earlier moment under Florentine influence, as suggested by the rhetorical separation of the index finger from the others, in the manner of Giovanni Bologna and his followers; the squarish cut of fingernails; the closely studied but androgynous anatomy in general; and the textural effect produced by cross-hatching on the circlet of drapery.

EX COLL. Oscar Hainauer, Berlin.

REFERENCES: W. von Bode, *The Collection of Oscar Hainauer,* London, 1906, no. 441; Untermyer *Bronzes,* 1962, p. 25, fig. 91.

315.

Venus Marina

> Girolamo Campagna (1549–1625)
> Italian (Venetian): late 16th century
> Heavy hollow-cast bronze with arms and dolphin cast solid; occasional solder repairs; dark brown lacquer patina, somewhat worn; incised on base: I and C separated by punched ornament
> H. 17½ in. (44.5 cm.)
> 68.141.19

Girolamo Campagna's style, dramatic but unfocused, is founded upon a painterly attitude toward sculpture—hardly surprising in the Venice of Jacopo Tintoretto. One of Campagna's important commissions was a series of large stone figures of

classical deities high on the balustrade of Jacopo Sansovino's Library in the Piazza S. Marco. His Venus, loosely adapted (in reverse) from the ancient Medici Venus, was finished by 1589. There exist many bronzes with variations on the composition;

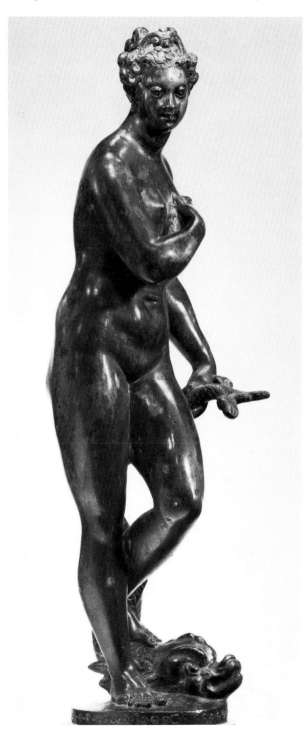

315 stands out among them for the expressive features and undulating flesh, conveying excellently Campagna's painterly bent. This is the largest of four bronze statuettes bearing the initials I. C. (Weihrauch, 1967, pp. 156–158). The signatures are nearly disguised in the punched ornament around the bases. None of these bronzes has the crispness of the monumental bronze sculptures cast from Campagna's models, such as those on the high altar of S. Giorgio Maggiore, where the metal has a sharper edge than is found in his work in stone. It has been hinted by Wladimir Timofiewitsch (*Girolamo Campagna. Studien zur venezianischen Plastik um das Jahr 1600,* Munich, 1972, p. 24) that the initials may be those of Girolamo's younger brother Giuseppe who, on one occasion, signed himself "iseppo." In the absence of positive information on the founders of Girolamo's bronze sculptures, the theory is not without merit. But it remains equally true that the best of the statuettes ascribed to Girolamo, such as this Venus, have a close relationship to certain of his larger works. The elaborate headdress and the approximation of chiaroscuro obtained in the features of the Venus are met in early works such as the stucco Sybils in S. Sebastiano (1582), more than in his later works. One might suspect that the statuette reflects an unused preliminary model for the Library figure. The problem is more one of identifying the caster than of recognizing the modeler; in this case, almost beyond doubt the model was Girolamo's own.

EX COLL. Ferdinando Adda, Cannes.
REFERENCE: Weihrauch, 1967, pp. 156–157, 504 note 210.

316.

Mars

Tiziano Aspetti (1565–1607)
Italian (Paduan): about 1590–1600
Very heavy cast; yellowish bronze with occasional small plugs; warm brown lacquer patina; circular bronze securing device soldered to underside
H. 21⅛ in. (53.6 cm.)
1970.314

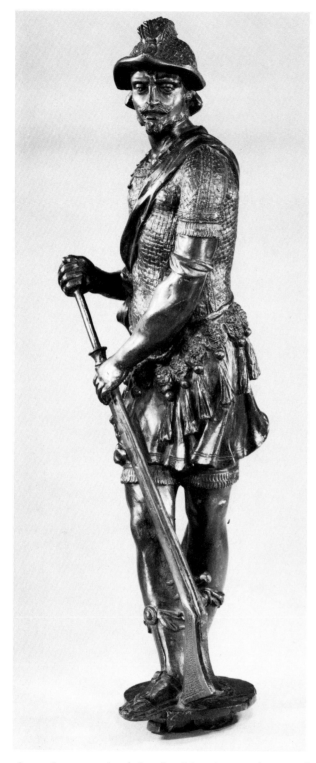

armed, down to the trim of Gorgon's heads and tassels on his cuirass. Another good example is in the Budapest Museum of Fine Arts. It is intended to represent a mere warrior, as its pendant is a similarly armed male figure. Elsewhere, the figure certainly represents Mars, as he accompanies Minerva or Venus. Typically, the figures formed the tops of andirons; this function is indicated in the attachment underneath 316. Aspetti also produced a more classical nude Mars for an andiron, an example of which is in the Frick Collection, New York. The rich accretion of detail and the finely faceted surfaces of 316, as well as the classical type of figure seen in the Frick composition, are equally visible in Aspetti's two reliefs with narratives from the life of St. Daniel of Padua, made in 1592–93 for the Cathedral of Padua and acquired by the Metropolitan Museum (1970.264.1, 2).

317.

Dido

Italian (Roman) or Flemish: about 1630–50
Hollow-cast golden bronze; remains of transparent brown lacquer; drapery separately cast and joined; blade of sword missing; "Boulle" base of wood inlaid with tortoiseshell and pewter
H. 9 in. (22.9 cm.)
64.101.1466

This small, eloquent figure, the work of a first-rate sculptor, shows knowledge of the rhetorical language of Bernini and Rubens in equal measure. Bronze statuettes of the Roman High Baroque are rather rare, since a sculptor's energies more often went into heroic designs on a larger scale. Another example of this bronze, less expertly chased, is in the Victoria and Albert Museum, and a silvered one is in the Bayerisches Nationalmuseum, Munich. The situation is somewhat analogous to the François Duquesnoy Flagellation groups replicated in bronze as well as various other media. Anthony Radcliffe postulated a lost original of the Dido in ivory or boxwood, which would help explain why the bronzes are usually attributed to a Flemish master under Roman influence.

Aspetti was trained in the Venetian tradition of Alessandro Vittoria and Girolamo Campagna, but his work gradually took on a detailed aspect with more picturesque effects. His thoroughly updated Mars loading a rifle, for example, is most stylishly

EX COLL. Charles Loeser, Florence.
REFERENCES: Untermyer *Bronzes*, 1962, pp. xxxv, 23, fig.
 79; A. Radcliffe, *European Bronze Statuettes*, London,
 1966, p. 108; Weihrauch, 1967, pp. 479–480; *Notable
 Acquisitions*, 1975, p. 232.

318.

Christ Child

Ferdinando Tacca (1619–86)
Italian (Florentine): about 1665
Hollow-cast reddish bronze: remains of transparent
 lacquer
H. 9¼ in. (23.5 cm.)
64.101.1467

This was long considered Flemish, as were many
statuettes that now can be seen to derive from the
Florentine workshop of Ferdinando Tacca, an artist
whose oeuvre was imperfectly known until it was
restudied by Anthony Radcliffe. Radcliffe showed
that Tacca's work occupied an important interim
position in Florence, and was a missing link, in fact,
between the mannerism of the long-lived Giovanni
Bologna school and the full-fledged baroque to
come. The slowly winding contrapposto of the
Christ Child is closely related to two candlestick-
supporting angels in the Wallace Collection, made
for the Palazzo Ducale at Massa before 1662, while
the long-haired juvenile type, rather flabby and
unfocused, is closer to that of Tacca's infant Bacchus
on a fountain in Prato, completed in 1665.

REFERENCES: Untermyer *Bronzes*, 1962, pp. xxxv, 23, fig.
 80; A. Radcliffe in Kunsthistorisches Institut, Florence,
 Kunst des Barock in Toskana, Munich, 1976, p. 22 note
 21.

319.

Panther

Italian (Roman): late 18th century
Hollow-cast reddish bronze; remains of black lac-
 quer
H. 7⅝ in. (19.4 cm.)
68.141.28

This and closely related examples in the Toledo
Museum and formerly in the Weininger collection,
New York, as well as elsewhere, were long consid-
ered to be Paduan bronzes showing early Renais-
sance vigor and naturalistic curiosity in the com-
plete exposition of musculature. However, the
extreme attenuation of form and sophistication of
casting indicate a much later date. H. R. Weihrauch
indicated their probable source in a 1795 price list
of the Roman founder Giovanni Zoffoli, in which
casts of a "Notomia di Tigre" (anatomical figure of
a tiger) were offered for sale at ten sequins. Weih-
rauch (1967, fig. 516) illustrated one example as by
Giovanni's slightly elder kinsman, Giacomo
Zoffoli.

REFERENCE: W. D. Wixom, *Renaissance Bronzes from Ohio
 Collections*, exhib. cat., Cleveland, 1975, no. 163.

320.

Crucified Christ

South German: about 1530
Polychromed limewood; arms carved separately
H. 11 in. (27.9 cm.)
64.101.1555

The figure was removed from a modern cross and
cleaned to reveal pigmentation that is eroded but
quite delicate. Even so, the polychromy does not
show the high degree of skill of the carving.
The carver was thought previously to be Georg
Schweigger, a leading member of the Renaissance
revival school in the seventeenth century, when the
works of Dürer and the early German Renaissance
were much restudied and imitated. However, the
figure has too complete a sense of conviction to be
anything other than a product of the earlier period.
The eddying wheels of drapery at Christ's sides and
the bodily expression of anguish are derived from
large crucifixes by Veit Stoss of Nuremberg, but
there are also elegant reminders of a second great
artist, Hans Leinberger of Landshut, in the pinched
waist and attenuated legs.

REFERENCE: Untermyer *Bronzes*, 1962, pp. lvi, 35, fig.
 165.

321.

Seated Hercules

German (probably Nuremberg): about 1525
Hollow-cast yellowish bronze; dark brown lacquer;
 holes in left side of head and neck; four holes for
 attachment in base
H. 9 in. (22.9 cm.)
64.101.1546

Yvonne Hackenbroch observed the derivation of the pose from the famous antique Belvedere Torso, which before the sack of Rome in 1527 still had both legs intact. Artists north and south of the Alps produced statuettes incorporating the Torso as a means of "completing" the fascinating fragment in their imaginations. The influence is particularly seen in the tremendous torsion of the back muscles. The inter-triangulation of forms and the stressing of

views from the corners have been seen as stemming from the workshop of Peter Vischer the Younger. There are indeed formal associations with Vischer's seated figures on the bronze tomb of St. Sebaldus in Nuremberg (1514–19), and there is no question that our artist saw these, but the intimacy of the association has perhaps been overstressed. Where the Vischer figures have surfaces that are lightly worked and even impressionistic, the imitator has a heavier touch, finishing his figure with broad cross-hatchings. Even so, it looks closer to the spirit of Vischer and his immediate followers than a replica formerly in the F. D. Lycett Green collection in Kent (N. Pevsner, *Burlington Magazine,* LXXX, 1942, pp. 90–91, ill.), in which the well-chased lionskin draped over the tree stump in 321 is absent and the hair is treated in rigid strands. In both statuettes, the objects held by Hercules in his clenched fists are missing.

REFERENCES: Untermyer *Bronzes,* 1962, pp. lii, 33, fig. 154; Y. Hackenbroch, *Jahrbuch der Hamburger Kunstsammlungen,* XXI, 1976, pp. 49–51.

322.

Neptune

South German: mid-16th century
Heavy hollow-cast bronze figure, dolphin hollow-
 cast and soldered to figure's leg; dolphin's mouth
 fitted with two spouts; soldered to quatrefoil-
 shaped bronze plate in turn soldered to capital
 with four heads, each fitted with spout; yellowish
 metal, natural brown patina with traces of red-
 dish lacquer; occasional plugs of varying shape
 (head, back, both legs); modern trident; the
 whole soldered to modern bronze socle and base
H. (to raised hand) 13⅝ in. (34.6 cm.)
64.101.1547

Little is known about this small fountain figure, one of the masterworks of the Untermyer Collection. South German artists specialized in such table fountains throughout the sixteenth century. Meller published 322 as a south German work of about 1570; Bange published it as Nuremberg, about 1520–30. The lack of solid information about south

German bronzes later than those of the Vischer family and the decrease of quality in German bronzes of the mid-sixteenth century make this wide range of dates all too possible. The quatrefoil shape of the base and the heads on the column are

medieval throwbacks that could support an earlier date, but the sinuous, curvilinear composition might equally betray a dim knowledge of mannerist developments in faraway Florence. No other work certain to be by this artist survives. There are the merest similarities with works by the "Master of the Budapest Abundance" (so-named for a statuette in Budapest) on the earlier side, and ones by the "Master of the Cleopatra Fountain" (so-named for a fountain figure in Berlin) on the later side. The sharply chiseled details of face and hair contrast with the planar but strangely supple flesh in a singular and exciting way.

EX COLL. B. Oppenheim, Berlin; Dr. H. Eissler, Vienna.

REFERENCES: S. Meller, *Die deutschen Bronzestatuetten der Renaissance,* Munich, 1926, pp. 42, 49, pl. 73; E. F. Bange, *Die deutschen Bronzestatuetten des 16 Jahrhunderts,* Berlin, 1949, pp. 34–35, 124, pl. 78; *Untermyer Bronzes,* 1962, pp. liv, 33, fig. 155; *Notable Acquisitions,* 1975, p. 232.

323.

Dancing Man

> South German: mid-16th century
> Hollow-cast yellow bronze; remains of black lacquer; hole in head, screw in forward foot for attachment to base
> H. (as presently mounted) 6⅝ in. (16.8 cm.)
> 64.101.1551

This very well chased figure, thought to be a runner, was mismounted. The erect carriage, the careful placing of the hands on both hips, and the festal costume indicate rather that he was performing a dance step. Dancing poses were a staple of Bavarian bronze artists throughout the Renaissance. This one has an updated modish look, and the hopping position has considerable elegance and vigor. The costume was probably made showier by the addition of a feathered hat, attached through the hole in the forehead.

EX COLL. Wilhelm Gumprecht, Berlin.

REFERENCE: *Untermyer Bronzes,* 1962, pp. liv, 34, fig. 161.

324.

Lady and gentleman

Dutch: early 17th century

Lady heavy hollow-cast yellowish bronze with dark
brown lacquer; gentleman hollow-cast reddish
bronze with remains of dark brown lacquer; both
on square wood bases painted black, with gilt
metal ball feet
H. 8¼, 8½ in. (21, 21.6 cm.)
64.101.1564, 1565

Several examples of this late mannerist pair exist,
including ones in the Rijksmuseum, the Louvre,
and the Herzog Anton Ulrich-Museum, Bruns-
wick. In most versions the lady carries a basket on
her left arm. The present pair, though chased iden-
tically, are made of entirely different metals, the
gentleman being of a cuprous bronze, the lady of a
relatively brassy bronze to which the lacquer has
not adhered as well. Bode (1912, III, pp. 9–10)
connected the couples with the artist of a group of
female nudes whom Weihrauch subsequently
named Master of the Genre Figures.

EXHIBITED: Musée des Arts Décoratifs, Paris, 1954,
Chefs-d'oeuvre de la curiosité du monde.
REFERENCES: H. Keutner in *Register of the Museum of Art of
the University of Kansas*, 8 June 1957, p. 9; Untermyer
Bronzes, 1962, pp. lix, 37–38, figs. 175, 176; Y. Hack-
enbroch, *Connoisseur*, CLIV, 1963, pp. 16–21; Weih-
rauch, 1967, pp. 365, 511–512 note 378; J. Leeuwen-
berg and V. Halsema-Kubes, *Beeldhouwkunst in het
Rijksmuseum*, Amsterdam, 1973, nos. 218a, b, pp.
177–178.

325.

Pair of doorknockers

German (probably Augsburg): about 1600–30
Bronze with dark brown patina; remains of brown
lacquer; iron fittings cast into backs
H. of each 12⅞ in. (32.7 cm.)
64.101.1558, 1559

The shield, once described as bearing the arms of
the town of Ulm, has no pigment surviving to

indicate the black and white zones of the Ulm arms.
The ornament, though well tooled, is too tame in
design to allow the former attribution to Hubert
Gerhard of Augsburg to stand. Gerhard's decorative
style, as seen in two grotesque masks made for a
fountain of the Fugger family at Schloss Kirchheim
(*Bayerisches Nationalmuseum Bildführer*, Munich,
1974, I, pp. 48–49, ill.), is more animated and
voluptuous. The maker of these doorknockers was
influenced by Gerhard, but he was conservative in
his combination of grotesque masks and lobate
strapwork with drily correct lions and infants'
heads. In this respect, there are some similarities
with the comparatively restrained ornamental work
of Gerhard's younger contemporary, Hans Reichel
(coat of arms in the Ulrichskirche, Augsburg, 1605,
A. E. Brinckmann, *Süddeutsche Bronzebildhauer des
Frühbarocks*, Munich, 1923, pl. 54).

EX COLL. von Pannwitz, Munich.

REFERENCES: E. Bassermann-Jordan, *Sammlung von Pann-witz, Munich,* Munich, 1905, nos. 78–79, pl. XXIII; Untermyer *Bronzes,* 1962, pp. lvii, 36, fig. 169.

326.
Cain and Abel (?)

Netherlandish: 17th century
Hollow-cast yellowish bronze; reddish brown lac-quer much rubbed; figures and base cast separa-tely; fine joins on club and at figures' shoulders
H. 10⅜ in. (26.4 cm.)
64.101.1562

A very similar bronze in the Liebighaus, Frankfort, appears to be the same as the group formerly in the Heseltine collection, London (Bode, 1912, III, pl. CCXXI). It is on an octagonal base with better-defined foliage that that of 326, and the upper figure wields the jawbone of an ass; consequently, it is known as Samson and a Philistine. 326 has been called Hercules and Cacus, probably owing to the club, which does not appear to be a later replace-ment. There is a suggestion of Old Testament fervor in the tautly constructed, linear composition, and a further possibility is that it shows Cain killing Abel. The Bible does not specify the weapon Cain used. The facture is as problematic as the subject. The fine, sinuous silhouette and expert casting have led scholars to see the Frankfort bronze as a six-teenth-century Florentine work, but the outspread arms of the vanquished nude and the foliate base are baroque in character. There is little or no sense of Italian monumentality. Everything is local, includ-ing the medallic precision seen in the chasing of the heads. One is tempted to posit a northern artist in close touch with Florentine casting methods for both these works, but one at least a generation later than Adriaen de Vries, who has been suggested as the author of 326.

EX COLL. Museum of Gotha.
REFERENCES: H. R. Weihrauch, *Die Bildwerke in Bronze und in anderen Metallen,* Munich, 1956, no. 107, p. 82; Untermyer *Bronzes,* 1962, pp. lvii, 37, figs. 171, 172; A. Legner, *Kleinplastik der Gotik und Renaissance aus dem Liebighaus,* Frankfort, 1967, no. 53.

327.
Hercules Skinning the Nemean Lion; Hercules Dragging the Erymanthean Boar before Eurystheus

Attributed to François Lespingola (1644–1705)
French: about 1675–90
Hollow-cast reddish bronze; dark brown lacquer patina, both cast in three separate parts: Hercules, lion with left part of base, female figure with right part of base; Hercules with boar, Eurystheus on throne, base; raised arm of female figure bro-ken and repaired; occasional repairs in form of rectangular plugs on both
H. 18¼, 16½ in. (46.4, 41.9 cm.)
64.101.1485, 1486

The only documented bronze by François Lespin-gola is a group of Hercules Rescuing Prometheus,

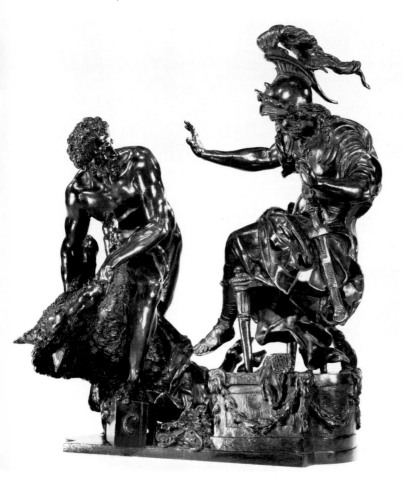

Hercules Strangling the Serpents, now in the Abegg collection in Switzerland along with two other groups of the series. Yet another of the series is in the Brinsley Ford collection, London. To date, seven related compositions have been recognized by Jennifer Montagu, who has kindly shared her findings. All treat the Hercules stories in richly pictorial ways, with a wealth of extraneous dramatic devices (such as the overacting naiad in the Nemean Lion group). Although it is odd that only the Hercules Rescuing Prometheus was known earlier as Lespingola's work, the groups are so integrally related in composition that it is fair to presume they are all by the same maker—one in close touch with painting as well as sculpture in Italy and France during the third quarter of the seventeenth century. These conditions are easily reconciled with the career of Lespingola, who was in Italy as a winner of the prix de Rome between 1666 and 1675.

EX COLL. Mr. and Mrs. Francis Kleinberger, New York; Cortlandt F. Bishop, New York.

REFERENCES: Untermyer *Bronzes,* 1962, pp. xxxv, 24, figs. 87–90; *Italian Bronze Statuettes,* exhib. cat., Victoria and Albert Museum, London, 1961, no. 192.

known in examples in the Grünes Gewölbe, Dresden, and in private collections in Toronto and Paris. A "bronzed wax" of the composition was mentioned among effects in the sculptor's studio in an inventory after his death, and the Dresden bronze was said to be by him when it was purchased by Augustus the Strong in 1715. The Dresden and Toronto examples are typical French casts with smooth brown lacquer patinas, but the Paris cast (*Le XVIIe siècle français,* Collection Connaissance des Arts, Paris, 1958, p. 164, ill.) appears to have the same hammered surfaces and darker, more opaque, Italianate patina as 327. They are similarly composed from many viewpoints and their highly charged narratives and forceful, surprising movements are so nearly identical as to warrant an attribution of these models to Lespingola as well. Originally several bronzes illustrating the labors of Hercules belonged together. When owned by Cortlandt F. Bishop, these two belonged with an Infant

328.

Louis XV

Jean-Baptiste Lemoyne (1704–78)
French: 1737
Heavy hollow-cast bronze; traces of reddish brown lacquer; incised on the back: J.B.LEMOYNE.FECIT/1737
H. 16⅛ in. (41 cm.)
64.101.1630

Lemoyne modeled the features of his royal patron so often that his biographer, Dandré-Bardon, was moved to state that he produced three or four busts of the king a year. This is one of the earliest surviving. It is an exceptionally heavy cast but minutely chased in an almost medallic way. There is a slightly smaller bronze of nearly identical pose, signed and dated 1742, in San Francisco, in which the king may be a bit thinner of face. The tumbling masses of curls and proud movement are late baroque conventions soon to be discarded by Lemoyne

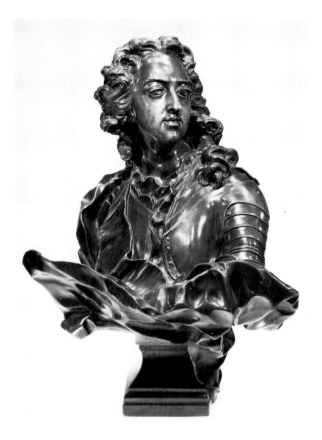

for a soberer format in his busts of the mature Louis XV, exemplified by the lifesize marble that came to the Metropolitan from the Blumenthal collection (41.100.244).

EX COLL. Countess Sala, New York.
REFERENCES: Untermyer *Bronzes,* 1962, pp. lxiii, 43–44, figs. 212, 213; *The French Bronze 1500 to 1800,* exhib. cat., M. Knoedler & Co., New York, 1968, no. 60.

329.

Cupid

> Northern European: probably 18th century
> Hollow-cast bronze; dark brown natural patina; hole in base for attachment; attribute missing from right hand
> H. 9 in. (22.9 cm.)
> 68.141.27

This mysterious bronze has considerable quality.

The head has a Renaissance look to it, and so has the facture, the surface having a roughened, shaggy treatment. But the composition rings an eighteenth-century note, with its amorous subject and attributes, and the active drapery. The Cupid is either writing or delivering a love letter in the form of a scroll.

EX COLL. Prince Nicholas of Rumania.

330.

Pair of dwarfs: Mars and Galatea

> Walter Pompe (1703–77)
> Flemish (Antwerp): 1770
> Cast terracotta, polychromed
> Male figure inscribed around the base: W:Pompe:fec:MERS Anvers 7/30; and on top of base: 1770
> Female figure inscribed around the base: W:Pompe:fec:GALATHEA:Anvers:1770 8/24
> H. 14, 13¼ in. (35.6, 33.7 cm.)
> 1974.28.146, 147

Pompe was a retardataire copyist and assimilator of the traditional masters of Netherlandish sculpture (Giovanni Bologna and Duquesnoy, for example). This theatrical couple are posed as deities in costumes from an earlier era, and are themselves part of a longstanding Netherlandish taste for gross but droll dwarfs and jesters. The marks indicate a sort of edition. There is an unpainted pair with variants, dated 1765 and numbered 19 and 16/2, in the collection of Mrs. Leopold Blumka, New York.

331.

Bust of a young woman

> David Le Marchand (1674–1726)
> French, active in London: about 1710
> Ivory carved in two pieces; neck fitted into bodice; metal brooch missing; mounted on later ebony socle
> H. 5½ in. (14 cm.)
> 1974.28.148

Le Marchand was a carver of the Dieppe school who transferred to London about 1705. His busts of English people have much presence and charm. This sitter has been identified as Anne Spencer, second daughter of the first Duke of Marlborough, who became Countess of Sunderland after her marriage in 1700. By his arrangement of drapery and forms, Le Marchand emphasized her swanlike neck. In the supporting self-plinth at the back, Le Marchand imitated a monumental marble bust in miniature.

332.

Four-light candelabrum

Probably Indian for the English market: about 1800
Turned and carved ivory in several threaded sections; various repairs
H. 31¼ in. (79.4 cm.)
64.101.1635

This amusing, spindly confection was identified by Clare Le Corbeiller as Indian rather than English by analogy with a comparable example in the Victoria and Albert Museum. The artist or team of artists, working from a European model (a late eighteenth-century invention by Michelangelo Pergolesi [P. Macquoid and R. Edwards, *The Dictionary of English Furniture,* London—New York, 1927, III, p. 32, fig. 2] was suggested by Yvonne Hackenbroch), easily assimilated the vocabulary of neoclassical decoration, as seen in the skillful carving of the rams' heads on top or the imitation cameos on the base. But in the flattened leaf ornaments and elsewhere the oriental imitator can be detected.

REFERENCE: Untermyer *Bronzes,* 1962, p. 45, fig. 218.

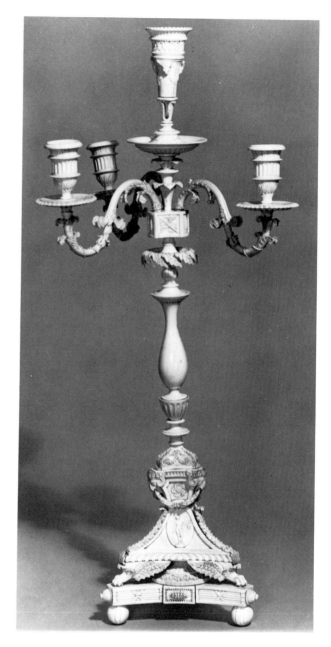

METALWORK: RENAISSANCE AND LATER

The entries are by
CLARE VINCENT,
Associate Curator, Department of Western European Arts.

Abbreviations

Untermyer *Bronzes,* 1962

Y. Hackenbroch, *Bronzes and Other Metalwork and Sculpture in the Irwin Untermyer Collection,* New York, 1962

333.
Set of pruning tools

French (Moulins): last quarter 16th century
Steel, partly gilded, and mother-of-pearl
L. 6½–14⅛ in. (16.5–35.8 cm.)
64.101.1470–1476

The set consists of four knives for grafting and pruning, a saw, a combination hammer, rasp, file, and auger, and a garden shears or clippers. The last has a spring device for releasing the blade at a distance and shows evidence of having once been attached to a long handle for reaching high branches. Two chisels that once belonged to this rare set are missing. All are impressed from one to three times with the maker's mark, a palm frond. One of the two large knives with curved tips is inscribed "faict A Molins ala palMe," and the other, "faict amolins Alapalme," indicating that the toolmaker's workshop at the "sign of the palm" was located in Moulins, a center of fine blade making during the sixteenth century. The blades of all the knives are decorated with engraved and gilded designs of fruit and foliage and the handles are of chiseled and gilded steel with mother-of-pearl inlay.

EX COLL. Johannes Paul, Hamburg; Richard Zschille, Berlin.
EXHIBITED: Detroit Institute of Arts, 1958–59, *Decorative Arts of the Italian Renaissance, 1400–1600,* no. 420; Museum of Fine Arts, Houston, Tex., *The Lively Arts of the Renaissance,* 1960, no. 35.
REFERENCES: A. Pabst, *Die Kunstsammlungen Richard Zschille: Besteck Sammlung,* Berlin, 1893, p. 26, no. 327, pl. 48; Untermyer *Bronzes,* 1962, p. 24, pl. 80, fig. 83.

334.
Chandelier

Dutch: second half 17th century
Brass
H. 71 in. (180.3 cm.)
54.7.20

The radial branched form of lighting fixture is thought to have originated in the Low Countries during the late Middle Ages. By the seventeenth century, Dutch brass chandeliers had evolved into handsome baroque structures such as this one, with its twenty-four S-shaped branches radiating from a sphere and baluster stem, surmounted by a decorative figure and reflecting panels. The figure and the panels, most unusual, represent a man holding a large pretzel and four giant, decorated loaves of bread that resemble the traditional products of Dutch bakers. The chandelier was probably the commission of a member of a Dutch baker's guild.

EX COLL. W. R. Hearst.
REFERENCE: Untermyer *Bronzes,* 1962, p. xlvi, pl. 124, fig. 135.

335.
Pair of andirons

English: about 1660 or later
Brass, enameled in blue, green, and white, with touches of dark red; on a wrought-iron frame
H. 23½ in. (59.7 cm.)
64.101.1611, 1612

Surmounted by the arms of the Stuart sovereigns, this pair belongs to a group that was traditionally reputed to have been made to the order of James I for Nonsuch Palace at Cheam. Subsequently it was recognized that the arms were actually those of the post-Restoration Stuart monarchs, Charles II and James II. In addition, the andirons were identified with a larger class of cast and enameled brasses that are thought to have been made in England during the second half of the seventeenth century. These two observations led to the abandonment of the traditional provenance in favor of that of a later seventeenth-century owner of the palace of Cheam, a royal mistress, the Duchess of Cleveland. At least three pairs of similar design were known to Edward Dillon when he made a census early in the twentieth century (*Burlington Magazine,* XVI, October 1909, pp. 262–263). One pair is now in the collection of the Victoria and Albert Museum. Another, then belonging to the first Lord Cowley, is possibly the Untermyer pair, although Lord Cowley is

known to have inherited at least two pairs from his father, the first Earl of Mornington. Two pairs belonging to Lord Cowley were among the exhibits at the South Kensington Museum's *Special Loan Exhibition of Enamels on Metal* (London, 1874, nos. 342, 345). Another pair is now at the John S. Phipps House, Old Westbury Gardens, Long Island.

EX COLL. Garrett Wellesley, first Earl of Mornington; Henry Richard, first Earl of Cowley; H. H. Mulliner, London (Christie's, 10 July 1924, p. 10, lot 21, fig. 21); W. R. Hearst.

REFERENCES: H. H. Mulliner, *The Decorative Arts in England: 1660–1780*, London [1924], fig. 146; P. Macquoid and R. Edwards, *The Dictionary of English Furniture*, London—New York, 1924, II, p. 77, fig. 12; Untermyer *Bronzes,* 1962, pp. lx, lxi, 41–42, pl. 178, fig. 199.

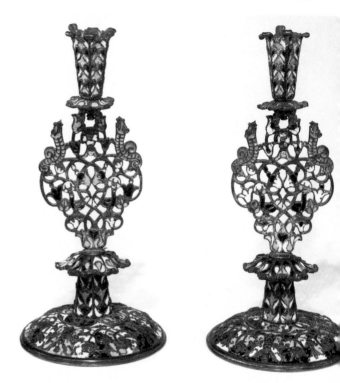

336.

Pair of candlesticks

> English: probably about 1660–80
> Brass, enameled in blue, white, and black; with
> traces of gilding
> H. 10⅛ in. (25.7 cm.)
> 68.141.322, 323

These belong to a small and puzzling group of objects decorated with predominately floral and foliate designs outlined by brass cast in low relief and filled with varicolored opaque enamels. Similarities of style and technique between these and other objects known to have been made during the period point to England in the second half of the seventeenth century, and more probably after the Stuart Restoration in 1660, as the place and time of their origin. Charles R. Beard (*Connoisseur,* LXXXVIII, 1931, pp. 219, 229) designated them "Surrey" enamels, on the supposition that they were the product of one of the brass works known to have existed in that county during the seventeenth century. The manufactory that Beard proposed as the source was set up at Escher in 1649 by Jacob Monomia or Momma and Daniel Dametrius, but subsequent investigation has produced records of the making of only brass wire at Escher. Thus,

the widely accepted term "Surrey" enamel is probably a misnomer. Alternative sites in the Midlands have been suggested, and, indeed, it is not entirely clear that all the enamels were made at one time and by one manufactory. It might be noted that brass founding was a traditional activity in London, and that the casting of brass candlesticks there goes back at least as far as the fourteenth century when the Worshipful Company of Founders was formed. While no firm evidence has been found to connect any of these enameled brasses with London, the adventurous nature of their design and manufacture seems to point to that city.

337.

Pair of candelabra perfume burners

> Boulton and Fothergill
> English (Soho, near Birmingham): probably about
> 1770
> Derbyshire spar, ebony, and gilt bronze
> H. 23½ in. (59.7 cm.)
> 64.101.1631, 1632

Matthew Boulton (1728–1809) is probably best known for his collaboration with James Watt in the development of the steam engine. He began, however, as a wholesale maker of buttons, buckles, and small decorative objects in various metals. Between 1768 and 1780, he and his partner, John Fothergill (d. 1782), manufactured decorative objects of gilt bronze, or ormolu. Both terms are somewhat misleading, for the actual metal was nearly always brass, with a thin layer of gold applied by the process known as mercury or fire gilding. Little is known about the earliest ornamental gilt bronze made at Boulton and Fothergill's Soho manufactory. By 1770, however, the firm was making large quantities of gilt-bronze ornaments suitable for mounting ornamental vases of various materials. Many of their vases were also supplied with fittings for use either as perfume burners or as candelabra, or both. The products of precocious experiments with a limited form of mass production and with the subdivision of labor, the best of these ornaments were of high-quality design and workmanship. Although the vases were never inexpensive, for a short period they challenged the supremacy of the French in Continental markets. Goodison has identified the design of 337 with one described in the catalogue of a sale of Boulton and Fothergill's manufactory held at Christie's, Pall Mall, 11-13 April 1771, as a "large vase of radix amethysti and or moulu lined with silver and perforated for insence with four branches for candles, supported by two caryatids standing on an ornamented ebeny plinth." The pair was bought by Pinchbeck (probably the clockmaker Christopher Pinchbeck) for £25. 4s.

REFERENCES: Untermyer *Bronzes,* 1962, pp. lxiv, 44, pl. 191, fig. 215; N. Goodison, *Furniture History,* VIII, 1972, p. 36, pl. 33B; idem, *Ormolu: The Work of Matthew Boulton,* London, 1974, pp. 51, 155, 255, fig. 76.

338.
Pair of candle vases

Attributed to Boulton and Fothergill
English (Soho, near Birmingham): probably about 1770

Derbyshire spar and gilt bronze
H. 18 1/16 in. (46 cm.)
55.148.1, 2

Although these cannot be identified absolutely with surviving designs or records of the Boulton-Fothergill partnership, the use of Derbyshire spar and gilt bronze in combination is typical of their products. Many materials were, in fact, used at their Soho manufactory for mounting with gilt-bronze ornaments, but a type of fluorspar, mined near Castleton in Derbyshire and popularly called Blue John, was the most favored. In 1769, Boulton bought fourteen tons of the varicolored mineral for the making of vases. The chasing and gilding of the decorative mounts, here, are particularly fine. The gracefully carved candle branches are rococo in spirit, while the remainder of the applied gilt-bronze ornament, as well as the shape of the lathe-turned spar vases, reflects the classical revival taste then sweeping England. Goodison has noted that Boulton's library contained some of the more authoritative sources of antique design, including Robert Adam's *Ruins of the Palace of the Emperor Diocletian at Spalatro,* Stuart and Revett's *Antiquities of Athens,* and William Chambers' *Treatise on Civil Architecture.* Boulton also drew directly upon prints, models, and designs provided by the architects themselves.

REFERENCES: Untermyer *Bronzes,* 1962, pp. lxiv, 44, pl. 190, fig. 214; N. Goodison, *Ormolu: The Work of Matthew Boulton,* London, 1974, pp. 46–61, 149–150, pl. 102.

339.
Pair of perfume burners

Boulton and Fothergill
English (Soho, near Birmingham): probably about 1770
Derbyshire spar, marble, tortoiseshell, gilt bronze
H. 13 in. (33 cm.)
64.101.1633, 1634

Boulton was first of all an entrepreneur, yet he took great care that his products would reflect fashionable

taste in decorative design. He was rewarded by
several royal commissions, including one in 1770
for a pair of "Sphinx" vases, probably those now in
the Queen's private sitting room at Windsor Castle;
these are similar to our pair, if somewhat more
finely finished. The sphinx supports for the upper
plinth, most unusual in an English decorative object
of 1770, seem likely to have been based on a design,
now in the Victoria and Albert Museum, by Wil-
liam Chambers, architect to George III. According
to Goodison, Chambers supplied Boulton with sev-
eral models for gilt bronze early in 1770, and the
sphinx may well have been among them. The urn
itself, of Derbyshire spar, is undoubtedly based on
an antique model.

REFERENCES: Untermyer *Bronzes,* 1962, p. lxiv, pl. 192,
fig. 216; N. Goodison, *Ormolu: The Work of Matthew
Boulton,* London, 1974, pp. 52, 163–165, 205 note 513.

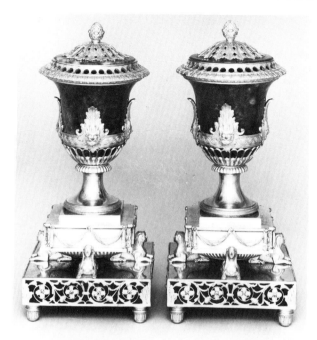

TEXTILES

The entries are by
JEAN MAILEY,
Curator, Textile Study Room,

except for 373, which is by
EDITH A. STANDEN,
Consultant, Department of Western European Arts.

Abbreviations

Seligman and Hughes

G. Saville Seligman and T. Hughes, *Domestic Needlework,* London—Paris, n.d.

Untermyer *Needlework,* 1960

Y. Hackenbroch, *English and Other Needlework, Tapestries, and Textiles in the Irwin Untermyer Collection,* Cambridge, Mass., 1960

340.

Chasuble-back (central orphrey removed): phoenixes amid vine leaves

Italian or Spanish: 14th century
So-called diasper, a compound weave with gold
 pattern wefts in twill binding on dark blue
 silk warp twill ground
H. 50¼, W. 28 in. (127.6, 71.1 cm.)
64.101.1388

This beautiful drawloom-woven fabric belongs to a
series of late medieval silks of unknown prove-
nance, all identical in weave and material. Their
exotic designs combine Near and Far Eastern influ-
ences. The *fêng-huang,* the ancient mythical bird of
China, and its Near Eastern equivalent, the phoenix,
are reflected in the birds. The vine leaves are classi-
cal; the ground arabesques are a more rigid version
of a popular Islamic ornament. Forming the pattern
are gold yarns of the type that made Cyprus famous
throughout the West: "linen thread entwined by
narrow strips of animal membrane, the outside of
which was gilded with the thinnest possible gold
leaf," according to the pioneer twentieth-century
textile historian, von Falke. These yarns first ap-
peared in the eleventh century and were widely
used as a cheaper and more supple substitute for the
gold wire threads of antiquity.

REFERENCES: A. S. Cole, *Ornament in European Silks,* Lon-
don, 1899, p. 62, fig. 47; J. Pascó y Mensa, *Catalogue de
la collection de tissus anciens de D. Francisco Miquel y Badia,*
Barcelona, 1900, pl. III, fig. 44 (piece now in
Cooper-Hewitt Museum); I. Errera, *Catalogue d'étoffes
anciennes et modernes,* 2nd ed., Brussels, 1907, no. 58;
E. Chartraire, *Revue de l'Art Chrétien,* LXI, 1911, p. 462,
no. 60 (wrapped around relic of St. Quiriace); O. von
Falke, *Decorative Silks,* new ed., New York, 1922,
fig. 289; *Special Exhibition of Textiles,* The Metropolitan
Museum of Art, New York, 1915–16, no. 90
(Cooper-Hewitt Museum piece); F. Fischbach, *Die
Wichtigsten Webe-Ornamente bis zum 19. Jahrhundert,*
Wiesbaden, 1902–11, III, pl. 140 (top right); *L'Antico
tessuto d'arte Italiano, mostra del tessile nazionale,* exhib.
cat., Rome, 1937, no. 51, p. 27, fig. 46; Untermyer
Needlework, 1960, pl. 166, fig. 211; A. Santangelo, *A
Treasury of Great Italian Textiles,* New York, n.d., fig. 8
(Metropolitan Museum 46.156.43).

341.

Purse: Lovers under an oak tree

French: first quarter 14th century
Linen tabby embroidered in silk split stitch with
 details in laid work; soft shades of yellow, beige,
 pale blue, green, with dark brown outlines; back-
 ground lozenge diaper of couched gold thread
 (silk or linen wrapped with strips of gold foil)
 from which gold is mostly gone; back: light
 brown (originally rose ?) velvet with horizontal
 rows of pile with marked lean; edging (except
 top) of couched silk cord with Turk's-head knots
 at intervals
H. 5¾, W. 6 in. (14.6, 15.2 cm.)
64.101.1364

Several of these little purses embroidered with pairs
of lovers (Museum für Kunst und Gewerbe, Ham-
burg; Cathedral Treasury, Sens; Musées Royaux des
Arts Decoratifs, Brussels) survive from the age of
courtly love. This particular pair may be those of a
popular *roman courtois* about the Chatelaine de
Vergy and her lover who used her little dog as
go-between (a similar motif appears on carved
ivory caskets in the Metropolitan: 17.190.177, 180).
Though this purse was made for secular use, it once
held a saint's relics.

EX COLL. Engel-Gros, Switzerland (Hôtel Drouot, Paris,
 6 December 1922, lot 88).
EXHIBITED: Museum of Fine Arts, Boston, 1940, *Arts of
 the Middle Ages,* no. 102; The Cloisters, New York,
 1968–69, *Medieval Art from Private Collections,* no. 198.
REFERENCES: P. Ganz, ed., *L'Oeuvre d'un amateur d'art: La
 Collection de Monsieur F. Engel-Gros,* Geneva-Paris,
 1925, I, pp. 311, 314, 328, no. 109, ill.; ibid., II,
 pl. 118a; Untermyer *Needlework,* 1960, p. 54, pl. 128,
 fig. 169.

342.

Three panels from the Life of Christ:
Three Marys at the Sepulcher,
Ascension of Christ,
Adoration of the Magi

Italian: second half 14th century

Unbleached linen tabby embroidered in silks, wrapped silver, wrapped silver-gilt yarns, couched padding (originally covered by couched metal yarns) of bunched, loosely spun cotton threads; split stitch, satin stitch details, couching; thin black or dark brown outlining threads following underdrawing beneath silks in shades of red, pink, yellow, green, brown, blue, lavender. Designs drawn first on linen ground in sepia ink with wash of same to indicate shadow

(a) H. 9¾, W. 7⅝ in. (24.8, 19.3 cm.); (b) H. 10, W. 7⅝ in. (25.4, 19.3 cm.); (c) H. 10, W. 7¾ in. (25.4, 19.7 cm.)

64.101.1383a–c

These scenes seem to relate closely to a group of vertical panels on the Life of the Virgin surviving in parts of orphreys in the Museum of Fine Arts, Boston, the museum at Douai, Belgium, and the Victoria and Albert Museum. In their original form they were apparently used on copes. In style and technique the group relates unmistakably to at least twelve horizontal panels and a partial panel (Ostoia, 1970, no. 72), as well as to the embroidered scenes making up the altar frontal in the Collegiate Church of Sta. Maria at Manresa in Catalonia, which bears the embroidered inscription GERI LAPI RACHAMATORE ME FECIT IN FLORENTIA. Yvonne Hackenbroch finds an Adoration scene similar to ours in a less closely related altar frontal, signed JACOBUS CAMBI FLORENTINUS 1336, in the Museo degli Argenti, Florence (Untermyer *Needlework*, 1960, p. 64). Scholars have suggested or seen relationships between these panels and fourteenth-century painters. Van Fossen quotes Cennino Cennini's instructions to artists in his *Il Libro dell'Arte* (probably early fifteenth century, but reflecting artistic practices of the previous century): "You sometimes have to supply embroiderers with designs of various

sorts." The rest of the passage describes exactly the technique of the arrestingly beautiful underdrawing of these panels. Van Fossen believes this supports Cavallo's idea of painters' pattern books from which craftsmen could select for their particular medium the drawing then to be done by the painter or some member of his atelier. Cavallo suggests Florentine painters influenced ultimately by Giotto in this connection; the Manresa panels are acknowledged by all to be part of another, more miniaturist tradition. Nothing further is known about the two embroiderers whose names have so proudly come down to us.

EXHIBITED: Museum of Fine Arts, Boston, 1940, *Arts of the Middle Ages*, no. 104.

REFERENCES: M. Hague, *Bulletin of the Needle and Bobbin Club*, I, XVII, January 1933, pp. 33–49; Untermyer *Needlework*, 1960, pp. lxvi–lxii, 63, pl. 161, fig. 205; A. Cavallo, *Burlington Magazine*, CII, December 1960, pp. 505–510; S. Wagstaff, Jr., *An Exhibition of Italian Panels and Manuscripts from the Thirteenth and Fourteenth Centuries in Honor of Richard Offner*, Hartford, Conn., 1965, p. 33; D. van Fossen, *The Art Bulletin*, L, 1968, pp. 141–152; V. Ostoia, *The Middle Ages: Treasures from The Cloisters and The Metropolitan Museum of Art*, exhib. cat., Los Angeles, 1970, no. 72.

343.

Orphrey panel: Madonna and Child
appearing to Bishop purifying a well

North Italian: about 1500

Linen tabby embroidered with silk, wrapped gold thread, and seed pearls in satin, long-and-short, split, back, and plaited braid stitches; laid and couched work including *or nué*, and raised work

H. 11⅞, W. 10¾ in. (30.2, 27.3 cm.)

64.101.1385

Many early churchmen and saints besides St. George were popularly believed to have overcome dragons, who were often depicted in or around wells or fountains. This symbolized the Church's conquest of evil, which kept the Christian soul from baptism and salvation. It is difficult to identify the triumphing bishop pictured in 343. The drawing, interpreted in

traditional Renaissance embroidery, suggests the style of Cosimo Tura (about 1430–95) of Ferrara.

EX COLL. Carmichael.

EXHIBITED: Detroit Institute of Arts, 1958–59, *Decorative Arts of the Italian Renaissance, 1400–1600,* no. 182, pl. 86.

REFERENCES: M. Symonds and L. Preece, *Needlework through the Ages,* London, 1928, p. 226; pl. XXXVIII; Untermyer *Needlework,* 1960, pp. 64–65, pl. 163, fig. 207.

artist behind the beautiful sepia underdrawing, while Yvonne Hackenbroch sees the hand of Francesco del Cossa (active 1455–70) in it.

EXHIBITED: Detroit Institute of Arts, 1958–59, *Decorative Arts of the Italian Renaissance, 1400–1600,* no. 183, pl. 87.

REFERENCES: *Meisterwerke Alter Kunst,* sale cat., Julius Böhler, Munich, 1958, no. 125; Untermyer *Needlework,* 1960, pp. lxvii, 61–62, color pl. 160, fig. 203.

344.

Picture: Birth of the Virgin

Italian: last quarter 15th century

Bast tabby embroidered in silks and various wrapped silver, gold, and silver-gilt threads; split, gobelin, stem stitches; various fancy couching treatments including paired metal threads couched with silk in various colors and variously spaced to emphasize color or metal (*or nué* or "translucent" stitch); black, shades of salmon, blue, green

H. 12⅝, W. 20 in. (32.1, 50.8 cm.)

64.101.1381

The versatile artists of the Italian Renaissance produced a great number of delightful interpretations of biblical subjects, especially those from the New Testament. Contemporary records show that the most famous artists were commissioned, along with their other projects, to design altar frontals or sets of vestments, to be worked by professional embroiderers. Beautiful pictorial panels from orphreys, where the medium of skillfully worked silk and metal threads gives them a distinctive charm, survive from the fifteenth and sixteenth centuries. While 344 is amazingly close in style and technical details to the Nativity panel in the series on the Life of John the Baptist from the set of vestments designed by Antonio Pollaiuolo (1429–98) for the Cathedral in Florence, the figures here seem to have a different tension, a slightly fuller form, a dreamier mood. Adele Weibel (*Decorative Arts of the Italian Renaissance,* exhib. cat., 1958–59, no. 183) thought that Benozzo Gozzoli (about 1420–about 98) was the

345.

Triptych from a folding altarpiece: Scenes from the Childhood of Christ

Flemish: early 16th century

Linen tabby embroidered in silks in split, brick, satin, encroaching satin stitches, laid work; wrapped gold and silver threads in plaited braid, underside couching, couching and laid work in combination with silks, patterned couching, *or nué,* and couched river pearls

(a) H. 21½, W. 6½ in. (54.6, 16.5 cm.); (b) H. 22, W. 15½ in. (55.9, 39.3 cm.); (c) H. 21¾, W. 6¼ in. (55.2, 15.9 cm.)

64.101.1380a–c

Like fourteenth-century needlework scenes, such as 342, those of the Renaissance had a preliminary drawing on the linen ground done in a professional artist's workshop and then worked by a professional embroiderer and his assistants. 345 reflects with unusual sensitivity the skill and preciosity of the Antwerp mannerist school. Jacob Cornelisz van Oostanen (1477–1533) is suggested by Colin Eisler as the possible originator of this style. The embroidery is extraordinary in its sensitive adaptation of stitches and material to the subject and in balanced use of techniques. Various fine stitches in silk are used for the faces, hands, hair, animals, and some costume and landscape details. Sometimes a single couched gold thread highlights the edge of a leaf. Gold and silver threads couched in arabesques and set with river pearls border some of the garments. Padded and underside couching, medieval techniques, are used for some architectural details.

Shaded gold, *or nué,* in which the colored silks that couch down the paired metal threads are variously spaced, either producing a deeper color tone or permitting the metal to gleam through the color, is used for the outer garments. This treatment seems to have first appeared in early fifteenth-century Florentine embroideries. It was used by Burgundian embroiderers before the defeat of Charles the Bold in 1477 for the vestments of the Order of the Golden Fleece.

EX COLL. I. D. Levy, New York.
REFERENCES: Untermyer *Needlework,* 1960, pp. lxx, 61, pl. 158, color pl. 159, figs. 201, 202.

346.

Cushion cover: Sacrifice of Isaac (Genesis 22)

> English, Sheldon looms: last quarter 16th century
> Tapestry, with silk and wrapped silver wefts on undyed wool warps; soft shades of red, pink, yellow, green, blue, cream, brown
> Woven inscription, top and bottom: HAVE A STRONG FAITH IN GOD—ONLY NOT THIS BUT MY GOOD WILL
> H. 8½, W. 11¾ in. (21.6, 29.9 cm.)
> 64.101.1282

The Sheldon looms were set up by William Sheldon on his estate at Barchester Manor, War., around 1560 to make "tapestrye, arras, moccadoes, carolles, plometts, grograynes, sayes and sarges." They flourished under the direction of Richard Hyckes, who was sent by Sheldon with Sheldon's son Ralph to study tapestry weaving in the Low Countries. This factory and another at Bordesley, Worcs., continued under Ralph Sheldon well into the seventeenth century. They are known today for large tapestry wall hangings and tapestry cushion covers—all that survive of their products. Like the great high-warp tapestries, 346 was woven with the warps at right angles to the picture. A strip of dark blue weft at either side divided the picture from the next panel woven on the same warps. In fact, four other cushion covers may well have been woven with this one: one with the same design (last known in the

Duke of Rutland's collection), one with the Adoration of the Magi (collection of Lady Binning), and two in the Victoria and Albert Museum with Christ and the Woman of Samaria, and the Flight into Egypt. All have the same dimensions, related border treatments with an outer edge of barber-pole stripes, biblical subjects, and flat, colorful pictorial style related to contemporary embroidery pictures. The boy leaning against his donkey at the right may be seen again in a seventeenth-century embroidered picture, 366.

EX COLL. Col. Henry Howard, Kidderminster (Sotheby's, 11 May 1934, lot 159).
EXHIBITED: Lansdowne House, London, 1929, *Loan Exhibition of English Decorative Art, in Aid of the Invalid Children's Aid Association,* no. 50; Wadsworth Atheneum, Hartford, and Baltimore Museum of Art, 1952, *2000 Years of Tapestry Weaving,* no. 106, pl. 12.
REFERENCES: E. A. B. Barnard and A. J. B. Wace, *Archaeologia,* LXXVIII, 1928, p. 293; A. F. Kendrick, *Burlington Magazine,* LIII, December 1928, p. 287; J. Humphreys, *Elizabethan Sheldon Tapestries,* London, 1929, pl. 13; Y. Hackenbroch, *Magazine of Art,* XLV, January 1952, p. 37; *Antiques,* LXII, 1952, p. 136; Untermyer *Needlework,* 1960, pp. xx–xxii, 15, color pl. 21, fig. 33.

347.

Cushion cover: The Circumcision; Charitas, Justitia, Ceres, and Pomona in corners of border

> English, Sheldon looms: late 16th, early 17th century
> Tapestry, silk and wrapped silver-gilt wefts on undyed wool warps; shades of beige, red, blue, green; design woven at right angles to warp with dark blue wool weft band separating it from preceeding and succeeding panels on same warps
> H. 24½, W. 39¼ in. (62.2, 99.7 cm.)
> 64.101.1281

The biblical scene was quite possibly taken from an engraving. The allegorical figures are seen in engravings by Adrien Collaert after Martin de Vos

(Charity and Justice) and on the title page of John Gerard's *Herball,* engraved by John Payne, London, 1633 (Ceres and Pomona). The position of Ceres and Pomona echoes their classical association with rich harvests and ripe fruit. The flowery field enriched with birds is a characteristic Sheldon treatment adapted from millefleurs tapestries of the late Middle Ages. The maids' heads in the border medallions, a popular Elizabethan motif, may originally have been a reference to Our Lady.

REFERENCES: H. Göbel, *Wandteppiche. . . ,* Berlin, 1934, pt. 3, II, pp. 167, 308, note 64, pl. 127; Untermyer *Needlework,* 1960, pp. xx–xxi, 14, pl. 19, fig. 31.

of Lancashire, whose arms around 1520 consisted of a blue shield with a silver cross with fleur-de-lis terminals, birds in the corners. The leopard-lion in the center of the armorial cross is an addition that probably represents a promotion in rank. The arms at the right are of an unidentified English public institution. The ornament of the field incorporates in closely set formal symmetry the same flowers, fruits, vegetables, insects, and birds more freely worked in bright silks and metal in Elizabethan costume embroidery, 351. The fruit and floral borders are somewhat like those of a table carpet woven in 1564 for the Lewknor family of Sussex.

348.

Table carpet (fragment)

English: 16th century
Bast tabby embroidered in wool tent stitch, silk details; white, shades of red, orange, yellow, green, blue, black outlines; mustard ground (field), dark blue border (restored)
L. 76½, W. 38 in. (194.3, 96.5 cm.)
54.7.8

Table carpets in various materials and techniques, in addition to handsome pile carpets from the Near East, were widely used in Europe and England during the sixteenth and seventeenth centuries. Those made at home or to order often had their owner's coat of arms in the design. The arms at the left, here, are those of a branch of the Plesyngton family

349.

Table carpet with story of Gombaut and Macée in border

French: about 1600
Wool and silk tent stitch on canvas (hemp tabby) in white and shades of green, tan, blue, pink, yellow; silk highlights in details, flesh areas
L. 107, W. 65 in. (271.8, 165.1 cm.)
54.7.1

From antiquity until the French Revolution "the shepherd's sweet lot" was extolled by poets and envied by townsfolk. In French fifteenth-century pastorals, Gombaut and Macée, the feminine form of Matthew, were common names for shepherds and shepherdesses. Their loves are mentioned as the subject of a tapestry in an inventory of 1532. That the subject appeared in even earlier tapestries is suggested by a tapestry in late medieval style, made in Bruges in the late sixteenth century (Metropolitan Museum 58.62). Six of the beguiling scenes in 349 are somewhat simplified designs paralleling anonymous woodblocks in *Les Amours de Gombaut et Macée,* published by Jean le Clerc, Paris, about 1585.

EX COLL. Lord Armstrong of Rothbury.
EXHIBITED: The Antiquarian Society, Art Institute of Chicago, 1941, *European Embroideries of the 16th and 17th Centuries,* no. 70.

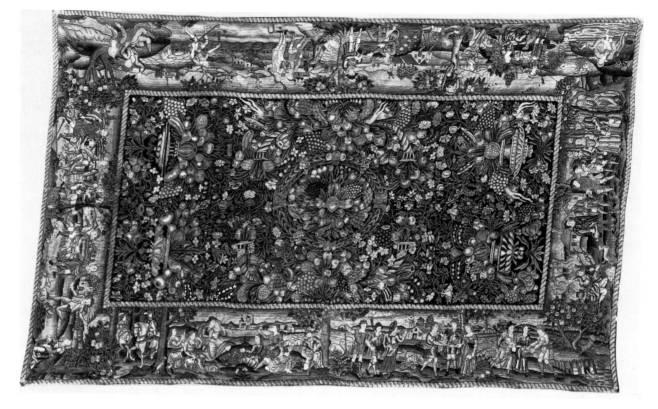

REFERENCES: H. Gariel, *Tapisseries représentant les amours de Gombaut & Macée*, Grenoble, 1863; J. Guiffrey, *Les Amours de Gombaut et Macée: Etude sur une tapisserie française du Musée de Saint-Lo*, Paris, 1882; *Gazette des Beaux-Arts*, LXI, 1919, pp. 352–368; M. Fenaille, *Etat général des tapisseries de la manufacture des Gobelins*, Paris, 1923, pp. 11, 219–224; H. Göbel, *Wandteppiche . . .*, Leipzig, 1923, pt. 1, II, pp. 202, 203, pl. 74; M. Crick-Kuntziger, *Bulletin de la Société Royale d'Archéologie de Bruxelles*, 1939, pp. 24–27; idem, *Bulletin des Musées Royaux d'Art et d'Histoire*, Brussels, May–June 1941, pp. 60–65; E. Standen, *Metropolitan Museum of Art Bulletin*, May 1959, pp. 231–234; Untermyer *Needlework*, 1960, pp. lxi–lxiii, 54–55, color pl. 131, pl. 130, fig. 172.

350.

Women's coifs and forehead cloths

English: late 16th century

Linen tabby embroidered in black silk, stem, and cross-stitches (64.101.1236, 1237); cross-, stem, braid, and satin stitches with French knots and couching; plaited braid stitch and speckling (64.101.1238); satin, chain, and buttonhole stitches, drawnwork, couched gold thread (64.101.1239, 1240)

(1236) H. 9, W. 8 in. (22.9, 20.3 cm.); (1237) H. 7, W. 19½ in. (17.8, 49.5 cm.); (1238) H. 8, W. 7½ in. (20.3, 19.1 cm.); (1239) H. 6¼, W. 14 in. (15.9, 35.6 cm.); (1240) H. 8¼, W. 16 in. (21, 40.6 cm.)

64.101.1236–1240

Often with matching forehead cloths, coifs were usually embroidered by women for themselves or as gifts, for embroidery was a practical as well as a genteel woman's occupation. No English portraits of the period show these headpieces, although the pieces themselves survive in some number. Their makers adapted roses, honeysuckle, acorns, grapes, and other floral patterns from herbals, pattern books, and samplers. The framework of scrolling stems seen in these examples in so-called blackwork, probably from an earlier *opus anglicanum,* came from a pattern book. Silk embroidery in a single color on linen was an elegant fashion of the period, and blackwork was considered the most elegant of

all. As used on the Continent in the fifteenth century, it consisted of double running or Holbein stitch. In Elizabethan England, where black and white was the queen's favorite color combination, it was worked in a great variety of stitches and styles, sometimes heightened with gold thread and spangles. Queen Elizabeth herself is depicted in several portraits with sleeves decorated with beautifully drawn rose stems or variegated flowers in blackwork, and on New Year's Day, 1578, "a cambric chemise, wrought with black-work and a pair of ruffles set with spangles" were her New Year's gift from Sir Philip Sidney, poet and statesman.

EX COLL. Sir William Lawrence (Sotheby's, 18 April 1934, lot 177 [64.101.1239], lot 178 [64.101.1240]).
EXHIBITED: Hastings Museum, Hastings, England, 1913, *British Needlework from the 16th Century Onward*, no. 49, pl. 3.
REFERENCES: Seligman and Hughes, p. 11, pls. 7-C (64.101.1239), 7-A (64.101.1240); *Report of the Exhibition of British Needlework from the 16th Century Onward*, Hastings Museum, Hastings, England, 1914, fig. 1 (top); Untermyer *Needlework*, 1960, pp. xv–xvii, 5, 6, pl. 2, fig. 2.

351.

Woman's coif with birds, insects, scrolling flowers

English: end 16th century
Undyed linen tabby embroidered in colored silks, wrapped silver and silver-gilt threads, spangles; buttonhole, chain, stem, plaited braid stitches; black and shades of red, pink, yellow, green, blue, brown
H. 9, Gr. W. 18½ in. (22.9, 47 cm.)
64.101.1258

A version of one of the most popular Elizabethan embroidery designs. Similar patterns appeared on bodices, sleeves, skirts, long pillows, and coverlets. The embroideress traced her design a bit off-center when she transferred it from a pattern book to the fabric, so the pattern does not fit within the edges of the piece. Despite this, the embroidery has the charm of an English garden in full bloom.

EX COLL. Sir William Lawrence (Sotheby's, 18 April 1934, lot 180).
EXHIBITED: The Metropolitan Museum of Art, New York, 1945, *English Domestic Needlepoint of the XVI, XVII, and XVIII Centuries*, fig. 9; Museum Boymans-van Beuningen, Rotterdam, 1963–64, *Betoverend Steekspel*, no. 73.
REFERENCES: Seligman and Hughes, p. 11, pl. 8-C; Untermyer *Needlework*, 1960, p. 9, color pl. 9, fig. 15.

352.

Panel: Musical garden party

Franco-Scottish: late 16th century
Bast tabby embroidered in silk and wool tent stitch; black, white, shades of blue, green, brown, yellow, russet
H. 22¾, W. 66¾ in. (57.8, 169.6 cm.)
64.101.1283

With its two pairs of lovers, attendant musicians, and two naughty page boys putting a white mouse on the open music book, this is probably part of a set of bed valances of the sort widely used in the British Isles and northern Europe during the sixteenth and seventeenth centuries. These were characterized by even stitchery that suggests professional work; their designs were often composed of figures copied from contemporary engravings that did not necessarily deal with the same subject as the embroidery. The elegant figures here are in French court costumes of the late sixteenth century. The tree at the left is hung with tags (all bearing the same illegible cipher), as seen in late medieval German engravings. In the background is a northern Renaissance garden. The scene probably represents an episode from the Old Testament or classical mythology.

REFERENCES: Untermyer *Needlework*, 1960, pp. xvii–xviii, 16, color pl. 22, fig. 35 (see also p. 13, comments under figs. 27–29).

353.

Panel: King Solomon and his wives (Kings 1:11)

Franco-Scottish: late 16th or early 17th century
Linen tabby embroidered in silk and wool tent
 stitch; shades of green, blue, beige, brown, red
H. 57⅜, W. 65½ in. (145.7, 166.4 cm.)
64.101.1370

Tent-stitch valances and panels with figures in French court dress may represent a style made popular in Scotland by Mary Queen of Scots during her brief reign (1561–67). They are often found in Scottish families associated with her son, James VI of Scotland (1583–1603) before he became James I of England. 353 depicts the scene where Solomon and his "strange wives . . . burnt incense and sacrificed unto their gods," and the prophet Ahijah, meeting the king's new deputy, Jeroboam, rent his garments into twelve pieces symbolizing the twelve tribes of Israel shortly to be ruled by Jeroboam. The story of Rehoboam and Jeroboam is mentioned in connection with hangings in the inventories of the effects of James V of Scotland in 1539 and of Mary of Guise in 1561. Three incomplete sets of tent-stitch valances dealing at least in part with this subject survive in Scottish collections today. R. Scott-Montcrieff, *Proceedings of the Society of Antiquaries of Scotland*, 11 February 1918, pp. 72–81, demonstrates

that the costumes date two of the groups to the late sixteenth century. The valances are very close in style to 353; in fact, the figures of Ahijah and Jeroboam appear to be present at the left of the middle valance of what Scott-Montcrieff calls "the Rehoboam hangings" (now mounted on a screen) almost exactly as they appear here. 353 is unusually large, nearly five feet in height, while the valances are under two feet. The coat of arms in the wreath suspended from the top of the rose arbor is unidentified.

EX COLL. Ellen B. Roberts, New York (American Art
 Association, New York, 13 December 1923, lot 868).
REFERENCES: Untermyer *Needlework,* 1960, pp. xvii–xviii,
 57, pl. 138, fig. 181.

354.

Panel: Scene from story of Esther (Esther 8)

French: about 1600
Linen tabby embroidered in silk and wool tent and
 cross-stitch over two warps and wefts; black,
 white, shades of beige, brown, blue, green, yel-
 low, rose; details in petit point
H. 27⅜, W. 79¾ in. (69.5, 202.6 cm.)
64.101.1369

From a distinctive group of northern European canvas stitch valances and panels of the sixteenth and seventeenth centuries, this is notable for the certainty of its nationality. The figures are labeled MARDOCHEUS, LA ROINE ESTIR, LE ROI ASUERUS, and AMAN. The scene at the left may once have included twice as many figures before ending with half a flowering tree, as seen at the right. The simple composition and naive quality suggest that this val-

ance was worked at home by someone who had seen costume plates like those of Joos de Bosscher (*Habits de diverses nations,* 1580). The border, vaguely in the style of the period of the valance and technically close to it, must have been worked separately and joined to it later. The small jewellike geometrical ornaments or crosses flanked by initials in the interspaces of the border suggest later thinking, perhaps as late as the nineteenth century, and give 354 the touching quality of a memorial, which it may well be.

REFERENCE: Untermyer *Needlework,* 1960, pp. lx–lxi, 57, pl. 137, fig. 180.

355.
Panel: Biblical or mythological scene

French: last quarter 16th century
Linen tabby embroidered in silk and wool tent stitch; white, black, shades of pink, orange, yellow, blue, green, brown
H. 19½, W. 77 in. (49.5, 195.6 cm.)
64.101.1368

Mathiam Bonhomme in 1552. Even the palm tree, the vine-entwined tree, and the fanciful architecture are as seen in Salomon's very personal and lively interpretation of the Fontainebleau style.

EX COLL. Freiherr von Zwierlein, Geisenheim; Albert Figdor, Vienna (O. von Falke, *Sammlung Dr. Albert Figdor, Wien,* Berlin, 1930, I, lot 174).
REFERENCES: *Künstlerische Entwicklung der Weberei und Stickerei, Vienna-Museum für Kunst und Industrie,* Vienna, II, 1904, pl. 272; Untermyer *Needlework,* 1960, p. lx–lxi, 57, pl. 136, fig. 178.

356.
Valance from a set of three: Moses parting the two quarreling Hebrews, and Moses and the Daughters of the priest of Midian (Exodus 2-3)

Flemish (?): about 1600
Bast tabby embroidered in wool and silk tent stitch with details in raised satin stitch; black, cream,

Probably part of a valance, this interprets woodblock illustrations in the little books that poured from the presses of Lyon during the second half of the sixteenth century. The slender, hurrying figures, in graceful poses, often on tiptoe, with expressive hands and tiny heads, suggest the style of Bernard Salomon (active Lyon, 1540–61). Some details are very close to those in illustrations for Barthélemy Aneau's *Picta Poesis ut pictura poesis erit,* attributed to Salomon and published in Lyon by

shades of yellow, beige, brown, pink, red, green, blue
H. 17½, W. 64½ in. (44.4, 163.9 cm.)
53.32.3b

In all the styles in the tent-stitch bed valances and fittings so popular around 1600, the biblical characters often dress like members of the court of Valois. The modified classical style in costume and coiffure in the scenes of 356 is very close to that seen in their sources in Bernard Salomon's woodcuts in the

Quadrins historiques de la Bible (Jean de Tournes, Lyon, 1553). However, in spite of their lively actions, the figures have a certain weightiness and lack the elegant elongation and sense of excitement characteristic of Salomon's work. The background hills set with round-topped trees are those seen in Brussels tapestries rather than the romantic architecture and exotic foliage of the French master. Could this set of valances have been made in Flanders after the Flemish translation of the *Quadrins* with Salomon's illustrations appeared in 1558?

EXHIBITED: The Antiquarian Society, Art Institute of Chicago, 1941, *European Embroideries of the 16th and 17th Centuries,* no. 71; Museum of Fine Arts, Boston, 1973, *Nancy Graves Cabot: In Memoriam,* p. 8, figs. 1ab, 2.

REFERENCES: E. A. Standen, *Metropolitan Museum of Art Bulletin,* April 1957, p. 167; Untermyer *Needlework,* 1960, pp. lvi–lvii, 58, pls. 139–141, figs. 182–184.

357.

Three valances: Scenes of hunting, fishing, and country life

English: first third 17th century
Bast tabby embroidered in silk tent, and satin stitch, French and bullion knots, and couching; shades of red, yellow, blue, green, brown, with black and brown outlines, many varieties of silver and gold threads; (very thin, flat strips, heavy silver foil wrapped on white silk, thin foil tightly wrapped on white silk, spaced wrapping on white and colored silks, tight curls of silver strips); faces and hands in wool tent stitch; some clouds worked on linen tabby and applied to sky; silk fringe, probably nineteenth century; silk galloon probably contemporary with embroidery

(1275) H. 12, W. 60 in. (30.5, 152.4 cm.); (1276) H. 12, W. 83 in. (30.5, 210.9 cm.); (1277) H. 12, W. 83 in. (30.5, 210.9 cm.)
64.101.1275, 1276, 1277

Against a romantic mountain background and among scattered huntsmen and a fisherman derived from the contemporary hunting and fishing theme popular on the Continent are set English oaks, fruit trees, flowers, milkmaid at work, praying shepherdess crowned with leaves, and a pelican in her piety. The mustached and bearded hunters, dressed in early seventeenth-century style and armed with various weapons, unsuccessfully pursue a fox, heraldic lion, and richly winged griffin. The extensive use of gold and silver thread, an unusual feature in tent-stitch valances of this period, combines with the predominant light, warm colors to enhance the idyllic quality of the scenes.

EX COLL. Dukes of Somerset; Leopold Hirsch, London.
EXHIBITED: The Metropolitan Museum of Art, New York, 1945, *English Domestic Needlework of the XVI, XVII, and XVIII Centuries,* fig. 32 (detail).

Detail

REFERENCES: P. Macquoid, *Country Life*, LV, 15 March 1924, p. 396; Untermyer *Needlework*, 1960, pp. xix-xxi, 12–13, pls. 14, 15, figs. 25, 26; W. Digby, *Elizabethan Embroidery*, London, 1963, pp. 136–137.

358.

Valance of eight framed panels

Scottish: 1631–1640
Linen tabby embroidered chiefly in wool cross-stitch; shades of beige, red, green, blue
Heraldry: arms of Campbell of Glenorchy (Glenurchy) impaling Campbell of Loudoun (Louden)
H. 16¼, W. 122½ in. (41.2, 311.2 cm.)
54.7.11

The flowering and fruiting plants set with birds and animals offer a charming but naive version of a decorative treatment popular in England and France, where it was handled in more sophisticated fashion in the sixteenth and early seventeenth centuries. The coat of arms is of particular interest. The St. Andrews cross in the first quarter is the canton of a baronet of Nova Scotia. The seventh Laird Campbell was one of the first Scottish gentlemen to join the new order of "Knights Baronets of New Scot-

EXHIBITED: The Merchants Hall, Edinburgh, 1966, *Needlework from Scottish Country Houses*, no. 1.
REFERENCES: E. Standen, *Connoisseur*, CXXXIX, 1957, pp. 196–200, figs. 6–10; Untermyer *Needlework*, 1960, p. 17, pl. 24, fig. 38; M. Swain, *Historical Needlework: A Study of Influences in Scotland and Northern England*, New York, 1970, pp. 4–5, 19, figs. 7, 8.

359.

Men's or women's leather gloves with embroidered cuffs

English: first half 17th century
Purple satin embroidered in colored silks, wrapped silver-gilt thread, bullion, and spangles; satin, float, long-and-short stitches, couching; bobbin lace trim in silver-gilt thread, silk tabby trimming; silk taffeta lining to lobes (64.101.1244, 1245)
White satin embroidered in colored silks, white silk floss in long-and-short and raised satin stitches, French knots, couching; wrapped silver and silver-gilt thread, bullion, spirals, spangles, wrapped silver-gilt bobbin lace edging; silk taffeta lining and trimming (64.101.1246, 1247)
White satin embroidered in colored silks, wrapped

358

land" evolved under James I. Each member, in return for 1,000 merks and six men sent out to Nova Scotia, was entitled to more than 10,000 acres there, and the prefix and suffix *Sir* and *Baronet*, his wife becoming *Lady, Madame and Dame*. The initials at the top of the shield include those of the titles, a practice recorded on old Scots buildings as well, and stand for Sir Colin Campbell, the eighth Laird, and his wife, Juliana Campbell, daughter of Sir Hugh Campbell of Loudoun.

EX COLL. Loudoun Castle, Galston, Ayr., Scotland (contents sold on the premises, 18–21 October 1921).

silver-gilt thread, bullion and purl; trimmed with silver-gilt bobbin lace, spangles; chain, satin, long-and-short, semi-detached needlepoint fillings, French knots, raised work, couching; trimmed with ribbed salmon silk tabby ribbons (64.101.1248, 1249)
L. 12–14, Gr.W. 5½–8¼ in. (30.5–35.5, 14–21 cm.)
64.101.1244–1249

Important accessories during Queen Elizabeth's reign (1558–1603) and that of her successor, James I (1603–25), gloves were often mentioned in inven-

tories and prominently displayed in portraits. The hands were usually of thin leather, the cuffs of precious silks with elaborate, sometimes emblematical ornament, embroidered by accomplished ladies, or by professional embroiderers. Elizabethan gloves were more close-fitting, with rounded fingertips and sometimes deeply scalloped cuffs, than gloves of the Stuart period, which are larger and fuller with a wider gauntlet cut straight at the edge, and an opening at one side held together by strips of leather or ribbon. Our gloves show characteristics of both periods. "Sweet," or scented, gloves were an especially complimentary gift, as were gloves used to contain a gift of gold coins, like those acknowledged by the irreproachable Sir Thomas More from a lady seeking to bribe him: "It would be against good manners to forsake a gentlewoman's New Year's gift, and I accept the gloves; the lining you will be pleased to bestow elsewhere."

EXHIBITED: The Metropolitan Museum of Art, New York, 1945, *English Domestic Needlework of the XVI, XVII, and XVIII Centuries*, figs. 11 (64.101.1246, 1247), 13 (64.101.1248, 1249).
REFERENCES: A. B. J. Wace, *Bulletin of the Needle and Bobbin Club*, I, XVII, 1933, pp. 18–19, fig. 5 (64.101.1248, 1249); Untermyer *Needlework*, 1960, p. 6, pl. 3, fig. 5.

360.

Two hand screens: A pelican in her piety and St. Hubert enclosed in quatrelobed medallions, wreathed in roses, carnations, poppies, and columbines, clasped with fleur-de-lis and ribbon bow on silver ground

French: second half 17th century
Hemp tabby embroidered in silk and silk yarn wrapped with strips of silver and gold foil in tent stitch (underside couching for metal threads on pelican screen); edged with wrapped gold bobbin lace; wrought iron handles with four tortoise-shell panels inlaid with brass foliate patterns (originally silvered?)

Gr. H. 17, Gr. W. 6½ in. (43.2, 16.5 cm.)
64.101.1377, 1378

Seligman and Hughes call these "fire-fans," explaining that such objects were an essential part of mantelpiece decoration until the mid-nineteenth century. People obliged to cluster around fires for warmth used them to shield faces that were often enhanced with wax-based cosmetics.

EX COLL. G. Saville Seligman.
REFERENCES: Seligman and Hughes, pp. 56–57, pl. XVII-B; Untermyer *Needlework*, 1960, p. 60, pl. 151, fig. 194.

361.

Panel: Tree with fruits, flowers, animals, and birds

English: first quarter 17th century
Linen tabby embroidered in silk tent stitch, couched and laid work, gobelin stitch; white, shades of pink, yellow, blue, green, and brown, with black outlines; traces of underdrawing in black paint or ink visible where stitches have dropped out
H. 22¼, W. 24 in. (56.5, 61 cm.)
64.101.1305

A decorative and fairly coherent arrangement of motifs from herbals, samplers, and pattern books of

the sixteenth and early seventeenth centuries, this recalls the ancient Tree of Life, or the Garden of Eden. The tree, with its varied fruits and flowers, is inhabited and surrounded by birds, insects, and floral sprays; it is flanked at ground level by animals. Across the bottom is a band of water filled with fish, on which a swan floats. A kingfisher is in the foreground. At top is a sun, crescent moon, and star, all set off by a cloud border.

EX COLL. Mrs. Wight-Boycott (Sotheby's, 11 December 1931, fig. 65).

EXHIBITED: Lansdowne House, London, 1929, *Loan Exhibition of English Decorative Art, in Aid of the Invalid Children's Aid Association,* no. 242, pl. 48; The Metropolitan Museum of Art, New York, 1945, *English Domestic Needlework of the XVI, XVII, and XVIII Centuries,* fig. 44.

REFERENCES: *Bulletin of the Museum of Fine Arts,* Boston, XXXII, April 1934, p. 27, fig. 4; Untermyer *Needlework,* 1960, p. 27, pl. 47, fig. 72.

362.

Picture: Months of the Year

English: second quarter 17th century
Linen tabby embroidered in wool, silk, wrapped
 silver thread, purl; in tent, back, gobelin, cross-,
 float stitches, and couching; black, cream, shades
 of red, pink, yellow, blue, green, brown

H. 20½, W. 22½ in. (52.1, 57.1 cm.)
64.101.1324

Classical and medieval shepherds' calendars pictured the activities of the countrymen's year; during the Renaissance, a tiny engraving of the activity of each month was set at the top of each printed calendar page. The designer of 362 evidently combined a series of these engravings depicting sowing, reaping, shearing, and haying as seen in earlier times. The activities, well spaced, are clearly labeled. The graybeard warming his knees at a fire in January is one of these traditional figures, though he is usually associated with December. The figures wear seventeenth-century English dress and are placed among English oaks, willows, and fruit trees. The blue green background is set with various large flowers from Elizabethan herbals.

EX COLL. Second Viscount Leverhulme, London (Anderson Galleries, New York, 2–13 February 1926, p. 239, fig. 511).

EXHIBITED: The Metropolitan Museum of Art, New York, 1945, *English Domestic Needlework of the XVI, XVII, and XVIII Centuries,* fig. 45.

REFERENCE: Untermyer *Needlework,* 1960, pp. xxxvi, 33, pl. 60, fig. 91.

363.

Casket top with portrait of a lady

English: third quarter 17th century
White satin embroidered in silks, wrapped silver
 and gold threads, bullion, silk-wrapped purl,
 spangles, tiny silk-wound paper strips; in padded
 satin, long-and-short, split, stem, float, and gob-
 elin stitches, French knots, and couching; shades of
 pink, yellow, green, blue, brown; sepia under-
 drawing visible around face where stitches have
 fallen out or were not worked (tendrils of hair)
 and in wall behind the figure; narrow silver gal-
 loon edging of same date
H. 12¾, W. 17¼ in. (32.4, 43.8 cm.)
64.101.1326

Said to be by Elizabeth Coombe, the most celebrated needlewoman of her time, associated with the court of Charles II. The elaborate materials and

stitches support this suggestion, as does the extraordinarily fine underdrawing. Many accomplished young women of the time, however, seem to have presented their gentlemen friends with appealing self-portraits of scarcely less demanding work, drawn first by some artist and then mounted by a cabinetmaker on the cover of a casket.

EX COLL. A. S. Davis, London.

REFERENCES: A. S. Davis, *A Collection of Stuart Needlework*, London, n.d., pp. 1, 12, fig. 9; Untermyer *Needlework*, 1960, p. 34, pl. 62, fig. 95.

364.

Picture: Four Elements and Five Senses

English: second quarter 17th century
Linen tabby embroidered in silk in tent, knot, moss, and rococo stitches; black, white, shades of red, pink, yellow, green, blue, brown
H. 16, W. 21½ in. (40.6, 54.6 cm.)
64.101.1315

The Elements appear in traditional classical personifications in the corners: Fire with the flaming phoenix, Air with the birds of the heavens, Earth with the cornucopia, Water pouring fish from her urn. The Senses, in seventeenth-century dress, are spaced throughout the flowery, fruitful landscape under a beaming sun and a rainbow spilling drops. Sight is a girl holding a mirror and combing her hair. Sound is a lady playing a lute. Taste is a gentleman emerging from a tent with a glass of wine, a well-set table before him. Scent is a lady with a pot of flowers, holding the choicest to her face. Feeling is a girl with a pet dove pecking her outstretched hand.

REFERENCES: P. Remington, *Metropolitan Museum of Art Bulletin*, October 1945, ill. pp. 52, 54; Untermyer *Needlework*, 1960, pp. xxxiii, xxxv, 30, color pl. 55, fig. 82.

365.

Book binding with medallion of King David as a young man playing the

harp (*front*), *as old man with scepter* (*back*); *containing* The New Testament (*Richard Whittaker, London, 1633*) *and* The Book of Common Prayer (*Robert Baker, London, 1636*)

English: second quarter 17th century
Medallions: colored silks, wrapped gold and silver threads, and purl; satin, long-and-short stitches, and couching. Cover: various wrapped metal threads, wires, purl, bullion, and spangles (overlaid to form inner frame of medallions); gobelin, tent stitches, flat and padded couching; black, white, shades of green, blue, pink, mauve, yellow
H. 7, W. 4½ in. (17.8, 11.4 cm.)
64.101.1294

A later, handwritten inscription says that this book belonged to Archbishop Laud; Laud tried to introduce more color and ceremony into the English church and was executed for "popery" by Charles I in 1645. The bookplate is that of Armine Wodehouse, Bt., Agincourt. David, the Old Testament figure, was one of the Nine Worthies of the Middle Ages and Renaissance. He appears in similar pose in Nicolas de Bruyn's engraving of the Nine Worthies, probably published in Antwerp, and on the title page of the Bible engraved by John Payne, published by Thomas and John Buck, Cambridge, 1629. The figure of the old David on the back cover is seen on the title page of the third volume of Gerard de Jode's *Thesaurus sacrarum,* the *Thesaurus Novi Testamenti* (Antwerp, 1585). Many other contemporary engravings may have been the sources for these superb needlework versions. The technical mastery of the cover as a whole indicates professional work, perhaps by a member or members of the Broderers' Company.

EXHIBITED: British Antique Dealers' Association, Christie's, London, 1932, *Art Treasures Exhibition,* no. 288, pl. 288; The Metropolitan Museum of Art, New York, 1945, *English Domestic Needlework of the XVI, XVII, and XVIII Centuries,* fig. 22; Walters Art Gallery, Baltimore, and Baltimore Museum of Art, 1957, *The History of Bookbinding: 525–1950 A. D.,* no. 426, pl. 75; Museum of Fine Arts, Boston, 1973, *Nancy Graves Cabot: In Memoriam,* pp. 30–31.

REFERENCE: Untermyer *Needlework,* 1960, pp. xxvi-xxviii, 22–23, color pl. 37, figs. 57, 59.

366.

Embroidered picture: Story of Abraham

English: mid-17th century
Bast tabby embroidered in silk tent stitch with satin-stitch details (eyes); black, white, shades of red, pink, orange, yellow, green, blue, brown
H. 21¾, W. 36⅛ in. (55.2, 91.7 cm.)
64.101.1306

Combines scenes from a series of engravings of the story of Abraham by Gerard de Jode after Martin de

Vos (1532–1603) in the *Thesaurus Veteris Testamenti.* Angels announce the coming birth of Isaac while Sarah listens in the doorway, Abraham dismisses Hagar and Ishmael, and Abraham prepares to sacrifice Isaac. The floral border set with birds, animals, and insects is rare in Stuart embroidered pictures but is seen in contemporary Flemish engravings and pattern books. Some other needlework pictures depicting the same story in whole or part, in an interesting range of treatments but all clearly from the same source: a petit-point panel sold at Christie's 21 April 1966, no. 156 (Abraham and the announcing angels, listening Sarah, departing Hagar and Ishmael); a picture with similar frame showing Sarah, Abraham, and the angels, in the Royal Scottish Museum (M. Swain, *Historical Needlework: A Study of Influences in Scotland and Northern England,* New York, 1970, pl. 19); a departure of Hagar and Ishmael in the Untermyer Collection (64.101.1301, Untermyer *Needlework,* 1960, fig. 66); a small version of the same, formerly in the Untermyer Collection, present whereabouts unknown (ibid., fig. 51); the sacrifice of Isaac, part of a much larger story of Isaac embroidered on white satin, Untermyer Collection (64.101.1321, ibid., fig. 88); and the right two-thirds as seen in 366 in a tent-stitch long cushion in the Victoria and Albert Museum (*Guide to English Embroidery,* Victoria and Albert Museum, London, 1970, no. 47). A panel with an earlier episode in Abraham's life to the left, the whole closer in drawing style to de Jode's engravings, was sold in 1970 (Sotheby's, 29 May 1970, no. 26). This picture's superb Renaissance border suggests a late sixteenth-century date and a possible Flemish attribution.

EX COLL. Percival D. Griffiths, Sandridgebury, near St. Albans.

EXHIBITED: The Metropolitan Museum of Art, New York, 1945, *English Domestic Needlework of the XVI, XVII, and XVIII Centuries,* fig. 46; Museum of Fine Arts, Boston, 1973, *Nancy Graves Cabot: In Memoriam,* pp. 24–26, fig. 16.

REFERENCES: Seligman and Hughes, pl. 75, fig. B; M. Bolles, *Antiques,* XLIX, 1946, p. 165; N. G. Cabot, *Bulletin of the Needle and Bobbin Club,* 1/2, XXX, 1946, pp. 33, 36, fig. 24; Untermyer *Needlework,* 1960, pp. xxix-xxx, 27–28, color pl. 48, fig. 73.

367.

Coronet cushion top

English: mid-17th century
White satin (warp at right angles to design) embroidered with silks, silver and silver-gilt wrapped threads, purl, flat silver, flat silver gilt, spangles, beads, bullion; flat and padded couching, raised work, long-and-short stitch, flat and padded satin stitch, stem, knot, and bullion stitches; red, cream, black, shades of pink, yellow, green, blue, lavender
H. 20⅝, W. 20 in. (52.7, 50.8 cm.)
64.101.1295

Coronets were stored on cushions with elaborate symmetrical designs. This one has a central fountain with sea horses in the lower corners, and, at the top, a Tudor rose flanked by thistles. Such cushions are depicted in pictures of British nobility, according to G. Saville Seligman and T. Hughes, who illustrate two (Seligman and Hughes, pl. 66). This kind of work was done by members of the Broderers' Company.

EX COLL. A. S. Davis.
REFERENCES: A. S. Davis, *A Collection of Stuart Needlework,* London, n.d., p. 13, no. 15; Untermyer *Needlework,* 1960, p. 23, pl. 39, fig. 60.

368.

Embroidered picture: Music-making in a garden

English: mid-17th century
Linen tabby embroidered in silk tent stitch; shades of green, blue, beige, brown, red, yellow; fine ink underdrawing showing in unfinished heads and hands
H. 14, W. 21½ in. (35.6, 54.6 cm.)
64.101.1314

The technical perfection suggests professional work. A formal garden in upward-tilted perspective with a few figures in the foreground was a popular treatment of the time. It occurs in a style close to this,

for example, in Crispin van de Passe's Summer Garden in the *Hortus Floridus* (Arnheim, 1614) and as the title page in N. Cochin's *Livre Nouveau de Fleurs très util pour l'Art d'Orfeverie, et Autres* (Moncornet, Paris, 1645). A similar title page for a book of music may have furnished the composition of this little picture with its fashionable ladies and gentlemen holding carefully delineated lutes, pochette, and flute, with Eros and the spirit of Music above.

EX COLL. W. J. Holt, London; Mrs. W. J. Holt.
EXHIBITED: Lansdowne House, London, 1929, *Loan Exhibition of English Decorative Art, in Aid of the Invalid Children's Aid Association,* p. 47, no. 279, color pl. 36; The Metropolitan Museum of Art, New York, 1945, *English Domestic Needlework of the XVI, XVII, and XVIII Centuries,* fig. 47.
REFERENCES: A. J. B. Wace, *Old Furniture,* II, 1927, ill. p. 119; ibid, III, 1928, pp. 125–126, ill; M. Symonds and L. Preece, *Needlework through the Ages,* London, 1928, pl. LXVIII, caption no. 1, p. 286; A. J. B. Wace, *Bulletin of the Needle and Bobbin Club,* I, XVII, 1935, pp. 25–26, fig. 9; *Connoisseur,* XCVIII, 1936, p. 151, ill. (Mrs. W. J. Holt collection); F. Morris, *Art News,* XLIV, November 1945, p. 18, bottom fig.; P. Remington, *Metropolitan Museum of Art Bulletin,* October 1945, ill. pp. 51, 54; Untermyer *Needlework,* 1960, pp. xxxiii, 29–30, pl. 54, fig. 81.

369.

Embroidered picture: David and Abigail (1 Samuel 25:14–35)

English: mid-17th century
Linen tabby embroidered in silk tent stitch, details in outline stitch; white and brilliant shades of russet, rose, green, blue, yellow; underdrawing outlined in India ink, shaded in graphite; some areas tinted
H. 16½, W. 21½ in. (41.9, 54.6 cm.)
64.101.1325

A professional undoubtedly made the beautiful preliminary drawing left visible by the incomplete needlework. The even stitchery suggests a professional embroiderer as well. Many of the figures in

ground figures and central tree in forms of but-
tonhole stitch; setting in finely worked tent, satin,
long-and-short, split, stem or soumak, and gobe-
lin stitches; knot, seed, plaited braid, stockinette;
saddle applied cut velvet
Embroidered inscription: S L adjoining picture at
lower left; traces of similar letters or numbers at
lower right; pink on blue tent stitch
H. 16¾, 21 in. (42.5, 53.3 cm.)
1974.28.200

Embroidery in relief, known as raised work, existed
in England for a hundred years and on the Conti-
nent for at least a hundred and fifty before a specif-
ically English version developed in the second half
of the seventeenth century. Girls are believed to
have been the main producers of the numerous
pictures, caskets, mirror frames, and other raised-
work objects that were usually mounted by cabi-
netmakers. An artist probably composed and
sketched on the linen ground the unusually skillful
and sensitive Old Testament scene of 370. The tents
and turrets in the background, the Elders of Gilead,
the single warrior in front of them, and Jephthah
himself are taken from different scenes in a series on
the life of David (*Patientias Davidis Regis et Prophetae
in Israel*) engraved by Johann Sadeler after paintings
or frescoes by Martin de Vos. Only the figure of
Jephthah was reclothed. The others wear Roman
armor, as they do in the engravings.

EX COLL. Percival D. Griffiths, Sandridgebury, near St.
Albans; Mrs. Emily Hesslein (Sotheby's, 30 March
1962, lot 99).

this and in 370 were taken from a series of prints of
the life of David (*Patientias Davidis Regis et Prophetae
in Israel*) engraved by Johann Sadeler after paintings
or frescoes by Martin de Vos. Yet the effect is dif-
ferent. The four Roman warriors used as the Elders
of Gilead in 370 appear here on a hill as some of the
"young men of David." Abigail, though in seven-
teenth-century dress, is in her traditional pose,
kneeling with arms crossed on her breast. The tents
and spires in the background, also seen in 370, are
elaborations of the originals in de Vos, by way of
Sadeler. The boy who bears a shield at the left
appears reversed in 370, leading a prancing horse.
The brilliant, smooth finish of David and Abigail
contrasts with the great variety of stitchery and
detail in 370. The David scene is decorative, the
Jephthah scene emotionally moving. Perhaps we see
here the essential difference between the work of a
competent professional and a loving amateur.

EXHIBITED: Museum of Fine Arts, Boston, 1973, *Nancy
Graves Cabot: In Memoriam,* p. 32, figs. 24, 25.
REFERENCE: Untermyer *Needlework,* 1960, pp. xlv, 34, pl.
60, fig. 92.

370.

Embroidered picture: Jephthah's Return (Judges 11:34)

English: second half 17th century
Linen tabby embroidered in colored silks; fore-

REFERENCES: M. Symonds and L. Preece, *Needlework through the Ages,* London, 1928, pl. LXVIII, caption no. 2, p. 286; P. Remington, *Metropolitan Museum of Art Bulletin,* October 1945, ill. pp. 53, 54; M. Bolles, *Antiques,* XLIX, 1946, p. 166; *Notable Acquisitions: 1965–1975,* The Metropolitan Museum of Art, New York, 1975, p. 298.

371.

Portrait of Charles II

> English: late 17th century
> Thin satins, molded in part over wood (?); some with painted decorations in blue, gold, black, details of face in brown paint; couched black and white silk cord on belt, linen needle lace jabot and sleeve ruffles; brown silk floss hair; gold foil laurel wreath
> D. 8½ in. (21.6 cm.)
> 64.101.1330

Adapted from the frontispiece to Moses Pitt's *English Atlas* (Amsterdam, 1680), engraved after a painting by J. B. Caspers, National Gallery, London.

EX COLL. C. W. Dyson Perrins, England (Sotheby's, 24 April 1959, lot 37).
EXHIBITED: Young Women's Christian Association, London, 1932, *Loan Exhibition Depicting the Reign of Charles II,* no. 418.
REFERENCES: Untermyer *Needlework,* 1960, pp. xl–xli, 36, pl. 66, fig. 100; A. F. Kendrick, *English Needlework,* 2nd ed., London, 1967, p. 134.

372.

Portrait of Queen Anne crowned by Fame and Peace

> English: first quarter 18th century
> White satin backed with linen tabby embroidered with silk; split, stem, back, satin, and raised satin stitches, French knots, laid work; black, white, shades of red, pink, yellow, green, blue; some details in ink and glass seed pearls
> H. 25, W. 20 in. (63.5, 50.8 cm.)
> 64.101.1353

Based either on a state portrait of Queen Anne by Sir Godfrey Kneller (1648–1723), court painter, or from a mezzotint after it by John Smith. The skillful embroidery is probably professional. A more modest double portrait in tent and gobelin stitches of Queen Anne and Prince George of Brunswick in the Metropolitan Museum (39.13.9), thought by some to be her predecessors William and Mary, was possibly derived from the same portrait.

EX COLL. H. H. Mulliner; Second Viscount Leverhulme, London (Anderson Galleries, New York, 24–27 February 1926, lot 28).
EXHIBITED: The Metropolitan Museum of Art, New York, 1945, *English Domestic Needlework of the XVI, XVII, and XVIII Centuries,* fig. 54.
REFERENCES: H. H. Mulliner, *The Decorative Arts in England: 1660–1780,* London [1924], fig. 190; Untermyer *Needlework,* 1960, pp. xlvi–xlvii, 50, pl. 116, fig. 154.

373.

Portrait of George II

> Woven by John Van Beaver (active 1732–50)
> Irish, Dublin: about 1737
> Wool and silk tapestry in original painted and gilded pine frame, made in Dublin, 1738
> Frame inscribed at top: The Workemanship of John Vanbeaver/Yᵉ Famous Tapistry Weaver; sides: G R II; bottom: Alexʳ Riky/Master/Richᵈ Whelling, Willᵐ Beasley/Wardens A.D. 1738
> H. 29¾, W. 23¾ in. (75.5, 60.3 cm.); frame: H. 56½, 36½ in. (143.5, 92.7 cm.)
> 64.101.1331

The helmets and gauntlets carved on the frame are a reminder that George II (r. 1727–50) fought at the battle of Oudenarde, 1708; he was the last English king to take part in a battle. The portrait is adapted from a 1717 mezzotint by John Smith after a painting by Geoffrey Kneller of 1716, showing George II as Prince of Wales; the long wig is more typical of 1716 than 1738. He wears the collar of the order of the Garter. John Van Beaver is probably the "famous face-maker" that Robert Baillie, a Dublin upholsterer, according to his petition to the Irish House of Lords in 1732, said he had brought from

Flanders to work in his tapestry manufactory. Van Beaver gave the portrait to the Dublin Weavers' Guild, who, on 1 January 1738, ordered the frame. The tapestry hung in the principal room of the guild's hall until 1840, when it was acquired by Richard Atkinson, a textile manufacturer (sold at Christie's, 12 March 1959, no. 140).

EXHIBITED: Grosvenor House, London, 1959, *Antique Dealers' Fair.*
REFERENCES: G. N. Wright, *An Historical Guide to Ancient and Modern Dublin,* London, 1821, p. 212; W. C. Stubbs, *Journal of the Royal Society of Antiquaries of Ireland,* XLVI, 1919, p. 65; F. Warner, *The Silk Industry of the United Kingdom,* London, n.d., p. 376, pl. XLI; A. K. Longfield, *Journal of the Royal Society of Antiquaries of Ireland,* LXVIII, 1938, p. 99, pl. XI; idem, *Burlington Magazine,* LXXXV, October 1944, pp. 254, 257, pl. II C; A. K. Leask, *Country Life,* CXXV, 14 May 1959, p. 1088; *Connoisseur,* CXLIV, 1959, p. 26; G. S. Sandilands, *The Studio,* CLVIII, October 1959, p. 118, ill. p. 121; Untermyer *Needlework,* 1960, pp. 36–37, pl. 67, fig. 101.

374.

Panel (one of three) from a set of bed or furniture fittings

English: first quarter 18th century
Linen tabby embroidered in chain, split, satin, buttonhole, and darning stitches; wool flowers in brilliant colors, pale yellow silk scale pattern around edges
H. 21½, W. 53 in. (54.6, 134.6 cm.)
64.101.1346b

Unlike Elizabethan floral patterns, the flowers of eighteenth-century designs usually fit exactly in their allotted spaces. The artful disorder of the flowers here is based on two floral sprays, an X-spray with profile carnation and a Y-spray with three small profile tulips, with X X Y closely juxtaposed. In the other panels of the set (50.176 and 64.101.1346a) the schemes are X Y and X Y Y. The scale pattern edging the design is sometimes found as a background diaper.

EX COLL. W. R. Hearst.
REFERENCES: Untermyer *Needlework,* 1960, p. 43, pl. 90, fig. 128.

375.

Pair of bed curtains with chinoiserie and bizarre designs

French: first quarter 18th century
Linen tabby embroidered in silk and wool in large cross-stitch and small tent stitch; white, black, shades of red, orange, yellow, green, blue, aubergine, brown, gray
(1) H. 134½, 34½ in. (341.7, 87.6 cm.); (2) H. 137½, 34½ in. (349.3, 87.6 cm.)
53.32.1, 2

The astonishing decorative style reflects, in the exotic figures and their exotic occupations, a romantic view of China derived from illustrations in books by Western travelers. Combined with these are

376.

Dalmatic

French: mid-18th century
Linen embroidered in wool chain stitch, details in
 buttonhole stitch and French knots; shades of red,
 pink, yellow, blue, green, aubergine, light brown
Gr. H. 42, Gr. W. 40 in. (106.7, 101.6 cm.)
54.7.2

Church vestments in the eighteenth century were
often decorated as lightheartedly as anything else.
Here, delightfully fantastic fruits and flowers com-
bined with stylized roses and carnations are bril-
liantly realized in *point de chaînette,* the favorite
French crewelwork stitch of the time. This same
entrancing ornament is also seen on contemporary
French brocaded silks and on embroidered or
painted cottons made in India for the French mar-
ket.

REFERENCE: Untermyer *Needlework,* 1960, p. 60, pl. 156,
 fig. 199.

377.

Overmantel panel: May Day

English: first quarter 18th century

unidentifiable designs from a series of so-called
bizarre silks, much used in the early eighteenth
century but of still undetermined origin. Strange
flowering and fruiting trees and exotic long-tailed
birds enhance the scene. Fierce fantastic animals,
seemingly recalled from the Romanesque period,
crawl agilely through the decorative confusion. All
are depicted in an extraordinary range of colors on a
brilliant yellow ground. It is hard to realize that this
style, seen frequently in early eighteenth-century
French canvas work, represents the first ungainly
throes of the elegant French rococo style.

EXHIBITED: Virginia Museum of Fine Arts, Richmond,
 1945, *The Human Story in Needlework,* no. 56.
REFERENCES: E. A. Standen, *Metropolitan Museum of Art
 Bulletin,* December 1954, pp. 144–147; *Antiques,*
 LXVII, 1955, p. 420, fig. 6 (detail); Untermyer *Nee-
 dlework,* 1960, pp. lxiii–lxiv, 59, pl. 144, color pl. 145,
 figs. 187, 188.

Bast tabby embroidered in wool tent stitch, details
in silk; black, white, shades of blue, green, or-
ange, yellow, brown
H. 21¾, W. 49¾ in. (55.2, 126.4 cm.)
64.101.1355

A spring day in the country is lovingly detailed
here, from the busy gardener, wandering milkmaid,
and shepherdess and shepherd, to the dance around
the Maypole. The figures and activities are probably
adapted from one or more engravings, but their
naive *joie de vivre,* the pale blue and white of the sky,
and the fresh greens of the setting are contributions
of the embroideress.

REFERENCES: E. Naramore, *Farm on Fifth Avenue,* New
York, 1951, ill. on cover; *Childcraft,* X, Chicago, 1954,
pl. 58; Untermyer *Needlework,* 1960, pp. xlix-l, 51,
color pl. 119, fig. 157.

378.

Screen or overmantel panel: The Chase

English: 1730
Bast tabby embroidered in wool tent stitch, details
in silk; black, white, shades of blue, green, red,
yellow, brown; frame in shades of light brown,
russet, cream
H. 47¼, W. 47⅜ in. (120, 120.3 cm.)
64.101.1356

In England, in the first quarter of the eighteenth
century, embroidered pictorial fire screens or over-
mantel panels, often tent-stitch scenes of hunting,
fishing, country life, and country estates, became
more popular than needlework pictures. The hunt in
the foreground of 378 is adapted from "The Chace,"
the second in a series of four hare-hunting scenes by
John Wootton (1678–1765), a painter of hunts and
races; the series, painted for Lord Oxford, was en-
graved by Bernard Baron in 1726. Perhaps the
embroideress herself—a Miss E. C.—changed the
hare to a fox and supplied one of the houses in the
background as well as the bucolic middle group
with cows, herdsmen, and sweethearts. Her initials
and the date 1730 appear in a cartouche at the top.

EXHIBITED: The Metropolitan Museum of Art, New

York, 1945, *English Domestic Needlework of the XVI,
XVII, and XVIII Centuries,* fig. 57.
REFERENCES: A. J. B. Wace, *Bulletin of the Needle and Bobbin
Club,* I, XVII, 1935, p. 33; N. G. Cabot, *Antiques,* XL,
1941, p. 368; *Antiques,* LIII, 1948, p. 114; Untermyer
Needlework, 1960, pp. l-li, 51, color pl. 120, fig. 158.

379.

Carpet: signed E. N., 1743

English
Bast tabby embroidered in wool in cross-stitch;
beige, brown, shades of red, aubergine, orange,
yellow, green, blue
H. 110, W. 69 in. (279.5, 175.3 cm.)
62.1

Carpets in heavy yarns and simple stitches were
worked at home after being drawn by a professional
designer who also supplied the yarns.

EXHIBITED: Lansdowne House, London, 1929, *Loan Ex-
hibition of English Decorative Art, in Aid of the Invalid
Children's Aid Association,* no. 349, pl. 72; Parke-Ber-
net, New York, 1942, *French and English Art Treasures of
the XVIII Century,* no. 577.
REFERENCES: A. F. Kendrick, *English Decorative Fabrics of
the XVI-XVIIIth Centuries,* Essex, 1934, p. 8, pl. 47;
C. E. C. Tattersall, *History of British Carpets,* Benfleet,
Essex, 1934, p. 103; Untermyer *Needlework,* 1960, pp.
lii, 47, pl. 107, fig. 145; A. F. Kendrick, *English Nee-
dlework,* 2nd ed., London, 1967, p. 148.

380.

Painted and embroidered picture: Cherry Ripe

English: end of 18th century
Hand-colored aquatint, painted silk tabby em-
broidered in floss and plied silk; satin, split,
long-and-short, float, and knot stitches; white,
shades of pink, brown, green, blue, mauve
H. 20⅛, W. 16½ in. (51.1, 41.9 cm.)
64.101.1357

The aquatint was engraved by A. Cardon for

L. Schiaronetti, 25 June 1795, after paintings by Francis Wheatley for a set entitled *The Cries of London*. A romantic pastoral setting for the cherry seller, her swain, and two little buyers was achieved by cutting away the engraving's dingy London streets and placing the figures against a skillfully painted sky, distant lake, and mountain, surrounding them with embroidered trees, barn, cottage, and mossy foreground. Except for heads and hands, the figures are embroidered mostly in glossy float stitches of silk floss. Pictures in this mixed technique were popular at the end of the eighteenth century. This is one of the most delightful of the group.

REFERENCE: Untermyer *Needlework,* 1960, pp. lii-liii, 52, pl. 123, fig. 161.

CLOCKS

The entries are by
CLARE VINCENT,
Associate Curator, Department of Western European Arts.

Abbreviations

Untermyer *Furniture, 1958* J. Gloag and Y. Hackenbroch, *English Furniture with Some Furniture of Other Countries in the Irwin Untermyer Collection,* Cambridge, Mass., 1958

381.

Hooded wall clock with calendar

English (London): about 1670
Case of ebony veneer on oak, gilt-bronze mounts;
 dial of gilded and silvered brass signed A. Fro-
 manteel Londini
H. 19½ in. (49.5 cm.)
1974.28.93

Ahasuerus Fromanteel, according to Brian Loomes (*Country Clocks and their London Origins,* London, 1976, pp. 32–53), was born in Norfolk in 1607 and trained there as a blacksmith. He established himself as a maker of iron turret clocks in London before 1630, and he probably died there in 1693. In 1657, he sent his son John to The Hague to learn the secret of the newly invented Huygens pendulum, and the following year the Fromanteels were advertising their pendulum clocks as the first in England. The movement of 381 has the shaped plates and short or bob pendulum characteristic of Fromanteel's early pendulum clocks. It is of eight-day duration, strikes hours, and it is equipped with a shutter device to maintain power while the clock is being wound. The use of the pendulum necessitated a new form of case for the movement, and early English pendulum clocks were housed in wooden cases of severely architectural character. The applied Doric columns supporting the architrave and pediment of 381 are of unusually pleasing proportions. A similar case belonging to a clock by Edward East, Fromanteel's contemporary, now in the collection of Lord Harris, indicates that Fromanteel and East patronized the same casemaker. Little is known, however, of the seventeenth-century London specialists in ebony cabinetry for clocks.

EX COLL. Lionel H. Moore.
EXHIBITED: Science Museum, London, 1952, *British Clockmaker's Heritage Exhibition,* p. 39, no. 84, ill. on cover.
REFERENCES: *Various Properties,* sale cat., Sotheby's, 8 July 1960, no. 117; *Notable Acquisitions: 1965–1975,* The Metropolitan Museum of Art, New York, 1975, pp. 264–265.

382.

Longcase clock with calendar

English (London): late 17th century
Case of walnut veneer on oak; dial of gilded and
 silvered brass, signed Joseph Knibb London
H. 77 in. (192.5 cm.)
1974.28.92

Knibb (1640–1711) was an outstanding London clockmaker of the same generation as John Fromanteel and Thomas Tompion. The movement of 382, of eight-day duration, is composed of three trains and strikes the hours and quarters on separate bells. It is of twelve-pillar construction with latched plates, the front plate removable in three sections so that any of the three trains can be separately exposed. The gilt and mat dial has a silvered brass skeleton chapter of hours that is typical of Knibb's finest work, as are the blued and chiseled steel hands. The simple, elegantly proportioned case is also typical of Knibb's clocks. The hood, made to slide upward in the standard seventeenth-century fashion, is framed by baroque columns and fretwork in the design especially associated with clocks made by the Knibb family. The broken pediment at the top was originally flanked by finials, and probably a third finial once surmounted the shell motif at the center. While similar crests are commonly found on Knibb's earlier clocks, certain features, such as the elaboration of the winged cherub heads in the spandrels of the dial, the pattern of the hour hand, and the substitution of a calendar for a chapter ring to register the seconds, would indicate that this clock was probably made not long before Knibb's retirement to Hanslope in 1697.

REFERENCE: *Important Clocks,* sale cat., Christie's, 16 March 1972, p. 13, no. 17, fig. 17.

383.
Table clock

English (London): about 1700
Case of ebony veneer on oak; gilt-bronze mounts;
dial of gilded and silvered brass signed Thō
Tompion/Londini fecit
H. 16¼ in. (41.4 cm.)
64.101.867

Thomas Tompion (1639–1713) was the foremost clockmaker of his time. His workmanship, the ingeniousness of his designs, and the greatly improved accuracy of his timepieces contributed to a large extent to the fame of English clockmaking. (For extended discussion, R. W. Symonds, *Thomas Tompion: His Life and Work,* London, 1951.) Except where royal and other special commissions warranted the use of more elaborate decoration, the cases of Tompion's table clocks tend to be rather sober. When ebony was employed, he relied on the pleasing contrast of the relatively plain black wood with the bright gold and silver dial. Here, the color of the feet, escutcheons, fretwork, finials, and handle echoes the gold of the dial, converting these largely functional elements into restrained but elegant decorations. Portable table clocks were developed in England simultaneously with longcase clocks. Their durable escapements and short pendulums permitted frequent and easy movement about the house. They were especially useful when, like 383, they were provided with repeating devices that allowed the user to pull a cord at the side, causing it to strike the time at night. The movement is of eight-day duration. The splendidly engraved backplate is signed and numbered 269. A slot in the dial is provided with a false pendulum connected to the real one, allowing one to tell at a glance whether or not the clock is running.

EX COLL. H. H. Mulliner, London.
EXHIBITED: The Metropolitan Museum of Art, New York, 1972, *Northern European Clocks in New York Collections,* no. 49.
REFERENCES: H. H. Mulliner, *The Decorative Arts in England: 1660–1780,* London [1924], fig. 60; *Untermyer Furniture,* 1958, p. 8, pls. 8, 9, figs. 12, 13.

384.
Traveling clock

English (London): about 1700–10
Case of silver, partly gilded; dial of silver and gilded brass, blued steel hands; movement of brass and steel, signed Paulet London
H. 9 in. (22.8 cm.)
64.101.868

Traveling clocks were comparatively rare in the late seventeenth and early eighteenth centuries. The pendulum, which had revolutionized clockmaking in the seventeenth century, was rendered useless by the demands of travel. The most common form was that of a large watch, but small portable clocks with spring balances similar to those employed in watches were sometimes made. Here, a universal ball joint at the top allows the clock to swing from its suspension ring, cushioning the jolts of motion. Similar clocks, one in the Victoria and Albert Museum, and another in the Fogg Art Museum, Cam-

bridge, Mass., are signed by the same maker. Both a Joseph and a John Paulet are thought to have worked as clockmakers in London, but neither can be linked with certainty to these examples. Yvonne Hackenbroch has noted that the ornament of the dial and of the repoussé silver case is strongly reminiscent of the ornamental engravings that the Huguenot émigré Simon Gribelin published in his *Book of Severall Ornaments* (London, 1682). It is tempting to suggest, therefore, that the clockmaker Paulet may also have been a Huguenot. The exquisitely worked dial and case are complemented by the decorative treatment of the backplate of the movement, visible through a glass door at the back. Overlaid with plates of pierced brass, the backplate is engraved with birds and foliate scrolls. The large and prominently placed balance bridge is decorated with a false end stone, and the balance is regulated with the aid of a oversized dial of champlevé silver. The movement strikes hours and is equipped with an alarm and calendar.

EX COLL. Percival D. Griffiths, Sandridgebury, near St. Albans; Geoffrey Bowes-Lyon (Christie's, 10 December 1953, lot 9).

EXHIBITED: Parke-Bernet, New York, 1955, *Art Treasures Exhibition,* no. 205; The Metropolitan Museum of Art, New York, 1972, *Northern European Clocks in New York Collections,* no. 70.

REFERENCES: R. W. Symonds, *English Furniture from Charles II to George II,* London, 1929, fig. 68; P. Macquoid and R. Edwards, *The Dictionary of English Furniture,* rev. ed., London, 1954, I, p. 131, fig. 19; Untermyer *Furniture,* 1958, pp. 8–9, pl. 10, figs. 14, 15; H. Alan Lloyd, *The Collector's Dictionary of Clocks,* New York, 1964, p. 177, figs. 448–450; Y. Hackenbroch, *Connoisseur,* CLXVIII, 1968, pp. 143–144, fig. 18; idem, *English and Other Silver in the Irwin Untermyer Collection,* rev. ed., New York, 1969, p. 50, fig. 94.

385.

Longcase clock with calendar

English (London): probably about 1710–15
Case of burl walnut veneer on oak, walnut herringbone inlay, gilt-bronze mounts; dial of gilded and silvered brass; name plate signed D. Delander/ London/no. 13

H. 91 in. (238 cm.)
64.101.864

Daniel Delander (d. 1733) was the most distinguished member of a long-active family of London clockmakers. Apprenticed in 1692 to Charles Halstead, he later became a journeyman assistant in the workshop of Thomas Tompion. By 1706, he had set up his own establishment in Devereux Court, Fleet Street. His clocks and watches are known both for their inventiveness and their fine craftsmanship. The movement of 385 is of eight-day duration with rack and snail hour striking and with bolt and shutter maintaining power. It has an experimental escapement similar in principle, if not in construction, to the later variety known as a duplex, which is perhaps the one listed by G. H. Baillie in his *Watchmakers and Clockmakers of the World* (London, 1929, p. 95). The maker of Delander's distinctive cases is unknown. One of several variants of the same model, the case of 385 has a number of rare features: the chamfered corners of the base, trunk, and hood, the hexagonal panel in the base, and the shape of the low broken arch dial, which is repeated in the outline of the top of the door to the trunk. Equally rare is the use of gilt-bronze fretwork in the panels at the sides of the hood, the design of which was undoubtedly inspired by ornamental prints of the variety associated with Huguenot designers. The cresting of the hood has been somewhat altered.

EX COLL. Henry P. Strause, Washington, D.C. (Parke-Bernet, 23 October 1948, lot 241).

EXHIBITED: Virginia Museum of Fine Arts, Richmond, 1937, *The Henry P. Strause Collection of Clocks,* no. C-33, pl. VII.

REFERENCE: Untermyer *Furniture,* 1958, p. 7, pl. 6, fig. 9.

386.

Clock

French (Chantilly): about 1740–45
Case and dial of soft-paste porcelain on base of gilt bronze; movement signed Benjn: Gray/Just: Vulliamy/London
H. 11⅞ in. (30.2 cm.)
1974.28.91

French rococo clocks were often decorated with porcelain figures and flowers assembled from various manufactories, both European and Chinese, and mounted with French gilt bronze. Porcelain cases made specifically for clocks were less common, and it is rare indeed to find one that also has a porcelain dial. The drum-shaped case, supported by floral-decorated rocks and flanked by two figures of Chinese, evidently once contained another movement, probably by a French clockmaker. The present movement, by Benjamin Gray (1676–1764) and Justin Vulliamy (1712–97), is probably not very much later in date than the case. Gray was appointed clockmaker to George II in 1742. The following year he went into partnership with his future son-in-law, Vulliamy, and together they produced a number of clocks for their first royal patron and later for his successor.

EX COLL. Charles E. Dunlap.

EXHIBITED: The Metropolitan Museum of Art, New York, 1949, *Masterpieces of European Porcelain,* no. 109, pl. XXIV; The Metropolitan Museum of Art, New York, 1972, *Northern European Clocks in New York Collections,* no. 71.

387.

Table clock

> English (London): probably about 1775
> Case of pinchbeck metal; painted enamel dial;
> plaque signed C. Pinchbeck
> H. 12¾ in. (32.4 cm.)
> 63.199

Pinchbeck metal is, like gilt bronze, a less expensive substitute for gold. A tarnish-resistant alloy of copper and zinc, it was invented by the clockmaker Christopher Pinchbeck (1670–1732), who used it extensively for the making of watch cases. Here, it is employed for the cast rococo mounts of the case for a clock by Pinchbeck's eldest son, Christopher (1710–83). Like his father, Christopher was a maker of elaborate astronomical clocks. Appointed

clockmaker to George III, he is known to have supplied an astronomical clock to the king in 1765, now at Buckingham Palace. According to F. J. Britten, 387, made by the elder Pinchbeck, belonged to George IV when he was Prince of Wales, but his attribution seems mistaken. The general form of the case, the lightness of the ornamental scrolls and floral swags, and the rocaille formations on the plinth all indicate that the clock was made much later, by the son. The eight-day movement is equipped with an alarm and an unusual repeating device that strikes both the hours and quarters on one bell. The clock is equipped with a contemporary outer case of mahogany.

EX COLLS. Prince of Wales, afterwards George IV (?); Louis Weltje, Hansard Watt.

REFERENCES: F. J. Britten, *Old Clocks and Watches and Their Makers,* 6th ed., London, 1932, pp. 381–383; Untermyer *Furniture,* 1958, p. 10, pl. 14, fig. 23.

PAINTING BY RUBENS
AND BRUEGHEL

The entry is by
MARY ANN WURTH HARRIS,
Senior Research Associate, Department of European Paintings

388.

The Feast of Acheloüs

Peter Paul Rubens and Jan Brueghel the Elder
Flemish: about 1614–16
Oil on wood
42½ x 64½ in. (108 x 163.8 cm.)
45.141

As Ovid recounts the story in the eighth book of his *Metamorphoses,* Theseus and his friend Pirithoüs with a band of companions were making their way home to Athens when they found their path obstructed by the flooded river, Acheloüs. The god of the river invited them to his grotto to pass the time until the waters receded. Water nymphs and a triton served them a magnificent feast while the gesturing Acheloüs regaled them with tales of nymphs transformed into islands. One can see many of the features that Rubens uses in this composition in Bernard Salomon's woodcut for the Lyons edition of the *Metamorphoses* of 1557. Jan Brueghel, also called Velvet Brueghel, who frequently collaborated with Rubens, painted all but the figures. He specialized in the precise rendering of details, and followed Ovid closely in depicting the still-life elements of this banquet in a cave formed of pumice and tufa, with a mossy floor and shell-encrusted ceiling. Fruits and flowers overflow a cornucopia made of animal horn, a reference to one of Acheloüs' own horns that Hercules had wrested from his head in a battle (*Metamorphoses,* IX). Julius Held was the first to re-establish this painting's subject, which had been forgotten for a century in large part because Rubens, in choosing not to depict the plight of the nymphs, had eliminated the best clue to it.

EX COLL. Princess de Scalamare, Rome; Giuseppe de' Medici, Prince Ottaiano, Palazzo Miranda, Naples; Onorato de' Medici, Prince Ottaiano, Palazzo Miranda, Naples; Clotilde de' Medici, Dowager Princess Carafa, Duchess of Bruzzano-Medici, Palazzo Roccella, Naples; Prince di Fondi, Naples; Baron Schlichting, Paris; Julius Böhler, Munich.

EXHIBITED: Naples, 1877, *Arte antica,* sala VI, no. 13; The Lotos Club, New York, 1919, *Masters of the XVII Century;* Detroit Institute of Arts, 1936, *Sixty Paintings and Some Drawings by Peter Paul Rubens,* no. 5.

REFERENCES: J. F. M. Michel, *Histoire de la vie de P. P. Rubens,* Brussels, 1771, p. 316; J. Smith, *A Catalogue Raisonné. . . ,* London, 1830, II, p. 151, no. 527; A. van Hasselt, *Historie de P.-P. Rubens,* Brussels, 1840, pp. 301–302, no. 780; A. Michiels, *Catalogue des tableaux et dessins de Rubens,* Paris, 1854, p. 27, no. 681; Gaetano Nobile, *Descrizione . . . de Napoli,* 1863, I, p. 65; M. Rooses, *L'Oeuvre de P. P. Rubens,* Antwerp, 1890, III, p. 136; W. R. Valentiner, *Zeitschrift für bildende Kunst,* XXIII, 1912, pp. 263–264, 271, no. 11, fig. 1; idem, *Art of the Low Countries,* New York, 1914, p. 185; R. Oldenbourg, ed., *P. P. Rubens, Klassiker der E. Cammaerts, Connoisseur,* CII, 1938, p. 87; J. S. Held, *Kunst,* Berlin—Leipzig [1921], p. 459, ill. p. 117; *Art Quarterly,* IV, 1941, pp. 123–133, ill.; H. B. Wehle, *Metropolitan Museum of Art Bulletin,* March 1946, pp. 179–183, ill.; J.-A. Goris and J. S. Held, *Rubens in America,* New York, 1947, p. 36, no. 68, pls. 66, 70, 72, 79; M. de Maeyer, *Albrecht en Isabella en de Schilderkunst,* Brussels, 1955, pp. 47–49, 118; S. Speth-Holterhoff, *Les Peintres flamands de cabinets d'amateurs au XVIIe siècle,* Brussels, 1957, p. 88; H. Bardon, *Le Festin des dieux,* Paris, 1960, pp. 41–42, pl. XVII B; L. van Puyvelde, *Gazette des Beaux-Arts,* 6th ser., LXIII, 1964, pp. 93–98, ill.